EDWARD WESTON OMNIBUS

EDWARD WESTON OMNIBUS

A Critical Anthology

Edited and with Introductions by
Beaumont Newhall and Amy Conger

➜P

Gibbs M. Smith, Inc.
Peregrine Smith Books
Salt Lake City
1984

Published by Gibbs M. Smith, Inc.
Peregrine Smith Books
P.O. Box 667
Layton, UT 84041

Photographs by Edward Weston © 1981 Arizona Board of
Regents, Center for Creative Photography.

The University of Arizona claims copyright to all Edward
Weston materials and permission has been granted, sub-
ject to inclusion of the following copyright statement:

Essays, articles, manuscripts by Edward Weston © 1981
Arizona Board of Regents, Center for Creative Photogra-
phy. Used by permission.

Library of Congress Cataloging in Publication Data

Edward Weston omnibus.

 Includes index.
 1. Weston, Edward, 1886-1958. I. Weston, Edward,
1886-1958. II. Newhall, Beaumont, 1908-
III. Conger, Amy, 1942-
TR140.W45E38 1984 770'.92'4 84-3214
ISBN 0-87905-131-0

Designed by J. Scott Knudsen

Manufactured in the United States of America

Cover photograph: Tina Modotti (?), *Edward Weston with
His 8 × 10-inch Seneca View Camera with a Graf Variable
Lens, Mexico,* ca. 1924. Courtesy of The Weston Gallery,
Carmel, California.

For
Ansel Adams
April 1984

Table of Contents

Introduction

I first met **Edward Weston** in 1940 when my late wife Nancy and I visited him in California. A lasting friendship at once followed. Nancy organized his first major retrospective at the Museum of Modern Art in 1946 and wrote the catalog, the introduction to which is reprinted here. Later she edited the *Daybooks of Edward Weston,* first published in two volumes by the International Museum of Photography at George Eastman House. Weston shared with us not only his recollections of his photographic career but also his personal archives from which some articles in this anthology are reprinted.

The origin of this anthology was a scrapbook of articles from my files that I prepared as research material for the graduate seminar on Weston that I held at the University of New Mexico in 1982. To this corpus my coeditor, Amy Conger, has added articles that she has discovered during her research for her doctoral dissertation at the University of New Mexico and for the exhibition "Edward Weston in Mexico: 1923-1926," which she curated for the San Francisco Museum of Modern Art, and the accompanying catalog published by the University of New Mexico Press.

Throughout his long career as a photographer, Edward Weston won international acclaim. This anthology brings together critical essays and biographical sketches from well-known publications and obscure periodicals. It is a chronicle, written for the most part by Weston's contemporaries, of the work and career of America's great twentieth-century photographer. It thus complements *Edward Weston on Photography,* an anthology of the photographer's writings edited by Peter C. Bunnell and published by Peregrine Smith Books.

Weston was born in Highland Park, Illinois, in 1886. As a boy he took up photography, at first with a simple box camera given him by his father. At the age of seventeen, he graduated to a view camera. After a short period as a student at a commercial photographic school, he decided to become a professional portraitist, and he opened a studio in California. National recognition soon came to him; in 1916 he was invited by the Photographers' Association of America to demonstrate his portrait technique at its Cleveland convention.

In addition to his professional work, Weston produced photographs from an artistic impulse. These were of the soft focus painterly style made popular by the members of the Photo-Secession in America, the Linked Ring in England, and its successor, the London Salon. Indeed, in 1917, he was elected to membership in the London society—one of six Americans to be so honored, and the only Californian.

Around 1920 he renounced the very style for which he had been honored and began to use his camera in a more straightforward way, rejoicing in sharpness of focus and bold compositions. He perfected this style in Mexico during his stay there from 1923

to 1926. His philosophy of photography was based on the medium's ability to capture the moment and the photographer's skill to visualize the final print at the very time the shutter was released.

The following essays which document this remarkable development and follow his career up to his death in 1958 are unedited except for general standardization of punctuation, capitalization, dates, and place names.

—*Beaumont Newhall*

Preface

Some photographers and photo-aficionados believe and argue that there is something irreverent and unfair about the act of disseminating work that is not an artist's very "best." "Best," in such cases, is frequently determined by the taste of the plaintiff, often a person who was close to the artist or someone with an investment in the work of the artist — or by synonymously defining "best" and "last." I would venture to suggest that a vital artist considers his latest work as his best — and it is for that reason he is vital and still in the business. Although an artist usually admires his early work at the time it was made and admits later that it contributed substantially to his formation and his actual position, it is extremely difficult for him to evaluate it from a historical point of view.

The articles in this anthology are intended to be judged in their proper context. Weston had read most of them and they could have influenced him — or even aggravated him or amused him. As Weston's photography was related to the time in which it was made, so are these articles. Not only did Weston's style evolve, but so did art criticism. Whereas some of the early articles seem to lack criticism according to today's standards, intermediate ones often refer to Clive Bell's theory of significant form and quote heavily from Weston's *Daybooks*. A few written in the seventies suggest that the critic felt strongly that more attention should be paid to contemporary work and, at the same time, felt frustration that so few photographers since Weston had photo-graphed shells or peppers and that even fewer had done it successfully. The presence of such a variety of articles in this anthology represents an attempt to understand Weston's work within the history of art and art criticism.

The criteria we used to select the articles included in this book were basically their lack of repetitiousness (therefore, there is little on whether photography can be art), their historical importance, insightfulness, diversity of approach, the reputation of the author, and their potential to be thought-provoking. Also, articles that were relatively or virtually inaccessible were often selected instead of ones that were readily available. Illustrations were selected with similar criteria, although little-known images were preferred to ones illustrated in the major books on Weston.

We did not choose the articles because of the reoccurring cast of characters found in them. In fact, we have been surprised by it. During Weston's career in California and Mexico, few people were making significant cultural contributions. If Weston did not personally know a major cultural personage in the United States, he probably knew someone who did.

I only know Weston through his photographs, his writings, his friends, and his family. So, at times, I have questioned my qualifications for discussing his work. However, though I have never seen couples making love in his paired peppers, or shells in

his clouds, or impending death and disaster in his late works from Point Lobos, I usually realize that I am at a certain advantage having never met him. His smile, sparkling brown eyes, and laughter do not become confused with his artistic personality and I do not feel that studying less than his "best" is desecrating him—but, instead, an attempt to locate the road he took, his reasons for choosing it, as well as to evaluate his role in twentieth-century art.

—*Amy Conger*

Acknowledgments

We thank the authors, their estates and publishers, for permission to reprint the articles, and the Center for Creative Photography of the University of Arizona, and collectors, both public and private, for permission to reproduce the photographs. We are especially grateful to Ellouise Van Gulick, William and Joye Lucas, and Jack and Beverly Waltman for their help.

Picture Criticism

WESTON SAVED A COPY of this clipping (now in the International Museum of Photography at the George Eastman House) and noted on it: "First 'press-notice,' 1903." In 1945 he recalled that it had been published in Photo-Beacon.[1] The one known print of this photograph (in the Weston Estate) was inscribed in his youthful hand: " 'Spring,'/Weston '03" (figure 1). The picture, however, was not published until April 1906, two months before he moved to California, and then in Camera and Darkroom.

Three landscapes of Chicago taken by Weston in 1903 and 1904 have survived. All of them are fairly austere according to the standards of the time. Of the approximately 450 photographs which have been located that Weston took before he went to Mexico in 1923, only nine could be called landscapes. Like still life, it is a theme which he would expand upon at length in Mexico.

In July 1933, Weston commented: "I feel that my earliest work of 1903 — though immature — is related more closely, both in technique and conception, to my latest work than are several of the photographs dating from 1913 to 1920, a period in which I was trying to be 'artistic.' "[2]

—A. C.

E. H. WESTON.—"Spring," (figure 1), although it bears all the earmarks of having been made later in the year, is a more than ordinarily successful rendering of a wooded landscape. The composition is highly "satisfactory" and the treatment shows that the maker is possessed of considerable artistic taste as well as technical ability. The print, which is on a rough developing paper, is very pleasing to the eye, but the quality of the negative seems better suited to platinum. Objection may be made to the strong halation in the topmost branches, but in this case it is well made use of to give the necessary effect of distance and atmosphere. We hope to see more of Mr. Weston's work.

Camera and Darkroom 9 (April 1906): 132-33.

1. Edward Weston to Nancy Newhall, undated answer to a questionnaire, Department of Photography, Museum of Modern Art, New York.

2. Statement for retrospective exhibition, on letterhead of 683 Brockhurst Gallery, Oakland, California, July 1933.

A Symposium:
Which is the Best Picture
at the London Salon?
The Honorary Secretary Pronounces
for a Series by Edward H. Weston

IN THE FALL of 1914 the British journal, Amateur Photographer and Cinematographer, *asked several photographers which was the most interesting picture in the London Salon of Photography of that year. Bertram Park, who was also honorary secretary of the Salon, responded that Weston's five works were his favorite as a group.*

All five of Weston's pictures were done in what he himself called "High Key,"[1] although here the style is termed "Cadbyesque," a reference to the work of the British photographer and member of the Linked Ring, William A. Cadby. His style was characterized by an emphasis on the purity, innocence, goodness, and sensitive natures of children, which he expressed through the use of light-toned areas.

In four of the five pictures Weston exhibited that year, he concentrated on the higher part of the tonal scale. In one of them, the subject is a young, blonde girl (figure 4); in another, a woman posing against an impressionist backdrop of leaves and flowers; in two others, Ted Shawn dancing nude; and in the fifth, Margrethe Mather, a photographer as well as Weston's assistant and friend, dressed as Carlota, the wife of Emperor Maximilian of Mexico (figure 3).

Certainly, this note by a person as influential as Bertram Park contributed to Weston's election to membership in the London Salon of Photography in 1917, a select group of thirty-seven people, only six of whom were from the United States, and only one, Weston, from the West Coast.

—A. C.

A FEW REPRESENTATIVE WORKERS in pictorial photography have been asked by us to put on record for the benefit of our readers which they thought the best, or at any rate the most interesting picture at the London Salon: some of the replies already to hand we give below.

The task is not an easy one, and we would advise those who are anxious to improve their work to profit by the opportunity which the exhibition gives them—it is to remain open until October 17th—and study the work there carefully. It may not happen that their choice will be the same as that of any whom we have asked, but the examination of the pictures and the attention given to each individual one in order to arrive at a decision must be in itself extremely valuable. . . .

IN REPLY TO OUR ENQUIRY, Mr. Bertram Park writes: "Which is the best picture in the Salon? That is a truly difficult question to answer, but I can tell you which I think

is the best group of pictures by the same artist. They are Nos. 98, 107, 153, 169, and 172, by Edward H. Weston, of California.

"Mr. Weston is evidently a man of original ideas, sound technique, a refined artistic perception, and sense for decoration. I cannot remember having ever seen any of his work before, and it is a very great pleasure to welcome a newcomer whose pictures show such a distinctive personality. No. 107, 'Toxophilus, a Decorative Study,' is truly decorative, an extremely interesting study of a nude archer. There is very little modelling in the tones, which gives one almost the impression of silhouette. No. 98, 'Summer Sunshine,' is a more elaborate arrangement with full modelling, but nevertheless a very narrow range of tones—an admirable posed full-length figure of a laughing girl in a rather dim light of diffused sunshine. No. 153 is an essay of quite a different character—'Child Study in Grey' (figure 4). A still narrower range of tones is used in delicate grey of a style which might be described as 'Cadbyesque,' a description which will be readily understood. The expression on the child's face is delightfully

natural, fresh and sparkling—in its own way quite a masterpiece of portraiture.

"No 169, 'Carlota,' another portrait, is in a lower key (figure 3). The model, as in the last mentioned, is lit from top and from the rear, so that her face is mostly in shadow with a halo of light illuminating her profile. There is a charming softness about the work, a softness which is so different from fuzziness, and an atmosphere of refinement and mystery which is exceedingly attractive. In the last few years at the Salon, we have had perhaps too many Austrian, Hungarian, and German prints, amongst the chief characteristics of which are a forceful, almost brutal strength, and rich decisive tone values, so that the delicate elusiveness of the pictures I have mentioned appealed at once as something which gave a fresh outlook and a welcome change."

Amateur Photographer and Cinematographer 38 (29 September 1914): 250.

1. Edward Weston, "Notes on High Key Portraiture," *American Photography* 10 (August 1916): 407-12; reprinted in Peter C. Bunnell, ed., *Edward Weston on Photography* (Salt Lake City: Peregrine Smith Books, Inc., 1983): 15-17.

A David Grayson Kind of Man

J. C. Thomas

CONTRARY TO WHAT the interviewer wrote, when this article was published, Weston was just twenty-nine years old and had been in his Tropico studio for only four years. Previously, he had worked in the Los Angeles studios of George Steckel and Louis A. Mojonnier as a cameraman from 1908 to 1911 — that is, from when he returned from the Illinois College of Photography until he opened his own business in Tropico.

David Grayson was an extremely popular writer of the time and served as a role model for those seeking the joy and lack of conflicts of nature and a simple country life. His most popular book, Adventure in Contentment *(1907), was first serialized in* American Magazine. *Lincoln Steffens, later a friend of Weston, praised Grayson's "straight vision and intellectual integrity," his "sense of beauty," and "so much fine, philosophic wisdom and, most wonderful of all — serenity."[1]*

"David Grayson" was, however, only the pseudonym of Ray Stannard Baker who researched and wrote on the Negro problem, made proposals for integration (1908), and went on to write about labor unrest and collective bargaining (1920). As Woodrow Wilson's official biographer, he published eighteen volumes, for one of which he was awarded a Pulitzer Prize.

Ironically, Grayson [Baker] and Weston are alike in that the public has tended to stereotype both as easy-going, laid back, Horatian countrymen.

— A. C.

OUT IN THE TOWN of Tropico, a beautiful suburb of Los Angeles, stands a shack studio of rough boarding that is so full of art that its range of influence reaches to the ends of the earth (figure 6).

In that studio, which cost perhaps six hundred dollars to build, dreams and works Edward H. Weston, "photographer," as the simple mission-style, brown-stained sign hanging in front of the door announces.

Weston is a David Grayson sort of man and he likes to read David Grayson books. He is only thirty-one years old and has been in his location but six years (figure 5).

Last June, to the great London Salon of Photography held in the galleries of the Royal Society of Painters in Water Colors, in London, Weston sent his six best-loved pictures. Of these, five were deemed worthy by the judges of hanging beside those of the most noted photographic artists in the world.

But that was not all. Bertram Park, honorary secretary of the salon, in a burst of enthusiasm and admiration for true art, said that in his opinion the best group of photographs by the same artist at the Salon was that by "Edward H. Weston, of California."

Weston was awarded first prize at the annual convention of the Photographers' Association of America at Atlanta, Georgia, last June, and one of his pictures was hung in the National Salon. He won a loving cup for the best four photographic prints at the convention of the Northwestern Photographers' Association at St. Paul in September.

The Photographic Salon in Toronto, Canada, last May awarded him second prize and two honorable mentions.

Now for the David Grayson part of this story:

"Many of my neighbors do not believe that I am making pictures like these," said Weston one day, "or that I am really exhibiting them at the salons. They think it is some kind of hoax, because, they say, how can a photographer doing his work in a little shack like mine win the great awards? He ought to be in a large city with a splendid studio. We don't believe he makes these pictures at all.

"Why should I go to the city?" he defended himself quietly.

"Suppose I did go there, and had a fine studio with stained glass windows in one of the largest buildings? My business would probably increase. Many of the wealthy customers who want my pictures do not come out here because it is so far out of the way.

"But I would have to pay large rents, while here I pay nothing. My worries and troubles would increase as rapidly as my business.

"But, worst of all," and he glanced again at the 'Carlota,' (figure 3) "I would be forced to have many assistants to help me in details. And that would mean my pictures would lose their individuality. Now, you see, I have but one assistant, who does only the minor things for me, and I make each photograph as I want it.

"I have read David Grayson's 'Adventures in Contentment,' and it is fine. I have a little farm, too, of one acre. Sometimes I think I would like to go out there and make my living from it; but I cannot do two things at once. I have no use for money, either, except when it enables me to study the things I like and make the pictures I wish."

Weston has a way of taking photographs for customers that seems to stamp him as a genius at once. Coming into the four-by-six reception-room of the shack studio, the customer prepares his features and necktie in the arrangement that he fancies he wishes them to be in the reproduction.

He is engaged in conversation by Weston; and before the visitor is aware, he is sitting in the skylit room in a big chair, answering Weston's questions as to his likes and dislikes. He talks carelessly and entirely at ease, waiting, as he believes, for Weston to finish preparing the big camera, around which he hovers.

When the sitter has begun to get nervous again, thinking that it is time to arrange his necktie and features once more, Weston quietly asks him to move his chair over a bit, into the ray of sunlight. He is not quite satisfied with the first six plates he has taken. Then the visitor realizes that, instead of hovering over the camera, Weston has been caressing it and coaxing from it the highest form of picture art.

"Plates are nothing to me," he says, "unless I get what I want. I have used thirty of them at a sitting if I did not seem to secure the effect to suit me." By the side of the camera he has a rack holding about two dozen plates, which he slips in and out of the

camera at an alarming rate when he sees in the sitter just the expression for which he is watching.

Much like Grayson, Weston was shut up in the city for several years in a huge studio, where he did nothing but print from plates all day long, a cog in the machine. It was not until he tore himself free from the city and built his shack in the country that he began to develop his individuality and widen his artistic horizon to the ends of the earth.

American Magazine 80 (August 1915): 55-56.

1. Ray Stannard Baker, *American Chronicle: The Autobiography of Ray Stannard Baker* (New York: Charles Scribner's Sons, 1945): 239.

An Artist-Photographer

THIS ESSAY *accompanied a portfolio of seven photographs by Weston: three portraits of studio assistants and four pictures of dancers. The reason for giving attention to Weston in this way was not only to honor the quality of his work, but also, apparently, to advertise his role in the forthcoming national convention of the Photographers' Association of America. This convention, the thirty-sixth, was held in Cleveland during the week of July 24, 1916, and was attended by about 1300 people.*

This was an opportunity not only for professional photographers to exhibit competitively, to examine new photographic equipment, and meet with dealers, but also for them to learn how to improve their profits. Lectures were delivered on "Art Principles as Applied to Photography," "Studio Advertising," "Direct-By-Mail Advertising," "The Photographer as a Business Man," "Personality in Business," and "Building a Business." Formal demonstrations were given on the importance of the receptionist's work and different retouching techniques. Six photographers, including Weston, lectured on their individual styles for coping with portraiture.

In the program for the convention, Weston was introduced: "Mr. Weston specializes in pictorial portraiture. While he is but a young man, his work has won honors and admiration both here and abroad. I am sure our members will be glad of the opportunity of seeing Mr. Weston work."[1]

Later his presentation was described in Photo-Era:

"The demonstrations were unusually attractive and brought out many new things. Those who were selected to instruct their fellows did so cheerfully and gave fully of their ripe experience. Edward H. Weston advocated using a small portable camera and then enlarging these negatives up to the size desired. Small cost of production, more natural and life-like pictures and portability were given as the desirable features. In his studio-work he used a spot-light to get cross-lighting effects with good results. Lightings were arranged as usual, and the light from a Mazda, Blue Bulb, 100-watt lamp was used to direct the light from the back. The light was filtered through two thicknesses of black mosquito netting. His 'bread and butter' work is of the class that is unusual in most studios."[2]

About 3500 prints by amateur and professional photographers were exhibited at the convention. Fifteen of them were added to the permanent collection of the Photographers' Association of America, including one by Weston. This was the third consecutive year in which he had been honored in this way and it was an unusual distinction, as was also the fact that he and his work were published in The Camera.

—A. C.

OUR COVER DESIGN for this month has been selected from the work of Mr. Edward H. Weston, of Tropico, California. We have picked out this particular subject, not merely for the exhibition of its admirable features, but more particularly for another quality which his work possesses and which is essential to all art, but here specially emphasized—that is, decorative effect. The motive being of less consideration in the scheme of the picture than the general impression it produces by artistic management

of the masses of light and shade and the adroit association of pleasing lines, so that the space allotted the design has all things in harmonious relation gratifying to the eye and appealing to the delight the mind has for symmetry and grace, a kindred effect to that by beautiful rhythm and verbal melody in poetry.

The striking feature in Mr. Weston's work is its originality. His schemes of illumination are unusual, but no attempt is made for effect by any sensational exhibit. Everything is in accord with Nature's way in the distribution of light and shade, and hence, though unexpected, always pleasing because always natural.

The novelty of the presentation is further heightened by the skill displayed in the association of the subject with the surroundings. The accessories are adapted to the motive of the picture. They are few and simple, and act supplementary to interpret the scheme presented and never divorce the attention from the essential topic. The unity of the picture is thus preserved and the main impression emphasized, while at the same time it is kept in perfect harmony and relation with the other parts of the picture, which act as a support to it. The space relations are also well considered to make the portrait head or figure fit properly into the dimensions assigned it. The balance of lines is well preserved, and the association of the masses of light and shade so managed as to give a pleasing, artistic, but not too pronounced, relief.

Altogether, Mr. Weston's work has the charm which an admirably painted portrait possesses, and his examples make a valuable object lesson of the application of high art principles to photography, and demonstrate the fact that technical skill and legitimate work by the camera may be intimately associated with the best art of the painter to make something beautiful and, withal, true.

Mr. Weston will demonstrate at the National Convention at Cleveland, and every progressive photographer is sinning against his light if he fails to avail himself of this valuable opportunity of learning how such beautiful results as these are secured.

The Camera 20 (June 1916): 343-44.

1. *Photographic Journal of America* 53 (May 1916): 224.

2. *Photo-Era* 37 (September 1916): 143.

Looking for the Good Points

Sidney Allan

SIDNEY ALLAN was a pen name used by Sadakichi Hartmann, one of the better-known if not always better-respected photographic critics in the United States at this time. By October 1915, he and Weston had corresponded; he had offered to review some of Weston's prints and Weston had sent him several. Two years later, in the same series of essays, he would review another of Weston's female portrait heads, although somewhat less enthusiastically. [1] Meanwhile, Weston made at least two portraits of Sadakichi dressed in a kimono.

The model for this composition, which was first exhibited in 1914, was Margrethe Mather, who was dressed and posed as Carlota, the wife of the would-be Emperor of Mexico, Maximilian of Austria (figure 3).

Since no indications of a Maximilian-Carlota revival have been found which might have inspired Weston, the possibility exists that he was already interested in Mexico. It was not uncommon for him, however, to assign literary titles to his portraits.

—A. C.

EDWARD HENRY WESTON of Tropico, California, has made quite a stir of late. He belongs to the truly artistic pictorialist class. He seems to be specially fond of making large prints of the unusual size of 11 × 14½, or thereabouts, and they are, as he writes to me, not enlargements, one of the favorite methods of California photographers, but regular contact prints. Those I have seen were in a delightful high key and sun-diffused to such an extent that the whole image was exceedingly soft without being exactly blurred. The California photographers will yet surprise us. The weather conditions favor them, and they are learning to utilize the "drawing by the sun." They are bound to excel in new and startling lighting schemes.

The print under discussion is one of Weston's smaller prints, and apparently, as the title indicates, meant more as the study of a type or a costume study than a portrait (figure 3). It has been manipulated at the back of the head, and also the thin light line on the upper part of the fan seems to have been put in by hand. Peculiar is the halation around the outline of the profile. You will notice a certain vague shimmer which repeats the contour of the face, or in other words, extends the light flesh values into the dark background. The painters call it to "envelop" a line or form. It is, strictly speaking, nothing but a softening process, the blurring of a line that without it would look too harsh. The face in this print is rather light, and the background as dark as it can be. Thus, without some softening of outline the effect would be that of a silhouette, too precise for any pictorial composition of this kind.

The pose is quite an individual one. By this we mean peculiar to the characteristics of the sitter, which in the depiction of a type is of special importance. It is expressed in the braced-up attitude of the spine, the

throwing back of the shoulders and the turning of the head with a sideway glance of the eye. The arm akimbo (as far as one can judge from what is visible) and the holding of the fan help to make up this somewhat unusual pose. And yet despite the Spanish or Mexican reminiscences of fan and mantilla, the figure does not look posed but quite natural. That is its special charm.

The profile shows exquisite light and flesh values, and its shape is sufficiently pleasing to the eye to dominate the somewhat dark tonality. The bright plane of the face is balanced by the touch of light on the shoulder, by the light seen through the fan, and the vertical streak of light in the background. The latter is a truly pictorial accomplishment. Generally, only a painter would think of such a thing.

The average professional seems never to understand the apparent perversity of the artist in his preference of introducing all sorts of flourishes and textural incongruities that a skilled operator would call crudities. For the desire of the pictorialist goes beyond faultless technique and perfect studio lighting, as he wishes primarily to realize the pictorial idea, his conception of the theme, and he makes both light and model accessory.

Bulletin of Photography 19 (November 1916): 472-73.

1. Sadakichi Hartmann, "Looking for the Good Points," *The Camera* 22 (September 1918): 460-62.

Epilogue: Poem Suggested by Mr. Weston's Picture

Y. Billy Rubin

THE PHOTOGRAPHER *Imogen Cunningham described this picture of Margrethe Mather and a shadow arrangement (figure 8) as an intellectual photograph.[1] Although Y. Billy Rubin was inspired when he saw it published in* Photo-Era *and wrote a poem about it, the picture seems to have disturbed the patterns of thought and vision of a few pictorialist photo critics. Wilfred A. French, editor of the magazine, wrote:*

"The beholder who would decide for himself the significance of the episode expressed by Edward Weston in his capricious design, 'Epilogue,' needs the gift of a fertile imagination. It is, perhaps, idle to speculate as to artist's intent, which may have [been] none other than to create something strikingly unconventional, based upon a plausible theory of design. There seems to be a logical connection between the well-placed aesthetic figure, which monopolizes the center of interest, and the decorative vases—but let those that study this arrangement on the front cover and repeated on the frontispiece—amid the cooling breezes of the seashore or the mountains, form their own conclusion. The reviewer, confined in his sun-baked office, is content to relinquish this pleasure to others."[2]

F. C. Tilney, in his annual review of the London Salon, showed even less comprehension in his comments: "I naturally finish with the 'Epilogue' . . . kindly supplied by Edward Weston. I cannot understand it. Is it modern art expressing disdain of naturalism?"[3]

It is not difficult to understand why Weston stopped sending his photographs to salons at about this time.

—A. C.

A dim gray ground
 For a bold black figure;
A soft vague light
 To lesson the rigor.

The stems rising up
 With their blossoms like mist;
Aware of a future
 Whose present they've kissed.

The vase's soft tale
 Of dreams that have been;
Dreams all unknown
 But to those who've looked in.

A line sloping down
 To a far greater mystery;
Adding and making
 Of the whole—quite a history.

Then a figure so svelt,
 A face so enticing;
With its languorous look,
 Half repelling, half inviting.

An arresting hand up,
 A fan poised perfectly;
With its arch and its line
 As if held for eternity.

A tale of what passed,
 And a hint of that to be
Are gracefully shown
 In this picture-fantasy.

Photo-Era 45 (November 1920): 231.

1. Letter from Imogen Cunningham to Edward Weston, 27 July 1920, Center for Creative Photography, University of Arizona, Tucson.

2. Wilfred A. French, "Our Illustrations," *Photo-Era* 45 (August 1920): 96.

3. F. C. Tilney, "Some Pictures of the Year: A Critical Causerie," *Photograms of the Year 1919* (London: Iliffe and Sons, Ltd., 1919-1920): 32.

Photographs as True Art

Rafael Vera de Córdova

ALTHOUGH THIS ARTICLE seems rather uncritical, it is particularly important because it is one of the factors that led Weston to move to Mexico in the summer of 1923. From his correspondence, it is evident that he had an exhibition in Mexico in the spring of 1922 which was arranged by the director of the Department of Fine Arts, Ricardo Gómez Robelo, whom Weston had photographed in Los Angeles in 1921 (figure 9) and by Roubaix de l'Abrie Richey, who was a fabric designer, Weston's friend, and Tina Modotti's husband. Weston's photographs were enthusiastically received in Mexico and when he heard about it, he mentioned it happily: "Tina wrote me the exhibit a great success in Mexico — 'already many of your prints have been sold' — 'a prophet is not without honor' etc. — I think I have sold two prints in the many years I've exhibited in U.S."[1]

This was not, however, a one-person show but included works by Roubaix (Robo), who died six weeks before this article was published; by Margrethe Mather, a photographer whom Weston had known since about 1912 and with whom he shared his studio in Tropico; and by Jane Reece, a well-known pictorial photographer from Ohio who had visited California frequently and had been friends with Weston since at least 1917, if not 1911. She had also done portraits of Robo, Tina, and Edward in 1919. No information has been found on the other three artists mentioned, even taking into consideration that their names are almost certainly misspelled.

The author compares these "artistic photographers" with a counterpart in Mexico, Gustavo P. Silva, who is the same photographer Weston mentioned in his Daybooks:

"That mad Mexican photographer came yesterday [to Weston's exhibit in October 1924 at the Aztec-Land Gallery], tells Tina, and after raving, and waving and tearing his hair, went up to a certain 'Torso,' exclaiming, 'Ah, this is mine — it was made for me — I could —' and with that he clawed the print from top to bottom with his nails, utterly ruining it. Tina was horrified and furious, but it was too late. 'I will talk to Sr. Weston,' said Silva. 'The print is mine, I must have it!' Tina was called away and later found that the mount had been signed — 'Propiedad de Silva' [Property of Silva]. I don't know whether Silva is really mad or only staging pretended temperament; if the latter, I could quite graciously murder him. Either way, the print is ruined."[2]

Two years later in the house of friends in Mexico, Weston saw some "life-size heads, 'hand colored' photographs — . . . by the famous Mexican artist-photographer, Silva" and he called them "fried photographs."[3]

The layout for this article consists of four photographs connected to the text by art deco motifs. Of the four, surprisingly, none were by Jane Reece, despite the extended description of her work in the text. Two of the reproductions were of works by Margrethe Mather done about 1918-20 and two by Weston: a full page, backlit portrait of Tina holding a fan in an oriental dance position from 1921; and a portrait of Ricardo Gómez Robelo, standing in front of a batik by Roubaix de l'Abrie Richey which Weston took in April 1921 and titled "Poesque."

—A. C.

ONE MORNING in the majestic building of the National School of Fine Arts, I ran into Mr. Gómez Robelo (figure 9) for the first time after many years of wanting to do so. He was trembling with emotion; he said to me with his eyes sparkling: "Come, come with me and you will see something delightful. . . ." and he almost dragged me by the hand to the administrative office of the school. There, on a table, was a large, silent and enigmatic canvas suitcase, stamped with seals from Customs. With a pagan and mystic religiosity, the refined author of "Satyrs and Loves" slowly lifted the top, and there, in front of my eyes sprang up the dazzling colors of some rare polychrome cloths and the living, light and dark breath of the most superb photographs.

"You have here, my friend," said the distinguished poet, "what I lovingly brought from abroad, batiks, playful fabrics, hand dyed by the most original artists from the United States, drawings and pastels with a vibrating, floral luminosity by Blaine, whom you knew in that charming city in California, Los Angeles, passed in front of me. And also, this collection of photographs that are true works of art within the purest aesthetic criteria."

And there in the official precinct of our works of art, in front of the prestige of old Mexican signatures, the Gallic and Saxon names of the batiks, pastels, drawings, and photographs that Ricardo Gómez Robelo showed me gently made me smile cordially. They were not foreign to my eyes, but, instead, evidence of the undeniable fraternity of true art, without provinces and borders.

I fondly remembered the plain and cordial welcome that Mr. Blaine, the stupendous American artist, had for me there in luminous and flowery California, and so many others that like him said to me affectionately in cold moments of exile: "You, Mexican artist, are welcome here," and that happened during the times when the Yankee mind was most up in arms against ours; when, in our honor, Hearst fabricated the most distorted anti-Mexican propaganda; however, in the meetings of Californian artists, where Ricardo Gómez Robelo's warm and knowing words were listened to apostolically and lovingly, defending our country, in favor of artistic and social culture, opinions about Mexico were extraordinarily favorable. It was then that Gómez Robelo began for this epoch the cultural and artistic exchange that exists between the two peoples despite lack of official recognition. Already someone has said that art does not have borders, nor a homeland, nor absurd laws that restrict it.

Today, with true affection, we are publishing in *El Universal Ilustrado* as an exclusive, some photographs that the administration of the National School of Fine Arts has had the kindness to lend us and that belong to the exhibition recently inaugurated in the gallery of that school.

It is there we see the very serene art of Mrs. Jane Reece. We are surprised by a head of Christ that is divided like a stained glass window and that has a very powerful emotional quality in the religious style of the Spanish painter José Ribera.

There is still more in the works by this pleasant artist—a photograph that is subdued and sorrowful; it is a rhythmic black woman, hiding the heat of her nudity in a large wide tunic; she is posed, adoring a

marble or gesso head that is lying on the ground. Perhaps Mrs. Jane Reece was inspired for this "photographic painting" by the biblical passage about the daughter of Herodias and made a modern Salomé out of the smooth splendor of the black race.

Edward Weston and Margrethe Walther [Mather], two formidable artists from Glendale, California, are the most splendid organizers of linear and chiaroscuro harmony, which they have interpreted knowingly in these compositions. These artists already are known throughout almost the entire world for their original compositions and for the prizes, medals, and diplomas— which they deserved—conferred upon them in different international exhibitions. So, just like them, Mrs. Reece, who is today exhibiting in Mexico, has obtained a first prize in photography at the National Exhibition of London. Each of those now showing here has been justly recognized in San Francisco, Los Angeles, Chicago, New York, Paris, etc.

These artists do not obtain good results by mere chance circumstance; they apprenticed in studios in order to accomplish serious things with the same calm and love that an artist working in color would have done.

But they did not work in photographic studios like those in which our beginning photographers work, places full of rigid and tormenting iron machines that immobilize the sitter by the neck in front of a background daubed with a temple and where he is represented with a ridiculous life view of a scenic park, of a romantic staircase with royal peacocks in the style of Martínez Sierra, or little lakes like Enrique Serra. No, in their studios, they produce works of art without artifice or tinsel. Instead, the artist shows a simple ornamental motif on the nude walls, a discreet choice of light to catch the subject's attitude and movement along with the psychological moment—as Rodin did in his Parisian studio. [They learn] the exact moment in which to release the camera to record on the plate all that is prepared and preconceived in the supreme sincerity of art. Gómez Robelo said to me: "And this distinguished work that you see is not merely the product of someone who is concerned with developing or printing well; no, it is not the craft of photographic technique that produces this. It is that and something more, much more; it is artistic culture which they have; it is that supreme refinement produced by good living: private libraries, fine music, museum visits, and the cultivation of taste, far from all vulgar banality."

And we see these words justified in the few examples we have in Mexico of artistic photographers: Gustavo P. Silva works with his camera in the style of the great American artists; he searches for the light and for the exact moment for himself and his subject. He never worries about whether the head is rigid or the eyes focused, as the professional photographers usually do. No, he arrests the exact moment and type that interest him. What we see in Silva's photographs is a very distinct pictorial emphasis found most infrequently in others.

But let us go on analyzing the American work that has provoked such enthusiasm in Mexico. In one glance we see the twilight landscapes of Horwietz, an artist from Los Angeles who has found poetry in eucalyptus trees in the style of Javier Martínez and who has great possibilities in his work with masses and values. Arnold Scoroder of San

Francisco presents proud figure studies that have deserved the warmest eulogies from the intelligent public, and last, we will occupy ourselves with the adorable and delicious work of that wasted artist, Roubaix de l'Abrie Richey, the author of the batiks that masterfully decorate this exhibition with refinement and elegance.

Roubaix de l'Abrie Richey was a Gallic designer. He collaborated with Gómez Robelo on "Satyrs and Loves," leaving in this book a work of strong spirituality that looks like the most "chic" of luxuries. In the batiks, cloths hand dyed by a rare procedure, he reaches the height of the exquisite in decorating them, dyeing them with all the exotic qualities of a colorful thousand and one nights. They are tapestries of illusions, miraculous cloths that you believe to have already seen far away in some mysterious and marvelous castle. They are cloths that have all the prestige of antique jewels and modern gems, and that make you dream of being a human being in a cloak of wonder, that you will be involved, idyllically, with a princess from the Far East. . . .

Translated by Amy Conger from *El Universal Ilustrado* 255 (23 March 1922): 30-31, 55.

1. Edward Weston to Johan Hagermeyer, undated, Center for Creative Photography, University of Arizona, Tucson.

2. *The Daybooks of Edward Weston, Vol. I: Mexico,* ed. by Nancy Newhall (Millerton, N.Y.: Aperture, 1973): 99. Hereafter referred to as *Daybooks I.*

3. Ibid.: 195.

The Edward Weston Exhibition

Francisco Monterde García Icazbalceta

FRANCISCO MONTERDE GARCIA ICAZBALCETA, editor of the Mexican avant-garde cultural magazine Antena, *was so impressed by Weston's exhibit at the Aztec-Land Gallery from October 15-31, 1924 that he wrote the following review for his magazine.[1] The verbal images which he created describe photographs which Weston hung in that exhibition.*

This was Weston's second major one-person show in Mexico and it consisted of between seventy and one hundred prints, all of which apparently had been made during his year there. His work was once again well received by the visitors and the press. One newspaper wrote:

". . . an entirely new conception of the possibilities of photography as a medium for the transmission of ideas is presented. . . .

"In Mr. Weston's work, one finds a new idea, an individual expression which might be considered as a coming together of science and art."[2]

Weston commented on this exhibit in his Daybook: *"Yes, my work is far in advance of last year: the striving, the sweat—though expended—is not so obvious in the prints."[3]*

—A. C.

THE PUPIL OF WESTON'S eye, circumscribed and clarified by his lens, is like a gunsight, and we have been presented with its conquests.

He has looked through it, as through a telescope—actually a Cyclops—to catch medallions of clouds, molded in high relief.

Encountering his aqueducts that go on stilts, one shrinks, becoming a citizen of Lilliput, and pulls up a part of the circus tent, pale with a trapeze artist's daring, with a childlike anguish, thinking about Monday morning.

And in the sea fields, his periscope steals fragments of the tide, frozen, like Niagara in winter.

From the light of his magic lantern emerge—enlarged—the Indian toys, the soul made out of cardboard, of reeds, and of clay: the profile of a little horse on wheels; the agrarian attitude of dolls with weapons, riders on the mules of Corpus Christi, and the sonorous silliness of the piggy-banks pretending to be fruit, posed on top of the bowls made from gourds that we discovered barely three years ago.

In order to portray ladies, Weston puts on a diplomat's monocle.

Like a lord, he looks at them from above, downward, creating a distance between them and his monocle that is both disdainful and respectful (disdainful, because it is necessary; respectful, because of the total beauty).

He loves sober English interiors where there is only a woman and a painting, a woman and a shade plant; but, cruelly, he prefers to guillotine heads in the noon sun: unreal necks and martyred eyes in harsh, insolent light.

He also has a telescope with which he focuses on the tips of ecstatic pine trees

(figure 13), and he looks out a window to see a well in the patio that is dying of thirst and a fountain, choking with mossy water.

So, looking downward, he catches the vertigo created by archaeological flights of stairs that fall down like ridges of a waterfall, or by the trunk of a palm tree that keeps rising like the arrow shot by a native archer.

Weston's close-up views of the pyramids, alone, make one feel the weight of the centuries that lies heavily on Teotihuacán.

But, afterward, he relieves us by presenting that Christmas landscape the railroads give away: a wax miniature in the cavity of a nut.

Landscapes. Landscapes.

The naive cubism of adobe houses, cut away unexpectedly by the surprise of the road, as they must be seen by birds—more fortunate than aviators.

The eloquence of ruins, devastated by the fingernails of time. Expressive admiration for the organ cactuses. A cross that dominates the width of that plaza in the town where all the neighbors died. Light that has passed through a sieve of leaves that protect the corner between the basin and the fountain.

And women.

The Woman, nude—like in Rouveyre [French designer]—artificial, painted, and improved.

To see nudes Weston uses an enlarging lens—when not a microscope—and patiently dissects their anatomy with a surgical pleasure.

The flesh of women—a riddle: where is the face—flesh oppressed from anguish or swollen from pleasure. Isolated breasts that stare at us, looking out of a fan of modest fingers.

The quiet maternity of the hand that wrinkles the silk kimono. The bronze torso, worked and polished like a virginal icon a thousand years old.

Woman nude in the sun: the temptation of the adolescent who looks through a crack at the servant's sunbath. A chaste, partial view of the torso, without sex or age. A perfect triangle, formed by the equidistant points of the breast and the center of the stomach. Breasts offered by manicured fingers; breasts, like fruits that will fall when ripe.

Translated by Amy Conger from *Antena* (November 1924): 10-11.

1. Reprinted as "Fotografías de Weston," *Forma* 2 (1928): 15-16; and in *Antena* in *Revistas literarias mexicanas modernas* (Mexico City: Fondo de Cultura Económica, 1980): 88-89.

2. "Weston's Exhibition This Year Shows Examples of Unusually Beautiful Photography," *El Universal* (27 October 1924, English news section): 2.

3. *Daybooks I* : 96.

A Transcendental Photographic Work: The Weston-Modotti Exhibition

David Alfaro Siqueiros

From December 1925 to August 1926, Weston was in California. On his return to Mexico with his son Brett, he was greeted by Tina Modotti in Guadalajara and an exhibition of his work was held in the State Museum in that city.

Two reviews of this show were published in the local papers. The headlines of one of them read: "Weston, the Emperor of Photography, Has a Latin Soul Despite His Birth in North America."[1]

The other was written by the painter David Alfaro Siqueiros who was then working in Guadalajara. Although there is no evidence that Weston and Siqueiros had met, it was almost inevitable since the number of artists and intellectuals in Guadalajara was small, and Weston must have seen Siqueiros's mural work at the Preparatoría in Mexico City. Further, they had such friends in common as the muralists Diego Rivera, Xavier Guerrero, and Dr. Atl; and the Governor of Jalisco, José Guadalupe Zuno, who may have purchased six prints by Weston at this time.

The review by Siqueiros was meaningful to Weston and he commented on it in his Daybook: *". . . Alfaro Siqueiros, painter, writer, radical, wrote a most intelligent, brilliant article which though directly concerned with the work exposed, might be read as an exceptionally understanding treatise on photography."[2]*

—A. C.

THE GREATEST PRAISE that can be given to the photographic work of Mr. Weston and Ms. Modotti, internationally renowned photographers now exhibiting their most select creations for the public of Guadalajara in a room of the State Museum, is that it consists of THE PUREST PHOTOGRAPHIC EXPRESSION; actually, the work of Weston-Modotti is the most impressive demonstration of what can be done and what MUST be done with the camera.

The immense majority of photographers (I especially want to refer to the ones who want to be called "serious photographers" or "artistic photographers") actually waste those elements, that is, the physical factors which are innate to photography itself; they sacrifice them searching for "pictorial" character; they assume that photography can follow the same needs as painting, and they dedicate themselves to making falsifications of primitive Italians, of decadent portraitists, of aristocratic European women, of impressionist painters, and of poor painters from the last fifty years.

With the same photographic elements — or perhaps with less than most photographers use to lie and to deceive the others and themselves with "artistic" TRICKS, Weston and Modotti create TRUE PHOTOGRAPHIC BEAUTY. Material qualities of things and of objects that they portray could not be more EXACT: what is rough is rough; what is smooth, smooth; what is flesh, alive; what is stone, hard. Things

have determined proportion and weight, and they are located at a clearly defined distance in relation to each other. In the feeling of REALITY that the works of these two great masters impose on the viewer, it is necessary to seek TASTE, BEAUTY, [and] PHOTOGRAPHIC AESTHETIC — which not only is different from PICTORIAL AESTHETIC by its very naturalness, but is diametrically opposed to it. One of the important values of photography is the organic perfection of details, a value that with the exception of the painters of the most detestable epoch of the history of painting, the academic epoch, has not concerned any painter of the good schools. In one word, the BEAUTY that surrounds the works of the photographers with whom we are concerned — and for this reason its great value — is simply PHOTOGRAPHIC BEAUTY; beauty which is absolutely modern and which is destined to have a surprising development in the future.

The photographers Weston-Modotti know perfectly well, and they demonstrate it in their works, that the only possible point of contact that can exist between good photography and good painting (a point unknown to the "artists" who wish to paint with photography) is that in good photography, as in good painting, EQUILIBRIUM, that is a RHYTHM of dimensions, directions, and weights within determined proportions must exist; the same applies to a wall that must be decorated as to a sensitized plate upon which a photographic image is going to be impressed. This is the reason why in the works of these masters, a group of factory chimneys (figure 10), an arrangement of cube-houses, the positioning and inclination of a woman's torso are always the cause for profound beauty.

I firmly believe that the understanding and observation of industrial photography — that which is intended to excite the public about merchandise as perfectly and as explicitly as possible — especially admirable industrial photographs of machinery — was useful to the photographers Weston and Modotti in order for them to find the exact route of photography as a GRAPHIC AND AUTONOMOUS MANIFESTATION and, therefore, [to isolate] its VERY OWN BEAUTY; a route that they have naturally enriched with all the complementary factors that were missing and indispensable to simple, industrial photography.

Intellectuals, painters, photographic technicians, and, in general, all intelligent men and friends of beautiful things have the magnificent opportunity at this moment to admire in a room at the State Museum what is perhaps the most transcendental work of contemporary photography.

Translated by Amy Conger from *El Informador* (Guadalajara: 4 September 1925): 6.

1. "Weston, El Emperador . . . " *El Sol* (Guadalajara: 5 September 1925): 1.

2. *Daybook I:* 128-29.

Edward Weston and Tina Modotti

Diego Rivera

IN 1923, before Weston had even been in Mexico a month, Tina took him to the Secretaría, showed him the murals by Diego Rivera, and introduced him to the artist whom she had met when she was in Mexico in 1922. Although they were handicapped at first by a language barrier, admiration, respect, and friendship developed between them. They followed each other's work closely and strengthened, if not influenced, each other stylistically.

Upon seeing the proofs of portraits Weston had made in the fall of 1923 of his wife, Guadalupe (Lupe), Diego paid him the ultimate compliment: "It bothers the painter to see such photographs."[1] Then, from one of the two dozen Graflex portraits Weston made of Diego in the Secretaría in November 1924, Diego painted his own self-portrait.

In January 1926, Weston commented: "Diego is a profound admirer of photography. 'I want to write about your work sometime,' he said. And—'the exhibit you mention of machinery and modern painting must reveal the painter's weakness. The best brains of our day, the strength, has gone into the machine. All the modernists are sentimental. Picasso is, except in his cubism. I like the work of Marcel Duchamp, but I like your photographs better.' "[2]

Four months later, Weston added:

"Diego often said he would write an article on photography. He did, and Frances [Toor] published it in the current Mexican Folkways. *The title is 'Edward Weston and Tina Modotti.' Though personalities enter in, it is really a lucid commentary on the art of today—and photography. 'Few are the modern plastic expressions that have given me purer and more intense joy than the masterpieces that are frequently produced in the work of Edward Weston, and I confess that I prefer the productions of this great artist to the majority of contemporary, significant paintings.' I should be pleased—and am—by such words."[3]*

—A. C.

A FACT THAT has been accepted by everyone for a long time is that photography set painting free. Photography marked the boundaries of the field between IMAGE, that is, a copy of the appearance of the physical world, and PLASTIC CREATION, a category that falls within the art of painting and for whose particular reality, PARALLEL TO NATURE, it is unimportant if an image of the exterior world is used. However, in order to exist, it is indispensable that ITS OWN AESTHETIC ORDER BE ESTABLISHED.

Already more than eighteen years have passed since Stieglitz, the great photographer, became one of the first men in New York to fight in favor of the work of Picasso, the renowned painter, my friend and colleague.

Our sensibilities today are not fooled by the novelty of the camera process; modern men clearly feel the individual personality of each of the authors of different

photographs, although made at the same time and in the same space. We feel the personality of the photographer as clearly as that of the painter, draughtsman, or printmaker.

Actually, camera and darkroom manipulations are a TECHNIQUE, like oil, pencil, or watercolor; and, above all, the means for expression of human personality.

One day I said to Edward Weston and Tina Modotti while we were looking at their works: "I am sure that if Don Diego Velazquez were to be born today, he would be a photographer." Tina and Weston replied that they had already thought the same thing; naturally, people would misunderstand and think that this was modernist drivel about the King of Genuine Spanish Painting, but anyone who is not a fool would agree with me. Considering Velazquez's talent to COINCIDE with the image of the physical world, his genius would have led him to choose the most appropriate TECHNIQUE for his style, that is, photography—taking into account that for Velazquez, his greatest perspicacity and power was in the VALUES he used. And I believe that Weston and his student Tina are on a parallel scale, equal to painters and other expressive artists of the highest rank and category.

There are very few examples of modern plastic expression that give me a purer and more intense pleasure than the masterpieces that are produced frequently in the course of Weston's work—and I confess that I prefer the work of this great artist to the majority of significant contemporary paintings.

Although Weston's talent has its place among top plastic artists today, and even though he is much less famous than they are in his country, the United States, they have not completely discovered him. In Mexico, where we are fortunate that he is living and creating, they ignore him, just as they ignore everything that the FOREIGN MASTER'S VOICE DOES NOT ORDER THEM TO ADMIRE. Any day that Weston wishes, the FOREIGN MASTER of the impoverished Mexican intellectual bourgeois will be able to admire what he teaches—if, in the meanwhile, Weston's modesty and indifference towards fame are not destroyed by chance or finances. Those who protested will then realize that in Europe there is no photographer of Weston's stature by a long shot. Then, in Mexico, they will realize that he exists.

Weston is the culmination of THE AMERICAN ARTIST; that is, one whose sensitivity contains the extreme modernism of the PLASTIC ARTS OF THE NORTH and the LIVING TRADITION BORN FROM THE LAND OF THE SOUTH.

Tina Modotti, his student, has created marvellously sensitive things on a plane which is perhaps more abstract, more ethereal, maybe more intellectual, which is natural for an Italian temperament; her work flourishes perfectly in Mexico and harmonizes with our passion.

Translated by Amy Conger from *Mexican Folkways* 2 (April-May 1926): 16-17, 27-28.

1. *Daybooks I:* 33.

2. Ibid.: 147.

3. Ibid.: 160.

Some Photographs by Edward Weston

Arthur Millier

WESTON LEFT MEXICO forever in November 1926 and opened a studio in Glendale, California. Within a few weeks he renewed his contact with Arthur Millier, who had just begun his thirty-two year career as art critic for the Los Angeles Times. *Millier, born in Britain, was also an etcher and a painter who often exhibited in California. He was impressed with Weston's Mexican photography and wrote the following promotional piece, describing the investment value of Weston's work.*

Millier also wrote several other columns praising Weston's work—often at the expense of other artists. Three years after this article, he expressed his continued enthusiasm for Weston's art: "Several panegyrics on Weston's photographs have been printed in these columns during the last four years, exhausting our stock of adjectives. We believe that the work and the influence of this photographer will be written large in the history of art in the West and in America."[1]

A. C.

DIEGO RIVERA, genius of the monumental frescoes in the Secretaría, Mexico City, and the first man in four centuries to "successfully epitomize a whole period and a whole people" in monumental works of art, wrote an article in *Mexican Folkways* on Edward Weston, and Tina Modotti, his pupil, whose work the mural painter had ample opportunity to study during Weston's residence and recent travels in Mexico.

Said Rivera in the course of his article:

"If Velazquez were to return to life he would be a photographer because his talent manifesting itself in coincidence with the image of the physical world, his genius would have led him to select the technique most adequate for the purpose; that is to say, photography. (Recall that the greatest subtlety, the greatest strength, just as the greatest originality of Velazquez, are to be found in his black-and-white values.) And I believe that people like Weston and Tina are on a parallel scale, equal to that of the painters and other plastic workers of their category which, in the case of Weston and Tina, is of the highest."

Further he says: "Few are the modern plastic expressions that have given me more intense joy than the masterpieces that are frequently produced in the work of Edward Weston, and I confess that I prefer the productions of this great artist to the majority of contemporary, significant paintings."

It is ironical to reflect that the most superficial draughtsman may etch a few lines on copper, sign his prints and dispose of quite a number from each plate at a higher price than Weston asks for the solitary platinum print he makes from each film, and is, usually, unable to sell. Here is a master of his art, an art which should, and will be, some day, as fashionable to collect as etchings are today, and he must make his living by portrait photography. Fortunately, the same superb artistry goes into these portraits, automatically limiting the demand to a few discriminating people.

The art collector who has really extracted the utmost joy out of his hobby has always been the one who looked ahead and bought works of art at the time of their making, when their true relation to their time was unimpaired. With the additional arts of painting, drawing and sculpture it is not always easy to separate the sheep from the goats on first sight, but in the case of Weston's photographs there is no question of their quality. It only wants a few collectors with the courage to begin. If one kind of print why not another? If this man, backed by twenty years of experiment, can see, and seize in a flash, amazingly beautiful forms, which sort of eternal recurrence can never occur again, why should his work have less value than that of the stodgiest laborer with paints or etching needle who makes at best only a poor imitation of a photograph?

Ten years from now the "John Doe Collection of Photographs" will be sought by museums and the Westons will be among the special treasures. Whisper softly the horrible thought; writing has fled before the onslaught of the camera and not a draughtsman among us can draw a line comparable to those of the chirographic artists of old China; representational painting will flee before the deadly lens of the camera. As yet it is only a thought. As Leo Katz said, while we looked over Weston's prints, "We portrait painters can still eat until you perfect your color processes." But he asked Weston to take him into his studio as a pupil in the art of photography.

Keenly sensitive artists with often unconscious instinct follow a direction which time later proves to have been prophetically guided. The future exists as well as the past and life perhaps could be run backward like a pianola roll. Before artists like Stieglitz and Weston saw and used the possibilities of camera technique, painters and sculptors were already moving away from representation and seeking symbols for their emotions which were parallel to, but unlike, the forms of the visible world. The unseen approach of the camera may have played its part in this movement.

What is certain is that, using his tools like any other artist, the photographer has enriched life with a new art which will inevitably fill a large place in the art of the twentieth century, and in the vanguard marches Edward Weston of Glendale.

Weston has found the stuff of art everywhere, in the human form and in the pure form of modern bathroom fixtures. Astonished at the uncanny sense which illuminated the silhouette of a master-potter's hand holding a clay shape, by a single thread of light round the tip of a finger, I asked him if he waited for effects of light.

"I never wait," he said. "Something equally fine will reveal itself ten feet away. I see form and photograph it in the same instant. As for diffusion and similar camera tricks, I never use them. My lens cannot be too sharp and clear."

The subject matter of these photographs is universal. Men, machines, buildings (figure 10), textures, toys, landscapes, skies (figure 13), anything that has or assumes form, and it is in his immediate sensing of — to use a hackneyed term — significant form, that Weston's artistry manifests itself. But the element of human drama enters very strongly into much of his work, as, for instance, in the almost monumental heads of

Diego Rivera's wife; of Tina Modotti; and the supremely human photograph of Rivera himself. His work with the nude is so simple and sheer that one thinks sometimes of the forms of Brancusi.

It was this 1000-year-old native art and the kind of society which could make it possible that drew Weston to Mexico, but he feels that his future lies here among his own people, and it is probable that the little studio on Brand Boulevard, with its sign, "Enter only on business. Friends and visitors please call after 5 o'clock," will be the center of his activities for years to come. Collectors should not neglect this opportunity, serious students of photography could learn much as his pupil, for Edward Weston is one of the few unquestioned masters in the new art of the twentieth century.

Los Angeles Times (2 January 1927).

1. Arthur Millier, *Los Angeles Times* (9 February 1930).

People Talked About

WESTON MOVED TO Carmel in late December 1928. He had visited there several times since the early 1920s. He now took over the Carmel studio of his friend, the photographer Johan Hagemeyer, and commented that it was ridiculous that he was moving to an artist's colony. What appealed to him about Carmel, however, was the hills, the beach—and having pine trees for neighbors, as well as the hope that the new environment would bring a fresh stimulus to his work. He did not overlook the importance of publicity and before he had been in Carmel twelve hours, he went to the newspapers and announced his arrival. [1]

The Carmel Pine Cone reviewed his successes frequently. In this article, it used the comment about the portrait of Perry Newberry to give even more local appeal to the story since Newberry was a prominent resident of Carmel, as well as a journalist, and at one point, mayor of the town.

—A. C.

EDWARD WESTON is having an exhibit at the Berkeley Art Museum. Report comes that his recent photograph of Perry Newberry is outstanding among the excellent ones in the exhibit. Someone has written the following appreciation of Weston's work:

"If I were going into partnership with a man or to marry a woman, I would want first to see a Weston portrait of him or her. It would constitute a report far more informative than any that could be submitted by a psychiatrist, a doctor, or a fortune teller.

"For presence of personality, there is all in a Weston photograph of one's parent or child that there is in the flesh. And sometimes more of the quality of giving happiness, such is the way of loved ones.

"Yet I have omitted that which is to me a precious quality about the man's photographs. They make my fingers tingle. Tingle with the feel of the milk bottle or pepper that he has pictured.

"It is the emotional quality—the surge, the feeling—that differentiates the work of genius from the work of talent.

"You have said that to yourself. You will understand as never before, exactly what you have meant, when you experience Edward Weston photographs.

"They are life, movement, energy—and emotion.

"All of this is evident in every Weston photograph, whether of a human being, a vegetable, or an object. And they are all beautiful. A beauty of which one never tires, for it is a natural beauty untouched by artificialities added before or after photographing.

"But most of all the Weston genius is evident in his portraits.

"A Weston portrait of yourself would make you introspective for days. And years from now, you would still be seeing, in it, facts about yourself unrealized before. All of character and beauty that is in you would be there, and perhaps other things."

The Carmel Pine Cone 15 (25 October 1929): 9.

1. *The Daybooks of Edward Weston, Vol. II: California,* ed. by Nancy Newhall (Millerton, N. Y.: Aperture, 1973): 101, 107. Hereafter referred to as *Daybooks II*.

The Music Society Relaxes

WESTON'S CARMEL DANCE debut, which is described in this article, took place on Monday, May 26, 1930. In his Daybooks, *he noted that for the occasion he wore a "classic Greek tunic" and "little pointed breasts." Although as Señorita Tabasco Bosco, "red-hot poker plant from the Pampas," he danced to Rachmaninoff's "Prelude in C Sharp Minor" and Mendelssohn's "Spring Song," the reviewer was sure he recognized it as "The Dance of the Crippled Onion."[1]*

His companions in this farce were mostly close friends and also men of some accomplishment. Vasia Anikeef, a Russian emigrant and a well-known singer on the West Coast, had been Weston's friend since the early 1920s and was photographed at least twice by him. Edward G. Kuster had moved to Carmel in 1920 and promoted the theater there for several years. Henry Cowell was a fairly well-known composer and actor; Weston had also taken his portrait. Dr. Laurence Bass Becking was an amateur actor and a respected scientist. He commented that Weston saw things from a scientific point of view and proposed that someday they should visit Point Lobos together and "use each other's eyes!" At the last moment, Weston proposed to Dr. Becking that he write the foreword to the pamphlet for his exhibition at the Delphic Studios in New York that opened on October 15, 1930, Weston's first one-person show on the East Coast. Becking accepted and composed the following statement:

"Natural science, as an impartial student of form, cannot but marvel at the rediscovery of fundamental shapes and structures by an artist. Weston has described the 'skeleton' materials of our earth — rock, bone, and wood — in a way both naive and ap-

pealing: in other words like an inspiring scientific treatise. He shows living matter, contorted like wrestlers' limbs, fighting the unseen forces of environment. He has seen the serene display of the spirals in the shell, the soft but stubborn curves of the kelps. . . . Reality makes him dream."[2]

—A. C.

BACCHUS INSTEAD OF BACH! Beethoven cast aside for Barnacle Bill the Sailor! And the insidious kazoo, most deadly of instruments, supplanting the classic bassoon!

Last Monday night at the Denny-Watrous Gallery, the Carmel Music Society, which has masqueraded for years as a staid and sedate organization, staged a party. A revel, a debauch, a jollification . . . a Sybaritical feast. Little did this uncritical critic [know] that he was going to have to exhaust the thesaurus, orgy department, to fully describe the society's annual meeting and frolic.

Hazel Watrous read the minutes of the last meeting. No excitement there. Dr. R. A. Kocher reviewed finances. Everything satisfactory there. President Denny rose again: "There has been nothing but praise of the past season," she began.

"I object," spoke Colonel Clair Foster, "I object strenuously! Carmel is loaded with natural talent. The Music Society has brought in high-priced outside artists. I object . . . I object. . . . " Fireworks were breaking loose.

"Second the objection!" called out Dr. Laurence Bass Becking, jumping to his feet. "It is outrageous! Shameful! I have on hand a company of artists — Carmel artists — local talent. If you would like to see what we have to offer . . ." he spread his hands.

"Bravo!" shouted the audience, "Bravo for Becking!"

And it was then that the Ladies Short-Wind Ensemble appeared. Armed with kazoos, Woolworth flutes, and tin horns, the choir sang into the exultant strains of "El Tarantula." Like our contemporary on the Alameda "Exhumer," we are unable to find words decent enough to express our opinion of the playing of the Ladies Short-Wind Choir. Marvelous, exquisite, tremendous, edifying, soul-stirring — none of these expressions apply.

Next came Señorita Tabasco Bosco, red-hot poker plant from the Pampas. With a bound that was part leap she was in the center of the room. The marihuna-drugged mask of her face surmounted by a delicate Teddy Roosevelt moustache appalled even the hardened audience.

Silence. Dead silence. Slowly the knobby knees of the dancer undulated, hairy forearms shot upward in the mechanized movements of the dance, eyes black with the misery of a tortured soul or as the result of previous engagements, turned slowly. . . . *Bingo!* The figure leaped to the piano — from the piano to the chandelier — and out of the door! "Ah-h-h-!" breathed the breathless spectators, "Tabasco, the great, the saucy Tabasco, in the Dance of the Crippled-Onion. . . ."

Señorita Tabasco must have heard. Like a living, smoking flame, a veritable kerosene torch of passionate innuendo, [before] you knew, she was back in the room. Attired in an ensemble of green baize, her toes barely pounding the floor, she would have been a study for such a photographer as Weston. Casting a flower here, a look there, she circled the stage three times, then stood in a graceless pose waiting for applause. None came. She ran, did not walk, to the nearest exit.

Then up stepped the doomed quartet. Four wretches in evening attire, they gazed with the defiance of despair at Edward G. Kuster.

Fritz Wurzmann, Doctor R. A. Kocher, Doctor Laurence Bass Becking and Vasia Anikeeff [sic] hopefully fingered "forty-eights." Of the four, Anikeeff alone seemed happy with the exulted resignation of a Russian who was doomed — and knew it. Out of work, broke, hungry and hopeless, they were to be given the chance of a local engagement. But before the try-out, Mr. Kuster thoughtfully relieved them of their armament.

"I'm Barnacle Bill the Sailor," boomed the bass, and the audience wondered why the fog horn was going on a clear night. "And I'm a fair young maiden," answered the sweet treble of Doctor Becking.

Mr. Kuster handed back the guns. Slowly they filed out. Four shots (pistol); the thud of bodies; Mr. Kuster's mocking laughter . . .

Next presented was "La Triviala," the opera which has brought tears of rage to the eyes

of millions. The company, bearing an uncanny resemblance to Henry Cowell, played and sang the parts of Madame Nitwitsky, Madame Human Crank, and Lawrence Babbits.

As he finished his rendition the impresario approached the directors of the society with an offer to pay five hundred dollars for the privilege of being allowed to perform next season. President Denny suggested that the body table the matter. A season-ticket holder suggested that the body be placed under the table.

All was over. Gazing hungrily at the refreshments was Edward Weston, photographer extraordinary. We passed on the suggestion that Señorita Tabasco was a fit and proper study for his lens.

"No thanks," said Weston, "I passed the self-portrait stage long ago."

The Carmelite (29 May 1930).

1. *Daybooks II:* 164.

2. Ibid.: 163, 188-89.

The Photography of Edward Weston

Merle Armitage

THIS WAS THE FIRST of many pieces written by Merle Armitage about Weston and his work. Edward and Merle had first met at a party at the critic Arthur Millier's house about 1923, soon before Weston left for Mexico.[1]

Merle was an impresario, a writer, and a book producer, as well as a close friend of Weston's during the second half of his career. He compiled two books on Weston's photography (1932 and 1947), both of exceptional graphic quality. The first book, The Art of Edward Weston, *brought him considerable attention and requests for exhibitions of his work from around the world. (This book may also be responsible for first publishing the legend that Weston never manipulated or retouched.)*

In 1934 when Armitage was director of the Public Works of Art Project in Southern California, he employed Weston, which was, it seems, the only instance then in the entire program of a photographer working solely as an artist.

Shortly before his death, Weston sent Merle a portrait of himself taken by one of his sons. He had inscribed it: "Others talk, Merle acts/Edward."[2]

—A. C.

ONE DOES NOT NEED to be familiar with modern movements in art to enjoy the work of Edward Weston, but one can understand him much more profoundly and can more fully appreciate the subtle nuance of his photographs if one knows something of the aims of the modernists. Weston might easily be called a "realist." He places his camera before an object—almost any object in fact—for he ranges from shells (figure 14) to green peppers (figure 16), from Mexican pyramids to bathrooms. His camera lens takes in every detail before it, with no diffusion and with a hard and sharp, almost a piercing, intensity.

It would be perfectly proper to assume that almost anyone with a fine camera could go this far. The thing which distinguishes the work of Weston from that of any other I have seen is entirely one of approach. Weston is interested in achieving that subtle essence of a subject which is the aim of many artists of the modern French school. Almost anything has some significant character. Take for example that old picture with which we are all familiar: "The Three Graces." I have not seen a reproduction of this for years, yet it left on my memory a certain impression. Last year, Picasso, with an economy of drawing suggestive of shorthand, drew "The Three Graces." As compared with the old elaborate and faithfully photographic, "The Three Graces," it was simply a few lines representing the three women. But what a revelation! The essential quality of this work was preserved and even accentuated but the unnecessary paraphernalia with which the old work was weighted down was cut away as with a knife.

I am not attempting to explain Picasso but this is certainly one of his qualities. So it is

with Weston. He takes not simply a photograph of something, he takes that something's essential character, if I may be permitted a banal phrase.

As most photographers approach a subject from a standpoint of fine photography, of unusual angles for a shot, of surface composition, I should say that Weston approaches it from the angle of revealing its true content, its natural decorativeness or design, its most significant form. The difference is not of mechanics so much as of mentality. The natural formations of ships' masts, of a grouping of chairs, of the human body, of rocks, of tree trunks, are revealed anew to us through Weston's camera, setting forth with startling clearness the individuality and the unlikeness of each. Although there is never the slightest resorting to "tricks" or to "faking," there is a strangeness about all Weston's conceptions, which is common to all great Art.

Touring Topics 22 (June 1930).

1. Merle Armitage, *Accent on Life* (Ames: Iowa State University Press, 1964): 237.

2. Ibid.: 244.

The Photography of Edward Weston

WESTON DID NOT FORGET about Mexico, nor did the Mexicans forget about him. The unknown author of this article (published in a Mexican magazine four years after Edward returned to the United States), not only discusses Weston's situation and stylistic development, but also refers to subjects particularly meaningful to his audience.

In the third paragraph, he compares Weston's cabin in Glendale to that of Legrand in "The Gold Bug" by Edgar Allen Poe. After the Revolution in Mexico, Poe was one of three writers considered especially worthy of being translated into Spanish for Mexican readers. He was also very popular in the United States at this time, and Weston had made a portrait of Ricardo Gómez Robelo, director of the Department of Fine Arts in Mexico, in front of a batik which showed a black cat, and he had titled it "Poesque."

Later, the author reminds the readers that the Japanese and the Mexicans were the first to appreciate Weston. This was not hyperbole; Weston had been ecstatic that his prints had been purchased in Mexico before he had even arrived there. The Japanese community of Los Angeles had organized exhibits of his work and had purchased prints, possibly in 1921 and certainly in 1925 and 1927. They also had offered to arrange for him to go to Japan. The money which he made from the 1925 exhibit, which he called the most interesting show of his work outside of Mexico, allowed him to return to that country. [1]

—A. C.

BY PUBLISHING THESE TWO WORKS by Weston [*Two Swan Gourds* (1924) and *Three Fish—*

Gourds (1926)], we have the opportunity to consecrate a memory of him—such an excellent and sincere friend of Mexico, and of a people whose beauty he has felt and expressed as few foreigners have done.

A very pleasant memory, stimulated more than anything else by considering his nostalgia for Mexico, was shown in intimate conversations immediately after his return to the United States.

He was in California around the spring of 1927. In his cabin in Glendale, that reminded me so much of Legrand's retreat on the Island of Golden Beetles, there were conversations in which Weston's love for Mexico floated in an exciting environment like something refreshing and revitalizing.

At that time, Jorge Juan Crespo [Mexican art critic and architect] arrived in Los Angeles and was moved by witnessing his nostalgia, which will be explained. Mexico was present in his collection there of serapes, figurines, toys, pots, textiles, and other marvelous examples of our popular arts.

It was present in Weston's way of dressing, like that of the most modest Mexican worker. He wore sandals from Cuernavaca and tied a wide red sash with blue edges around his waist.

They were unlucky days for Weston. He had presented two exhibitions in the places most conducive to success, and a total indifference worthy of Hollywood and its

suburbs rewarded the magnificent and original work of the greatest of Yankee photographers. He did not even manage to obtain the understanding of one critic.

As in the past, Weston's melancholy made him seem like Poe!

On the other hand, Japanese residents in California became ecstatic over his photoplastic creations and even proposed that he go to Japan where his success would be inevitable. Weston commented on his failure among his close friends: "—Here in California, the Japanese and the Mexicans are considered 'inferior' races, but they are the ones that have esteemed my work; they have understood me."

Weston was being overcome by penury; his studio was only visited by one or another of those exquisite spirits that the USA produces by mistake, and that in that ocean of velocity, of machines, of vulgar ambitions, seem to be sleepwalking navigators. They are capable of admiring Weston's work; but his economic situation was as unfortunate as he was.

Finally, one good day, Weston disappeared and his cabin, so welcome, so cordial, remained quiet and moist on a mountain of parched weeds. Weston went to search for new horizons. Months later, we knew that he went to San Francisco, lacking success, underestimated—however without withdrawing from his peak of artistic integrity. Weston turned down several proposals from movie studios in Hollywood to commercialize his art. Weston is the prototype of the sincere artist who prefers hunger to sacrificing his feelings.

What great consolation to know that the USA, besides the plethora of champions, of mystifiers, of caramel children, and false women, also gives this epoch such outstanding examples of spirituality.

However, it is time that we speak about the work of Weston, which we left in his evolutionary stage three years ago. We suppose that he has advanced in America as well as in Europe and that he has students that have managed to equal him—among others, his son Brett Weston.

According to his simple form of expression, Weston practices a photography that corresponds to his very own, primordial means of expressing himself and he does not try to create with his lens what is appropriate for the pencil, the pen, the brush, or the burin. Photography is photography. This also applies to technique—in what refers to aesthetics. Weston is a realist in the wide sense in which St. Augustine is, he who sees in all beings, animate and inanimate, "creatures of the Father," that is to say, beings that are internally impelled by spiritual inquietude.

Even in the most common objects, Weston finds an angle from where its unsuspected plastic beauty appears like a revelation; then, he focuses his thought and discovers that besides that exteriorization, that particular being has a special state of existence determined by the circumstances of its arrangement in the world plane.

From the intersection of these things, Weston manages to obtain perfect photographic compositions that express as much or more than the best creations of form and

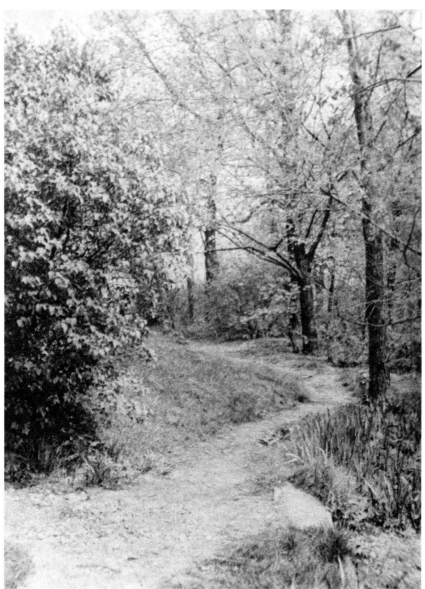

Figure 1.

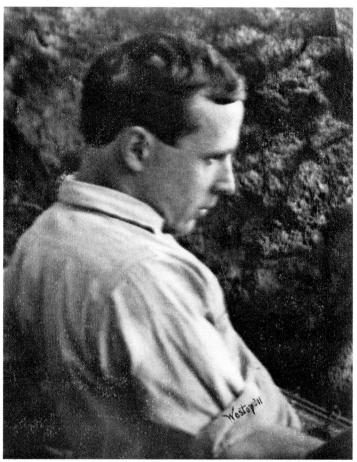

Figure 2.

Figure 3.

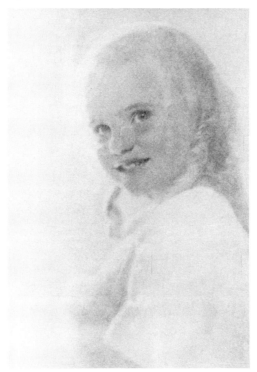

Figure 4.

Figure 5.

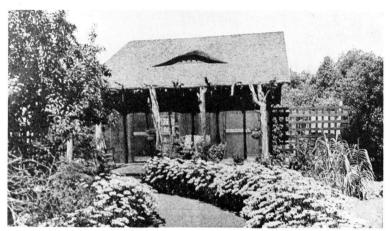

Figure 6.

Figure 7.

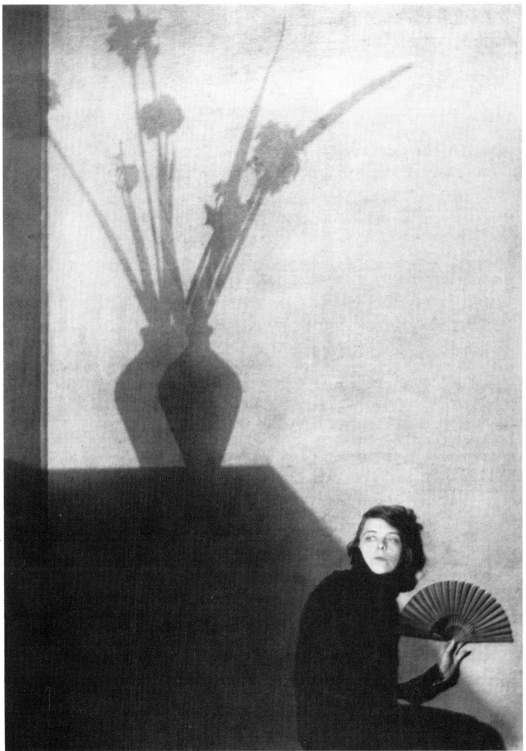

Figure 8.

Figure 9.

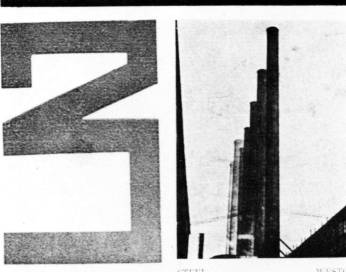

Figure 10.

of color carried out by means which are not mechanical, as photography is.

Alone—since he does not have antecedents or teachers—Weston has managed to make photography an art, that is, as intelligent critics have said, something which should not be confused with "artistic photography."

Weston's intervention is only that of an artistic observer and he respects the objects for their unique qualities. Now, another beautiful characteristic of photography is beginning to triumph—one in which the creators not only change reality within the limitations of the camera but create a different reality that, in itself, is aesthetic for the eye before being so for the lens. Weston's photography, closer to what we feel the pulse of, is not less subjective. Its merit is increased by finding out that he lets as little artifice as possible intervene in his work.

The collection of Mexican things in Weston's work is very numerous: a palpable demonstration of his love for Mexican life. The reproductions here are part of this series.

Translated by Amy Conger from *Nuestra Civdad* 2 (October 1930).

1. *Daybooks I:* 121-22; *Daybooks II:* 8, 17, 26, 29, 41, 145.

The Art of Edward Weston

José Rodriguez

José Rodriguez, a Guatemalan journalist and occasional photographer, went to Carmel in early August 1930 to meet Weston and to hear Dane Rudhyar—a mystic, a musician, a composer, an aesthetician, and once Rodin's secretary. Coincidentally, two weeks later, Weston photographed Rudhyar's hands, an especially meaningful subject since Rudhyar was also a palmist.[1]

Although Weston and Rodriguez had mutual friends, this was their first meeting. Rodriguez finished his article quickly since Edward quoted from it a month later, even though it was not published until November.[2]

In his article, Rodriguez compared Weston to a Jesuit and, in order to understand his still lifes, referred to the Spiritual Exercises *of St. Ignatius Loyola, the founder of that order. It was an indirect comparison, rich with implications, which Rodriguez left for the reader to elaborate upon by himself—since St. Ignatius Loyola is historically remembered for his relative tolerance of others, for his uncompromising personal standards, and for his exceptional gift of friendship.*

Vestiges of orientalism could still be found in cultural circles and Rodriguez also compared Weston to the Japanese printmaker Katsushika Hokusai since both were concerned about form: ". . . this very preoccupation with shape as a fundamental definition makes them both out-and-out mystics." This particular passage pleased Weston so much that he quoted it in his Daybooks. *Rodriguez also wrote: "For the true mystic does not know where the material and the spiritual part. One is the other and vice versa." Was Rodriguez aware that Weston owned and treasured a print by Hokusai at least as late as 1923?[3] And that his awareness of oriental prints was clearly and frequently reflected in the pictorial work of his salon photography?*

—A. C.

EDWARD WESTON is a quiet little man with lively brown eyes. He lives in a world where the only unit of time is a split second and where the visual impact of the split second defines for once and for all the spiritual entity of a form.

There are four sons in the Weston family, one of whom is married and has a son, thus making Weston a grandfather, which seems almost absurd in a man of such obvious youth. He looks to be no more than forty. His life has been spent literally behind a lens—although peregrinations of the Weston eye have included inaccessible portions of Mexico and of our own country. Needless to say that whoever is avant-garde in modern aesthetic thought or action, has at one time or another found himself talking to Edward Weston and looking with wonder at his pictures.

Weston is crazy about photography in the same sense that Hokusai was crazy about drawing. There is, in fact, a strong affinity between these two artists—born in different centuries of different races. To both, the physical thing is immensely significant.

Superficially, this would make them both stark realists, but the second thought follows irresistibly that this very preoccupation with shape as a fundamental definition makes them both out-and-out mystics.

This writer went to Carmel-by-the-Sea recently for the express purpose of seeing Weston and hearing Rudhyar. He found Weston in a gray cottage surrounded by pine trees. In appearance, the photographer resembles a very efficient but very timid caretaker: a green eye-shade pulled low over the brow; a nondescript sweater with practically no buttons; a pair of corduroy trousers, and moccasins. The voice is gentle as a Jesuit's, and the manner is serene and indomitable as a Jesuit's.

Indeed it is somewhere in the spiritual exercises of St. Ignatius Loyola that we may find the key to Weston's attitude toward his art. You may remember that tremendous question in the exercise: "What am I? Who made me? What is this chair, this table, this bowl, this tree? What are these things— what is the tree, the bowl, the chair?"

What are they indeed?

In his photography, Weston postulates a new answer to this question.

Let us take as an example, the series of pictures that Weston is making of the green pepper—that fragrant, spicy, bloated, shiny, juicy, grotesquely rounded half-fruit half-allspice so common in California (figure 16).

Now, a pepper is many things to many people. It is a singularly polymorphous vegetable and its character is legion. To Weston, the pepper is a mysterious receptacle for many plastic truths.

At first, we are apt to believe that Weston has merely attempted to make suggestive pictures of the peppers. They suggest bronze statuettes. They give impressions of human organic forms: sometimes they are fairly accurate sculptural forms of groups of people in all possible positions and contortions.

We ask ourselves: Is Weston merely trying to catch the shapes of other things in one thing? Is he repeating the school-boy trick of photographing clouds because they look like bearded old men?

Let us look again at a couple of prints. Let us forget their uncanny mastery of black and white, the luscious texture of the print, the crisp delight of the little flashing lights which play in and out of the utter black voids. Let us consider only the outlook of Weston as this fine print tells it to us.

No, Weston is not interested in making green peppers look like the Laocoon group. He doesn't give a damn, in fact, if he can make a pepper look like the Nike of Samothrace. What he does give a considerable damn about is to show, by means of a black and white print, that the green pepper is a thing that moves and lives, that has fragrance and richness.

It would be easy indeed to enter here into an interminable and profitless discussion of whether photography, or any graphic art, can invade the realm of philosophy and set forth certain truths of being through the eye alone. But photography is the art of movement, physical movement. What painters

have done with still life, can be done again with photography. But we must do more with photography.

I say these things to Weston. He answers:

"Yes, it's true. With the right apparatus we can photograph a bullet leaving the muzzle of a gun. This is photography of movement, but it *isn't* photography of movement. The bullet, in the picture, looks nothing at all like a bullet. The bullet was moving, but the picture is not. Photographs of racing horses are not good pictures of movement. The horses look frozen, the little clods of dirt look like daubs on a wall. There is no movement there."

"Perhaps you are concerned with another form of movement?"

"Yes, I think so. There is an inside movement that is rarely manifested in an external manner. A kind of breathing, a sort of stirring inside—"

Weston is not happy with words. He wants to tell me of that peculiar and indefinable illusion we receive sometimes at night, when we imagine the earth is breathing, when the hills of her breasts seem to fill and refill with a nameless and imponderable breath. This also is movement.

And at last, in our tortuous seeking, we come to some kind of mental hold on Weston's approach to movement. That is what we meant when we called him—with Hokusai—a true mystic. For the true mystic does not know where the material and the spiritual part. One is the other and vice versa. Weston cannot say, "This is physical movement, this is spiritual movement," anymore than he can say, "This is physical form and this is spiritual being." The boundaries of things which we adopt in our conventions of viewpoint cannot exist for Weston. He cannot say, "This is moving, this standing still." In his quiet and confident view he trusts in a measuring-stick which is far more accurate and changeless than is our rationalization, the measuring-stick of beauty.

"All my photographs are first seen, complete in every detail—the finished print is there as it were on my ground glass *before exposure*. Printing is but a careful carrying on of my original conception."

Is this not the alpha omega of genuinely artistic procedure?

Weston follows this in the case of portraits. He first sees his man, then he develops a print. Whatever cunning and skill enter into the darkroom with him, we are tempted to believe he considers just so much technical equipment, necessary but entirely subservient to the life-germ of his art, which is the ability *to see*.

Any account of Weston, or his work, cannot be complete without reference to a certain Rabelaisian quality in his makeup. He is too much of an honest man to be prim; he is too much in love with life to ignore the roguish elements of our existence. He is almost mediaeval in his attitude toward those biological processes which have become degraded by the Victorian prudery which preceded modern right-thinking.

Consider the inconsequential daring, the impudent high-heartedness of his portrait of articles not ordinarily mentioned in

polite society! This is abstract humor, we grant you, but it is also marvelous, decorative photography.

Here are the same factors which went to make his portraits of Robinson Jeffers (figure 15) and José Clemente Orozco such magnificent records of personality. Here is the same detached humor and naive delight in life that make his portraits of his tow-headed sons such endearing outbursts of pure affection.

It is easy to be voluble and dithyrambic about Weston's pictures. It is much harder to enter with him into that strange world of realities out of which he has emerged with old, but (in our days) very strange truths about the restless glory of form.

The world does move in Weston's photography.

California Arts and Architecture 26 (November 1930): 36-38.

1. *Daybooks II:* 183-84.

2. Ibid.: 185.

3. *Daybooks I:* 20.

Lowly Things That Yield
Strange, Stark Beauty

Frances D. McMullen

THIS ARTICLE was written as a review of Weston's first one-person show in New York City which opened at the Delphic Studios on October 15, 1930. It had been arranged by José Clemente Orozco, the Mexican muralist, painter, printmaker, and caricaturist whose portrait Weston made in July 1930, and by Alma M. Reed, a journalist, art historian, and dealer who specialized in Mexican work and, specifically, in promoting Orozco.

Weston commented disappointedly that it was probably due to the depressed economic situation that he had sold only five prints from the show. One of these was "Rock No. 37" that the photographer Edward Steichen purchased when he visited the exhibition; reportedly, he thought it was "magnificent" and commented that "New York should be truly ashamed of not buying out the entire collection."

McMullen remarked that the photographer Arnold Genthe exclaimed on seeing Weston's work: "These open up entirely new paths to photographers."

Walt Kuhn, the East Coast painter and one of the organizers of the Armory Show, and photographer Ralph Steiner had also been favorably impressed by Weston's photographs. His friend from Mexico, the painter and critic Jean Charlot, had written to him after seeing the exhibition that he hoped critics would finally recognize him as a great artist. Weston was delighted to receive a congratulatory note from the painter and photographer Charles Sheeler, whom he had met and whose work he had admired when he had visited New York in the fall of 1922. [1] Sheeler wrote: "I am among the many who will thank you for having shown your photographs in New York. . . . It must always be encouraging to those who insist that photography should stay within the bounds of the medium to witness such an outstanding demonstration as you have given that the medium is adequate."[2]

Although the New York Times *had written directly to Weston to obtain more information about him and his aesthetic philosophy,[3] the material from his* Daybooks *which they published came from the article that had appeared in* Creative Art *in 1928 (some of which was not included in the printed* Daybooks*).[4] His statement on his personal philosophy about photography ultimately derived from a statement that he made before leaving Mexico in 1926.[5] In other words, for all practical purposes, the verbal articulation of his views had not changed radically since 1926.*

—A. C.

THE SPECTACLE of the market stall dumped into the art gallery now gives New York pause. On the market stall green peppers (figure 16) writhe and shine, cabbages sit sullen and stolid, celery shakes out ruffles. And there are people who stop to admire, as long as the artificial dew of refrigerated freshness holds the forms crisp and firm. But their admiration is not unmixed with the calculation, conscious or subconscious, of peppers stuffed and baked, of cabbage shredded and boiled, of celery trimmed and curled.

Who would think of peppers, cabbage, and celery for their looks alone? Who would dream of posing them before the camera's eye in quest of new revelations of beauty? Who would essay to draw from them, by photograph, messages of such import that even artists would acclaim the experiment?

Edward Weston has thought of it and has done it, not only with vegetables but also with other usually prosaic subjects, as his fifty photographs on view at the Delphic Studios attest. It is through him and his camera as a medium that one is treated to the extraordinary sight of lowly things just as they are, untranslated by the magic of crayon or brush, elevated to the sphere of art.

With all the ardor of the modernist, Mr. Weston has joined in the search that animates all modern art, the quest for "significant form": but he has gone about it in a way utterly different from the painter, the sculptor, the sketcher. They look within, searching the soul for conceptions to transfer to canvas or marble. He looks about him, finding within easy reach abundant exemplifications of the qualities they grope for.

He discovers them on the pantry shelf, in the scallops of a summer squash; in the yard, in a bit of soil or a handful of pebbles; by the sea, in a tortuous knot of stubborn kelp or the stately spiral of a shell (figure 14). They are foundation shapes and structures of nature's creating, scattered everywhere for man to perceive and reveal, if he can.

Seven green peppers hung on a gallery wall are seven green peppers any housewife would recognize—and rail at for the troubles their involutions offer to the stuffer. But they are "more than peppers," in the Weston phrase. They are seven varied expositions of composition and line, of mass and proportion, of texture and form. Here is a mere green pepper photographed against the bottom of a pan, but fancy sees it as a human torso poised with grace and strength; another, a mere green pepper catching the highlights on curves molded against a somber background, might be a modernist conception of a man's struggle to evolve from lower forms.

A bunch of bananas becomes a study in simplicity of line; a halved cabbage is a revelation of intricacy of design. The slender upright trough of a celery heart, bending slightly from firm, massive base to flame-like tip, might be a latter-day memorial shaft. An egg slicer, opened and set at an angle, suggests some gaunt structural pattern. Half-hidden roots; bones picked and discarded; bits of old wood, weathered and grooved—such are the subjects that draw the Weston eye.

As an exhibitor Mr. Weston is a stranger to New York. He comes with the acclaim of his adopted California, with praise from Mexico, where he has become widely known, and with echoes from abroad, where he has been hailed as an exponent of the New World's own peculiar brand of newness.

Edward Weston is a member of a New England family that moved toward the West. His grandfather was Edward P. Weston, a poet. His father was a physician in Chicago. It was in the environs of that city that his youth was passed, a youth

enlivened by a hobby that lures many boys: picture-taking.

When scarcely more than a boy, he made his way to California. At Glendale he picked up a good deal of practical experience in the studio of a professional photographer; and there, after a few years, he decided to go into business for himself.

From Glendale he passed to San Francisco and Los Angeles, then back again to the small town, choosing Carmel-by-the-Sea with its penetrating natural loveliness and its colony of literary and artistic folk.

When Weston went to Carmel many were curious to see what its spell would do to him. Of all who had settled in the art colony, none had proved adamant to the appeal of certain picturesque features. They all did cypresses; they all did Point Lobos. Could he resist the fascination, however obvious?

He could not. He paid obeisance duly to the tribe of twisted trees; he made the pilgrimage to Point Lobos and took his kit along. But his "Cypress, Carmel," is not a tree. It is only a stretch of storm-wrenched root. The whole harassed spirit of the tree spoke to him through that bit; for him, it alone sufficed to tell the entire tale of its tortured growth. His Point Lobos is but two palms' stretch of stained and sculptured rock, but in that fragment he has caught the force and endurance of a mountain's face.

One fine day the photographer went to Santa Monica to record a sycamore tree and, between exposures, to sleep in the grass. What that day's expedition yielded was no reflection of a giant's heavenward sweep, but merely a detail of the trunk where the roots reached down into the soil. Sunlight outlining the main forms conveyed to him the feeling of a strangely beautiful torso, and this was message enough for his camera to take away from the sycamore.

From Mexico Weston returned with such fresh impressions as a mass of humble pots, puffy succulents snapped close to the earth, a thorny maguey outlined starkly against the sky.

"I often pointed my camera toward the great church tower," his diary recorded those days, "but always it was finally pivoted away to the cacti and maguey; of the latter there was much to say, but the church had already been exploited."

Weston is a stern realist. The distinctiveness of his plates is traceable to the fact that he sets out to determine the telling character of his subject, the quality that differentiates it from all else, with all the candor and sincerity he can muster.

The result is a beauty that is strictly photographic, relying for its peculiar quality upon exact rendition of the physical texture of things. The sinuous curves of seaweed, caught just out of the water with bubbles on their surface, are rubbery and unmanageable; shell is thin and fragile; wood is tough; eroded stone is pitted and hard. The technique is one of detail, hard, sharp, relentlessly intent.

Weston's attitude toward his craft is as lucidly defined as his prints are: "To express clearly my feeling for life with photographic beauty, present objectively the texture,

rhythm, force in nature, without subterfuge, or evasion in technique or spirit, to record the quintessence of the object or element before my lens, rather than an interpretation, a superficial phase, or passing mood—this is my way in photography."

For those photographers who would turn dexterous technician or would look to their craft for release of some personal aspiration, he feels high disdain. They could not handle such an honest, direct, uncompromising medium, he says, without resorting to tricks—diffusion of focus, manipulation of prints, or worse, in his opinion, the recording of calculated expressions and postures; whereas what photography needs in his estimation is to free itself from impressionism, to get away from incoherent emotionalism to clear thinking, to eschew cleverness for honesty. It can take its place as a creative expression, he thinks, only through sincerity of purpose; it is worthless when imitative of another medium through technical tricks or influenced viewpoint.

Some of his best exposures have been made in thirty seconds, but again he has worked hours to isolate a bit of maguey to his satisfaction. When asked the secrets of his particular effects, his reply was simple and direct:

"I do not use artificial light. I do not retouch or manipulate my negatives. I use an 8 × 10-inch camera with a lens that costs $5. The prints are all contact from direct negatives. Work done in the field is never arranged—the kelp washed ashore by a storm, for instance. I visualize my finished print when focusing upon the ground glass. The shutter's release records this image exactly, never to be changed in the printing, which becomes but a careful carrying on of my original conception. Mechanically or chemically I work no differently from other photographers. An obvious conclusion is that a personal viewpoint can be recorded by photography without manual interference."

His "Day book" further reveals his methods: "I am still concentrating on the same shell forms: five versions actually recorded. Hours were spent studying the ground glass. I feel sure now the fourth negative is the one I shall use. The exposures have been long; with a tiny aperture, bellows extended, and K-1 filter, four to five hours prove none too many."

Joy runs through the book. Each plate is a record of an exploit, electrifying, no matter how trivial appearing.

"I was awake at 4, my mind full of banana forms! I have two new loves, bananas and shells. Because of the afternoon appetite of small boys I shall have to hide all edible subject matter. A fine bunch of bananas disappeared—with after confessions! And I cannot find another so perfect."

And, later: "From shells I have turned to radishes, eggplants, cantaloupes. Indeed the whole market place is a new adventure; each day brings fresh discoveries. One negative which delights me is of three long white radishes; they combine into a flame-like rhythm as exciting as the shells."

Mr. Weston has done other subjects besides market produce, shells and seaweed, rocks and bark. He has gone in for portraiture, nude studies (figures 18, 19), dancing figures and even interiors. Examples of his

portraiture are on view at the Delphic Studios—one of Robinson Jeffers (figure 15), his head reclining against a rock as thoughtfully furrowed as his cheek; another of José Clemente Orozco, Mexican mural painter, vision-seeking in the manner of his own Prometheus; another of Manuel Hernandez Galvan, Mexican statesman, who was assassinated two months after Weston caught his image.

One of the photographer's accounts gives the key to his spirit: "I am finishing the head of Guadalupe de Rivera: it is a heroic head. In direct sunlight I caught her with the Graflex, mouth open, talking. It is so I shall always remember Lupe."

It is the other things, though, the vegetables, the refuse, the roots, that hold his heart. It is they that signify what he wishes to stand for in his art. And it is they, in his hands, that led a recognized authority, Dr. Arnold Genthé, viewing his New York exhibition to exclaim: "These open up entirely new paths to photographers." But, as the blazer of this new trail himself acknowledges, Edward Weston is not for those who do not find beauty in cabbages, plumbing fixtures and smokestacks, as well as in clouds, faces and flowers (figures 10, 13).

New York Times Magazine (16 November 1930): 7, 20.

1. *Daybooks II:* 191, 192, 194, 195; *Daybooks I:* 6-7.

2. *Daybooks II:* 192.

3. Ibid.: 194.

4. Edward Weston, "From My Day Book," *Creative Art* 3 (August 1928): xxix-xxxvi.

5. Amy Conger, *Edward Weston in Mexico: 1923-1926* (Albuquerque: University of New Mexico Press, 1983): 72-3.

Photography

Ansel Adams

THIS REVIEW WAS WRITTEN by Ansel Adams on the occasion of an exhibit of 150 photographs by Weston at the De Young Museum in San Francisco, the largest show he had ever had.[1] Two weeks earlier, Adams had invited the readers of his column to see the work, and commented: "May I suggest that you leave at home your 'painter's conciousness' and come to this exhibition prepared to see a profound expression in the medium of pure photography."[2]

The review demonstrates that Adams did not see photography in the same way that Weston did. José Rodriguez had pleased Weston by the way he had killed the possibility of finding symbolism and literal association in his images.[3] Weston must have sighed when he saw that Ansel had dedicated three paragraphs to the subject of symbolism. Weston's response—a letter to Adams— follows the review.

—A. C.

ONE OF THE FUNCTIONS of criticism is to reveal the fundamental intentions of the artist in relation to his medium. Another function is to consider the intensity and perfection of his expression. It is assumed that some definition of art underlies the critical attitude, and this definition should be extended to include a thorough understanding of the medium. There is a fairly general comprehension of the aims and technique of painting and etching; these expressions possess a surfeit of precedent and contemporary standards which assure the attention and understanding of artists and intelligent laymen. Photography, on the other hand, as a pure art form, possesses a minimum of precedent, and its present-day standards are painfully fuddled by the overwhelming amount of advertising, news, snap-shot, and "camera-art" productions that confront us in almost every phase of life.

In this huge mass of photographic production there is very little indeed that indicates the development of a new art form; the greatest part of intentionally "artistic" work may be classed as the effort of the Pictorialist, who strives for the syntax of painting and etching in the language of the camera. There can be no charge of insincerity in the Pictorialist productions: they are honest attempts to go beyond the mechanics of the lens and approach the vaguely "poetic" effects implied by a romantic-sentimental understanding of the old established medium. The logical weakness of the Pictorialist lies in his inability to realize the austere limitations of his medium; he does not know that within these limitations exists a tremendously potent art form.

Since the beginning of photography, scarcely a dozen workers have fully realized the possibilities of the camera. Atget, Stieglitz, Strand, Steichen, and Weston, and a few others, have sustained photography in the realm of pure art. The work of Edward Weston represents a distinguished and specific phase of photographic expression; his prints testify to his knowledge, taste and perception as an indisputably fine artist. Any critical estimate of his work must be

based on the acceptance of photography as an art, for his interpretative vision is always the vision of the lens, and it is the task of the reviewer to attempt an intelligible appraisal of his presentations from a strictly photographic point of view.

Weston's mechanical technique may be dismissed as completely adequate. It is the result of many years of thought and experience under an attitude of clean and conscientious workmanship. His interpretative technique is constantly growing; it possesses a conspicuous logic of development in relation to his perception. In Weston's work one never feels that the presentation is inferior to the "seeing"; it is obvious that his imaginative perception is brought to satisfying fulfillment in his prints.

So much for technique and presentation. Photography is really perception—the analytic interpretation of things as they are. In a strict sense photography can never be *abstract*, for the camera is not capable of synthetic integration. This basic limitation is indeed a fortunate one, in that it strengthens the incontrovertible realism of the lens. Photographic conceptions must be unencumbered by connotations—philosophical, personal, or suggestive of propaganda in any form. The representations of objects and materials must be convincing in their complete realism; the stylization of form and substance is utterly foreign to the function of pure photography.

Weston is a genius in his perception of simple, essential form. To say that his point of view is *direct* means nothing in itself; rather we must ask if it is logical in respect to his mental and emotional ideas. Replying to the last statement in the affirmative, one

may occasionally question the highly *decorative* aspect of some of his work on the grounds of austere aesthetics. Probably the thought of purely decorative effect seldom enters his mind, but he often makes his objects *more* than they really are in the severe photographic sense. While succeeding therein in the production of magnificent patterns of definitely emotional quality, he occasionally fails to convey the prime message of photography—absolute realism. In the main, his rocks are supremely successful, his vegetables less so, and the cross-sections of the latter I find least interesting of all. But I return with ever-growing delight to his rocks and tree details, and to his superb conceptions of simple household utensils. While his portraits are of striking quality and worthy of most careful study and appreciation, I will not discuss them here, reserving comment for an article on photographic portraiture. I feel that photography will find itself in the not too distant future reverting to the simplicity of style that distinguishes the historic work of Atget. I also feel that Weston's work is tending in that direction; as he fortunately dates his prints, we gain a satisfying perspective on his development.

The simplification of form which is apparent in Weston's work opens the way for interesting comment, some of which, however, well meant, can react unfavorably on his entire work. He is often accused of direct symbolism—pathologic, phallic, and erotic—and this accusation is serious for the artist who is unable to argue on the basis of stylization. I feel that this attitude toward his work needs clarification, and I am very anxious at least to define the basis of such opinion. In discussion with Weston on this very point, I became convinced that there is

no conscious attempt to imply symbolism of any sort in his work. In deference to him as an artist, I must accept his word that he is not conscious of any effort in this direction—that his photographs are entirely devoid of intentional symbolic connotations. I submit the following points as a possible solution to the problem:

First: as the camera cannot stylize, there is no augmentation or alteration possible in the image of the object. It is true that the object may be "seen" in such a way as to *imply* form and content other than that which it possesses in actuality, and it is entirely possible that Weston could have unconscious tendencies of perception which would lead him to superimpose secondary implications of form on the basic structure of his subjects.

Second: there is an essential relation (not necessarily physical) in the form and structure of all natural objects. The very complexity of the natural world obviously implies coincidence of form and function through our imagination. In certain aspects, a pepper may easily suggest the curved lines of a human torso, even though the presentation of a pepper in this aspect was not intended by the artist.

Third: we must consider the mental processes of the spectator— the psychological *point-of-view* rather than the free imagination. While Freudian principles are too well known to invoke here, I feel that the accusation of symbolism may be explained thereby. Given even the faintest hint or lead, a certain type of mind will construct a most elaborate morbid interpretation of the simplest and most "innocent" object of nature or of art.

I am satisfied that an answer to the charge of symbolism will be found in some combination of the above integration. As an artist, Edward Weston rightfully resents any intrusion of morality into critical estimations of his work. The extraordinary realism of the camera augments the weight of implied connotations once they are attached to any work of photographic art.

It is a pleasure to observe in Weston's work the lack of affectation in his use of simple, almost frugal, materials. His attachment to objects of nature rather than to the sophisticated subjects of modern life is in accord with his frankness and simplicity. The progress of Weston's work to date is rapid and significant, and his development in the future promises to be an important strengthening element in the complete establishment of photography as a fine art. Finally, may I quote what Diego Rivera said as we were speaking of Edward Weston—"For me, he is a great artist."

The Fortnightly 1 (18 December 1931): 21-22.

1. *Daybooks II:* 232.

2. Ansel E. Adams, "Photography," *The Fortnightly* (4 December 1931): 25.

3. *Daybooks II:* 185.

EDWARD REACTED STRONGLY to Ansel's review. The statement that he seems to have found most discrepant was: ". . . he occasionally fails to convey the prime message of photography—absolute realism."

On January 28, 1932 Weston typed a three-page, single-spaced letter to Ansel, explaining his views:

"I have on occasion used the expression 'to make a pepper more than a pepper'

(figure 16). I now realize that it is a carelessly worded phrase. I did not mean 'different' from a pepper, but a pepper plus—seeing it more definitely than does the casual observer, presenting it so that the importance of form and texture is intensified. . . .

"Photography as a creative expression—or what you will—must be seeing *plus*. Seeing alone would mean factual recording.

"The 'plus' is the basis of all arguments on 'what is art.'

"But photography is not at all seeing in the sense that the eyes see. . . . It is not 'seeing' literally, it is done with a reason, with creative imagination. . . .

"But, after all, Ansel, I never try to limit myself by theories; I do not question right or wrong approach when I am interested or amazed—impelled to work. I do not fear logic, I dare to be irrational, or really never consider whether I am or not. This keeps me fluid, open to fresh impulse, free from formulae: and precisely because I have no formulae—the public who knows my work is often surprised; the critics, who all, or most of them, have their pet formulae are disturbed, and my friends distressed.

"I would say to any artist—don't be repressed in your work—dare to experiment—consider any urge—if in a new direction all the better—as a gift from the Gods not to be lightly denied by convention or a priori concepts. Our time is becoming more and more bound by logic, absolute rationalism: this is a strait jacket!—it is the boredom and narrowness which rises directly from mediocre thinking.

"The great scientist dares to differ from accepted 'facts'—think irrationally—let the artist do likewise. And photographers, even those, or *especially* those, taking new or different paths should never become crystallized in the theories through which they advance. Let the eyes work from inside out—do not imitate 'photographic painting,' in a desire to be photographic!"[1]

Weston summed up Ansel's review, noting: "It contains debatable parts, though on the whole intelligently considered."[2]

1. Edward Weston to Ansel Adams, 28 January 1932, Center for Creative Photography, University of Arizona, Tucson.

2. *Daybooks II:* 239.

Foreword to *The Art of Edward Weston*

Charles Sheeler

WESTON'S CLOSE FRIEND Charles Sheeler was asked to contribute a foreword to The Art of Edward Weston *(1932). His contribution was lean and precise, the style characteristic of his paintings. On receiving a copy of the book, he wrote Weston: "What a fine record it is for the future, as well as the present, of the fact that you have been here and have used your eyes. The physical make-up of the book is all that could be desired, in every detail. The plates are superb."[1]*

—A. C.

I WISH THAT I knew five hundred words which, upon being put in their proper sequence, would make an adequate statement of my appreciation of your work. Unfortunately, I do not have the gift which makes it possible. In choosing the medium of painting and photography for my language I have at least convinced myself that I have chosen the best means of communication for me. I am as yet unable to state in words an equivalent for the visual satisfaction derived from seeing a great photograph or a great painting. In fact, I am not sure that I should not question the validity of the visual satisfaction if I were able to state it adequately in the written word. The best I can say to your public is, look at Weston's photographs. If they see the qualities which make them outstanding they will not need to be advised; if they do not, then nothing I can say will make them see.

The Art of Edward Weston, ed. by Merle Armitage (New York: E. Weyhe, 1932).

1. Charles Sheeler to Edward Weston, 23 January 1933, Center for Creative Photography, University of Arizona, Tucson.

Review of *The Art of Edward Weston*

Ansel Adams

IN THIS REVIEW of his friend's first book,[1] which came out while the f/64 exhibit was still hanging, Ansel Adams dismisses the text as trivial and the design as tasteless. Weston was disappointed and wrote Ansel:

"You certainly eulogized my work, if you did 'pan' Merle. I can understand, enjoy, believe in controversy — if it is creative argument. But when you label Merle with 'self conscious altruism' I take exception. For years others talked of a E. W. book; Merle acted! And by the way, I have had dozens of letters congratulating me on the fine presentation of my work — and from important critics and artists. But I must not get started on this now!"[2]

— A. C.

THE PHYSICAL ENVIRONMENT of the California coast has left an impressive mark on Edward Weston. In the whirl and social vortices of the huge centers of civilization, it is easy to forget the simplicities of stone and growing things and the hard beauty of the implements of human relations with the primal forces. I do not mean to imply that Weston is inclined toward primitivism, but that he is on the frontier of a more subtle naturalistic order of life. While I doubt that he rationalizes his position — a deficiency that may have its advantages — he certainly is aware of the essential modernity of his medium.

Weston has dared more than the legion of brittle sophisticates and polished romanticists ever dreamed. While much of modern art is documentary in the social sense — a record of the dynamic situations of the times — his photography is documentary in the sense of recording actualities of the natural world, presenting basic and simple things which, through his presentation, assume the qualities of elemental necessities.

One might occasionally wish for an even more simplified presentation and an avoidance of certain connotations of form and texture, but it must be borne in mind that few workers with the camera have chosen to take their subjects from the wealth of material vitally related to our physical and emotional existence and that Weston, in making this selection, has not ignored certain tenets of art in his exploratory work.

I choose to believe with Weston that pathologic and erotic suggestions discovered in his work by purist crusaders are merely coincidental, deriving from his frank acceptance of the importance of living forms.

His portraits, achieved with the clarity and directness of his rock and plant forms, comprise a very important phase of his work.

A considerable amount of critical appraisal of Weston's photography exists, and he has written to some extent himself on the philosophy of the camera, but it is all, to me, very inadequate. He is an artist of real importance and great achievement, an artist most fortunately attuned to his chosen medium and environment.

I can find no relation between his work and chromium steel decoration, the frigid structure of modern cities, Fifth Avenue and Hollywood. Unfortunately, this book implies such a relationship, but that is not Weston's fault. The editor of the volume has included rather tasteless adulatory texts of no actual critical worth and often savoring of the character of bookjacket blurbs.

My first reaction to the book was a surge of pleasure of possessing a collection of reproductions of Weston's photographs. My second was one of regret that the vehicle was inferior to the subject. Mr. Armitage's gesture of self-conscious altruism might have been convincing, had he permitted the photographs to speak for themselves.

I sincerely advise all who are interested in the art of photography to get this book; the magnificent work of Edward Weston triumphs over the manner of its presentation.

Creative Art 12 (May 1933): 366-82.

1. Merle Armitage, ed. *The Art of Edward Weston.* Foreword by Charles Sheeler; Appreciation by Lincoln Steffens; Prophecy by Arthur Millier; Estimate by Jean Charlot; Statement by Edward Weston; Biography, and thirty-nine full-page reproductions. E. Weyhe. $12.50

2. Edward Weston to Ansel Adams, postmarked 9 June 1933, Center for Creative Photography, University of Arizona, Tucson.

Dedicated to Edward Weston

W. K. Bassett

IN THE SUMMER of 1935 Edward Weston closed his studio and left Carmel. Several problems motivated him to move to Santa Monica Canyon and set up a studio with his sons. One of these was that business in Carmel at this point in the Depression was almost nonexistent. Then, Weston had been tempted by offers of work: to photograph soil erosion for the government and to be reinstated in the WPA Project Merle Armitage was directing. It also should be taken into account that he and Charis Wilson had developed an intimate relationship and it was widely known that they would live together. Santa Monica would give them a freedom unavailable in a small town like Carmel.[1]

Leading residents of Carmel wrote appreciations of Weston to accompany the official farewell of The Carmel Cymbal. *Clearly, his photographic prowess was respected by his neighbors.*

Henrietta Shore was a painter and printmaker who had studied with Robert Henri and William Chase. She and Weston had met in Los Angeles in 1927. At his suggestion, she later went to Mexico. Eventually, she moved to Carmel. They admired each other's work, made portraits of each other, and were often excited by similar subject matter, such as shells, Mexican life, and Point Lobos. They presented each other's work to potential buyers and museum directors, and Edward introduced her to Merle, who eventually did a book on her also.[2]

Hazel Watrous was one of the proprietors of the Denny-Watrous Gallery in Carmel, where in 1931 Weston had his earliest retrospective exhibition. In 1930 Weston had at least two other shows of his work there, including a duplicate of the Delphic

Gallery exhibit, and in 1932 he had still another show at the Denny-Watrous Gallery.[3]

Johan Hagemeyer was a photographer; he and Weston had met about 1917 and had been friends for many years. Weston rented his Carmel studio but had moved out because of personality conflicts.

About four months after he arrived in Carmel, with great trepidation, Weston met the poet Robinson Jeffers (figure 15) and his wife Una — and immediately realized that his timidity was not justified. He made portraits of Jeffers several times, and he treasured and enjoyed the first editions of poems that the Jeffers gave him.[4]

The appreciation submitted by Lincoln Steffens, a social scientist and journalist, often called a muckraker, was the same piece which was published in 1932 in The Art of Edward Weston. *It simultaneously reflects his fondness and admiration for Weston and his own sense of irony.*

—A. C.

EDWARD WESTON, photographer, is leaving Carmel which has been his home and the scene of his work since 1928.

This, a plain statement of simple fact, has tremendous connotations. It will create human reactions as diversified as the emotional potentialities of each and every one of the scores of Carmel people who know Edward Weston and have seen his pictures. There will be two common, involuntary

emotions—one of regret [and] one of well-wishing for him in the years that are to come.

Perhaps I who have known him so short a time, who have seen so few of his pictures, comparatively, should not be writing this general expression of goodbye and appreciation, an expression which aims to fill the need of those who have not had the opportunity individually to voice their thoughts about him in these pages of *The Cymbal.* Perhaps again it is both fitting and proper that I should do it, I who have come so recently and suddenly upon this man and his art.

There are many men of whom it is said, "You have to get to know him well to like him; to understand him; to love him." This is said of men who either have that inarticulation of shyness or extreme modesty, or whose honest personalities are hidden beneath an uncontrollable sheath of an unfortunate and repellent manner. Edward Weston is neither of these. He has modesty of soul, but he is frank of face and frank, gently and sweetly frank, of manner. He is as the lens of his camera, taking things as they are, taking you as you are. He sees and suspects no guile: what is, is good of itself, to the measure of its line and form and depth. You feel, as you talk with him, that what may be the fourth dimension of you he visualizes.

So I, who know nothing of his background and cannot consider it, have seen the Edward Weston that is, back through everything he has been and far into everything that will be. He walks in our midst asking no judgment but what you find on the face of him and have the capabilities to see in

the depth of him. He has no superiority in his thoughts. "I see it this way," he says, and that is what his camera says. There you have the man and there you have his art.

Edward Weston is leaving Carmel on an important mission. The exact nature of this mission cannot today be revealed. Red tape, often as tangled as the kelp his camera sees, gnarled as the cypress roots it takes, prevents detailed explanation of what he is leaving Carmel to do. But he is going and his destined work will keep him happy, and for us and for him that is enough.

Edward Weston was born March 24, 1886, in Highland Park, Illinois. His parents, Weston-Brett, came from Maine, deriving from ancestors who left Kent, England, in 1630. Farther back, 1066, the Brett line extends to Brittany, France. His youth was spent in Chicago.

When he was sixteen years old his father gave him a box Kodak. When he was nineteen he moved to Los Angeles and in his words, he "photographed everything from babies to funerals." He is the father of four boys—Chandler, Brett, Neil, and Cole.

In 1911 he opened his own "studio," a little shack in Glendale. As a portrait photographer, the other side of photography remained an adventure in expression. After many salon honors and medals, he instinctively quit and sailed to Mexico in 1923. He returned to San Francisco in 1923 [1926], but, a few years later, wearying of city life, came to Carmel.

Portraiture has been of necessity his vocation. He uses a 3¼ × 4¼ Graflex, making instantaneous exposures by day-light on fast

panchromatic film. All other work is his expression without compromise. For this he uses an 8 × 10 view camera fitted with a three-focus rapid rectilinear lens costing five dollars.

The Cymbal is reproducing four of Mr. Weston's pictures—a portrait of Robinson Jeffers (figure 15), eroded rock, a cypress, and kelp. The photograph of himself was taken by his son, Brett.

With a deep sense of humility before him I dedicate this edition of *The Cymbal* to Edward Weston, well knowing that only his photographic contributions to it and the expressions of appreciation from those who know him lift these pages above the ordinary.

The Carmel Cymbal 4 (17 April 1935): 3, 8-12.

1. Conversation with Charis Wilson, 2 February 1983.

2. *Daybooks II:* 5, 6, 12, 21, 34, 36, 37, 48, 51, 189, 190.

3. Ibid.: 191, 193, 254; "Edward Weston Photographer," [flyer] from Denny-Watrous Gallery, 1931.

4. *Daybooks II:* 116-17, 123-25, 142.

Appreciations of Edward Weston

Mary Bulkley

"Where once I was blind, now I see"; that is, I see more than I used to, though not as much as Weston.

He has never forced his viewpoint on me, to say: an eroded mud bank is like this, a green pepper like this (figure 16), and cypress bark is of this pattern. But because of his seeing, I, too, can find almost rapture in mud banks, misshapen vegetables, tree roots and the like, which I would never have noticed had it not been for him. I am glad to acknowledge a great debt to him for he has enlarged my world.

His approach to Nature has no sentimental reverence but is frank and sensual. He means no esotericism, no parables; he is passionately given over to the strange allure of the patterns and the plans he discovers for himself. The mountain may be large, the shell, tiny; but largeness or smallness does not matter, in his gay endeavor to see for himself (and make his seeing endure). The amazing complexity, the abounding simplicity of sticks and flowers and stones are his affair.

His pictures are disarmingly innocent; they have apparently only a concern with forms, and the outside of things.

Yet I challenge any one at all sensitive to thumb through a portfolio and not find himself with thoughts which question the very roots of being.

Henrietta Shore

To one who has watched the development of Edward Weston the man, and Edward Weston the artist, it is significant to note the salient character of both man and artist to be—integrity!

Edward Weston is a creative artist who has chosen photography as his means of expression. His choice has been justified by its results. Alert in his understanding of the forms of nature, appreciating the limitations enforced on him by his medium—he has used these limitations as a stimulus to fuller expression. To quote Mr. Weston, "The mechanical camera and indiscriminate lens-eye by restricting too personal interpretation, direct the worker's course toward an impersonal revealment of the objective world."

Edward Weston is one of the most important creative artists of our day, and is justly recognized by artist, layman, museum, and critic alike. He has brought new value, new vision, new achievement, and a clearer understanding to the realization of those who are eagerly alive to the wonders of nature.

New dignity, greater interest has been accorded to photography; its possibilities and probabilities of future development and future use have been disclosed by the beauty of the work of this great artist.

Edward Weston's finest work has been done in Carmel and surrounding country—that

this work will inevitably lead to even finer achievement is clearly foreseen.

C. Sumner Greene

Today the rational mind dominates, it sees Nature as all inclusive and Art as Man's exclusive part of Nature. It beholds Nature and Art forever separate. You, Edward Weston, with joyous heart and a modern tool in hand, have reached beyond personal experience to the root of Truth, finding beauty by the way, where, and as you looked.

Paul Dougherty

Good-bye, Edward Weston. Good luck! Come back to us soon.

Hazel Watrous

Now comes the news that Edward Weston is leaving Carmel. As I think of what he, through his work, has brought to us and is leaving with us, I can see that it is natural that a broader field should be presented to him at this stage of his development. To us in Carmel the news at once brings a sense of loss. The gain will appear when we can proudly say in the future that Edward Weston worked for six years in our little village; and during that period of his work, he ceased to retouch professional portraits, he decided to make his prints with a glossy surface, he has used direct contact instead of enlargement in portraiture, he helped to establish the *f*/64 Group, and through Merle Armitage brought forth a book of his works. While he was at work in Carmel, he sent out exhibitions to New York, Cambridge, Buffalo, Chicago, Brooklyn, Denver, University of Wisconsin, University of

Nebraska, Los Angeles, San Francisco and throughout California and one to Paris, Brussels, Stuttgart, and Berlin. His work has also been represented and is in the possession of many museums throughout this country and Europe.

All of these steps have been taken logically and as a result of his honest devotion to that form of art through which he has chosen to express himself. I believe, when biographers write the story of Edward Weston, that the years he spent in Carmel will stand as a very vital and important period of his achievement.

Edward Kuster

The more I esteem a man, as a man, the less glib become tongue and pen in trying to express the measure of my regard. Let others testify to the genius of Edward Weston the artist—I will speak only of the unfailing good humor of the man underneath, the ready smile and the friendly light in his eye. Those of us who are left behind to function amidst the terrors of an "art colony" will miss Edward Weston. Auf Wiedersehn!

Nelly Montague

To my knowledge, Edward Weston is the only man who has utilized mechanical media, so as to translate line, mass, and tone, into a creative expression of the fundamental rectitudes of nature, which after all is beauty.

Ella Winter

Someone comes in your sitting room and his eye is immediately caught by an odd

shape, in vivid black and white contrast, on your mantel shelf. If he knows anything, before he has gone ten steps and screwed up his eyes, he will say: "Ah yes; I thought so; a Weston." And then he'll walk on up to it and stare, and during most of his visit you will see his eye rove over to it as if drawn by a spirit.

And it is drawn by a spirit: by the spirit of beauty, the arresting spirit of some true bit of nature caught within the framework of a photograph, which pervades all Weston's work. His peppers and his old churches, his kitchen utensils and odd shapes of rock and sand and tree-trunk and stone strike the senses and give that catch in the throat that only something honest and real and straightforward can give. Weston strives after no reaction the object itself does not give; he never attempts any of the artificial catches other photographers strive for. His true artist's eye sees, and his camera reproduces, the beauty that is in Nature and in life, in the kitchen and in the sky, in the soft valleys and the curving hill, as few American artists have found and reproduced it. We are sorry to lose you, Edward, but we will look forward to seeing what you find and send back to us from the length and breadth of America. For in all of it we will find—you.

Edith C. Dickinson

I can't say much that's worth saying about Weston as an artist, that's my limitation! As a man, I'm glad of this chance to pay him my tribute. I have never heard him say anything mean or unkind or bitter. I know that he's a genuine friend with a fine understanding of human values, a sense of humor and a sweet smile. A happy journey to you, my dear Edward, and a safe return!

Johan Hagemeyer

Contrary to the true words of the Nazarene that "a prophet is not without honor save in his own country and among his own kin and in his own house," here is a man—Edward Weston—a prophet in his own right, who has the exceptional privilege and honor to be recognized not only abroad but at home as well, in short throughout the world of art, as one of the most outstanding, virile and prolific workers in the medium of photography.

With a deep awareness of the significance of his work I wish in all modesty, but with conviction, to add my own sincere admiration for that work and appreciation of the man-artist and long-time friend.

(And by the way: may I not in connection with the above quotation fling a bouquet to *The Cymbal* for its alertness in behalf of our vital contemporaries.)

Una Jeffers

Fine artist, hard worker, generous friend— that is how we at Tor House think of Edward Weston. During these years we have watched his disciplined intensity when at work and his determination to present sincerely each subject he undertook, whether it were a fissure in granite or a string of kelp, the face of a child or thunder-clouds over Taos Pueblo. And always his response to other people's work has been eager and appreciative. I hope he will think of Carmel as home and come back often with new brilliant tokens of work in progress.

Frederick Burt

You'll find it a sort of aesthetic education to study what this keen, sensitive man has

done—often with a two-dollar camera. But the value of his work is in studying it—a very annoying corollary, of course. But such study will repay the most dumb gawper, revealing possibilities of beauty in most things of this world. That phrase "possibilities of beauty" means only that depth of appreciation and mental burgeoning depend upon the student or beholder. But, with study, there is the chance of seeing a light in the darkness of that great void where echo the cries of the lost and the damned who can but squawk, caw or coo, "What Is Art?" Even the dumb gawper should be grateful for light where darkness has reigned so long.

For the light you have set in your department of life those who, through you, have come into even the penumbra of understanding must say, "Thank you, Mr. Weston."

William P. Silva

I met Edward Weston about twenty years ago at the Friday Morning Club in Los Angeles. He was a bashful young man and his photographs, which he was exhibiting there, were rather conservative. Times have changed and now Weston is a wizard with the camera. He is poised and sure. He can take less than a sow's ear and make more than a silk purse out of it. He can take a turnip and make a Mohammedan temple of it, an ordinary potato and make a mountain.

Fritz T. Wurzmann

Much of my realization of the significance and beauty in nature was awakened by Edward Weston. Formerly I passed by

many of its creations without perceiving the masterful conception in its detail work.

Now it must be confessed: I never liked the green Mexican pepper, either its appearance or its taste; heaven knows why. But one day I had a revelation. I saw his photograph of a green pepper with the light playing on its harmonious contours. The spirit of the picture caught me and awakened my curiosity; yes—not only challenged my former dislike but dissipated it.

Now I like the green pepper—its appearance, its shape, and, not least of all, its taste. You have opened my eyes, Edward Weston.

Frederick R. Bechdolt

Once in a while we find an artist of distinction whose personality means as much to the rest of us as his work. Edward Weston is one of these. Many of us have found a keen pride, akin to the pride of possession, when we have shown his pictures to strangers who have not seen them.

But we will miss his gentle presence even more than his pictures. And we will hope that, perhaps, like more than one other who has departed the village, he will come back to us again one of these days.

Lincoln Steffens

Your pictures, Weston, proclaim something that I, too, have begun to discover: that when we look and look again, we see beauty; that it matters not whether we use a microscope or a telescope, a camera, my muck-rake or your naked eye, we find more and more beauty. In your cut cabbage, in

my graft, there is design. In unemployment there is mass leisure, in overproduction there is plenty for all; in the machine there is God. As we know, you and I; as you show, Weston, you and your beautiful pictures.

Herbert Heron

To know Edward Weston as an artist or as a friend is to know a man of high quality. It has been my privilege to know him as both, and also in the business relation of tenant vs. landlord, which could easily have blurred the other relationships. But it didn't, because of the fine sense of justice which Edward Weston possesses among his many sterling qualities.

Of his photography it is almost superfluous to speak, so widely known it is. It speaks so clearly for itself, as art must always speak, that words can add nothing to its rank.

His personality, rich in a simple dignity veined with a delightful humor, cannot be catalogued. It can only be appreciated.

So what is there left for me to say, except that we shall miss him very much. It must be our consolation that Carmel's loss is Weston's gain and our hope that when the work for which he goes is done he will return to us.

The Carmel Cymbal 4 (17 April 1935): 3, 8-12.

Edward Weston—A Word Portrait of the Man

Thomas Welles

THIS ARTICLE, written by a newspaper photographer, Thomas Welles, emphasizes the technical features of Weston's work. No illustrations of photographs accompany it. Apparently, the closest Welles came to Weston's pictures in his visit was sitting in the chair they had occupied before his arrival. For Welles, Weston's reputation was sufficient reason to ask him about his formula for developer since this was the type of information that sold popular photographic magazines.

—A. C.

I RAPPED DISCREETLY on the jamb of an open front door at a modest bungalow in one of Los Angeles's quieter residential sections. I had heard something of the "temperament" of the man I had come to see—one of the world's best-known photographers—and I wondered, with some misgivings, just what would happen next.

In the few seconds that I stood there before rapping and during the second or two of silence afterward, I recalled, for example, that I had heard it said he often refused to sign his own portrait pictures because he fancied his sitter had been a bit too forward in offering suggestions as to pose and camera angle, and that he regarded projection prints of all kinds—especially bromide prints—an "abomination."

Would the man prove to be an impossible neurotic—egotistic, and scornful of my own slight knowledge of photography? Would he, perhaps, decline to be interviewed? Or would he assume a condescending air?

A hearty "Come in!" interrupted my reverie.

So this was Edward Weston, the "temperamental" artist, who had just been notified that he had been awarded a second Guggenheim fellowship?

"Sit down," Weston invited, "if you can find any place to sit."

That didn't sound at all like the offer of an egocentric neurotic, so I interrupted my wary study of this suntanned master photographer, who lounged about his home in a henna-colored sports sweater, long enough to glance about the room.

Its furniture comprised two chairs and a small stool, a desk, several cabinets, and a bed. Both chairs were piled high with photographs. Weston lifted the pile from one of them and shoved it toward me. He sat on the edge of the bed and studied me with kindly eyes set beneath bushy brows.

Weston himself opened the conversation. "That second fellowship was a God-send to me," he said. "I wouldn't have been able to go on with the work I'm doing now—making a photographic record of California—if it weren't for it. I might," he

chuckled, "have had to go back to making portraits for my bread and butter."

"You don't like portrait photography?" I asked.

"Well-l-l; but it's made my bread and butter for twenty years." I dropped the subject. I thought I understood how things were.

I tried a new tack—although I was aware by now that it was wholly unnecessary to handle Edward Weston "with kid gloves."

"I have heard," I said, "that you shoot a great many of your landscapes at *f*/128."

"*f*/256," he corrected. "Of course, no diaphragm is manufactured that will stop down to that point; I had to have mine rebuilt." He chuckled. "I suppose that sounds a little balmy to a newspaper photographer, but you must remember I work with long-focus lenses, and the nature of my work requires that everything from a few feet in front of the camera to infinity be in sharp focus."

When I first came in I had noticed an exceptionally heavy tripod leaning against the wall. Now Weston dragged two large cases from behind one of the cabinets. Both were painted white. "I carry the camera in one and the film holders and lenses in the other," he explained. Noticing the question in my eyes, he added, "My focusing cloth is white, too. The sun is hot out in Death Valley; I discovered it would burn right through a black cloth and into my bald head. Had to keep scratching all the time. And you can't scratch your head and concentrate on the ground glass at the same time."

So this was the "egotist" I had heard so much about! Telling me the sun made him scratch his bald head!

Weston lifted the camera from its case and set it on the tripod. "There's really no reason for setting the thing up this way," he remarked, "except it's so darn clumsy it's hard to handle any other way."

The camera itself was a conventional 8 × 10 view, with triple-extension bellows, and it was equipped with a special top brace of Weston's own design. "The brace keeps it from shaking too much in the wind," he explained. "At *f*/256 my exposures, naturally, have to be pretty long."

Weston ordinarily carries two lenses for the outfit—a Turner-Reich triple-convertible anastigmat with its widest aperture at *f*/6.8 and convertible to 12-, 21-, or 28-inch focal length, and a Carl Zeiss Protar of 19-inch focus, working, wide open, at *f*/12. "The diaphragm for the Protar," Weston said, "can only be stopped down to around *f*/180, but, even at that, it seems to give rather sharp definition."

I thought of my own camera, with its smallest stop at *f*/45, and was inclined to agree with him.

Weston observed me eyeing the outfit appraisingly, and, as though reading my mind—"Lift it," he invited. I did. The camera and tripod alone must have weighed close to sixty pounds! And this was the camera which, with its accessories, Weston cheerfully packs up sheer rock precipices under a blazing desert sun rather than risk losing a single degree of detail through the enlarging that would be necessary if he used a smaller camera!

"I use only chloride paper," he said, as if in anticipation of a question. "It's really too slow for projection printing; and besides, quality is lost in making projections; there's no getting around it. As for bromide paper—it's an abomination!"

"If you have no objection," I asked, "would you mind telling me if you have any preference in developing technique?"

"I have no objection," Weston said, "and"—his eyes twinkled—"I certainly have a preference. I do all my developing by inspection, and in an ABC pyro formula containing about half the usual amount of carbonate. That means rocking a tray for around twenty minutes at a stretch, but it means, too, that I get perfectly even gradations with no blocked highlights."

"And it must mean, also," I suggested, "that you avoid the super-sensitive pans."

"Yes," Weston nodded, "the film I ordinarily use has a Weston (meter) rating of only 16. After all," he added, "there would really be no advantage in using a faster film, since most of my work is in landscapes and still life."

"By the way"—his eyes sparkled as he suddenly changed the subject—"here's a set of prints from miniature negatives that my companion on that Death Valley trip made. I think they're rather fine, don't you?"

Well! So this was Edward Weston, "egotist!" An internationally famous master, who thought nothing of lugging around close to 100 pounds in equipment himself, but who could offer high praise for work that a friend of his had done with a miniature!

But even now I wondered what his reaction to my next question would be.

"Will you pose for a picture, Mr. Weston?" I asked.

"Of course I will, if you wish," he grinned. "Tell me just what you want me to do, though. A photographer is the hardest subject in the world to photograph!"

The Camera 57 (September 1938): 151-52, 154.

Edward Weston

Jean Charlot

WESTON FIRST MET the French painter and muralist Jean Charlot in Mexico in the fall of 1923. They soon became close friends (figure 11). They went on outings and to parties together; Charlot introduced him to pre-Columbian art and to Mexican artists; they exhibited together, criticized each other's pictures, and exchanged works. Less than a year after they met, Weston wrote: "Among [my few friends here]. . . Jean Charlot remains as the one whom I am most strongly drawn towards. . . . Charlot is a refined, sensitive boy, and an artist."[1]

In 1927 Jean ended one of his letters to Edward with the words: "Write me please, there are so few people who live *for art."[2]*

After Weston returned to California in 1926, apparently they saw each other only a few times but their relationship survived. Edward asked Jean to write an introductory essay for The Art of Edward Weston *(1932), which he did; then a year later, when Jean was visiting him in Carmel (figure 12), Edward asked him to compose a foreword for the brochure for his exhibition at the Increase Robinson Galleries in Chicago and also to select the one hundred photographs which would be shown. The following article was derived by Charlot from these two statements, to which Charlot added a discussion of the importance in Weston's work of spiritualism and oriental art.*

—A. C.

BY DEFINITION photography is a most objective medium. By vocation, Edward Weston makes it more so. To survey chronologically his "oeuvre" is to witness a purposeful shelling away of subjective addenda, of trimings that, to the average observer, transform a photograph into a work of art.

In his earliest work, lyrical qualities strive to express themselves against the logic of the camera. He idealizes objects through "flou" effects or spider webs of shadows, much as a French chef will induce a fish to look like a chicken and taste nearly as it looks. Those trickeries soon discarded, Weston tried to retain a well-earned right to unusual photographic angles, subtle space composition and sophisticated layouts. It seems that, without such pride feeders, an artist's personality would cease to be. But his destiny was to strip himself still further. In his present work, the last vestiges of self-obsession have disappeared. In the concrete, implacable way which is its own privilege, the camera records whatever it is, rock, plant or tree trunk, that Weston innocently squares plumb in the middle of the lens.

The increased effacement of the man behind the machine has resulted in deepening and heightening the aesthetic message. With a humbleness born of conviction, the artist distracts our attention from himself as a spectacle, shifts it to nature as a spectacle. The search for a super-objectivity produces an art which accomplishes the inner aim of all great art, to make us commune with the artist's clairvoyance in the minute of creation.

This application of the apologue of the man who found himself by losing himself clashes

with this epoch of artistic theorizing. People now profess that objective vision and subjective understanding are incompatible, that the former is trash compared with the latter. Yet man speaks but of himself; however objective his aim, he does not describe objects, but only his own sensuous contact with them. The more tenaciously a painter clings to normal vision, the more clearly will he state, as does Vermeer, that the human optic is a more perfect means of emotion than of cognizance. The camera too gives us not the object, but a sign for it written in terms of light and dark, often at odds with the experience gathered through touch, smell, mental knowledge, or even an average eye. As concerns the supposed hierarchy between an inner and an outer world, let us remember that the only possible commerce of the optical arts is within the realm of the visible, deals with the description of physical bodies. This does not mean that art must be de-spiritualized. The very fact of the visibility of the outer world is proof that it has laws, rhythms, and phrases to which, both being attuned to the same diapason, the laws, rhythms and phrases of our spiritual world answer. To describe physical biological phenomena, erosion, growth, etc., is to refer to similar happenings in our mental world. There is a mystery in the objective realm as loaded with meaning as are the voyages that one makes into oneself. Weston has understood those things as few others have. More exactly, as artists—at least in the heat of creation—do not think, Weston has lived these things. The more objective he strives to be, the more inner chords he strikes, and in so doing, points to a means of liberation for his fellow artists, away from the current and exasperating creed.

There is nothing in his photographs to enthuse the kind of aesthete who expects from art the same soothing or tickling that one demands from an ivory scratcher. Poussin justly stated "the aim of art is dilection," but many mistake pleasure for dilection. Superseding the physical, and even the emotional, true dilection is of the realm of the spirit.

The physical exertion inherent to the technique of painting, the multiple twists of arm, wrist and fingers, as well as the time that goes into the creation of a picture, are too often deemed the standards of its excellency. Yet they often result in a muddling of the mental image that the painter forms at the start, and then patiently mutilates. The Chinese understood better this fact that physical exertion is incompatible with the highest forms of meditation; their greatest masterpieces, devoid of color, jugglery or patience, were created in five minutes with a broken reed, a feather, or a finger smeared in ink.

Weston's art is a culmination of the Oriental concept. Hand and wrist work give way to the mastery of the machine, eliminating such uncertainties as are corollaries of muscle and time. Under the stupendous concentration of the artist's mind, 1/35 of a second suffices to create an image with which to perpetuate his spiritual passion.

Weston's world of ordered bodies is as fitted a tool towards contemplation as the hierarchy of blacks in the greatest ink paintings—with this added security, that Nature being actually such as revealed in his well-focused photographs, we come closer to the mechanical proof of its being, in essence, divine.

Jean Charlot, *An Artist on Art: Collected Essays* Vol. 1 (Honolulu: University Press of Hawaii, 1972): 171-76.

1. *Daybooks I:* 79-80.

2. Letter from Jean Charlot to Edward Weston, envelope dated 15 August 1927, Center for Creative Photography, University of Arizona, Tucson.

Edward Weston

F. H. Halliday [Charis Wilson]

This lively account of Edward Weston's photographic expedition was written by his wife, Charis Wilson, under the pseudonym of F. H. Halliday. Currently she is writing a book about her experiences while living with Edward Weston.

— B. N.

In March 1937, when I read the list of newly appointed Guggenheim Fellows, I rejoiced, first that there was a photographer among them, second that the photographer was Edward Weston. A wiser choice I could not have imagined. I haven't seen a write-up of Weston since that failed to mention that he was the first photographer to receive this accolade. But to me, far more interesting than the mere statistical fact, is what he did with it.

First, to explain just why I rejoiced, I'll have to go behind 1937 for some background material. Edward Weston was sixteen when his father gave him a camera, thereby deciding a good deal of his future. It wasn't any time at all before Weston Jr., found that school work interfered too much with his photography. When Weston Sr., discovered the same fact from a casual glance at the report cards, it was decided that the young photographer might as well quit school and go to work.

Edward Weston ran through a variety of jobs before it occurred to him that he might as well make a living with his camera, whereupon he built a studio in Tropico, California (now absorbed by Glendale and Los Angeles), and became a portrait photographer. He had the age-old problem of the artist's compromise pretty well worked out. Portraiture was to be his bread and butter—in that field he would please the public; his other photography would be done for himself, to please himself—if anyone wanted to buy it, fine; if no one did that was all right too.

For a while the system worked beautifully. Weston married and had four sons. He was prospering. Then he gave up the whole business and sailed off to Mexico.

The system had begun to break down, and in the years that followed its collapse continued. The simple fact was that Weston had too much integrity for his own financial good. He couldn't keep his right hand from finding out what his left hand was up to. Every time he removed seventy-five pounds from a buxom matron (with such skillful retouching that she'd really believe the result) he got a little sicker, and finally he stopped doing it altogether. First he stopped using soft lenses and soft papers, then he stopped retouching, then he stopped enlarging. If you get a Weston portrait today, it's an unretouched 4 × 5 contact print on glossy paper, and incidentally it's likely to be the most beautiful portrait you have ever had. Weston hasn't stopped flattering his sitters by a long shot, he has only stopped doing it by artificial means. What a less skillful photographer strives for via spotlights, diffusion disks, and the

retouching pencil, Weston attains with daylight, sure technique, and excellent psychology.

Such measures were bound to reduce the ranks of Weston's prospective sitters—the world being full of timid souls who are terrified at the mere idea of a portrait's looking like them. So Weston, when he should have been about his own work, had to stick close to his studio for fear of missing the sittings that did come. (A state of affairs not altogether blameworthy since it may be held partly responsible for Weston's important close-up period—shells, vegetables, etc.—and the beautiful series of fragment nudes [figures 14, 16-19].) But to get back to my rejoicing: not only was the time ripe for the Guggenheim Foundation to bestow a fellowship on a photographer, it was equally ripe for Edward Weston to reap the full benefit of a period of freedom from financial pressure.

Anyone believing that all artists are impractical dreamers would be shocked to meet Weston, an eminently practical man. I don't know a business man who could have done as much with a year of freedom and $2000. Weston and his (second) wife Charis—daughter of novelist Harry Leon Wilson—planned the project of photographing the West in such a way that every possible cent would go for photography and travel. I made one trip with them, and if I ever saw living reduced to essentials, that was it.

It was a week without radio, newspaper, or mail; without anything I would formerly have called a regular meal or a possible bed. The Westons didn't even carry a watch. For the first two days— during which we touched no settlement—I suffered

sugar-and-cream-less coffee and saltless food. But even when these deficiencies were remedied, life was rough enough. In the morning—and I mean morning: four or five A. M.—we rushed into clothes, swigged down fruit juice and coffee, packed up the car, and were on the road before sun-up.

After that the order of the day was dictated by the surroundings. Charis was chauffeur. She piloted Heimy (the travel-scarred Ford sedan) along at fifteen mph when the country was good; raced along at thirty-five if the going was dull. When Weston saw something he wanted to work with or investigate further, Heimy was halted, the 8 × 10 camera fixed to its heavy tripod. With that hoisted on one shoulder, the holder case in his free hand, Weston trudged off to examine his find. Meanwhile Charis pulled out her portable typewriter, set it up on the front fender, and pounded away at the daily log. If Weston made but a single negative, fifteen minutes would see us packed up and driving on. If he found several things to do, we might stay half an hour or half the morning. There was no destination, no routine. One day we could cover a hundred miles; another day less than ten. One day would net two negatives, another day, eighteen.

After a week of this itinerary, I was not unhappy to return to the decadence of apartment-dwelling, as represented by hot bath, frigidaire, radio, tables, and chairs. But after a year of it, the Westons can hardly be blamed for failing to get back into step with urban existence. When a second Guggenheim Fellowship, awarded for six months more travel and photographing and six months of printing, made a permanent dwelling a necessity, the Westons built

what a discerning friend calls the *Palatial Shack*. Neil, third of Edward Weston's sons, carpenter and boat builder, put it up for them.

The oblong building perches on a bluff above the coast highway and the sea, four miles south of Carmel. A small darkroom and a bathroom are partitioned off at one end with a storage loft above them. The remainder of the building is one large room, 20' × 28', to be precise. There's a fireplace at one end, a kitchen stove at the other; a bed in one corner, a desk in another. There's a concrete storage vault for negatives, a set of built-in cabinets for prints, a big work table.

Now in case anyone is wondering why all the description and when am I going to say something about Weston's work, the answer is that that's what this is all about. In his photographs as in his living, Weston has followed a process of stripping away the nonessential. Discarding all the *extras* that are commonly added to a photograph to make it "art," he presents his subjects with uncompromising clarity. His straightforward technique and penetrating vision extract from whatever object lies before his lens a recreation so compelling that in it the beholder grasps the significance of its basic truth. I have looked at a scene while Weston was photographing it, studied it over to decide just what he was including and leaving out, then (when his negative was made) looked on the ground glass to find the scene revealed in such different terms that I had to admit I was *seeing* it for the first time. That is the way Weston has recorded the West. Whatever his subject— an old shoe on the highway, a ghost town on the desert, flying clouds over a winter

landscape, the hot dry foothills of the Sierra Nevada—each is revealed in its essence so that the beholder who is familiar with these scenes and objects comes to see them really for the first time. And all this Weston accomplishes with the simplest set of tools any modern photographer ever set out with: one camera, one lens, a couple of filters.

The technique of processing is equally simplified, for Weston—and here he must be just about unique among photographers—doesn't like darkroom work. Right now, with less than one hundred of his Guggenheim negatives still to be printed, Weston is at work on a set of five hundred prints for the permanent collection of the Huntington Library. His antidote for too much darkroom work is cutting down and cutting up all the dead pines on the place, and there is some talk—I think Charis is responsible for most of it—of his giving up photography to be a lumberjack.

Far from burying themselves in the country, the Westons appear to have set up house on a main travel artery. At least they have a heavier traffic in visitors and sitters than ever found them in Los Angeles. But in spite of that, they manage to go on living in highly uncivilized comfort—working hard, eating when they're hungry, going to bed when they're sleepy, enjoying their fantastic family of ten cats. Visitors often shudder delicately and ask "But what do you *do* with them all?" (Any cat lover knows that's a silly question, cats being the one animal you don't have to *do* anything with.) But to the question "Why so many?" Charis responds by pointing out that if you only have one cat or even two cats, they belong in the pet class; and since they associate more with you than cats, they become, to a degree,

humanized. But if you have enough of them to form a community (apparently ten is enough) then they develop in relation to each other and remain more catty. However, no one could call the Weston cats spoiled brats. Good manners are mandatory; yelling for food is sternly dealt with, climbing on tables forbidden; all members are taught to shake hands like ladies and gentlemen, and some of them even jump through hoops to show off for company.

California Arts and Architecture 30 (January 1941): 16-17, 34-35.

Ex-Rabbit

THIS UNSIGNED PIECE was written when Weston was in New York for his retrospective exhibition at the Museum of Modern Art in early 1946.

The quotations are somewhat suspect—unless, of course, Weston had gotten into the mood in which the interviewer wrote this profile.

—A. C.

EDWARD WESTON, 261 of whose photographs of such things as sand, cats, eroded rocks, parts of cypress trees, and vegetables (figures 16, 22) constitute a current one-man show at the Museum of Modern Art, is here on a visit from his California home, and a few days ago we buttonholed him. He had a paper bag full of avocados on his lap during our talk, in the course of which we learned that he was born in 1886 in Highland Park, Illinois, where, sixteen years later, his father presented him with a Kodak Bullseye. He soon threw this away and graduated to an eleven-dollar second-hand camera, complete with an Ideal Ray Filter, which he bought out of carfare savings made possible by 220 walks. Two 1903 Ideal Ray Filter pictures are in the museum show. Weston was working at Marshall Field's in Chicago when he took them—or, to be precise, until a couple of hours *before* he took them. "I was one of those rabbits that jump up and wiggle their ears when anybody rings a little bell," he told us. He escaped in 1906 and began to take what turned out to be a forty-year rest when he entrained for California to visit a relative. He looked around when he arrived, breathed deeply, and resolved to stay. After a brief spell as a stake-pounder for surveyors laying out a railroad, he became a full-time photographer, specializing in babies, pet cats, funerals, and family reunions, for a living, and for art's sake, doing portraits, landscapes, etc. That was in the soft-focus days. "I couldn't think what to do with all that wonderful detail," Weston says, "so I used a soft-focus lens and dissolved it away in a romantic haze. I thought of photography as an Art and even got myself a cape. One day, around 1920, I went out into the bright California sunshine—nothing hazy—and began to think things over. I washed all my old photographic plates clean as a whistle, or possibly as a hound's tooth, and used them for windowpanes in a house I was building."

We now come to the sharp-focus days, during which Weston abandoned fuzzy effects for realistic vegetables, shells, landscapes (figures 14, 16, 17, 22, 23, 32), and so on. These include at least 400 cypress-root and eroded-rock studies, mostly made at Point Lobos, California, as well as many shots of sand dunes, some brightened up with crystal-clear nudes. In 1937 and '38, he was a Guggenheim Fellow and in that capacity drove 38,000 miles in California, stopping only to take pictures, eat, sleep, and change tires. He developed a theory, to which he still clings, that everything worth photographing is in California, and in 1941 left the state rather reluctantly in order to make pictures for a Limited Editions Club edition of *Leaves of Grass* after the publishers had explained to him that Whitman, never having

been to California, probably hadn't been writing about it. Weston made a remark to us about cabbage that sums up his professional credo: "I just want to make it the most cabbagy cabbage a man ever looked at and then chopped up into coleslaw."

Cabbage's champion is a small, quiet, twinkly man who looks like Roland Young, only less Brooksy. He generally uses an 8 × 10 camera on a tripod, crouching behind it enveloped in a huge, double-thickness cloth which is black inside and white outside (deflects the sun's rays). "When I'm inside that cloth, the light perfect, the focus just right, and in front of me something entirely beautiful—in that split second I'm the most powerful man in the world," he said, flexing his muscles. He never enlarges or trims, and he uses an old-fashioned developing solution that stains his fingernails dark brown. A few years ago he heard a woman in a restaurant say she wouldn't think a man like Edward Weston would paint his fingernails; since then he keeps his fingers folded into his fists whenever he's away from his place near Carmel, where everyone knows him. He has a wife, four sons, and fifteen cats, one of whom is called Henry Wallace and all of whom he has photographed with fearless realism. He still does an occasional commercial portrait, using an ordinary Graflex, but he won't retouch a single line, and the ladies, on the whole, eschew him, professionally. "No prettying up—that's my philosophy," he says. "Furthermore, after every negative, an avocado. A well-balanced life."

The New Yorker 22 (23 February 1946): 22-23.

Edward Weston in Retrospect

Beaumont Newhall

I HAVE BEEN ASKED by *Popular Photography* to review the Edward Weston exhibition which the Museum of Modern Art is holding from February 12 to March 31. As I write, it is the middle of December. The show exists in five bundles of mounted prints in a cabinet in my office at the museum, and in the manuscript which my wife, Nancy, has written for publication by the museum. To review the exhibition before it is installed would be artificial. And the Weston exhibition has been for so long a cherished project that a truly critical review is out of the question. We who have organized the show are not the ones to judge it. The test will come when the photographs are on the museum walls and the public has seen it in New York and in the other cities throughout the land where it will be shown later.

But I can preview the exhibition. I can tell the story of how it came about and, from our association with Edward Weston, I can perhaps give some feeling of his way of working and his approach to photography.

When the museum, after the success of its first large photographic exhibition in 1937, thought of establishing a permanent Department of Photography, it was definitely planned to have a series of large one-man exhibitions. In the summer of 1940 Nancy and I went to California on a busman's holiday. Ansel Adams took us to Carmel to meet Weston. We planned to stay a few days, but our visit lasted two weeks. We looked at hundreds of Weston prints—many more than we had been able to see in the

East. We went photographing together. Edward's hospitality was extended to include the use of his darkroom. We not only observed him at work, but worked with him, putting to practice the theories we learned. As we grew to know Weston and his work we longed to share this experience with others, and an exhibition at the museum seemed imperative.

In 1942 plans were all set when I joined the Air Corps. Nancy stepped into my place at the museum. But it was no time to hold such an important exhibition. Everything was unsettled. So the show was postponed. In 1944 Nancy went to Carmel again. The tremendous task of going through thousands of prints began in earnest. So 1946 was set as the tentative date.

On my return from Europe last spring we went again to Carmel on leave. More selection, more discussion. The exhibition was now taking definite form. Three hundred or so prints, ranging from 1902 down to the present, were chosen.

Nancy spent long hours listening to Edward tell his life story, gathering material for the book. Bulging scrapbooks crammed with reviews and catalogs documenting seventy-one of the many one-man exhibitions Weston has already had were brought out. And every afternoon at four o'clock, Edward ground and brewed coffee, and we sat around the fire and talked.

It would have been ideal if we could have completed the selection and the research at

Carmel. But I was a soldier then, and duty called. Edward further refined the selection, made new prints to replace those which did not come up to his high standards. The scrapbooks were sent on to New York.

In October the exhibition prints arrived at the museum—more than we could use—all neatly arranged in bundles marked with the year of production. We sorted them out and began to plan the exact sequence in which they would be arranged on the walls.

The first two prints are Weston's earliest, made with the Bullseye camera his father gave him in 1902. Then came a few soft-focus pastoral scenes and portraits, work of a sort which is seldom associated with Weston. For fifteen years he won prizes and honors in the pictorial world; in 1917 he was elected to the London Salon. He later repudiated this work and destroyed most of it. Should the few remaining examples of this period be included? His friends argued against it.

"Ansel Adams does not agree with me," Weston said, "in hanging old 'historical work.' (Only the best you've ever done, only examples of the photography you believe in should be shown.) Well then I say why a retrospective at all? I think a presentation of one's growth is of interest and importance—even early corn."

We agreed. We felt that Weston's mature work could be explained and made more significant by showing the past. The commercial work which he did for a livelihood we couldn't show because we couldn't find any of it. But Nancy has told about it in the essay.

"With a postcard camera he went from house to house, doing babies, pets, family groups, funerals, anything and everything . . . he attended a 'college of photography,' learning a solid darkroom technique and what *not* to do when posing a sitter. For a year or so he held various jobs with commercial portraitists, becoming a first-class printer and learning to make exact duplicates even from the badly exposed and poorly lighted negatives of his bosses. In 1911 he built and opened his own studio. With an 11 × 14 studio camera, with a Verito lens and a reducing back, a headscreen and a reflector, he awaited customers. The first week brought him exactly one dollar—for a dozen postcards. But the clients who drifted in were pleased with the sitting and the results. Keeping his camera activities to an inconspicuous minimum and talking with his sitters, he was often able to make several exposures before they were aware of it. He still posed by suggestion and had a tendency toward chiffon scarves. When even these failed, he banished awkward shoulder lines, large busts, and other things he did not know how to manage, by vignetting. And he retouched so deftly and with such regard for actual modeling that his patrons, unconscious of any change, were convinced they really looked that well."

The Weston so many of us admire is first seen in experimental work of the early 1920s—in "R. S.—A Portrait" (1922) where just the hair and eyes of a girl form the bottom of a composition of diagonals and triangles—in a nude study showing the circle of a breast and the diagonal of an arm. But we felt that in his Mexican work he had emerged. He went to Mexico in 1923

and, except for a six-month trip to the States, stayed there for three years. It was a period of intense self-criticism and self-analysis. He tells about it in his *Daybook* (published in the magazine *Creative Art* for August, 1928): "I am only now approaching an attainment in photography that in my ego of several years ago I thought I had reached long ago. It will be necessary to destroy, unlearn, and rebuild."

He had several exhibitions in Mexico and we translated some of the newspaper reviews in the scrapbook. "Weston, the emperor of photography, although born in North America, has a Latin soul," wrote one Guadalajara reporter. The sincerest praise came from painters, from Siqueiros, Orozco, Diego Rivera, the leaders of the Mexican Renaissance.

Rivera wrote in *Mexican Folkways:* "Few are the modern plastic expressions that have given me purer and more intense joy than the masterpieces that are frequently produced in the work of Edward Weston, and I confess that I prefer the productions of this great artist to the majority of contemporary, significant paintings."

Many of the prints chosen from the Mexican series are original palladiotypes. Some are recent glossy chloride prints. All of them are 8 × 10 inches. The bulk of the negatives were made with an 8 × 10-inch view camera, the type of camera which has remained to this day his preference. A few portraits were made with a Graflex. From the 3¼ × 4¼-inch negatives enlarged duplicate negatives were made for printing. The subjects are landscapes, architecture (Mayan pyramids and naively painted native bars or *pulquerias*), sculpture,

markets, and giant maguey plants. He traveled to little-known parts of Mexico with his son Brett and Tina Modotti, making illustrations of sculpture and native arts and crafts for Anita Brenner's *Idols Behind Altars.*

The next group of photographs is of a quite different character. They are extreme closeups, made after his return to California in 1926. He found beauty in the vegetable bin—in the fantastic convolutions of peppers (figure 16), in the delicate and complicated internal structure laid bare by halving an artichoke or a cabbage. Among the most striking closeups of this period are shells (figure 14). With superb craftsmanship he recorded the luminosity of their nacreous surface; by isolating them against black backgrounds he emphasized their form and structure. In the rich, varied, and often exotic landscape of Point Lobos, on the Monterey Coast just south of Carmel where he moved in 1929, he found an infinite number of motifs which he treated in the same manner as the vegetable and shell still lifes. Closeups of eroded rocks, the weathered silvery gray trunks of Monterey cypress, seaweed, and kelp upon the beach, the feathers of a fallen pelican's wing are some of the subjects which make up this moving series.

The Mexican painter Orozco saw them in Carmel in 1930 and was so impressed that he arranged for Weston's first New York one-man show at the Delphic Studios. Reminiscing on this visit, Edward wrote us that Orozco told him that he should call himself the first Surrealist photographer. "I didn't know what Surrealism was (doubt if I do now) and didn't like labels even then, so didn't fall for the idea, thank the god of all emulsions."

Weston's portraits have seemed to us to be the least known of his work. We have selected a small group of them. They are unretouched. He began making this kind of portrait together with the more conventional commercial work which he did for a living. He was dissatisfied with the division of standards between his personal and his professional work. Although he was a skillful retoucher, he disliked doing something in which he no longer believed. So he began to persuade his clients to choose the direct prints instead of the worked-up ones, and in 1934 he was able to hang out a sign "Unretouched Portraits."

Many of the portraits and nudes are made with a 4 × 5-inch RB Auto-Graflex, fitted with a 10¾-inch f/5.5 Meyer Plasmat lens. I learned at first hand his way of making portraits when, one overcast day in Carmel, a burlap screen was moved into the backyard and I was invited to sit on a rather uncomfortable stool in front of it. Edward set up the Graflex on the sturdy Ries tripod. After a few minutes of conversation I lost camera shyness. Edward was peering into the ground glass while he talked; and every so often, seeing an attitude which he liked, he asked me to hold it while he made an exposure. He gave no stage directions. He did not ask me to look to the right or to the left. He did not tell me how to hold my head or where to place my hands. He did not adjust my clothing or surround me with reflectors. He waited patiently for things to happen in a natural way. And when he had exposed a magazine full of films the sitting was over.

As we went through Weston's work making the selection with him, we noticed how the prints produced each year grew in number.

Weston has an important theory about photography which he calls "mass production seeing." He wrote about it in *U.S. Camera 1940:* "I have always considered the rapidity of the camera's recording process an important asset since it means the number of pictures a photographer can make is limited only by his ability to see. Quality, in quantity, is possible in photography to a degree unequalled by any other medium."

This theory he was able to test when, in 1937 and again in 1938, he was awarded the Guggenheim Fellowship. For two years he traveled with his second wife, Charis, throughout the West photographing where and what he liked (figure 22). It was difficult to choose from the fifteen hundred photographs of the Guggenheim series. The subjects are most varied—from closeups to the immensity of Death Valley. In many ways this part of the exhibition will be the most stimulating. Weston the artist seems to have reached the complete assurance of maturity.

In 1941 he wrote us: "News! We will see you before many months. Leaving here by May 1st to criss-cross America, I signed with Limited Editions Club to do 'faces and places' for *Leaves of Grass* (by Walt Whitman). What a project! I approach it humbly but with plenty of enthusiasm." Later he explained: "There will be no attempt to 'illustrate,' no symbolism except perhaps in a very broad sense, no effort to recapture Whitman's day. . . . This leaves me great freedom—I can use anything from an airplane to a longshoreman. I do believe, with Guggenheim experience, I can and will do the best work of my life. Of course I'll never please everyone with *my* America—wouldn't try to." The job brought

him to the Atlantic Coast where he found fresh material. We think that many photographers will see with surprise Weston's penetrating photographs of New York City, of Connecticut barns, of Louisiana plantation houses (figure 32).

The selection includes work done during the trying war years. Security regulations and gas rationing limited his field to his own backyard. Long tedious hours of volunteer lookout service, which he shared with his wife, made heavy demands on his time. All four of his sons entered the service. Charis drove the mail and worked in a canning factory. A victory garden was raised and tended. He worked with various subjects near at hand—full length portraits in natural surroundings—an amusing series of the cats which were a feature of the Weston household (virtuoso technical performances made with the 8 × 10 view camera)—symbolical and allegorical compositions combining objects and people.

The exhibition is a large one—the largest collection of one photographer's work which the Museum of Modern Art has ever shown. Even so the exhibition is too small. Weston has produced such an enormous quantity that important work would be missed if the show were ten times bigger. "I will be criticized," he wrote us when he sent the prints on, "for the size of my show. But I am a prolific, mass-production, omnivorous seeker. I can't be represented by 100, 200, or even 300 photographs to cover forty-four years of work."

As it is the show is so varied, so broad in its material, that almost every photographer who goes through it will find subject matter which he himself has photographed. And it will become at once evident that it is not subject matter which is responsible for Weston's extraordinary results.

Nor are these results to be explained by the mechanics of his technique.

Weston has shaped his technique wonderfully to record his seeing. Except for some of his portrait and nude work he always uses an 8 × 10 view camera, and he invariably prints by contact. A writer once proved, with the aid of a slide rule and optical formulas, that Weston could obtain better results by making $2\frac{1}{4}$ × $3\frac{1}{4}$ negatives and printing by projection. This writer argued that the loss in detail through enlarging would more than compensate for the loss of definition which in theory takes place when a long focal length lens is stopped down to the small apertures required to secure adequate depth of field. I am sure that Weston would be glad to be freed of his bulky and heavy view camera if this attractive theory could be put into practice.

Years ago he enlarged regularly. Then he discovered that his way of seeing demanded the use of a large camera. Projection prints do not give him the quality which he wants. And the view camera gives him a full scale image from which, before exposure, he can completely visualize the finished print. Except in the case of portraits, which depend so much on the evanescent, often unpredictable expression of the moment, he almost invariably makes only one exposure with a given setup.

His previsualization is developed to such a degree that fifty percent of the first prints he makes are mounted and signed. His method is diametrically opposed to that of

the miniature camera worker who makes a great many exposures and composes later on in the darkroom by cropping.

Weston does not crop because he doesn't need to. When *U.S. Camera* sent him a questionnaire from which the editors compiled technical data for the 1939 volume, opposite the question "Cropping and Composition" he wrote: "Never crop if that is modern for 'trim.' We used to crop horse tails when I was young. Trimming is an admission of poor seeing, or seeing nothing, in the first place. There should be no need for trimming when camera is used on tripod." This opinion is neither whim nor dogma; it is a logical outgrowth of his aesthetic approach. Cropping simply is not necessary because the picture is created in his mind's eye before exposure.

More than forty years experience with the same basic equipment and technique has given him a mastery of the medium. He photographs rapidly and deftly. Once he finds a subject he sets up the camera without hesitation. He handles the bulky 8 × 10 with surprising quickness. "I had myself timed the other day," he told Nestor Barrett in an interview for the June 1938 issue of *Popular Photography,* "and discovered it took me exactly two minutes and thirty-one seconds to make the complete setup, from opening the case to making the exposure."

His darkroom is much simpler than those of most amateurs. I should judge its size as six by eight feet. Down the long side is a shallow sink. Waist-high benches run around the narrow sides and up to the door. He develops 4 × 5 films in a tank, but he prefers a tray for the 8 × 10

because development, particularly of sky areas, is more even.

When I first worked with him I foolishly failed to take notes. I appealed for help and he obligingly answered: "I use the standard ABC pyro soda such as Agfa 45 for stock solution (distilled water); tray development—60 oz. water, 6 oz. pyro, 4 oz. sulphite, 3 oz. carbonate. Temperature 65°. I start inspection (series 3 safelight) after ten minutes, when the first ones will usually be ready to come out. Use a short stop rinse—water 32 oz., acetic acid 1½ oz. Your water conditions, or personal desires, may call for modification. Just remember that sulphite controls color, carbonate contrast. Pardon me if you know all this. While in Yosemite (teaching with Ansel Adams) I desensitized for the first time! It was much better for the class to see the procedures. Perhaps you should do this because small negatives are difficult to judge. I found yours difficult." (I was using 3¼ × 4¼ filmpack.)

I had a preconceived idea before I worked with Edward. I thought that the secret of his brilliant work lay in a rigid, mechanical technique. A printing session with him changed my ideas. He showed me how, with a printing frame and an overhead bulb, dodging could be done as easily and as effectively as with an enlarger. Most of his negatives he can print directly, but he does not hesitate to dodge in areas of excess density by holding back the shadows.

He uses amidol developer for rich black tones on glossy paper, and consequently the fingernails of his left hand are stained. But only of his left hand, for he never puts his right hand into the developer. That is

reserved for agitating prints in the hypo. Carelessly I wiped my hypo-wet fingers on a towel without first rinsing them. Edward threw the towel on the floor. It was a vivid lesson in the scrupulous cleanliness which superlative technique demands.

Helpful as this technical advice may be — and Weston has ever been generous in sharing his experience with others — it is his work and his bold conception of photography which we have found to be a challenge and a stimulus. In the wisdom of his years he is never dogmatic. He realizes full well that his way of working is only one of an infinite number. "Seeing" is a word he often uses; that, to him, is the essence of photography. Composition he defines as the strongest way of seeing. Technique is a result, not a cause; a means, not an end. Apropos of categories into which photography is too often forced he wrote: "Can anyone say where and when the 'Pictorialist' and the 'Purist' part ways? Can anyone be worse than a puritanical Purist! I can honestly say that I never based my way of seeing on moral grounds. I just think — *today* — that there is nothing so beautiful as a sharp, long scale, glossy photograph. But tomorrow? I have a sneaking suspicion that someday I'll throw my 'fans' into utter confusion by making a series of soft focus negatives, just to contradict myself and say, 'It can be done.' "

Popular Photography 18 (March 1946): 42-46, 142, 144, 146.

Edward Weston

Nancy Newhall

THIS ESSAY WAS published in book form with twenty-three plates by the Museum of Modern Art, New York, 1946, to accompany the Weston exhibition.

—B. N.

IN 1902 two letters passed between Dr. Edward Burbank Weston and his sixteen-year-old son Edward Henry, who was spending the summer on a farm. The first, from Dr. Weston, accompanied a Bullseye camera and contained instructions on loading, standing with the light over one shoulder, and so on. The second, full of Edward's thanks, excitedly discussed his failures and a first success—a photograph of the chickens.

From then on photography absorbed young Edward; his interest in school dwindled. When a magazine reproduced one of his sensitive little landscapes, such ambitions as wanting to be a painter or prizefighter vanished; he was definitely a photographer.

A livelihood, however, was something else. He came of generations of New England professional men. Edward, born in Highland Park, Illinois, in 1886, and his beloved sister Mary, were the first children born out of Maine for more than two centuries. His grandfather taught at Bowdoin College before moving to the Midwest to head a female seminary. His father, a general practitioner, found time during his rounds to teach in a local college. His mother, rebelling at the family tradition, left it as her dying wish that Edward should escape and become a business man.

After three dull years as an errand boy in Chicago, Edward went on a two-week holiday to visit Mary, now married and living in Tropico, California. Enchanted by the place, he decided to stay, and immediately got a job with some surveyors, punching stakes in orange groves for a boomtown railroad nobody intended to build. Later, carrying the level rod on the Old Salt Lake Railroad, he found mathematics in the hot desert sun overpowering. Returning to Tropico he set up as a photographer. With a postcard camera he went from house to house, photographing babies, pets, family groups, funerals, anything for a dollar a dozen. He fell in love and, full of responsibility, began seriously studying his profession. He attended a "college of photography," learning a solid darkroom technique and how *not* to pose a sitter. For a year or two he held jobs with commercial portraitists, learning to make exact duplicate prints even from the poorly exposed and lighted negatives of his bosses.

In 1909 he married. Four sons were born: Chandler, 1910; Brett, 1911; Neil, 1916; and Cole, 1919.

In 1911 Weston built his own studio at Tropico. The customers who drifted in were delighted; even with his 11 × 14 studio camera, he was often able to make several exposures before they were aware of it. Posing by suggestion, he hid ungainly shapes in

chiffon scarves or vignetted them away. The soft-focus Verito lens helped, and he retouched so deftly and with such regard for actual modeling that his patrons, unconscious of any change, were convinced they looked that well.

He was particularly successful with children (figure 4). Trying to capture their activity, he bought, around 1912, a 3¼ × 4¼ Graflex. The curtains obscuring his skylight and sunny windows came down; the subtleties of natural light absorbed him. "I have a room full of corners—bright corners, dark corners, alcoves! An endless change takes place daily as the sun shifts from one window to another. . . . All backgrounds have been discarded except those for special decorative effects, which are brought out when needed.[1]

He worked outdoors as well—his baby sons in the garden, Ruth St. Denis in Japanese costume standing in a shimmer of light and space with one spot of brilliant sun slanting across her cheek. From 1914 to 1917 he received a shower of honors. Commercial and professional societies awarded him trophies and asked him to demonstrate. Pictorial salons in New York, London, Toronto, Boston, Philadelphia, elected him to membership. Many one-man shows at schools and clubs brought him further acclaim.

But he was not content. Something was wrong—with himself, with his hazy Whistlerian and Japanese approach. At the 1915 San Francisco Fair he first saw modern painting; radical new friends introduced him to contemporary thought, music, literature. His conservative friends and in-laws frowned; instead of settling down as a successful man and father, he began to

sport a velvet jacket and a cape. He ceased to send to pictorial exhibitions. His work was changing.

By 1920 the Japanese arrangements were violently asymmetrical. An attic provided semi-abstract themes of angular lights and shadows. By accident he discovered the extreme closeup; focusing on a nude, he saw, in the ground glass, forms of breast and shoulder so exciting that he forgot his customers. Groping, with occasional flashes of insight, he was still trying to impose his "artistic" personality on his subject matter.

Then in 1922, the dark and exciting Tina Modotti took some of Weston's personal work to Mexico and exhibited it at the Academia de Bellas Artes. Her friends— Rivera, Siqueiros, the artists of the surging Mexican Renaissance—were enthusiastic. What is more, they bought—a new experience for Weston. He decided he would go to live in Mexico.

In November he went East to say goodby to Mary, whose husband was now with the steel industry in Ohio. The Armco plant, with its rows of giant smoke stacks, excited Weston to a series of photographs in which his own vision emerges unmistakably (figure 10). Mary urged him to go to New York and see the legendary masters there. In New York, with his mind full of the forms and rhythms of industrial America, he haunted the bridges and rode endlessly on the buses, looking up at the towering city. Articles on Stieglitz by Paul Rosenfeld and Herbert Seligmann had helped him discover why he was dissatisfied with his own work; actual contact with Stieglitz left him rather bewildered, though much moved by the

photographs of O'Keeffe. His greatest enthusiasm was evoked by the clear structure of Charles Sheeler's architectural photographs.

In August 1923, he sailed for Mexico. With Tina, whom he had taught to photograph, he opened a portrait studio in Mexico City. His exhibition at "The Aztec Land" in October contained palladio-types of industrial themes, sculptural fragments of nudes, highly individual portraits, people in contemporary life. The Mexican artists immediately accepted him. "I have never before had such intense and understanding appreciation. . . . The intensity with which Latins express themselves has keyed me to high pitch, yet viewing my work on the wall day after day has depressed me. I see too clearly that I have often failed."[2]

The three years in Mexico were years of ruthless self-scrutiny and growth. Unable in his halting Spanish to control his sitters by conversation, he took them out into the strong sunlight and watched in his Graflex for the spontaneous moment. A startlingly vivid series of heroic heads against the sky resulted — the keen-squinting Senator Galván at target practice, Rose Covarrubias smiling, with the sun in her downcast lashes. Commenting on the head of Guadalupe de Rivera, Weston wrote (1924): "I am only now reaching an attainment in photography that in my ego of several years ago I thought I had reached long ago. It will be necessary to destroy, unlearn, and rebuild."[3]

Between sittings — desperately poor, he was much confined to the studio for fear of losing a customer — he worked searchingly with still life — Mexican toys, painted gourds,

jugs — arranging them again and again in new lights, new relations. Within the courtyard, from the rooftop, whenever he could get away, he was at work with a more powerful and articulate clarity on the massive forms of Mexico; the vast landscapes, the huge pyramids, the people-sprinkled patterns of the little towns.

More even than to the mental stimulation of such friends as Diego Rivera, Weston responded to "the proximity to a primitive race. I had known nothing of simple peasant people. I have been refreshed by their elemental expression. I have felt the soil."[4] Close to them, confusions fell away. Eliminating every illusion, convention, process or device which impeded creation, he concentrated on vital essentials. "Give me peace and an hour's time and I create. Emotional heights are easily obtained, peace and time are not. . . . One should be able to produce significant work 365 days a year. To create should be as simple as to breathe."[5]

In 1925 he went to California for six months. Contact with his native land produced sharper rhythms, more complex motifs — industrials again, and unposed 8 × 10 portraits. Returning to Mexico with his son Brett, he photographed with a stronger feeling for light and texture the markets, the wall paintings outside native bars, Dr. Atl standing beside a scribbled wall. Reviewing the Weston-Modotti show at Guadalajara, 1925, Siqueiros wrote, "In Weston's photographs, the texture — the physical quality — of things is rendered with the utmost exactness: the rough is rough, the smooth is smooth, flesh is alive, stone is hard. The things have a definite proportion and weight and are placed in a clearly

defined distance one from the other. . . . In a word, the beauty which these photographs of Weston's possess is *photographic beauty!*"[6]

With Tina and Brett, Weston traveled through almost unknown regions photographing sculpture for Anita Brenner's *Idols Behind Altars*[7] and bold details of cloud and maguey for himself. But he was not and never could be Mexican; the time had come for him to return home.

His friends grieved. He had brought them an important stimulus and vision. Jean Charlot, in an as yet unpublished history of the Mexican Renaissance, wrote: "It was the good fortune of Mexico to be visited, at the time when the plastic vocabulary of the Renaissance was still tender and amenable to suggestions, by Edward Weston, one of the authentic masters that the United States has bred. . . . Weston's photographs illus-trated in terms of today the belief in the validity of representational art . . . cleansed . . . of its Victorian connotations. . . . He dealt with problems of substance, weight, tactile surface, and biological thrusts that laid bare the roots of Mexican culture. When Rivera was painting *The Day of the Dead in the City* in the second court of the Ministry we talked about Weston. I advanced the opinion that his work was precious for us in that it delineated the limitations of our craft and staked optical plots forbidden forever to the brush. But Rivera, busily imitating the wood graining on the back of a chair, answered that in his opinion Weston blazed a path to a better way of seeing, and, as a result, of painting."[8]

Back in Glendale, Weston missed Mexico and was at first unable to work. Then, in the studio of the painter Henrietta Shore, he picked up some shells of which she had been making some semi-abstract studies. His mind was suddenly filled with the dynamic forces of growth, the vital forms and lucent surfaces of shells, fruits, vegetables (figures 14, 16). Often he worked for days on a single form in various nuances of natural light, seeking "to express clearly my feeling for life with photographic beauty — present objectively the texture, rhythm, form in nature without subterfuge or evasion in spirit or technique — to record the quintessence of the object or element before my lens, rather than an interpretation, a superficial phase or passing mood. . . ."[9] He began to free the forms in space. One superb pepper came most thoroughly alive within the shimmering darkness of a tin funnel. At the same time, with the same feeling: "I am also photographing a dancer in the nude. . . . I find myself invariably making exposures during the transition from one position to the next — the strongest moment."[10]

With Brett, already at seventeen a remarkable photographer, he opened a studio in San Francisco. Cities increasingly oppressed him; in 1929 he welcomed a chance to move to Carmel among the Monterey coast mountains. Here he discovered what his friend Robinson Jeffers (figure 15) has described as "the strange, introverted, and storm-twisted beauty of Point Lobos." He photographed the writhing silver roots of cypresses and the strangling kelp, the starred succulents and monumental eroded rocks, incandescent salt pools and winged skeletons of pelicans. Orozco, passing through Carmel in 1930, was so moved by these transcendent images that he arranged Weston's first New York one-man show that fall.

In 1927 the reaction to the first shells was surprise and dismay. Many people, including Rivera, thought them phallic. As the closeups grew more subtle and powerful they struck beholders with the force of a revelation. Sober reviewers from Seattle to Boston discovered they were "art" and prattled of "miracles," "lowly things that yield strange, stark beauty." They declared Weston one of the most significant artists in America in the twentieth century; they found him the peer of Picasso, Matisse, Brancusi, and Frank Lloyd Wright. In 1932 Merle Armitage brought out a handsome book of thirty-nine reproductions, *The Art of Edward Weston.* [11] One-man shows swept spontaneously from Berlin to Shanghai, from Mexico to Vancouver. Unaided, with neither agent, group, nor institution to back him, Weston responded to innumerable requests with more than seventy different shows between 1921 and 1945.

With his first New York show, composed entirely of glossy prints—the shells and rocks demanded a brilliance and clarity beyond the bronze tones and matte surface of the palladiotype—Weston's concept stood forth clear and mature. "This is the approach: one must prevision and feel, *before exposure,* the finished print. . . . The creative force is released coincident with the shutter's release. There is no substitute for amazement felt, significance realized, at the *time of exposure.* Developing and printing become but a careful carrying on of the original conception. . . ." [12] He had, and has, two cameras: an 8 × 10 view camera and a Graflex for portraits. There is one background, occasionally used behind a sitter. Settling his friends or clients somewhere, indoors or out, where the light is favorable, he lets them become themselves while he watches fleeting expressions and gestures. He uses one film, one paper. He tray-develops his negatives in pyro-soda, by inspection, bringing each one to the exact degree of delicacy or density he wants. Working under an overhead bulb with a printing frame, he makes only contact prints, dodging in areas beyond the scale of paper so deftly that the balance of light is never upset. Developed in amidol, scrupulously fixed and washed, more than half of the first prints from his negatives are exhibition quality. These prints are then dry-mounted on white boards and spotted. This is technique at its most basic and direct; the result of decades of experience, its emphasis is entirely on vision.

In his professional work he was still compelled to use evasions, enlarging the Graflex negatives onto 8 × 10 film with the old Verito lens stopped down just short of sharp. Printing the results on matte paper either eliminated retouching or hid the last traces of his almost invisible pencil work. This division between personal and professional standards bothered him. He campaigned among his sitters. More and more people discovered that the reality of one's own face, worn into character, quick with thought and feeling, the composition completed by mobile hands, has a curiously exciting quality. Friends liked the little prints and the unostentatious way they fitted into contemporary living. By 1934 he could at last hang out a sign: *"Unretouched Portraits."*

To thousands of photographers Weston was becoming a challenge; to his friends a sanctuary as well. To live more freely and simply than Thoreau, to work with a bare technique and produce brilliantly, to walk free, without help or compromise—these

things are not easily achieved in the cluttered and frantic twentieth century.

His isolation was ending. Brett was changing from a prodigy to a co-worker and others were coming to share the stimulating companionship: Ansel Adams, whom they met as a pianist with some promising but immature photographs; Willard Van Dyke, who left his filling station for two weeks to study with Weston. These young photographers, wrestling with creative problems, discovering new subject matter, groping for their own approaches, began to form a group around Weston. The more they grew away from Pictorialism the more intolerable they found it that there should exist a system which put a premium on the obvious and the sentimental and consistently squeezed any honest or original thought into decadent impressionistic formulae.

The idea of organizing occurred to them. One night in 1932 Willard Van Dyke called a meeting and proposed Group *f*/64 — *f*/64 being one of the smaller shutter stops and therefore associated with sharp focus (figures 20, 21). Lloyd Rollins, the new director of the M. H. de Young Museum in San Francisco, strongly encouraged the nascent group and held its inaugural exhibition in the fall of 1932. The most ardent protagonists, Adams and Van Dyke, both opened galleries, wrote vigorously for the press, and started a salon of "pure photography." With some of their pronouncements Weston could not agree. Gently, he withdrew. As an active spearhead, Group *f*/64 lasted only a year or two; as the violent peak of a great contemporary movement, its influence still persists.

In the early 1930s Weston was alarming his friends by breaking away from the extreme closeup, doing clouds and villages in New Mexico, perspectives of a lettuce ranch in Salinas, the massive naked hills of the Big Sur. Then came, in 1936, a classic and majestic series. From their new studio in Santa Monica, Edward and Brett worked together among the vast, wind-rippled sand dunes at Oceano which rose from deep swirls of morning shadow to stand dazzling and sculptural at noon, and sank again, bright-crested, into darkness. Photographing across from one bank to another, with the sun along the same axis as his camera, Weston made a series of nudes in which a subtle line of shadow outlines the figure, rounding the living skin away from the harsh brilliance of the sand.

The old longing to be free of clients led Weston to apply for a Guggenheim Fellowship "to make a series of photographic documents of the West." In 1937 he became the first photographer to receive this award. After twenty-six years he was at last able to concentrate on his personal work alone.

He wanted to see if he could now meet what he considered photography's greatest challenge: "mass-production seeing." In most mediums, he felt, the artist is retarded by his process. He may not in a lifetime bring to birth a fraction of what he conceives. The photographer, realizing and executing in almost the same spontaneous instant, is limited only by his own ability to see and to create.

In *California and the West*[13] his second wife, Charis, has written the log of that journey — the planning of the $2000 grant down to the last cent for a maximum of photography and travel, the canned foods stewed together over campfires, the slow drives through desert heat, mountain snow,

and coastal fogs. During those 35,000 miles, deep-rooted thoughts and emotions began to coalesce into an image of the American West. It concerns the span of geological ages and the enormous savage earth momentarily littered with a brittle civilization. Elemental forces are the true protagonists in Weston's vision—forces which irresistibly produce a flower or a human being, erode granite, and make strange beauty not alone of skeletons but even of the decay of man's works (figure 22).

In 1938 the fellowship was extended. In the bare and simple darkroom of the little redwood house built by Neil on a mountainside looking down over Point Lobos and the Pacific (figure 30), Weston spent most of the year printing the fifteen hundred negatives made on his travels. The only duplicates were of unpredictable moving objects such as waves or cattle. Very few were discarded because they did not meet Weston's severe technical or aesthetic standards. The series constitutes an astonishing achievement in variety of vision. Weston felt he had learned a great deal; he longed to go on.

Returning rather reluctantly to Lobos, he discovered new themes—surf and tide pools, fog among the headlands starred with succulents and dark with cypresses. The stream of visitors began again. Weston photographed them more and more with the 8 × 10, sunning on the rocks (figures 24-27, 41), against his house, among the ferns and flowers of his garden.

In 1941 he was asked to photograph through America for an edition of Walt Whitman's *Leaves of Grass*.[14] His aim was not to illustrate but to create a counterpoint to Whitman's vision. During the journey

through the South and up the East Coast he found the land and the people weary, the civilization more strongly rooted in a quieter earth; he saw blatant power in industry everywhere, strength still standing in old barns and houses. In Louisiana he worked intensely on the decay and beauty of swamps, sepulchers, ruins of plantation houses (figure 32). A miasma of gray light and smoke obscures the cities. In New York it seemed to wall him in.

The trip was cut short by Pearl Harbor. The Westons returned to Carmel, joined civilian watchers on the headlands. All Edward's sons were swept into the war. Lobos was occupied by the army. Security regulations and gas rationing confined Weston to his backyard. Here he began photographing a beloved tribe of cats. Capturing their sinuous independence with an 8 × 10 produced an amusing series—and a formidable photographic achievement. With the robust humor and love of the grotesque that have always characterized his work, he also began producing a series of startling combinations—old shoes, nudes, flowers, gas masks, toothbrushes, houses—with satiric titles such as *What We Fight For, Civilian Defense*, and *Exposition of Dynamic Symmetry*.

On March 24, 1946, Weston will be sixty. For him, the long vista of growth focuses on today; in a recent letter he wrote, "I am a prolific, mass production, omnivorous seeker." His latest work surges with new themes. All the signs point towards fresh horizons.

The charter members of Group *f*/64 were Ansel Adams, Imogen Cunningham, John Paul Edwards, Sonia Noskowiak, Henry Swift, Willard Van Dyke,

and Edward Weston. Later members were Dorothea Lange, William Simpson, Peter Stackpole. Associates were Preston Holder, Consuela Kanaga, Alma Lavenson, and Brett Weston. References to shutter stops rather than to the group have been standardized throughout as *f*/64, etc., in accordance with contemporary, international usage.

1. *Photo Miniature* 14 (September 1917): 354-56.

2. *Creative Art* 3 (August 1928): 29-36.

3. Ibid.

4. Ibid.

5. Ibid.

6. David Alloro Siqueiros, "Una Transcendental labor fotográfica," *El Informador* (Guadalajara: 4 September 1925): 1.

7. Anita Brenner, *Idols Behind Altars* (New York: Payson and Clarke, 1939).

8. Jean Charlot, *The Mexican Mural Renaissance: 1910-1925* (New Haven: Yale University Press, 1963). This quote, however, was not included in the final version.

9. Edward Weston, "From My Day Book," *Creative Art* 3 (August 1928): 29-36.

10. Ibid.

11. Merle Armitage, ed., *The Art of Edward Weston* (New York: E. Weyhe, 1932).

12. Edward Weston, "Statement," *The San Franciscan* 3 (December 1930): 22-23.

13. Edward Weston and Charis Weston, *California and the West* (New York: Duell, Sloan, and Pearce, 1940).

14. Walt Whitman, *Leaves of Grass* (New York: Limited Editions Club, 1941).

The Camera's Glass Eye

Clement Greenberg

AT THE TIME this was written, the position of photography as a fine art was still controversial.

Clement Greenberg, a New York art critic noted for having championed abstract painters, disliked the inanimateness and "merciless" sharp focus of the work he had seen at Weston's retrospective exhibition at the Museum of Modern Art. Instead, Greenberg advocated what Peter Henry Emerson had called "naturalistic focusing," that is, sharp focus restricted to one element in a scene.

With a certain reluctance, Greenberg accepted the possibility that photographic expression when documentary in nature could be art. He recommended that photography should be literary to compensate for that which was no longer acceptable in painting—that it should be naturalistic, anecdotal, and convey a message. This, of course, would push photography more toward an aesthetic of illustration rather than interpretation.

Weston's theme for most of his career was light: in his review, Clement Greenberg never considered this photographic possibility. Weston, however, concentrated on light—not totally abstract light which would have been relatively easy to appreciate and understand, but light as it entered through a misty window upon which his son, Chandler, nude, was drawing in 1912; light as it reflected off three fish-gourds on a silver paper ground, off a shell balanced in a tin funnel, off a nude sprawled across the sand; and light as found in a forested and rocky gully. Perhaps his emphasis on the behavior and nature of light was one of the factors that caused so many critics to discuss his work in spiritual and metaphysical terms, qualities which Greenberg felt were inappropriate to the medium.

—A. C.

PHOTOGRAPHY is the most transparent of the art mediums devised or discovered by man. It is probably for this reason that it proves so difficult to make the photograph transcend its almost inevitable function as document and act as work of art as well. But we do have evidence that the two functions are compatible.

The heroic age of photography covered the half-century or more following immediately upon its invention in the late 1830s. During this period its physical technique was still relatively imperfect in result and clumsy in procedure. However, since art is a matter of conception and intuition, not of physical finish, this did not prevent—indeed it seems to have aided—the deliberate or accidental production of a quantity of masterpieces by such photographers as Hill, Brady, Nadar, Atget, Stieglitz, Peter Henry Emerson, Clarence White, and others. Hill's photographs were conceived in accordance with the portrait-painting style of his time—he was a painter himself; Brady's documentary photographs, with the exception of his portraits, became art more or less unconsciously; Atget's likewise. In an instinctive way both Brady and Atget anticipated the *modern* and produced a legitimate equivalent of post-impressionism in painting; which was permitted them no doubt by a medium clean of past and tradition, through which they could sense contemporary reality naively and express it directly, untrammeled by reminiscences and precedents that in an art such as painting could be escaped from only by dint of conscious effort on the part of a sophisticated genius like Seurat. Stieglitz, for his part, absorbed impressionist influences in his early work but

transposed them radically into terms proper to his own medium. And so, to a lesser extent, did Clarence White.

Since the beginning of the twentieth century the procedure of photography has been made swift, sure, and simple. Yet its results, in the hands of those who strive to render it art, have on the whole become more questionable than before. The reasons for this decline are complex and have still to be cleared up. But a few of the more obvious ones become apparent in the work of such a serious and ambitious contemporary as Edward Weston, a selection of whose *oeuvre* to date is being shown at the Museum of Modern Art (until March 31).

Two of the most prominent features of latter-day art photography are brilliant physical finish—sharpness or evenness of focus, exact declaration of lights and darks—and the emulation of the abstract or impersonal arrangements of modern painting. In the first respect, modern photography, eschewing the blurred or retouched effects by which it used to imitate painting, has decided to be completely true to itself; in the second respect, which concerns subject matter, it takes this decision back. This logical contradiction is also a plastic one. Merciless, crystalline clarity of detail and texture, combined with the anonymous or inanimate nature of the object photographed, produces a hard, mechanical effect that seems contrived and without spontaneity. Hence the estranging coldness of so much recent art photography.

It again becomes important to make the differences between the arts clear. Modern painting has had to reduce its ostensible subject matter to the impersonal still life or landscape or else become abstract, for a number of reasons, historical, social, and internal, that hardly touch photography in its present stage. Photography, on the other hand, has at this moment an advantage over almost all the other arts of which it generally still fails to avail itself in the right way. Because of its superior transparency and its youth, it has, to start with, a detached approach that in the other modern arts must be struggled for with great effort and under the compulsion to exclude irrelevant reminiscences of their pasts. Photography is the only art that can still afford to be naturalistic and that, in fact, achieves its maximum effect through naturalism. Unlike painting and poetry, it can put all emphasis on an explicit subject, anecdote, or message; the artist is permitted, in what is still so relatively mechanical and neutral a medium, to identify the "human interest" of his subject as he cannot in any of the other arts without falling into banality.

Therefore it would seem that photography today could take over the field that used to belong to genre and historical painting, and that it does not have to follow painting into the areas into which the latter has been driven by the force of historical development. That is, photography can, while indulging itself in full frankness of emotion, still produce art from the anecdote. But this does not mean pictures of kittens or cherubs. Naturalism and anecdotalism are required to be as original in photography as in any other art.

The shortcomings of Edward Weston's art do not usually lie in this direction, rather in its opposite. He has followed modern painting too loyally in its reserve toward subject matter. And he has also succumbed to a

combination of the sharp focus, infallible exposure and unselective atmosphere of California—which differentiates between neither man and beast nor tree and stone. His camera defines everything, but it defines everything in the same way—and an excess of detailed definition ends by making everything look as though it were made of the same substance, no matter how varied the surfaces. The human subjects of Weston's portraits seem to me for the most part as inanimate as his root or rock or sand forms: we get their coverings of skin or cloth but not their persons. A cow against a barn looks like a fossilized replica of itself; a nude becomes continuous with sand, and of the same temperature. Like the modern painter, Weston concentrates too much of his interest on his medium. But while we forgive the painter for this, because he puts the feeling he withholds from the object into his *treatment* of it, we are reluctant to forgive the photographer, because his medium is so much less immediately receptive to his feeling and as yet so much less an automatic category of art experience. This is why the photographer has to rely more upon his explicit subject and must express its identity or personality and his feeling about it so much more directly.

Nor do the abstract factors make up in Weston's art for the lack of drama or anecdotal interest. To secure decorative unity in the photograph, the posing of the subject and the effects of focus and exposure must be modulated just as the analogous elements in painting have to be modulated for the same purpose. (Of course, decorative unity in photography is made more difficult by the infinitely more numerous and subtle gradations between black and white.) The defects of Weston's art with respect to decorative effect flow from its lack of such modulation. In this Weston resembles the Flemish "primitive" painters, who also liked to define everything in sharp focus and who likewise lost decorative unity by their failure to suppress or modulate details—rejoicing self-indulgently as they did in the new-found power of their medium to reproduce three-dimensional vision. Unlike the Flemish, however, Weston tries to achieve decorative unity at the last moment by arranging his subject in geometrical or quasi-geometrical patterns, but these preserve a superimposed, inorganic quality. Or else they overpower every other element in the photograph to such an extent that the picture itself becomes nothing more than a *pattern*.

The truth of this analysis is borne out, it seems to me, by the fact that almost the best pictures in Weston's show are two frontal views of "ghost sets" in a movie studio. Here the camera's sharply focused eye is unable to replace the details left out by the scene painter or architect, and the smoothly painted surfaces prevent that eye from discovering the details it would inevitably find in nature or the weathered surface of a real house. At the same time, a certain decorative unity is given in advance by the unity, such as it is, of the stage set.

Weston's failure is a failure to select, which is moved in turn by a lack of interest in subject matter and an excessive concentration on the medium. In the last analysis this is a confusion of photography with painting—but a confusion not so much of the effects of each as the approaches proper to each. The result, as is often the case with confusions of the arts, shows a tendency to be artiness rather than art.

If one wants to see modern art photography at its best let him look at the work of Walker Evans, whose photographs have not one-half the physical finish of Weston's. Evans is an artist above all because of his original grasp of the anecdote. He knows modern painting as well as Weston does, but he also knows modern literature. And in more than one way photography is closer today to literature than it is to the other graphic arts. (It would be illuminating, perhaps, to draw a parallel between photography and prose in their respective historical and aesthetic relations to painting and poetry.) The final moral is: let photography be "literary."

The Nation 162 (9 March 1946): 294-98.

Greenberg's review prompted Bruce Downes, Eastern editor of Popular Photography, *to write the following letter to* The Nation:

Tortuous Animadversion

Dear Sirs: Mr. Greenberg's tortuous animadversion on the subject of Edward Weston's retrospective exhibition at the Museum of Modern Art is, I fear, another shameless demonstration of the art critic talking—and talking obliquely—through his beret.

Mr. Greenberg sits as an oracle, audacious enough to tell photography what it ought to be. And what is that? "Let photography be 'literary.' " I quote his final sentence.

Now let us examine Mr. Greenberg's devious route to this conclusion. He points out that "modern photography, eschewing the blurred or retouched effects by which it used to imitate painting, has decided to be

completely true to itself." But then he complains because photographers, using the medium as it should be used, in its crystalline clarity of detail, are selecting the wrong subject matter! Since when is the artist to be told what is or is not proper subject matter for him?

Specifically, Mr. Greenberg does not like Edward Weston's photographs because, as he puts it, Weston "has followed modern painting too loyally in its reserve toward subject matter," and because "he has succumbed to a combination of the sharp focus, infallible exposure, and unselective atmosphere of California." The first reason is meaningless, and I leave the reader to figure out how the atmosphere of California can be unselective.

Mr. Greenberg complains also that Weston concentrates too much of his interest on his medium. This is a ridiculous statement in view of the well-known simplicity of Weston's direct photographic approach to his subject matter. Mr. Greenberg fails to discern that what appears to him as concentration on the medium is in fact intense concentration on subject matter, which is exactly what makes Weston's work explicitly clear and luminous. It is precisely this concentration which produces the aesthetic pleasure to be derived from his photographs. Weston has seen powerfully into the form and texture of his subjects and has succeeded in showing them forth in his prints. In them we see peppers, cabbages, shells, sand dunes, and so on in a way we have never seen them before.

Is it not presumptuous to tell an artist what he is to concern himself with? And to say that photography should be literary is as

ridiculous a statement as any art critic has made in the last century. Doesn't Mr. Greenberg know that photography went through its literary period in the 1850s, and doesn't he know that it was photography's most disgraceful period? In his decree that photography should be "literary" I assume, of course, that he means Marxian literature, since he doubtless would be in a frightful tizzy were some photographer to take him literally and choose non-Marxian literature as his aesthetic gospel.

In simple point of fact photography should be photography, painting, painting, literature, literature — all these facets of the one organic whole, art.

Bruce Downes, Eastern Editor
Popular Photography
New York, 15 March

Mr. Greenberg replied in rebuttal:

Dear Sirs: Mr. Downes's and my differences amount in the end to the fact that he enjoys looking at Edward Weston's photographs much more than I do.

When an artist gets bad results from the subject matter he handles right now, it is permissible to suggest that he change his subject matter, or his way of creating it. One certainly had a "right" to tell the painter David, at the time, to stop illustrating incidents from Plutarch and do more work from nature as he saw it around him. In this case, the justification for one's "right" to tell the artist what to do lies in David's portraits, which are so much superior to his historical paintings.

Simplicity or transparency of approach does not exclude overemphasis upon approach. It may be that Weston concentrates so much upon seeing his cabbages and sand dunes clearly that he forgets to feel them. More feeling for them would perhaps have prevented them from disappearing, as they do, into mere objects of "clear and luminous" vision.

As for "Marxian literature"—I think Mr. Downes has only the slightest notion of what he means by that. I hesitate to offend his intelligence by saying what most people would think he means. Aside from that, he has no basis whatsoever for assuming that I wish to prescribe any particular sort of subject matter to any art. True, I may be a Socialist, but a work of art has its own ends, which it includes in itself and which have nothing to do with the fate of society.

Clement Greenberg
New York, 1 April

The Nation 162 (27 April 1946): 518-19.

Introduction to
Fifty Photographs: Edward Weston

Robinson Jeffers

The poet Robinson Jeffers was a long-time friend of Weston (figure 15). He had contributed to the community tribute to Weston in The Carmel Cymbal *in 1934. The sensibility of both men to the beauty and power of the Pacific Coast was so in tune that lines from Jeffers's poetry have been published together with Weston's photographs.[1] Although Jeffers knew little about the photographic medium, he understood Weston as a fellow creative artist.*

— B. N.

WAITING FOR WESTON to come in, I looked at the row of books along his mantel-shelf, and a fat one caught my eye—Taine's *History of English Literature,* the same edition and binding that used to stand in my father's library—a book that had excited me when I was very young. I took it down and opened at random, wondering whether the Frenchman's enthusiasms would still be infectious after so many years; and indeed the book opened on treasure; two ten-dollar bills lay between pages. A dollar was still a dollar in those days, and when Weston came in I made haste to tell him what I had found. He answered rather sheepishly, as if ashamed of owning so much money: yes, he didn't need them at the moment, and had tucked them away there; this book was his bank. I think of the anecdote because it seems characteristic; Weston's life and his work are like that, simple, effective, and without ceremony. He knows exactly what he wants to do, and he does it as simply as possible. He is not interested in the affectations and showmanship that distract many talented persons; I think he has never even been interested in having a career, but only in doing his work well.

But concentration is not enough; there must be energy also; and this brings to mind my earliest impression of Weston at work; the almost unseemly contrast between the hot vitality of his red-brown eyes and the cold abstract stare of his camera; as if the man and the instrument had been specially designed to supplement each other. W. B. Yeats had something very different in mind when he wrote of "passion and precision" made "one," but the line is applicable. Photography in itself is only a mechanical kind of reporting and recording; the directive passion, the energy for endless experiment and the passion for beautiful results, make it much more than that.

Now I hear rumors of an old-fashioned controversy on the subject of art; can photography be considered an art? It seems to me that the question is rather verbal than vital; but it may be answered by looking at the photographs. If they have the effect and value of works of art, as clearly these do, then photography is the art that produced them; for we judge a tree by its fruits. And if the intention and effect are primarily aesthetic, then photography, at that level, is one of the fine arts. It has not the prestige

of history and prehistory, as painting has; and its future is doubtful, for it depends on a machine, and machines have a high mortality rate, they are always being superseded; but for its active century or two, and as long afterwards as the films and prints survive or are reproduced, photography has its honored place. It does not compete with painting; it has its own special qualities—its precision, infinite value range, instantaneous seeing—and they are important.

Edward Weston was a pioneer in the recognition and development of these qualities. He was one of those who taught photography to be itself, not a facile substitute for painting, or an anxious imitator. It was an exciting adventure; and the more so because of the newness of photography. The field was nearly clear; whereas the painter has twenty thousand years of experience to guide—and discourage him. The human hand with a graver's tool or a daub of pigment is the same hand that made pictures on the cave-walls in France, in a bay of the last ice-age; and really it has not increased in skill—look at the best of the cave-paintings!—though the mind has longer knowledge and the brushes are a little better. But the camera was something new to work with.

And Weston wanted pure photography; he was zealous, he was honest, he was for a time even bigoted, in his refusal to retouch or use any kind of trick or mistiness. He really believed in the beauty of things, and that included their accidents and asperities; the beauty of harsh stone, or broken wood, or a blemished face. He would choose, of course, long and carefully, but he would not conceal nor soften. Nothing perhaps since the beatitudes is more endlessly quoted and less believed than that famous line about "beauty is truth, truth beauty." I doubt whether Keats himself believed it, except in some transcendental sense; but Weston believes it.—And on this note let me end. I am not qualified to speak technically of Weston's work, nor of his wide and living influence; but one does have ordinary human judgment. I know the man, and I can recognize honesty, single-mindedness, originality, ability, when I see them.

Merle Armitage, ed., *Fifty Photographs: Edward Weston* (New York: Duell, Sloan and Pearce, 1947): 7-10.

1. David Brower, ed., *Not Man Apart: Lines from Robinson Jeffers, Photographs of the Big Sur Coast* (San Francisco: Sierra Club, 1965).

Edward Weston, Photographer:
The Birthday of a Modern Master

Kevin Wallace

ALTHOUGH THIS ARTICLE was written for the popular press, it is unusually accurate except for a few dates in the last paragraphs. It also includes most of the classic clichés found in articles on Weston, such as the hungry cats, his unpretentious darkroom, his simple life, and the description of his little brown hut in the vale. Wallace also recorded for history a quote from Weston which otherwise we might have lost: "When I catch myself thinking, I know something's wrong, and I quit."

—A. C.

CARMEL HIGHLANDS, April 1—Edward Weston celebrated his sixty-fourth birthday here last week by forgetting all about it. He was a little surprised that so many others remembered, and called him.

Being reminded of arbitrary milestones, like birthdays, is one of the mild nuisances of being acclaimed photography's greatest artist. The acclamation, which has become fairly standard in the past few years, was said again in San Francisco last week by another celebrated camera artist, Ansel Adams:

"Weston is one of the five or six great living artists ranking with Picasso and Marin, Epstein and Stravinsky—or whoever else you choose to represent the other arts.

"The point is that Weston is THE great photographer—the culmination of a line that began more than one hundred years ago with David Octavius Hill and came up through Alfred Stieglitz to Weston."

'An Art Itself'

A student remarked: "Especially because of Weston, photography has become an art itself, resting on its own merits—no longer a mere literary byproduct or an imitation of romantic painting. . . ."

But no brazen tokens of Weston's preeminence decked last week's birthday. The milestone went unattended in the tranquility of Weston's tiny redwood studio cottage here, hidden in sunlight behind climbing nasturtiums and Monterey pines on Wildcat Hill, 200 feet above the ocean and the rocks he loves.

The cottage was built by one of Weston's four grown sons, and it contains no trophy cups, no distinguished whiskys to be endorsed, not so much as a Venetian blind nor a "By Appointment Only" card on the door.

Visitors are welcome, if they can find the way, and they may buy any Weston print for $25—it doesn't matter about the size or the subject. "The flat rate saves bookkeeping."

Nothing Fancy

The studio room boasts no glass brick or theatrical lighting installations—just French

windows and a skylight through which the sun provides roving illumination and shadows, as it pleases.

The tiny darkroom has no chrome.

Illness has cut down Weston's once enormous productivity, but he nonetheless takes care of himself and his house, carries in the firewood, and is reminded about meal time by the positive declarations of his ten cats—cats who wander in and out through their own foot-high swinging door. This door has a peep-hole, cats being a cautious race.

Weston has a small plyboard bedroom at one end of the studio, but no guest quarters. Guests arrive, however. In recent weeks, two field classes came down from San Francisco's California School of Fine Arts to camp on the lawn and drive their pedagogue to photogenic sites (Weston never learned to drive himself). A third student group is due in the next few days.

Wide Correspondence

In the mornings, from 7 o'clock on, Weston is usually engaged in answering letters—from "students" he has never seen, and from friends, scattered over the world. In various ways from this unperturbed center, Weston's influence goes out far and wide and emphatic. Some evidences lie on the studio table:

On the table last week there was a "dummy" copy of a book scheduled for publication by Houghton Mifflin Company—Virginia Adams, entitled *Edward Weston—My Camera on Point Lobos.*

It will be the best of Weston's numerous books, for several reasons.

The volume is designed by Jo Sinel, engraved by Walter J. Mann Company, and printed by Crocker-Union—all of San Francisco—and its thirty photographic reproductions are a landmark in a technic whose importance is not widely understood.

Engraving Process

Briefly, this is it:

With few exceptions in the past, printed reproductions cloud the precise tonal values—and so the "feeling"—of original photographs. That's because the photograph's free-flowing surface must be cross-hatched by fine lines across the printing plate, leaving raised points for the ink to grip.

The reproductions on this page are photo-engravings sliced by two diagonal sets of lines, 85 to an inch—a finer-than-average chopping up in newspaper engraving. The new Weston book employs a careful letter-press process with 150 lines per inch.

But the final authenticity of the printing—which even the trained eye can mistake for a photographic original—is due to the painstaking supervision of the process by Virginia Adams and her husband, Ansel, whose *My Camera in Yosemite Valley* launched the publishing series last fall. For the first time, Weston reproductions may have the same impact as an exhibit of Weston originals.

Tributes to an Artist

As for exhibits:

Also on Weston's studio table last week was a cablegram from the United States Embassy in Paris, asking permission to borrow Weston's recent one-man exhibit in Paris of 125 prints.

Weston has had over one hundred different one-man shows—more than any other artist, according to his biographer for New York's Museum of Modern Art, Nancy Newhall—and the big one in Paris won typical response.

Reported French photographer Daniel Masclat: "People stood in line. . . . There were three kinds—those who were stupefied with shock; those who were thrilled and satisfied; and those who didn't understand. But they will never understand."

The Paris exhibit (two others are current, one at New York's Camera Club, the other in Holland), will go to the embassy to adorn the European premiere of the Voice of America's "The Photographer," an event worth discussion on its own.

"The Photographer" is the first documentary movie ever made about a man in that calling. The State Department intended the film for overseas release only—to show the world a way of life that can occur in America—but after one look at the movie, the U.S. Information Service has agreed to give it general release in this country, too, later this year. It felt Americans should also know about this special way of life.

"The Photographer" was produced and photographed by Willard Van Dyke, organizer eighteen years ago of the famous f/64 Group—the group of young photographers who followed Weston in revolt against the soft-focus, academic "rules" of salon photography, in favor of sharp focus, deep-field "straight" photography that employs lens apertures of f/64 (eight times smaller than the usual snapshot opening) and smaller. The technical revolt symbolized an underlying philosophical one—from "salon" to "straight."

Producer Van Dyke contributed another item on Weston's studio table last week, a letter reminding Weston of the old days and describing the new movie as "a tribute to my 'maestro,' as well as to the kind approach to photography and to life that you taught me to respect. If that sounds high flown . . . it is true."

"The Photographer," in the documentary is, of course, Edward Weston.

It was a happy birthday, all things considered. And there was one more token of it on the table—a clipping of "The Ripples" from the *Chicago Tribune*'s Sunday comics, in which a hypertonic adolescent is seen exclaiming: "Look at these GREAT photographs by Weston and Adams!"

"When we found ourselves in the funny papers, Ansel and I realized we had arrived," Weston said.

His career in picture-taking dates back forty-eight years—back, exactly, to a letter dated August 18, 1902 from his father, Dr. Edward Burbank Weston of Highland Park, Illinois, accompanying a Bullseye camera, mailed to the Michigan farm where sixteen-year-old Edward was vacationing.

"Dear Ted," it began, "I have no book of instructions," and it went on with a home-made set of rules for rolling the film into the camera, and locating the shutter. . . .

"After you are ready, and see your picture in the Kodak, all you have to do is press, or move, the lever sidewise. . . . You can only take twelve pictures, so don't waste any on things of no interest. . . . I hope I have made it plain. Your aff. Father. P.S. When are you coming home?"

On August 20, two days later, Edward responded on ruled paper:

"Dear Papa: Received camera in good shape. It's a dandy. . . . I think I can work it all right. . . . It makes me feel bad to think of the fine snaps I could have taken if I had had the Kodak the other day. I was within six feet of two swallows perched on a wire fence. I was only a little distance from a wood dove and could nearly have touched another little bird.

"I suppose I'll have plenty of chances and I'm going to wait for good subjects. I'm so glad to be able to use the camera. . . . Must close now and meet Aunt Guss at train. Your loving son, Ed."

To California

Weston came to Tropico, Southern California, in 1914 [1906], and shortly set up as a portrait photographer. By 1917, when he was thirty-one, he was an established success, a member of the London Salon and salons in New York, Boston, Toronto and Philadelphia.

But success didn't suit him, and he felt uneasy about his soft-focus, cropped, and retouched enlargements on sumptuous soft papers—mechanical imitations of painting in the best accepted traditions. In 1923 he junked the success and the traditions and went off to Mexico to start a new career in photography—to make it "an art form that would be a synthesis of the apparently irreconcilable viewpoints of science and aesthetics."

For two years he worked with his friends in the "Mexican Renaissance"—Rivera, Orozco, Jean Charlot, Siqueiros—and when he returned to this country, he had his synthesis: his way of exploiting the super-human sharpness of the camera eye to contemplate the wonderful substance of nature.

By the time he moved to Carmel, in 1929, he knew his materials so thoroughly that they had become a part of his reflex sensory equipment: he could (as he does) approach his subject, landscape or still life or portrait sitter, with no preconceived ideas—intuitively pick the camera's most rewarding approach to it ("composition is only the strongest way of seeing a thing; it has no rules")—and knowing precisely what the finished print will be, walk away after making just one exposure ("saves film, saves time in the darkroom, saves expense . . .")

Of this intuitive method, he remarked the other day: "When I catch myself thinking, I know something's wrong, and I quit."

Self-Expression

Weston defines "self-expression" as "imposing your own bellyaches" on the subject, which he prefers simply to photograph, without "interpretative" tampering! Not that his aim is to "copy nature" ("no use to exactly copy a butterfly—better to see it floating in

summer sky"). Photography, he suggests, is "seeing plus," when "the camera, controlled by wisdom goes beyond statistics."

San Francisco Chronicle (2-3 April 1950).

Figure 11.

Figure 12.

Figure 13.

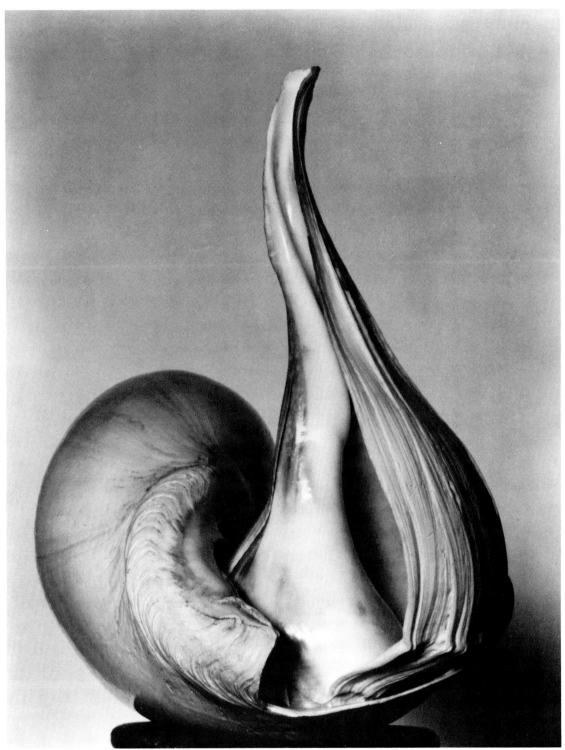

Figure 14.

Figure 15.

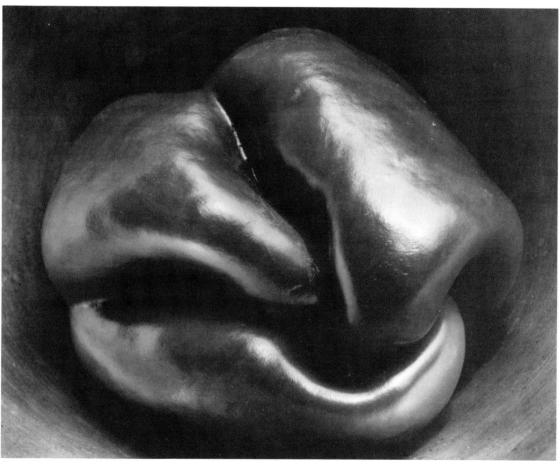

Figure 16.

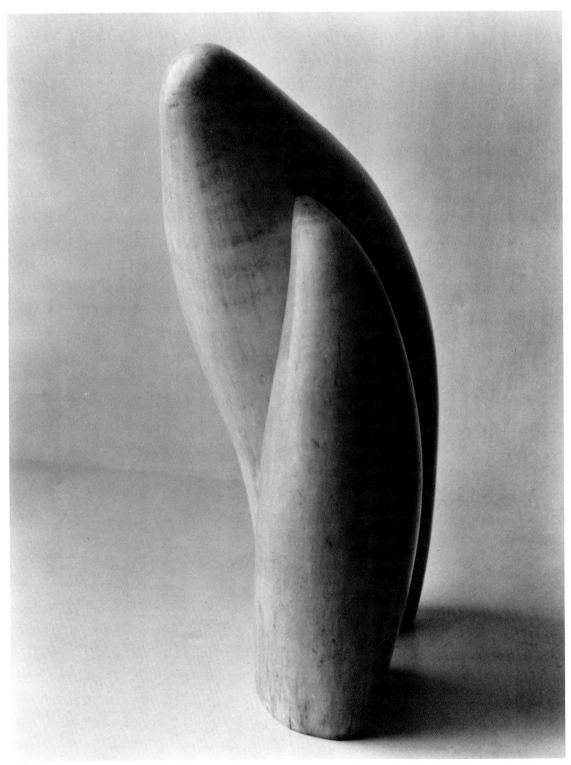

Figure 17.

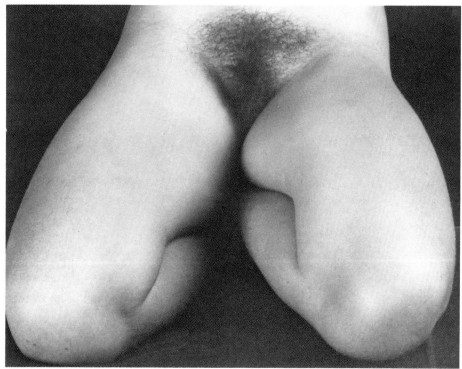

Figure 18.

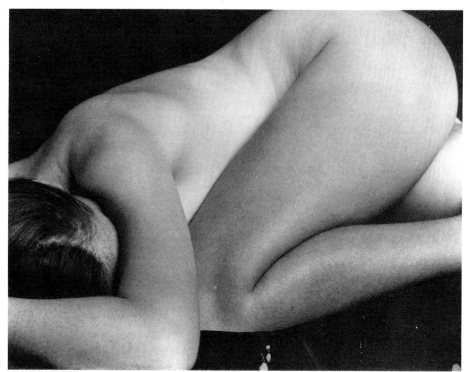

Figure 19.

Figure 20.

Edward Weston and the Nude

Nancy Newhall

THE NUDE IS a basic human fact. We are all born naked! But that fact immediately clashes with another fact: for thousands of years, we have not wandered unclothed about the earth or, if we did, were promptly clad by scandalized neighbors or thrust briskly into jail. So we clothe this cloistered phenomenon, the "nude," with such illusions in our minds that when we do meet with it, it astounds us, not by its beauty, which often only the eye of affection or the artist can detect, but by its variations from our ideal illusions.

But equally, for thousands of years, artists have kept returning to the Nude because it is fundamental and vital. It is a reality — and a reality difficult to present in a world where it is rare and illogical. So the artists have worn thin the few logical glimpses of intimacy, such as bathing and dressing. They have worn out the Greek myths and the Bible; they have covered walls with Hercules and ceilings with Venus, and churches with everything from Adam and Eve to Susannah and the Elders. They have used the Nude as a symbol juxtaposed with other symbols. They have mined in the subterranean vistas of Freud. To throw all this frippery of rationalization out of the window takes the courage of a master. For to present naked reality nakedly, you have to be a reality yourself. The artist confronted by the Nude is as naked psychologically as his model in actuality. The painter's sleight-of-hand can no more conceal behind a convenient flutter of drapery who he is, at what stage of growth, and where his

imagination halts, than the photographer can hide behind his camera, which has always revealed who is behind it more mercilessly than who is in front.

But the painter has free choice! He can ignore a vein, a mole, a fold of flesh — or accentuate them, as he pleases. He can omit a face, or change the broken, swollen feet of a professional model. The photographer must face every fact about his subject. If he cannot think how to turn an ugly fact inside out, he must sink it in shadow or leave it outside his ground glass. He has only one advantage: literally, the speed of light. He does not need the model who can fit back into a pose as if into a mold, or simulate action by a careful equilibrium. (Increasingly, painters prefer photographs, by themselves or somebody else, to such poses.) Even with a big camera and slow exposures, the photographer can come closer to the mercurial substance of humanity. With a small camera or in bright light, he does not need poses; he can watch a living form in spontaneous motion, seize instantly its significant moments.

To the painter, even such moments are merely a genesis; to him, reality is so imperfect he has to do something about it. But the invention of photography gave other kinds of men, in earlier years painters, a medium closer to their thoughts. To the photographer, reality is miraculous. The universe, from galaxy to storm, from death to life, is endless and exquisite. His job is to try to understand and to reveal. The

imperfections that worry him are his own blindnesses and stupidities and those of other men.

Edward Weston had to find his way alone.

He began with little or no background in the arts. The magazines on the family table showed pictures that hung in gold frames on a museum wall somewhere. They seemed remote to Edward; they had no connection with what he saw or might do. But he had the one essential, without which knowledge and technique are worthless; a passion for his medium. From that skyrocket day when, as a kid of sixteen, he was given a box camera, to that tragic day when, suffering from a disease of the nerves, he realized he could no longer focus his image on the ground glass, there were nearly fifty years, and during them, he lived for the hours when he could be alone with his camera.

He had friends who brought him the generative thought of this century; he had criticism that helped him define his work—and painters were the most understanding. He had friends who were photographers, and with them, in the early days, he talked far into the night. But there was no photographer with an equal passion, searching for the same unknowns, nearer than a continent away. Not until he had fought through his problems was he to have photographers of his own kind as companions. He learned to treasure his aloneness, rising before dawn, brewing coffee, and writing down in his daybook what there was none to hear—the volcanic emotions under his quiet appearance, and always, endlessly, his search for the then unknown and unsaid answers to the question: "For what end is the camera best used?"

After trying various livelihoods, he decided that by becoming a portrait photographer he would at least own the tools he needed. In between sittings and printing orders, he could photograph for himself. "I do a thing because I want to, I feel it," he wrote in his daybook, years later. "I don't *have* to please the public, for thank the gods, my portraits earn my salt!" But henceforth he was, with a few brief interludes, tied to a studio and to the human ego. What he photographed for himself had to be close by—the old trite studio standbys: still life, portraits, the landscape outside, and nudes.

The Nude as a Theme

The Nude as a theme runs through nearly forty years of his work. Always he was working with a concept, never with subject matter— "How little subject matter counts!" he wrote. The Nude served him as a touchstone. Again and again, when groping, he turned to it and discovered his way.

He began, as most of us do, with the Nude as Sentiment, which at that is a notch or two above the pin-up. Mist and light veiled everything: his young wife Flora in a misty meadow, his baby sons wandering in misty gardens, friends sitting in misty spotlights in his studio. He was grasping only shimmer, never substance. He refers to this as his "Untouchable Period." But he began to want to see sharp, to touch. He was thirty; he had a home, a family, a prosperous business, honors from professional and pictorial societies. Most men at this stage settle down. Edward had just begun to grow. He became impatient with haze and superficiality. He scraped the prize-winning emulsions off his old negatives and used the glass to make a window.

He began to see Form. On the way to the Abstract, he fell into the usual traps — the fragments, angles, and tricks whose newness, even in 1922, wore off so soon. In one nude, he photographed the wheel-like shadow from a Japanese lantern falling on a breast. This print was highly praised, but to Edward it looked more and more sleazy. "Tricky — I destroyed the negative."

He began to see the dynamics of his time — the thrust of smoke stacks, lift of skyscrapers, leap of bridges. He began to look at Actuality. He saw the Nude sharp, in sunlight, a woman lying on a beach. And at this stage, he departed to live and work in Mexico, where he foresaw that the picturesque awaited him like a booby-trap.

Of two churches he complains: "Both places were quite too beautiful. *The element of possible discovery was lacking, that thrill which comes from finding beauty in the commonplace.*" In the real Mexico, the land and the people helped him to lose layer after layer of blindness. He learned to see beauty in the humble and the abhorred, and not to fear "fearful heights" and "beauty in alien guise."

From Abstract to Real

The painters in Mexico helped him too. They were more aware than he was of what he was achieving — a passage through the blind alley of the Abstract into the Real.

Diego Rivera, "looking at the sand in one of my beach nudes . . . said, 'This is what some of us "moderns" were trying to do when we sprinkled real sand on our paintings, or stuck on bits of lace or paper or other bits of realism.' "

Photographing clouds from the roof-top, Weston looked down and for the first time saw the Nude unposed outdoors. "My cloud 'sitting' ended, my camera turned down on a more earthly theme." For such happenings, he could thank his own drive toward the simple and vital. "But I want to simplify life! — my life!" Just as he eliminated tricks, artificial light, and enlarging from his technique, so he believed in fruits and vegetables, in air, cold water, fasting, and sunlight rather than doctors.

Of one such series, "Some criticized my latest nudes . . . because of 'incorrect drawing,' but Charlot did not mind it. He tells me Picasso got his inspiration to use false perspective from amateur photographs. Diego had another interesting note on Picasso — that he was never influenced by, nor went for inspiration to Nature — always to other schools of art."

Edward was going to Nature. But he found in himself two apparently divergent directions he was at a loss to coordinate. "For what end is the camera best used? . . . The answer comes always more clearly after seeing great work of a sculptor or painter . . . that the camera should be used for a recording of *life,* for rendering the very substance and quintessence of the *thing itself,* whether polished steel or palpitating flesh.

"I see in my recent negatives . . . pleasant and beautiful abstractions, intellectual juggleries which presented no profound problem. But in the several new heads . . . I have caught fractions of seconds of emotional intensity which a worker in no other medium could have done as well . . . I feel definite in my belief that the approach to

photography—and its most difficult approach—is through realism."

But the abstract continued to happen to him. "Yesterday I 'created' the finest set of nudes I have ever done, and in no exalted state of mind. I was shaving when A. came, hardly expecting her on such a gloomy, drizzling day. I made excuses, having no desire—no 'inspiration' to work. I dragged out my shaving, hinting that the light was poor, that she would shiver in the unheated room. But she took no hints, undressing while I reluctantly prepared my camera.

"And then they came to me, the most exquisite lines, forms, volumes!—I accepted, working easily, rapidly, surely.

"A.'s body was in no conventional sense lovely," but Edward could now see through conventions; he could see what was actually in front of his camera. And he saw elemental forms, the forms from which all life evolves, whether leaf, fin, or hand. He ceased to worry much about categories such as Real or Abstract anymore. "I am not prepared to argue these issues. Enough if I work, produce, and let the moment direct my activities."

Returning to California again, he found that industry now seldom excited him. "Form follows function"—yes, but the forms now rising to obsess his mind were those expressing the huge functions of life and death. He found them in shells, peppers (figures 14, 16), a leaf of cabbage, half an artichoke—and in rocks eroded, trees bent by wind, the wing of a dead pelican, kelp twisted by the fury of the sea.

Then, one day, he felt the horizon again, and was swept by the desire to work with the great spaces and rhythms of his earliest love, landscape. To leave his livelihood was not easy; it was to take him four years and a Guggenheim Fellowship to get free to travel. As usual, in transition, he turned to the Nude.

How He Worked

His cinematic series of small nudes was made in 1933 and 1934, in a studio north light, with a 4 × 5 Graflex on a tripod and a lens uncapped for usually a fifth of a second, "without any instructions to the models (I never use professionals, just my friends) as to what they should do (figures 18, 19). I would say, 'Move around all you wish to, the more the better.' Then when something happened, I would say, 'Hold it.' And things did happen all the time. I could often use a magazine of eighteen in an hour or less." There are no devices or accessories; if you look hard you can see an old velvet sofa serving as model stand in some of them. It wasn't necessary. The big nudes made with an 8 × 10 outdoors, show Weston's expanded feeling for sky and space, blazing with sunlight, or holding the subtle luminosities of a gray day, just as the little nudes summarize his closeups of dynamic forms and prevision the long lines of the hills he would photograph next.

All the negatives were developed in open tank or tray, by inspection, with ABC pyro; he reduces the carbonate because he believes in a full exposure and a weak energy developer that "gives the shadows a chance to build up to full possibilities after blocking the whites." The prints were all made on a glossy chloride paper by contact under an overhead bulb that allows any necessary dodging, and developed in amidol. This, the oldest and simplest technique still in

use, is all Weston needs. His eye and his experience do the rest.

These nudes are bare and classic, without evasion or rationalization. Instead of avoiding accidents such as the glimmer of a nail, a change in skin texture, or the strange shapes actuality assumes in passing, Weston takes them as his themes. He uses light like a chisel. The light he loves best is almost axial with his lens—the same light-angle at which a news photographer's flash bulb flattens faces and collapses space with its fake shadows. Here the luminous flesh rounds out of shadow; the shadow itself, from subtle recession to deep void, is as active and potent as the light. In the torso of his little son Neil, where he indicates how that long-neglected theme, the Male Nude, might be approached, sinuous shadows give life to delicate whites.

In these, as often in Weston's work, the beholder sometimes recognizes, with a tingle down his spine, the originals from which artists in various centuries launched whole schools of thought. Here is a torso with the pure calm flow the Greeks took as ideal. The photograph is not Greek; it does not need to be. The reality it reveals existed before the Parthenon; it is continuous with man. Here is a body, tense, sinewy, wrapped in shadows, with the brooding power and hidden conflict Michelangelo felt in human destiny; here, from the same figure, crouched and kneeling, is a terrible image—Grunewald sensed the same agony and fatality in mortal flesh. Here are, enclosed in living skin, the forms Brancusi sought.

An English critic once attributed to Weston, to Weston's great amusement, "a gigantic Picasso eye." But as Edward, who is another little man with a boxer's torso and a red-hot eye, wrote recently, "The painters have no copyright on modern art!" And to the editor of *The Professional Photographer,* Charles Abel, who was writing an article on him, he wrote: "I read, in an article by you: 'I would be the last to place photography on a par with painting or sculpture as an art.' Well, I would be the first. I believe in, and make no apologies for, photography; it is the most important graphic medium of our day. It does not have to be, indeed cannot be, compared to painting—it has different means and ends." The article, titled "Edward Weston, Artist," was sent to him in galley. He circled the word *Artist,* adding: "Cut, or change to 'Photographer,' of which title I am very proud."

Modern Photography 16 (June 1952): 38-43, 107-10.

Color as Form

Nancy Newhall

TO SEE COLOR *first,* and see it integral with form, line, shadow, depth—isn't easy. And when, for nearly fifty years, you have taught yourself to see the world in black-and-white, only to be suddenly stripped of controls that by now are almost instinctive, and bereft of the magic you can work with glittering whites, luminous grays, and sharp blacks, it is still less easy. You are reduced to bare vision—and in the present primitive state of color photography, you can't even get all you see.

You can see unusual colors and subtle relations between them, and know in advance that the coarse prismatic scale will lose both. You can see a dazzling dominance of certain hues and be unhappily assured that the supporting darks will go watery and blue. The shrill dyes have been deliberately stepped up to please a public with little experience in any but obvious color. Worse still, your expensive transparency itself is fugitive; not even in printers' ink or in carbro will your image survive long.

Color photography today is about where black-and-white was when the daguerreotype was new. The controls are few and insufficient—corrective, not creative. The image has unexpected qualities, harsh and strange to the eye that has been steeped in painting. The challenge, then as now, is a boomerang: to the scientists, inventors, manufacturers to find something more flexible, permanent, and simple, and to the photographers to stop thinking in terms of other media and start seeing in a medium they must discover for themselves.

Edward Weston had not merely looked at painting; he had himself through his work been a source of excitement and discovery to a number of good painters. For him, there was no conflict between painting and photography. He was quite aware of the importance of photography, and he knew it was an end in itself, comparable to no other and still relatively unknown. For years he had been thinking quietly about color, without the cash or the necessity to practice it. When the opportunity finally arrived, he accepted blithely. He was used to bare vision, he had deliberately limited his own technique to essentials, and he possessed one advantage so unorthodox as to be almost unfair.

Since 1915 or thereabouts, when he was winning prizes for his "high key" portraiture, he has believed in a massive exposure. Developing in a weak energy developer, by inspection, he could then get both the highlights and the shadows rich, or let the shadows go black if he preferred. Long before meters became electric and more sensitive than the eye, Weston, like any good man in that day, learned to be a meter himself—"to feel the light." He still trusts his eye and experience more than any meter. Young photographers are confused and amazed when they behold him measuring with his meter every value in the sphere where he intends to work, from the sky to the ground under his feet. He is "feeling the light" and checking his own observations. After which he puts the meter away and does what *he* thinks. Often he adds everything up—filter, extension, film speed, and

so on—and doubles the computation. With most photographers this would result in gross overexposure and unprintable negatives. With Weston it works; nearly fifty years of judging the light, and developing and printing lie behind any decision. When he came to color, this habit, by now almost unconscious, stood by him towards phenomenal success; most photographers *underexpose* color. But Weston, following the Kodak instructions *and* himself, made only one mistake in timing in his first two dozen 8 × 10s. When Kodak published a portfolio of his color, the data on stops and speeds caused a flood of bewildered letters.

All the locales he worked in with color were familiar to him. Point Lobos and Big Sur he had worked in and around for twenty years. Death Valley had been an intense and highly creative theme during the Guggenheim Fellowship which enabled him to photograph through the West. He was therefore freed from the strain of discovering what, for him, lay in those places; building on previous experiences, he could immerse himself in color. Leave his black-and-white film and thinking at home, and *think in color.*

In Death Valley, he had fun: set up his tripod on the same mud hill where he had set it ten years earlier, and photographed in color the same bunkhouse and strange striated hills he had done previously in black and white. In Bodie, once the most notorious of mining camps but now a ghost town, he saw an old boot hung on the wall.

Both were burnished gold by the sun and the freezing wind. To make the rich color live, he needed a dark accent. With the same sense of revealing, not arranging, that helped him with his great early series of shells, peppers, artichokes, and so on, he hammered an old nail he found nearby into the wall and achieved his accent.

Back in Carmel, where he lives, he saw a barn door where his sons had wiped their brushes after painting a house—and the relation of the wild soft color to the opalescent pallor of his then apprentice and present daughter-in-law, Dody. On Lobos, under a blue day, he saw the rocks and tidepools with the cobalts and ceruleans the Impressionists were laughed at for seeing.

Color, for Weston, with all its crudities and limitations, was an exploration into another technique and another vision. He found in it no conflict with black and white; there are subjects that come alive only in color and there are subjects that cry out for the sharp magic of black and white. Color to him was like finding another hand or eye; it is an extension of the photographer's scope, through which he may now discover the world anew.

Modern Photography 17 (December 1953): 59, 142.

This article was published with Weston's "Color as Form," which is reprinted in Peter C. Bunnell, ed., *Edward Weston on Photography* (Salt Lake City: Peregrine Smith, Inc., 1980): 156-57.

—*B. N.*

A Great Photographer Dies: Edward Weston 1886-1958

Nancy Newhall

ON NEW YEAR'S MORNING, 1958, Edward Weston died. He was seventy-one and a victim of Parkinson's disease; death for him was a release from helplessness. But for his family—four sons, seven grandchildren, two great-grandchildren—for the hundreds who, down the years, came to his simple shack overlooking the Pacific like pilgrims to a shrine, and for thousands to whom his work had been a revelation, his death left a huge gap on the horizon—a gap to be filled only by renewed dedication to the ideals toward which his life had been a passionate journey.

Born in Highland Park, Illinois, in 1886, he came of a long line of New England preachers, teachers, doctors; his mother's dying wish was that he should escape this austere tradition and go into business. But when he was sixteen, his father gave him a Bullseye camera; thenceforth, for nearly fifty years, until he could no longer see or focus, Edward lived for the hours when, alone with his companion camera, he could embark on voyages of discovery and vision.

Three dutiful dull years as a "rabbit"—his own term for errandboy and salesman—ended when he went on a two-week holiday to California, looked—and stayed. First he punched stakes surveying for railroads, then he punched doorbells to drum up trade for his postcard camera, then he fell in love, married, and decided to become a portrait photographer, since he would then have the

tools for his personal work. In 1911, he opened his own studio at Tropico, now Glendale, California (figures 2, 5-7); very successful, especially with babies and dancers, he was soon winning prizes in pictorial and professional salons everywhere with his "high-key" portraits and unusual use of natural light (figures 3, 4).

Then modern art struck; sick of his fuzzy, arty effects, he scraped the emulsions off old prize plates and used the glass for windowpanes. No photographer on the West Coast at that time shared his drive to create; alone, he rose before dawn to write in his daybook and try to focus his thoughts in words. Groping, he began to find in the sharp, the close, the angular something dynamic and contemporary (figure 8). In 1922, a trip East, where he saw the thrust and sweep of industry (figure 10), bridges, skyscrapers, and met for the first time, photographers who were his peers—Stieglitz, Strand, Sheeler—confirmed this approach.

Then he went to Mexico, where enthusiasm for his personal work led him to hope he might live there on its sale and be free of sittings and retouchings. This proved an illusion, but the three years 1923 to 1926, except for a six-month return to San Francisco, were years of ruthless self-scrutiny and growth. Hailed by Rivera, Siqueiros, Charlot, Orozco as one of the great masters and pioneers of twentieth-century art, he found the proximity of a primitive, simple

people still more stimulating; he tried to simplify his life, like theirs, to bare essentials. In his work, avoiding the pitfalls of the picturesque, he searched for the vital and elemental (figure 13).

Back in California, in 1927, the forms of growth obsessed him; he began a series of massive closeups of shells, peppers, halved vegetables (figures 14, 16). In flight from cities, in 1929 he moved to Carmel and discovered in the storm-twisted beauty of Point Lobos an even more astonishing series — the cypress-like flames, the wave-knotted kelp, a pelican's wing. These excited Orozco into arranging and hanging Weston's first one-man show in New York and Merle Armitage into publishing his first book, *The Art Of Edward Weston.*

The stark purity and logic he had now achieved in both vision and technique inspired younger photographers; with Ansel Adams and Willard Van Dyke (figure 20), he formed Group *f*/64, that peak of the movement toward "pure photography." And in 1934 Weston at last resolved the dichotomy between his professional and personal standards; he hung out a sign saying "Unretouched Portraits."

But his camera was finding wider forms; he longed to quit his studio altogether and return to his first love, landscape. In 1937, the first Guggenheim Fellowship ever awarded a photographer set him free to travel and see if he could meet what he considered photography's greatest challenge: mass-production seeing. The scope of the photographs published in *California and the West* in 1940, proves how versatile was his eye (figure 22). Another opportunity came when he photographed through the South

and East for a special edition of Walt Whitman's *Leaves of Grass* (figure 32).

In 1946 the Museum of Modern Art in New York gave Weston a major retrospective exhibition. The following year, Willard Van Dyke made a movie of him, *An American Photographer,* for the State Department; during the shootings, they returned to Death Valley and other places Weston had already stated magnificently in black and white. This time, he concentrated on a new medium for him: color, and achieved images in which color is the dynamic agent.

But already he was stricken with Parkinson's disease, which is a progressive disintegration of the nervous system. His last photographs, made at Point Lobos in 1948, are tragic, intricate, intense. Creation ceased; presentation continued. A major show in Paris, the publication by Ansel Adams of *Edward Weston: My Camera on Point Lobos,* the production, with the aid of his son Brett of his *Fiftieth Anniversary Portfolio* of fine prints, and finally, through the generosity of a friend, printing, again with Brett's help, eight sets of the thousand negatives he considered the finest of his life's work.

Valiantly Weston fought each encroachment of paralysis; stoically he faced each inevitable and humiliating loss of control. At the last he was helpless, a prisoner in his own body. Death came quietly; two of his sons, come to greet him and help his new nurse get him up and into his wheelchair, noticed he was very still.

Together his four sons went to Point Lobos and scattered his ashes on the beach where so many monumental images had materialized on his ground glass. From all over the

world letters, phonecalls, wires, tributes, plans for exhibitions, publications, memorials were pouring in; his presence seemed very strong. For his sons, "Now that he is dead, he is more alive than ever."

Written for *Modern Photography*, only a few paragraphs of this moving obituary were published in the April 1958 issue.

— *B. N.*

Edward Weston's Technique

Beaumont Newhall

THROUGOUT HIS DAYBOOKS *Weston makes frequent technical notes and observations. To orient and inform the lay reader the following notes were appended to Nancy Newhall, ed.,* The Daybooks of Edward Weston, Vol. I, Mexico *(Millerton, N.Y.: Aperture, 1973).*

– B. N.

EDWARD WESTON BROUGHT to Mexico an 8 × 10 view camera and a 3¼ × 4¼ Graflex. His battery of lenses included an "expensive anastigmat" of unspecified make and several soft focus, or diffused focus, lenses, among them a Wollensak Verito and a Graf Variable. These lenses had the characteristic that the degree of diffusion (i.e., spherical aberration) could be altered at will.

The Variable was basically an anastigmat, fully corrected for its maximum aperture, *f*/3.8. By changing the distance between the front and the rear elements of this double lens, varying amounts of spherical aberration could be induced. Theoretically it thus produced either a needle sharp image or one so diffused that it hardly seemed to be produced by a lens.

The *f*/4 Verito was described by its manufacturer as "a specially designed double lens . . . which, while it gives the desired diffused or soft optical effect, shows no distortion, double lines, or other optical imperfections, and being rectilinear gives an even diffusion over the whole plate . . .

will not make sharp negatives with wiry definition unless stopped down to *f*/8."

When Weston wrote, on Easter, 1924, "Sharper and sharper I stopped down my lens; the limit of my diaphragm, *f*/32, was not enough, so I cut a smaller hole from black paper," he was referring to this characteristic of the Verito as well as to the fact that great depth of field is given with small lens openings.

He had trouble with the Variable. Although he stopped it down to the smallest aperture, he found troublesome flares. An optometrist deduced that this was caused by the large glass surface of the *f*/3.8 lens. On June 24, 1924 he purchased for 25 pesos a second-hand Rapid Rectilinear lens. This type of lens had long been considered obsolete, if not archaic. Years later he gave this lens to his son Brett, who has most generously presented it to the George Eastman House. It bears no maker's name. On the barrel is inscribed: "8 × 10 THREE FOCUS," and the scratched dedication, "To Brett – Dad, 1937." Examination on an optical bench proves it to be an unsymmetrical form of Rapid Rectilinear of 11¼-inch focal length, well made and well centered. It has no shutter – Weston used a behind-the-lens Packard shutter – but an iris diaphragm marked "R.O.C. and C. CO." (Rochester Optical and Camera Co.). The smallest opening is marked "256." Measurement proves this to be the long-obsolete "Uniform System," the equivalent of *f*/64.

Weston used panchromatic sheet film. This material, capable of recording all visible wavelengths—in contrast to orthochromatic emulsion, which is relatively insensitive to red and overly sensitive to blue—was an innovation in film form: it was first marketed in America by the Eastman Kodak Company only two years before Weston sailed to Mexico. Notations of exposures in the Mexican Daybook indicate that the speed of this "panchro" film would be rated today at 16 by the American Standards Association system. A portrait in full sunlight required 1/10 sec. at *f*/11; an open landscape was stopped down to *f/32* for an exposure of 1/10 sec. with a K-1 filter. He had no meter to calculate the exposure. Experience guided him: "I dislike to figure out time, and find my exposures more accurate when only *felt.*"

On August 24, 1924 Weston noted: "I have returned, after several years use of Metol-Hydroquinone open-tank developer, to a three-solution Pyro developer, and I develop one at a time in a tray, instead of a dozen in a tank!" This technique he used for the rest of his life. It is classic; he undoubtedly learned of it at the "photographic college" he briefly attended. The 1908 instruction manual of a similar institution—the American School of Art and Photography—recommends it as the standard developer. Weston used it with less than the usual amount of sodium carbonate. (Interestingly, the Wollensak Optical Co. advised: "Negatives made with the Verito should be fully timed, and slightly underdeveloped, using any standard developer with a minimum amount of carbonate of soda . . .")

He printed on several kinds of paper. In his early years in Mexico he was especially fond of the platinum and palladium paper made

by Willis & Clement, which he imported from England. This paper, which became obsolete in the 1930s, was sensitized with the salts of iron and platinum (or palladium), rather than silver. It gave soft, rich effects quite unlike any other kind of paper, and was cherished by pictorial photographers. Prints were exposed in sunlight for minutes, developed in potassium oxalate, and fixed in hydrochloric acid. The addition of potassium bichromate to the developer gave an increased brilliance in the whites; this technique Weston used in his struggle to get prints of the dramatic white clouds which so moved him. The paper had a tendency, especially if damp, to solarize, i.e., partially reverse in the highlights, giving a dark edge instead of a light one. Printing was slow work. To make fourteen prints from as many negatives in one day, as he did on September 20, 1924 was unusual.

On this day he noted with surprise that proof prints, made on Azo paper, gave him as much satisfaction as platinotypes. This material, which is still produced by the Eastman Kodak Company, was a typical gelatino-chloride developing-out paper exposed to artificial light. Weston always referred to it as "gaslight paper," a name given to it in the 1890s, but which was retained decades after electricity became universal.

Although Weston preferred an 8 × 10 camera (he rejoiced in "the precision of a view box planted firmly on sturdy tripod") he made increasing use while in Mexico of his 3¼ × 4¼ Graflex—hand held even at exposures as long as 1/10 second. To enlarge these negatives on platinum or palladium paper was tedious. An enlarged negative had to be made. First an 8 × 10-inch glass positive was made from the small negative.

From this, in turn, he made a new negative, which he then printed by contact. Apparently he never printed by projection — although it was entirely practical to do so with gelatino-bromide papers which were then readily available. On his return to California he abandoned platinum and palladio papers, and settled on glossy chloro-bromide papers — which he invariably printed by contact.

This simple technique Weston used throughout his life. It was a direct outgrowth of his formative Mexican days.

The Daybooks of Edward Weston

Minor White

IN THIS HIGHLY personal review, Minor White pays tribute to the memory of the man whose life and work so greatly inspired him. One of America's great photographers, White was also a highly influential teacher, philosopher, and both founding editor and publisher of the quarterly Aperture.

He met, worked with Weston, and became his friend in 1946. About that time he wrote an analysis of Weston's work, probably inspired by the retrospective at the Museum of Modern Art of that year. He sent Weston a copy of his manuscript. Weston replied: "You have written well and thought deeply . . . before reading your manuscript I told you that I considered critics psychoanalyzed themselves — and no more. I feel that you have revealed yourself more than you do me."[1]

—B. N. and A. C.

AFTER THREE DAYS with the first volume of the *Daybooks* of Edward Weston, the diary style has taken over my ordinary writing habits. I am tempted to date this — why not?

Rochester, New York, 26 March 1962

Today a long-held wish has been gratified. I hold a certain book in my hands; I was beginning to think that I never would. At least Volume I is printed and that covers the years that Weston spent in Mexico. It is as if the man were back again. The nostalgia sweeps in like the afternoon fogs of San Francisco and any critical sense that I might have had takes a vacation. I find that I do not want to write a book review.

Maybe it's the nostalgia. For a deeper reason I give preference to a reluctance to contribute to any reader's feeling that he knows a book because he can talk glibly at a cocktail party about something that he has never read.

The nostalgia is personal, what I bring to the reading of the book. (Weston's writing in a diary has its share of memories mixed with positive and generative statements.) For one thing I relive the days and evenings in Weston's house perched over the Pacific Ocean. Especially the time when he let me read what he had written in his *Daybooks*. As fast as I would finish one notebook he would find the next: Mexico, California, Mexico again (where the first volume stops), the long Carmel and Lobos years, the Guggenheim Fellowship. The light poured in the window, the skylight, and I over the mutilated typescript. Edward had edited with a razor blade. Seeing in the words the man unfold during his fruitful years long before I met him was a strangely moving experience. Much came together, his whole influence on me when I was learning to photograph and live. Another kind of affirmation, this time written — to add to the support he had given me by gesture and glance as I tried to work at Point Lobos.

But a bit about this unfolding of his that moved me so. Schooling past, he went to Mexico — not the three R's but camera. He did not learn photography in classrooms, but mainly in professional photography the same as thousands of others. Self taught

really. By 1920 he had earned his spurs. In Mexico he tried them out. At first recognized as an artist by the powerful artists and cultured class of Mexico City—in fact this was his first recognition as an artist— he luxuriated in recognition like any young lion—still we can see laid in those few years the beginnings of the man as an artist of a different order. These glimmerings of an independent artist, or artist in another and deeper sense, were written down with all the rest. Bullfights, passing love affairs, the city, public pubs with romantic names, market places, food, drink and the constant making of portraits to earn his living is all a part of making pictures. The way he lived photography, any separation between man and artist, on whatever level, seems slight. Looking back at least through the pages of a book—some drive, some compulsion, inner stamina, why not call it soul, began to make itself felt and Weston heeded the promptings. A dozen years later I can trace a little of why I was so strongly affected by his Mexican Daybooks. Because another had surmounted the turmoil of his own beginnings, I felt affirmation for my own shaky foundation.

Reading the notebooks in his house, in the sunlight, in his presence—that was similar to watching a slow-motion movie of some life process that would lend itself to such drastic treatment. Yet he had borrowed himself for his own relentless observations and wrote facts and conclusions down in the hour before dawn.

27 March, 5 A.M.

To reconsider this man who influenced me as far as I was able to be affected, or permitted myself to be—that is, to either go under in a soft foam of memorable euphoria, or march unerringly through a relentless desert. As I continue reading, the vivid images of his presence flicker across the pages. *Either* and *or*—somewhere he learned that yes and no are as the two feet of a man. In my memory his presence stands clearly balanced between sensuous love of living and disciplined self-scrutiny. Not one *or* the other; the harmony instead, or resonance, that says "no" only to those things that stand in the way of inner development. He is still a moving force.

Steaming coffee—dawn through a horizon slit in the clouds—it will be a cloudy day in Rochester. Will we have to wait another ten years before Eastman House or some other publisher produces the second volume for us? At Lobos and on his trips across the country, the inner growth first appearing in Mexico takes form in words and photographs. His growth inwardly never stopped even though the Daybooks, after fifteen years, were discontinued when a way of working was forged. And further growth left words behind. In later years he said little, "How young I was. That covers everything." He showed us photographs that covered the wordless.

Aperture 10 (1962): 39-40.

1. Edward Weston to Minor White, undated, Center for Creative Photography, University of Arizona, Tucson.

The Monster as Photographer

George P. Elliot

THE NOVELIST George P. Elliott here uses an episode from Weston's Mexican Daybooks *to illustrate the objectivity of the master photographer even at the height of subjective emotion.*

—B. N.

WHAT A MONSTER is the artist—that is, a man who dedicates himself to constructing works of art, and who believes that a great work of art is the highest of all things made and that making one is the highest of all occupations. When The Artist has purged himself of vanity and doubt, like Joyce, like Edward Weston, then he is monstrous indeed, for then he is wholly justified. The religion of art is like Calvinism: in both, the elect are known by their works but are justified by their faith, by their very being.

Let Tolstoy and Van Gogh represent another sort of artist. Both of them elevated *Uncle Tom's Cabin* into the ranks of important art, an error of judgment The Artist would be incapable of making. But they saw true art as efficacious in revealing the unknown or instructing to virtue, and the efficacy of *Uncle Tom's Cabin* had been demonstrated unmistakably. They saw an artist as important, first as any man is important, then as he succeeds in making a work of art which creates a communion among those who admire it. They were concerned to save us, to help us save ourselves. They despised The Artist, some of whose works they could not help admiring.

Let Poe's tales and poems be the blazon of The Artist. Baudelaire to Valéry—the theorists of The Artist made him their own. His work was in every way inferior to theirs, yet it was the emblem they reared—an error of judgment Tolstoy or Van Gogh could not have made. Like Poe, they defined themselves against: social involvement, religious belief, art as communion. They created a mirror cult, that is, a cult of self-consciousness, a cult in which things are reversed. In that reversed religion, The Artist is a saint: Rimbaud a martyred saint, Picasso an heroic saint. Now that The Scientist has lost his capital letters and is becoming one of the boys, has joined the commissars, generals, executives, and engineers, we may be in for a bad stretch during which The Artist is worshipped uncontended. What this means in effect is more and more beat bohemians, mescaline mystics, self-regarding phoneys. This very worship, one can hope, will help to end The Artist; any new giant capable of becoming a true Artist-Hero will also be too fastidious to endure being slobbered on by the ready-made cultists, who are now too numerous to escape.

Edward Weston was The Artist as photographer. To be sure, in the advanced regions of art criticism, still photography has no status as an art, though the photography of cinema is deemed worthy of discussion. Unbelievable nonsense, if it is on canvas, is exhibited for sale, discussed seriously, and hung in museums; whereas books or exhibitions of photography are not discussed in

the advanced intellectual journals, and only one important museum in the country has a permanent exhibition of even the best photographs by even the acknowledged masters.[1] A chic attitude toward photography is that it removed a tiresome burden from painting, the burden of representing the visible world as it appears; such representation being held irrelevant to true art, photography is suspect just because it does suggest the visible world better than any other medium. It is likewise chic to suppose that, because a photograph is the result of a mechanical process, it is not also the result of an artist's creating.

One remedy for such snobbery is looking at good photographs. Weston records such a conversion. A woman arranged a meeting between him and a man who, unknown to Weston, hated photography and photographers.

"Finally, deadlocked in our differences, I opened the portfolio to prove a point. The first two prints were enough, he retracted everything, he capitulated absolutely. His admiration was deep, enthusiastic, sincere: he proved one of the keenest critics I have met lately, thanking me for having changed his attitude. Once he said, 'Anyone seeing that line and recording it could have done great things in any art!' "

Another remedy for the notion that photography is an inconsiderable art is to read Weston's *Daybooks,* for in them he reveals himself as being so austerely The Artist, and his intelligence and honesty are so considerable, that it is not conceivable he would have wasted his time on a mechanical frippery. He was a relentless self-critic, and strove for and sometimes attained perfec-

tion. He took, and preserved with formidable consistency, the aesthetic view of things: it was the form that counted, no matter what object embodied the form, whether a green pepper, a nude woman, or a toilet bowl; when he caught the face of a man in sudden action, he sought the moment of revelation, not because the truth would be revealed so much as because at that moment the face would make the most beautiful image. He was against religion, puritanism, respectability in dress and play; he was indifferent to civic responsibility; he was for free love, primitives, Art. In his life he subordinated everything to his pure dedication to his photography, to himself as image-maker. Here is a passage which suggests something of his quality.

"Morning came clear and brilliant. 'I will do some heads of you today, Zinnia.' The Mexican sun, I thought, will reveal everything. Some of the tragedy of our present life may be captured, nothing can be hidden under this cloudless cruel sky. She leaned against a white-washed wall. I drew close . . . and kissed her. A tear rolled down her cheek—and then I captured forever the moment.

"Let me see, $f/8-1/10$ sec. K 1 filter, panchromatic film—how mechanical and calculated it sounds, yet really how spontaneous and genuine, for I have so overcome the mechanics of my camera that it functions responsive to my desires. My shutter coordinating with my brain is released in a way as natural as I might move my arm."

Is this not The Artist's mirror world, self-conscious and reversed? His mistress is sad. He kisses her—and then, so perfectly is his camera a part of him, he inserts it

between. The photograph he made on that occasion is stunning. To us who look at it only as a picture in a book, its beauty is moving. But a chill seizes me to learn that at the moment when he might have consoled her, have wept with her, he instead took her picture. Why then? Because no model could have generated an expression of woe so genuine, so valuable for his art. Is this not the authentic monster's uncommuning coldness of heart?

Hudson Review 15 (Winter 1962-63): 627-29.

1. The George Eastman House in Rochester, New York, under the direction of Beaumont and Nancy Newhall. Mrs. Newhall edited the first volume of *The Daybooks Of Edward Weston,* published by The George Eastman House at $10. Another volume will be published when it is prepared. She was also appointed by Weston as his official biographer, and is working on the biography.

Edward Weston

Ansel Adams

IN THIS ESSAY — to my mind the most perceptive in this collection — Ansel Adams sums up Weston's philosophy and life style from a close friendship that began in 1928. He shows how Weston's seemingly simple technique is the direct expression of the spiritual urge that dominated his vision or, as Weston called it, his "seeing." Too often critics have considered this seeing as the outgrowth of technique. Of special interest is Adams's account of Weston as a teacher by example and parable, as preceptor rather than pedant (figure 39).

— B. N.

IN THE FIVE years since Edward Weston passed away in Carmel, California, he remains in memory as a man of great spirit, integrity and power. To me he was a profound artist and a friend in the deepest sense of the word. Living, as I do now, within a mile of his last home, sensing the same scents of the sea and the pine forests, the grayness of the same fogs, the glory of the same triumphal storms, and the ageless presence of the Point Lobos stone, I find it very difficult to realize he is no longer with us in actuality.

Edward understood thoughts and concepts which dwell on simple mystical levels. His own work — direct and honest as it is — leaped from a deep intuition and belief in forces beyond the apparent and the factual. He accepted these forces as completely real and part of the total world of man and nature, only a small portion of which most of us experience directly. As with any great artist, or imaginative scientist, the concept is immediate and clear, but the "working-out" takes time, effort, and conscious evaluations.

Edward Weston, contrary to so many now practicing photography, never verbalized on his work. His work stood for him, as it does for most of us, as a complete statement of the man and his art. Edward suffered no sense of personal insecurity in his work; he required no support through "explanations," justifications, or interpretations. He was amused at the guff which was written and spoken about him, but he was nevertheless tolerant of the need of some people to struggle for the truth through complex involvements and slippery intellectual bogs. A frequent comment of his was "Well, if it means *that* to him it's all right with me!"

I have looked at prints with Edward many times; they have been put before me with a kind of potent silence, and always with the humility of the great artist. Never the attitude of "How worthy this print is of your attention"! Rather "I hope you may find something here, but I shall understand perfectly if you don't." This is an important difference in attitude and rare among artists and other extroverts!

When Edward looked at other photographers' work he separated them automatically into two classifications — those who were honest and *trying,* and those who were conscious or unconscious phonies. With the first group he had enormous patience and

gentle understanding. His comments were never dictatorial; whatever he said was directed to the enlargement of the knowledge and experience of the photographer — he never imposed any sense of his own style or methods, or discoursed on modern cultish trends. Many a time I have seen a young student almost faint with happy shock when Edward, after looking at one of his prints simply said, "I wish I had done that!" Of course, imitation was certain to occur and many a young or old photographer bought an 8 × 10 camera and turned to pyro for his negatives and amidol for his glossy prints. Always the shock came when, with all the paraphernalia and "method" at hand, the results did not carry the impact of "seeing" and quality of the work of the master! Edward would gently warn them that the material aspects of the medium merely made possible the creative expression. Edward's expression was best achieved for him through certain ways of doing, but that did not imply there were not other ways for other photographers — as many ways as there were photographers! He would say "I don't care if you print your negative on a doormat — so long as it is a *good* print!"

Edward Weston had no secrets; there were no locks on his darkroom door or on the door of his mind. Contrary to some common opinion, Edward was not as simple a person as the style of his living and working would suggest. He was a person of large human experience. He was well-read and basically articulate. However, in order to assure the greatest energy for his work, and to minimize distractions, he selected a way of life which, to some, suggested privation and discomfort. It is true that at various times after he gave up his flourishing portrait business at Glendale, California, he

endured straitened circumstances. But all in all, there was usually enough work sold and portrait commissions undertaken to keep the larder reasonably full and the taxes paid.

All great people gather myths about them and Edward was no exception. Amusing interpretations of his work are legion. Those who are prone to think of anatomical shapes can find them in Edward's rock and vegetable pictures (figures 16, 22, 23). Weston freely admitted he sometimes considered such relationships, but he certainly was not obsessed by them. Weston believed in the mystical currents of life but never had much patience with those who, by trying to over-analyze them, destroyed them. He entertained an interesting dichotomy: as a photographer he employed equipment and materials based on advanced technical and scientific principles, yet he was anti-science in principle, and attached to the pronouncements of Charles Fort! As did so many artists of his time, he did not realize that art and science are closely related and that the difference is one of description and communication; both seek the truth, both are based on the intuitive searching of the spirit. There is always the unfortunate confusion of science and technology, just as there is the confusion in photography between revelation, information, and technique.

Edward also had scant appreciation of the self-conscious aesthetician and critic. He believed that art was a doing, not just a talking, experience. Edward was a clean man in body, spirit, and mind; to him confusion and destructive complexities of the mind were severe faults, and dishonesty was incomprehensible. "That's *it*" he would say

about some fine statement—and that was all that was needed. On his wall was a printed quote: "MAN, IF YOU HAS TO ASK WHAT IS IT YOU AIN'T NEVER GOIN' TO KNOW!" (Louis Armstrong).

While I never "worked" with Edward in the usual sense of the term, we were on many trips together—to Yosemite, to the Sierra Nevada, to the Owens Valley. We were always aware of each other, but never "associated" in the limited sense of the word. We were joined in a common enterprise with Group *f*/64 in the early 1930s, and I worked closely with Edward and Dody in the production of *My Camera on Point Lobos.* It is difficult to tell others, especially through the printed word, what a profoundly important experience it was to know Edward as a man and an artist. I have had a few other close associations—with Cedric Wright, Alfred Stieglitz, and Beaumont and Nancy Newhall (figures 35-38, 41), and some others of various persuasions and interests, and all these close associations have stimulated both the spirit and the enthusiasm for work. Perhaps Edward's greatest effect on people was the stimulation of enthusiasm—enthusiasm for "seeing" and understanding, and enthusiasm (and courage) for expressing what was perceived.

Today we are confronted with a dichotomy of the first order; techniques (including automatism) have progressed to unbelievable levels, but expression has largely degenerated into purely functional, or purely subjective levels. Exceptions exist, of course, but many of these relate to highly personalized, psychologically-motivated experience—even reaching into the domains of therapy, hypnotism, or analysis. Perhaps these have an important validity in the de-

velopment of the art of our time, but Edward avoided conscious introspections and considerations of this character. He would not necessarily deny them, but he would not divert his mind to them. He always favored the grand sweep of creative projects—perhaps the creative attitude would be the better term. Out of uncounted thousands of photographers only a handful of serious workers support the best of photojournalism, illustration, documentation, and poetic expression. Edward was aware of the loneliness of the artist, especially of the artist in photography, but he accomplished more than anyone, with the possible exception of Alfred Stieglitz, to elevate photography to the status of a fine-art expression. This he did more through *example* than by intellectual propaganda and "promotion."

As Coleridge stated around 1812, all art is the balance between the external and the internal. I have paraphrased this by proposing the *external event,* and the *internal event* (subject vs. spirit). It must be recognized that photography encompasses a huge spectrum of thought, expression and function. Unfortunately, the proponents of certain styles and functions stoutly disclaim the value of other approaches and this intolerance has served to retard the progress of the medium in many domains. Edward Weston was very careful not to enter fields in which he felt himself inadequate, but he was also frank in expressing admiration for fine work in any field. He often remarked that it made no difference to him if photography was considered an "art" or not; *photography,* to him, was an adequate term. But to the man in the street photography is many things—good, bad, inspiring, dull, factual, informative, and so on. But art is, of course, a blanket term that covers both

miracles and atrocities, and Edward was content to allow his statement to speak for itself. He agreed with Wilenski that "all art is the expression of the same thing," and it was this all-encompassing spiritual and emotional Thing with which he was entirely concerned.

Perhaps some intelligent critical mind might be able to clarify Weston's message—at least make some interpretations of the flow and growth of his work which might add a little to its stature and to our comprehension of it. Nancy Newhall has done nobly in her monograph on Weston (Museum of Modern Art) and in the foreword to the first volume of the *Daybook*. Perhaps in the second volume of the *Daybook* (in words as well as picture selections) she will round out the definitive statement on this truly great artist.

It is rare that any major artist has said so much and so clearly to so many people, yet there were (and are) those who, in their gross lack of appreciation and sensitivity, were very disdainful of his work. Years ago I brought Edward's work to the attention of the California State Park authorities—why not promote a booklet of Edward's Point Lobos photographs along with an informative text? The reply was abrupt and opaque—"We want pictures of Point Lobos, not of just piles of rocks!" The fact that Edward had the grandest *landscapes* of Point Lobos extant made little impression on these people; he had turned his camera on "just rocks" and tree trunks, tide pools, and beach flotsam, and this—because it was sensitive and somewhat transcendental in approach and statement, scared the wits out of the official guardians of this sublime bit of the natural scene. Edward would have

been the first to recognize the need for straightforward geological and ecological record-informative photographs, and probably could have done a resoundingly fine job with them, once he had accepted the challenge. But the deeper significances—natural, esthetic, and human—dominated his attention, and he was not inclined to *initiate* more-or-less representational projects.

Just what constitutes Edward Weston's contribution to photography—other than his basic creative expression and production? He reduced his mechanics to a minimum. One might say that, thereby, he also limited the scope of his work: 8 × 10 for landscape, 4 × 5 for portraits, no enlarger, no retouching (in the usual sense), no darkroom manipulations, pyro for negatives, amidol for prints, no toning, no artificial lighting, no exotic techniques, etc. Only factual titles and negative numbers on the backs of his mounts, and a simple E W and perhaps an edition number on the face of the mounts; what did all this signify in the "advancement" of photography? I recall a statement by Charles Sheeler at a large retrospective-historical exhibition in New York—"Isn't it remarkable how photography has advanced without improving?" Edward Weston's approach bypassed the vast currents of pictorial photography, photojournalism, scientific-technical photography, and what is generally lumped together as "professional photography" (portraits of the usual "studio" kind, illustrations and advertising, etc.). About 99 percent of his work had nothing at all to do with the total world of photography. He made no basic technical discovery or application, established no new system of craft-procedure, wrote no books (excepting, of course, his impressive *Daybook*), and produced very few articles and

written comments. His work is displayed in two Merle Armitage books, and in *California and the West, The Cats of Wildcat Hill* (texts for both by Charis Weston) and *My Camera on Point Lobos* (text and editing by Dody). He was represented by interpretative illustrations in the Limited Editions of Whitman's *Leaves of Grass,* and in a few other publications. Edward was not a preacher, aggressive teacher, promulgator, or verbal prophet. He was, simply, there — and his work is almost everywhere.

The ego-scrambles of the salons and the amateur societies, the "judging" of exhibits, etc., amused him and also profoundly disturbed him. I recall him describing the process of "judging" prints at a large eastern Pictorial Salon: "I just held the NO button down until something good showed up. My thumb was cramped!" While amused at the somewhat ridiculous antics of these affairs, he was also profoundly compassionate: "These are people with cameras; think what they might do if they only *wanted* to see!"

Hence, in describing the things which Edward was *not,* and those things of the photographic world which he did not support, we are left to ponder on what his contributions were (again, apart from his actual creative work). First, I feel, was the vast confidence he imparted to colleagues and students to live their own lives and speak their own hearts. Second, was the revelation of the virtues of mechanical and technical simplicity. He had everything he needed, but he would not have hesitated to acquire equipment and establish fresh methods if such related to a truly creative purpose. The elaboration of the pictorial darkrooms often exceed those of the most functional professionals; Edward's darkroom contained a small sink, a few trays, a few bottles of solutions, a print-washing device, a few safelights, an overhanging lamp with a frosted bulb for contact printing in a printing frame, a few necessary accessories (brush, tanks, etc.), and a dry-mounting press. He used to refer jokingly to my darkroom as my "factory" or "production line," but he knew that I had to have what I had because of a considerable variety of work. He knew I could not make a 40 × 60-inch print in 11 × 14-inch trays!

Third, I am sure, was his demonstration of the supremacy of the intuitive creative process. He knew very little about photographic theory and freely admitted it. His approach was empirical. Of a naturally acute mind, he demonstrated the principles of "feedback" in all his procedures. To watch him use an exposure meter was both an amusing and an impressive experience. Readings would be taken by waving the meter over various areas of the subject, then a few moments of mental calculations, then a setting of the dials, with a remark such as "about one second at $f/32$," and then the actual exposure which might be four seconds! What happened was, of course, the meter gave him a few external parameters upon which he built an exposure decision based on experience and intuitive-computational ability. Few photographers of twenty or thirty years ago really *knew* anything about the Reciprocity Effect — except that it existed. Edward knew that when exposure times were basically long he had to make them much longer to hold shadow detail, and that he also achieved greater contrast and therefore had to watch carefully the development of his negative. Twenty or thirty years ago few photographers knew anything about lens flare. Paul Strand could not

understand why Stieglitz's four air-glass-surface Dagor gave a "crisper" image than his own eight air-glass-surface Cooke. (Now with lens coating, both lenses would have about the same transmission and image contrast.) Edward was concerned about this, as he was with camera flare, but he solved his problems by gravitating to lenses appropriate to the purpose: the Dagor for landscape, etc., and a Graff Variable for portraits, for example. Once I obtained for him a single component of the Zeiss Protar (a 19-inch lens) but neither of us knew that the single element should be placed *behind* the diaphragm, and that the focus of a single component usually changes as the lens is stopped down. Consequently, the lens was "no good." (Later, with a little practical knowledge, I used the same lens with exceedingly sharp results.) Most photographers fumble their way through the thickets of photographic techniques; Edward carefully explored, and evaluated—intuitively—as he progressed. He developed his negatives largely by inspection (after a long immersion in pyro with 50 percent normal alkali content, the relatively slow Isopan film was sufficiently desensitized to permit examination by a fairly bright green safelight). He usually (as far as I can recall) developed to what would now be known as a fairly high gamma. Achieving a negative of the *kind* of full scale which pyro with reduced alkali and full development yields, he was obliged to use printing papers of contrasts more-or-less related to the contrast of the original scene. He did not negate my Zone System approach but simply stated that he did not need it; to this I most heartily agreed. However, he made intuitive selections of subject material which could be expressed through his chosen techniques, and he intuitively rejected subject material

which his techniques could not manage. Perhaps a greater knowledge of practical sensitometry would have resulted in a few more pictures, but certainly would not have "improved" the great images of his career.

Occasionally he would make an error (as do we all!). I recall his return from his first trip to Death Valley, his first experience with earth of dominant yellow and red hues. He used a G (orange) filter with an exposure factor of three or four (as he would around Point Lobos or the Sierras). As a filter freely passes light of, and close to, its own color, the pictures were considerably over-exposed! On his next trip he used the G filter without any exposure factor and the results were superb. I suggested that his over-exposed negatives could be reduced, but he scorned any such procedure as an attempt to cover up his own error (I could never agree with him on that point).

His fourth great contribution was that he opened up wonderful new worlds of seeing and doing, and many were the students and experts whose lives and concepts were profoundly modified by Edward's non-aggressive, non-preaching, but ever-comprehending approach to people and their expression problems. "Seeing" the Point Lobos Rocks was one thing, making wondrous pictures of them another thing; but encouraging another person to "see" something *in his own way* was the most important thing of all. In this Edward succeeded admirably, but he was always bothered by those who were content only to "see" Edward's way.

He was annoyed by those who would come to him as they would to some august intellectual or artistic potentate; to touch the sleeve or shake the hand of the "greatest"

photographer. Nothing bothered him more than the sycophantic use of the term "greatest." He would often say, "There is no such thing as the *greatest* artist or *greatest* photographer — every artist is the 'greatest' in his own particular expression. *Famous* is another term (and probably what they mean) but you can be very famous without being very great!"

Edward's works need no evaluation here. I would prefer to join Edward in avoiding verbal or written explanations and definitions of creative work. Who can talk or write about the Bach *Partitas*? You just play them or listen to them. They exist only in the world of music. Likewise, Edward's photographs exist only as original prints, or as (sometimes) adequate reproductions. Fortunately, his work is very widespread now; museums and libraries and private collections have thousands of his original prints, and his books — or the books in which his work appears — are reasonably available everywhere. Look up his photographs, look at them carefully, then look at yourselves — not critically or with self-depreciation, or any sense of inferiority. You might discover, through Edward Weston's work, how basically good you are, or might become. This is the way Edward would want it to be.

Infinity 13 (February 1964): 17, 25-27.

Frederick H. Evans and Edward Weston on Pure Photography

Beaumont Newhall

IN 1964 I organized an exhibition of work by Frederick H. Evans, the British photographer who specialized in architectural subjects. He was a champion of "straight photography" back in the 1900s. Evans was a prolific writer, and I was much impressed by the similarity of his aesthetic understanding of photography to that of Weston. For the opening of the Evans exhibition at George Eastman House, Rochester, New York, I gave the following lecture in which I pointed out that an artist's style cannot be judged by the materialistic analysis of his technique. Only after delivering this lecture did I come to learn that Weston admired Evans's photography.

—B. N.

EVANS, OF COURSE, has never been completely forgotten and will never be forgotten by historians and students of photography because of the recognition given him by Alfred Stieglitz in *Camera Work,* No. 4 (1904). Eight photographs of cathedrals were reproduced, with an article by Evans, a tribute by Stieglitz, who hailed Evans as "the greatest exponent of architectural photography," and a brilliant essay by George Bernard Shaw who, in characteristic precise and penetrating fashion, summed up Evans's approach:

"His decisive gift is, of course, the gift of seeing: his picture-making is done on the screen; and if the negative does not reproduce that picture, it is a failure, because the delicacies he delights in cannot be faked: he relies on pure photography not as a doctrinaire, but as an artist working on that extreme margin of photographic subtlety at which attempts to doctor the negative are worse than useless."

In 1963, when we decided to inaugurate the series of exhibitions of less-known photographers which I have already mentioned, Evans seemed a logical man to start with. I discovered that Evans was a most prolific and profound writer on photography. I began to collect his articles, and to compile from reproductions a catalogue *raisonné* of his photographs. I found that the finest collection of his work was in London, at the Royal Photographic Society—the gift of Evans and of his good friend, Alvin Langdon Coburn. So I went to London to see them and to continue my research in the Society's library. I was graciously permitted to borrow for the George Eastman House what prints we needed. Evans was a generous man, and he gave prints freely to his friends. From the Metropolitan Museum of Art in New York and the Art Institute of Chicago, I obtained on loan prints he gave Alfred Stieglitz. From the Library of Congress I borrowed prints he gave F. Holland Day. To these four institutions we express our thanks.

The photographs in the exhibition are all originals, made with love for friends. Every print—with one exception—is shown in the

original mount. The exception, a portrait of Coburn, was given by Evans to Coburn unmounted.

Evans's extraordinarily delicate platinum prints have always been the despair of photoengravers. Stieglitz was bitterly disappointed at the quality of the plates in *Camera Work*. Evans, when asked by the *Photographic News* to choose his favorite photograph, complained that every quality which made the photograph his favorite one would probably be invisible in the reproduction.

Evans cannot be appreciated unless one looks at his original prints.

On reading the eighty articles which Evans published, I realized that he also cannot be appreciated without knowing what he thought about photography. He was an ardent and passionate believer in pure photography, which he defined as "the straightest of straight photography." His aesthetic theory is startlingly modern in its concept. At times, reading his words, one thinks immediately of Edward Weston.

For example:

EVANS, 1900: " . . . the whole success of this as art, whatever printing process be adopted, depends on the quality of the negative, on the conditions under which the subject was taken, and that is where the artist reigns supreme; *his* work is there, behind the camera; any radical error there can never be atoned for, no after treatment will make it 'come out right,' and no printing control will make it appear to have been the right instead of the wrong thing to have done."

WESTON, 1930: "One must feel definitely, fully, before the exposure. My finished print is there on the ground glass, with all its values, in exact proportions. The final result in my work is fixed forever with the shutter's release. Finishing, developing, and printing is no more than a careful carrying on of the image seen on the ground glass. No after consideration such as enlarging portions, nor changing values—and of course no retouching—can make up for a negative exposed without a complete realization at the time of exposure."

Or, again:

EVANS, 1909: "I feel slow to admit that any but the straightest of straight photography can do anything to merit the epithet *new* in art; to be really new the parentage by camera and lens must be instantly and absolutely apparent. By straight photography I always mean that . . . one knows at first glance it *is* a photograph."

WESTON, 1930: "Great painters . . . are keenly interested in, and have deep respect for photography *when it is photography* both in technique and viewpoint, when it does something they cannot do: they only have contempt, and rightly so when it is imitation painting."

Both Evans and Weston realized that photography is at once the simplest and most difficult of arts:

EVANS, 1904: "Unfortunately, photography will do so much so cheaply—so easily, that a real study of its full possibilities is but rarely given it by the so-called (but untrained) artistic worker. He gets things he

likes, and stops there, instead of asking how much better they could have been had he known the full capabilities of his tools or his subject."

WESTON, 1930: "The direct approach to photography is the difficult one, because one must be a technical master as well as master of one's mind. Clear thinking and quick decisions are necessary: technique must be a part of one, as automatic as breathing, and such technique is difficult."

Even in details of technique the parallel is remarkable. Weston's predilection for small lens stops led his friends to name themselves Group *f*/64.

EVANS: " . . . I always prefer to expose at as small an aperture as my time for exposure will permit. I prefer *f*/32 to *f*/16 for landscape work, for instance. . . . Large apertures tend to disintegration of image on some plane or other. . . ."

It would be easy to gather many more statements by these two masters which parallel one another. Both wanted their pictures to be recognized as photographs and not to look like drawings or paintings. Evans said that he preferred platinum paper because it best showed "the photography of the photograph." He once condemned a gum print: "Everything has been wiped off it; why call it a photograph?"

In considering his work, I thought that I could prove that Evans was a herald of modern photography, particularly of the "straight photography" movement of the 1920s, of which Weston was but one spokesman of many. I thought I saw a link between nineteenth-century photography and contemporary photography.

What I overlooked was that the vision of these two masters and the vision of the two epochs in which they lived and worked differed totally. I recognized something so obvious I should have long before understood: that any mechanistic explanation of an art, however valuable to the artist, is fallacious. I had already pointed out the mechanistic fallacy in 1934, when Ansel Adams wrote an eloquent essay for the *London Studio Photography Annual*. I challenged his dogmatic statement that "the delineation of the most minute detail must be obtained in all parts of the picture." I pointed out that to put an image out of focus is a purely photographic control: or, rather, we should say a camera control, since Charles Seymour has demonstrated so beautifully in the *Art Bulletin* that the peculiar character of drawing in certain paintings by Vermeer can be based on his use of an out-of-focus camera obscura.

The fallacy of my theory that Evans was a pioneer of modern photography became evident in a flash. In 1908 the Photographic Salon, organized by the Linked Ring, was largely dominated by Coburn and Steichen. The jury discarded all but one of Evans's photographs and he was most angry, for he had worked long and hard as a member of the Linked Ring. He had been on the selecting committee for years and had hung four of the exhibitions. In his anger he sent his photographs to a "Salon des Refusés" organized by the *Amateur Photographer*.

He wrote Stieglitz of his disappointment. "I would not have growled or been disappointed had the *admitted* things been better than mine." He was particularly incensed with Coburn's "Flip Flap" and Steichen's "Steeplechase Day," and asked: "What is there of artistic vision or sensibility in them

and what of the commonest technical knowledge; their double tones are abhorrent; no modelling, no planes, no gradation, no lighting of any truth, in short no *photography* of any worth in 'em." He was particularly scornful of Coburn's "Flip Flap." "I am curious to hear if *you* will tolerate the vulgarity of his 'Flip Flap.' "

By any definition of pure photography, Coburn's "Flip Flap" must be accepted as legitimate. Neither Evans's nor Weston's arguments *pro* pure photography could disallow its legitimacy.

But Evans's vision was utterly different from Coburn's or Steichen's. Evans photographed things he loved. He loved the great cathedrals, and wanted to share his love. He invited you to walk with him through the naves and aisles of Ely and Chartres and Lincoln and Bourges. He thought of himself as your guide; leading you from darkness to light. To him the cathedrals were an inspiration. Photography was but a means to an end, and not an end in itself. It was the medium through which he expressed himself. As George Bernard Shaw wrote, "He relies on pure photography not as a doctrinaire, but as an artist."

This is the lesson which I learned from my study of Evans: Art cannot be explained by a doctrine as simple as "pure photography"—which is basically a mechanistic concept. Only by relating the vision of an era to the highly personal, creative vision of the individual artist, can we hope to understand his work and his message.

Edward Weston:
Dedicated to Simplicity

Cole Weston

Of Weston's four sons, Brett and Cole are respected as photographers today. In 1946 they assisted their father when he became handicapped by Parkinson's disease. In his will Edward appointed Cole to print from his negatives after his death. Cole writes insightfully about his father's work as well as his own.

—A. C.

IN THE IMMEDIATE years following my father Edward Weston's death I found it extremely difficult to speak objectively about his work, but in the the past few years, working with his negatives as I have, this problem no longer exists. His work speaks for itself and any keen observer who has been surrounded by it as I have will come to many of the same conclusions.

Aside from the apparent genius of E. W., simplicity was the most important factor influencing his work. In the days when our society was being cluttered with automatic washing machines, dishwashers, T.V., appliances of every sort, gadgets, a new car every year, a chicken in every pot, and time plans to take care of your every need—he lived and worked with the barest necessities, giving his undivided energy and attention to his work, and *not* to the occupation of acquiring the latest manufactured goods in order to keep up with the Joneses.

His house, built by Neil in 1938, cost $1000 and was 800 square feet (figures 12, 30).

One large studio room with fireplace, studio bed in one end, and corner kitchen with a screen around it in the other. A bathroom with a shower and the darkroom next to it. Later on a small bedroom was added. The furnishings were an old desk, one couch in front of the fireplace, a few captains' chairs around a large table, which was work table, dining table, and conference table combined. Aside from a few personal momentos from his travels to Mexico and around the country this was it. Simplicity itself. Just the necessities.

His food was even more uncomplicated; Wheat Chex with honey, wheat germ and milk for breakfast. Lunch consisted of the leftover salad and cold vegetables. Dinner, a huge salad of lettuce, avocados, tomatoes, and anything else handy and with this would go either split pea, lentil or lima bean soup. Dessert was coffee, nuts and dates. You can see by this, Safeway made little money on E. W. et al.

His darkroom and equipment were basic. Darkroom 7' × 10', wooden sink 3' × 6', the printing shelf had one paper drawer in it with an adjustable 100-watt to 300-watt bulb hanging over an 11 × 14-inch printing frame. The sink had four trays of various sizes with a red bulb under the developer, a safelight over it, and an inspection daylight bulb for the prints. One loud ticking alarm clock counted his seconds for printing and a 3-minute egg timer timed the developing. Finally, washing was done in a large tray

with a syphon circulator. Negatives were developed in pyro, and printing was done in amidol.

The camera equipment was just as simple and lacking in gadgets as his darkroom. An 8 × 10 Ansco Commercial View for his personal creative work, and a 4 × 5 Autograflex for his portraiture. Twenty 8 × 10 holders for the 8 × 10 camera, two 18 septum magazines for the Graflex. Filters, K1, K2, and G which he rarely used, and that was about it. As far as film and paper were concerned, from the time Isopan came out until he had to stop working this was his film. Printing was done on several different papers, but Haloid was his favorite during the 1940s.

With this simple uncomplicated approach to daily living he was able to concentrate most of his time on his work, and this he did. Up before dawn, with coffee at his desk for an hour of writing, then into the darkroom. He would print for an hour or so, then have a break for a bowl of Wheat Chex. Then back to the darkroom until lunch. This usually was a leisurely time as he was a very slow eater and enjoyed his food immensely. After lunch he would print for another two hours, then out of his darkroom for a 15- to 20-minute nap. This short time on the couch stretched full length and eyes closed he said completely reenergized him and he was able to go back to the darkroom with renewed vigor and print until 5 P.M. This was a typical working day for E. W.

A day in the field with the cameras was treated with the same dedication and consideration. Holders were usually loaded the night before, as the darkroom, being board and bat, was not too light tight and all preparations for the coming day were done the night before. A typical day at Point Lobos in 1946, when I came to work with him and continued to do so for the next ten years, would start early in the morning with a feeling of great exultation and anticipation of what the day might bring. Cameras were loaded into the car and off we would go to Point Lobos only one mile away.

Although I had been with E. W. in the darkroom and in his studio, photographically speaking, 1946 was the first time I really went out in the field and had my first direct contact with him when we were both working photographically in the same area. There was no pressure from him, but I found it extremely inhibiting and found myself seeing nothing but E. W.'s on my ground glass no matter where I focused my camera. I talked to him about this problem, and he explained that even though he had worked so intensely at Lobos, there were many, many different ways in which the area could be photographed and that I should approach it with my own eyes, my own personality, my own being; in other words, what did *I* have to say about the material at hand? Even though I was using the same size camera, the same film, printing on the same paper, in the same darkroom, he would point out that we were different human beings on different levels of growth in our lives and therefore would see things differently. A perfect example of this was one day on the north shore. I was photographing and he was just resting on the rocks. I had focused on the side of the North Dome, the tripod balanced on a very precarious round pinnacle and extremely immovable. After many minutes of looking through my ground glass at this composition of rocks, dead and live cypress, and

succulents, I called to him and suggested that he might look through the ground glass as I felt there was something there but I was not content with the composition. He placed himself behind the camera under the focusing cloth and within minutes he took the ground glass and turned it from horizontal to vertical, changing the position of the camera not a fraction of an inch, and proceeded to make the exposure which is now one of his most famous *last* photographs; namely PL 46L1 North Dome, Point Lobos. His amazing sense of composition, form, organization, or whatever you want to call it immediately directed him to make it vertical, taking up a large round boulder at the base of the composition, tying it all into a beautiful photograph. He always said whenever he showed this photograph, which was in his *Fiftieth Anniversary Portfolio*, that it really should have been signed Edward and Cole Weston. I was greatly flattered.

This mastery of his equipment coupled with his uncanny vision was brought out over and over again in his ability to set the tripod and camera up in one position and make the desired exposure without so much as moving the tripod an inch. This familiarity with his equipment also enabled him to set up from a fully cased camera in the back of the car to complete exposure, in some instances within a minute and a half. In contrast to his superspeed exposures under pressure, I have also seen him stand poised with his hand on the cable release for as long as a half hour waiting for the correct light conditions, clouds, animal positions, etc. Another aspect of constant usage of simple equipment and his keen eye and complete understanding of what he wanted to say about the subject matter was his abil-

ity to see on the ground glass his completed print. So unlike the average photographer who spends hours in the darkroom behind his enlarger trying to decide what portion or section of the negative he will use as his final composition. No two exposures were ever the same and never did he make a duplicate exposure to cover any chance of error. He was so certain of his equipment and of what he saw.

Along with this simplicity of equipment it would naturally follow that his personal tastes were not very complicated. He was extremely athletic although he was only five feet, five inches in height; he could easily surpass his larger five feet, eleven-inch sons in running, broad jump and many other sports in which he excelled in school. He loved nothing better than to outrun his sons on the Carmel Beach, much to our chagrin. He also took great interest in prizefighting. One of my earliest recollections is standing in Glendale with him outside a radio shop listening to the Dempsey-Tunney championship fight, and in his later years when he was incapacitated with Parkinson's he would spend hours in front of the T.V. watching any sporting event that was on.

Bach was his favorite composer, and he loved all classical music, but he was also extremely fond of dancing tangos and rumbas and was the life of any party. He would do the most fabulous Chaplinesque imitations at the drop of a hat. He had a great sense of humor, which can be seen in many of his wartime photographs such as "Civil Defense" and "Exposition of Dynamic Symmetry."

Politically he was very liberal and spent many hours writing letters to congressmen,

senators, etc., regarding issues that he felt were necessary for the benefit of the general public. The Japanese Americans in the Monterey area still remember him for his letters of protest regarding their evacuation from their farm lands in the Carmel area to the concentration camps in Central California during World War II. The myth of his being a recluse and living in an ivory tower which is usually attached to a man of his creative ability was certainly not so with E. W. But E. W. was never a businessman. Although the opportunity to exploit his work was offered to him many times, he never accepted it. His largest yearly gross income was $5000. His philosophy as far as business was concerned, and I quote: "Be your own boss and never become a slave to your overhead." And he practiced it.

In the last ten years of his life, in which he suffered from Parkinson's disease, he was unable to work. But he never turned a visitor away who wanted to see his photographs. Though barely able to speak he would indicate to the visitor large crates of mounted prints. He would then sit by the fireplace and watch without a word as they would go through his work.

E. W. lived his life simple, uncluttered but fully dedicated to his work and what he had to say. He died on January 1, 1958, in his one-room shack on Wildcat Hill overlooking the Pacific, and we spread his ashes over the surf on "Weston Beach" at Point Lobos.

Modern Photography 33 (May 1969): 66, 71, 104.

Edward Weston

Dody Weston Thompson

DODY THOMPSON BEGAN working with Weston in 1948. He especially respected her talent for printing and she is an accomplished photographer today. As Brett's wife she became a member of the family and spent considerable time with Edward. Her interest in the man and his work is vividly seen in some of her activities today.

Although the first three paragraphs in Dody's memoirs might seem exaggerated, perhaps the most surprising thing I learned from doing research on Weston for four years was that people who had known him from as early as 1915 never indicated that they had ever felt anything but extraordinary fondness for him.

—A. C.

I CANNOT WRITE other than an affectionate memoir of Edward Weston, and I may as well say at once that I have few negative memories to report: it would not be true to my experience of the man who was my teacher and father-in-law, and whom I remember as one of the nicest human beings I ever knew. He was unfailingly kind to me and that rare thing, undemanding in his affection. This is not my view alone, of course; despite his fame as a photographer, he was beloved by a remarkable number of people of all kinds and both sexes. I am speaking of the attachments of friendship, although he was a great Don Juan for long years in his middle life, between his two love marriages, early and late. He never understood why he attracted what he once called "this tide of women," which indeed at times rose to the levels of French farce, with multiple mistresses and anecdotes of someone tiptoeing out the back door to avoid a senior mistress coming in the front.

"Here I am, isolated, hardly leaving my work rooms, but they come, they seek me out—and yield (or do *I* yield?)," he wondered in his journals, and commented with typical candor that he wasn't even a particularly good lover because his interest in one person was not sustained—and besides, he had always his overriding love, his "work," to fall back upon. Another time, looking back over the past, he speculated with sincere if slightly histrionic earnestness about personal relationships. There was more to be learned, he felt, from women than was possible "from a close friend of my own sex, chosen maybe because of similar tastes and ideas. Such a friendship is stimulating only through bolstering our own egos. . . . But the opposite sex provokes, excites growth, and most important affords an opportunity to give . . . and to give freely . . . [which] is the very meaning of life and the way of personal growth."

Without having intended to begin in this vein, I am rather glad, really, to have the subject disposed of. Friends have sometimes attributed Edward's plethora of love affairs to a compensatory reaction to his slight stature (he was about five feet, five inches tall), and if so I suppose it could be construed negatively, as a weakness to be reported. He himself believed— at one time, at least— that the attraction was due to the glamor

that surrounded his growing reputation: "Women are hero worshippers." But there was more modesty than truth in this for, since most of his former loves remained staunch friends, my own view is that the love affairs were merely one aspect of his general magnetism, that forever mysterious alchemy of personality which drew to him every kind of person, from poets and painters to coupon-clippers and ex-convicts. His own children remained attached to him as adults—a phenomenon by no means universal. He was the best-loved man I ever knew.

When I met him in 1947 the magic was still going strong, though he was sixty-two and beginning to be not well. I was vacationing in Carmel, California, at the time, and had recently been profoundly stirred by the photographs in his book *California and the West,* for which he had made a photographic safari that yielded 1500 negatives in two years, an immense undertaking for a photographer who worked alone with a bulky, 8 × 10 field camera, and whose aesthetic further called for personally processing, printing, and mounting each large negative with individual devotion. I knew (from the text provided by Charis Wilson, his wife) that the project had been funded by the first Guggenheim Fellowship ever awarded to a photographer; and since this annual cash trophy in the arts is prestigious as well as substantial, it constituted a very public recognition of his status from 1937 onward. Otherwise I knew of him only what the world did: that this recognition had been growing since 1923, when he left California for three searching, fecundating years among the painters and writers of the Mexican Renaissance; that since his return to California a swelling number of books, articles, and exhibitions of his prints—which

were shown throughout the United States, and abroad from Vancouver to Munich to Shanghai—had earned him an international reputation, capped, in 1946, by a major one-man retrospective show at New York's Museum of Modern Art. By that time those sharply focused, glossy prints in black and white, a mere 8 × 10 inches in size (since he would not enlarge) and uniformly mounted on chaste white board, were considered by a wide public to be the works of a master. They were purchased like paintings by museums and connoisseurs.

A long roster of the famous had sat to his portrait lens. Igor Stravinsky sent a note, *"Mille meilleurs remercies, cher Monsieur Weston, pour ces splendides photographies. . . ."* Diego Rivera said Weston had blazed a path to a better way of seeing and therefore of painting, and brushed in his own self-portrait on the staircase of the Mexican Ministry of Education from the Weston portrait in his hand.

I knew nothing of the hidden drama that might lie behind the general facts, nor anything of the Weston personal life, except that he lived somewhere near Carmel. Upon discovering one day that his address was in "Carmel Highlands" a few miles south along the California coast, I decided impulsively to play tourist, to merely go and look. The day was sharp and bright as I drove leisurely past the mouth of the Carmel River issuing from its lush valley, past great fields of artichokes on the good river-bottom flats, past a shaded, modest gate-house labelled "Point Lobos," to where high evergreen hills came down steeply to the granite coast. The road wound along their flanks, twisting and turning, now in dappled sun among pines, now opening out to

a windswept view uninterrupted all the way to Tokyo. Here and there the roof or chimney of a mansion showed discreetly between the trees: the local residents were not on view. With the thoughtlessness of youth, I hadn't counted on Weston's home being sheltered by this sort of privacy—the privacy of wealth—even though, illogically, I had rather thought that a battery of secretaries must protect his fame.

A sudden bend in the road revealed a mailbox standing at the foot of a low bluff on the landward side. The box was commodious and neatly made of unpainted pine, looking rather like a comfortable doghouse that had somehow got set in air on a wooden post. "EDWARD WESTON," said the sign above in large, clear letters. Beside it, a country road of decomposed granite that had once been black-topped led gently upward a few yards before turning out of sight. Nothing but treetops showed above. I was forced at last to admit my unavowed purpose; but though for the next twenty minutes I drove back and forth past that tantalizing mailbox, I couldn't get up courage to telephone, much less barge in unannounced.

When finally I parked at a lookout point and perched gloomily on the low rock parapet at its edge, oblivious of the fresh breeze and the sea winking and glittering below, a middle-aged couple shortly pulled up also, and within a few minutes had drawn me into conversation. In the end I put my dilemma to them, the way one can to passing strangers. "What would you do," it burst out of me, "if a famous photographer lived near here, and you wanted to study with him but didn't have much money to do it with, and you didn't know him at all or anyone else who knew him?" They considered gravely,

put several questions, and then he turned to me. "Well frankly, what you're dreaming about happens in fairy tales, but not in real life. Now if you had a letter of introduction—*that's* the way these things are usually done." But she leaned around his shoulders and gazed dark-eyed at me, and gentle: "Still, what possible harm could it do to try?"

They left then, nameless still and a bit embarrassed. But the pragmatist's answer had challenged my youthful idealism, and her encouragement stiffened my spine. I rushed for the nearest public phone, and in short order heard ringing at my ear the bell in that unknown house on the bluff. A husky masculine voice answered hello. "May I speak to Edward Weston?" Bravado. My knees were weak.

"This is Edward Weston," the quiet voice answered, and waited. That was all. No secretary. No facade. Not even an insistence to know my business. I gave my name and added that although he did not know me, I admired his work and would like to meet him and talk to him.

"What would you like to talk about?"

"Photography."

"Well, that's my favorite subject," said the voice, with a tinge of amusement to be heard behind it. "When would you like to come?"

It was as simple as that. In a sort of daze I agreed to appear at his home later in the afternoon.

When I finally drove up the little road beside the mailbox, it was to confront at the

top a house of the most rustic simplicity in the most gorgeous of natural settings. It rested toward the back of a broad, gently sloping flat at the top of the bluff, surrounded by trees, overlooking the Pacific. On one side grew a stand of tall pines that looked rooted there forever. ("I simply put them down one day and said grow if you can," Edward once told me later.) On the other side, a deep ravine fell to a creek out of sight below, opening out a tapestried view of wooded hills reaching far back inland to distant mountain heights. Directly behind the house rose another copse of pines, going off up the hill in a tangle of wild undergrowth. How well I remember that the morning sun and morning fogs used to get tangled in their branches too.

In one corner of the flat before the house a huge pile of logs appeared to have been spilled carelessly beside a stump into which a gleaming axe stood bitten, as though someone had just recently left off chopping firewood. The house itself was a modest pine cabin of board and batten, whose exterior and interior walls, as it turned out, were merely two sides of the same plank. A pair of French windows, painted blue, in which the westering sun reflected, opened on a little high railed balcony smothered in vines. (It was a teasing family joke, I learned, that these were Passion vines.) A mass of bright nasturtium climbed up toward the Passion fruit.

Having heard a car drive up, Edward Weston himself came down the path to greet me with the same directness that characterized his conversation and his mailbox. He was a smallish, tanned, sturdy-looking man, not particularly handsome, with a ruff of gray hair and a strong nose, but with

especially nice eyes that have frequently and accurately been described as "hot brown." They were exceptionally warm, gay and penetrating by turns; his art came through them, and they showed it. I noticed, too, when he gesticulated once, that the nails of his right hand seemed to be neatly polished the same color as his eyes. It was the result, he explained, of using old-fashioned developing agents called pyro soda and amidol which washed off the skin but stained the nails: he didn't like to use a glove. Today, this distaste seems to me symbolic: between himself and his vision nothing must obtrude. His way in any case was always to use the simplest means, with the least fuss. The poet Robinson Jeffers, while visiting the neighboring Weston household one day, accidentally came upon two ten-dollar bills stuck between the pages of Taine's *History of English Literature.* Edward's "book was his bank;" and it struck Jeffers as so typical that he commented in print: "Weston's life is like that, simple, effective, and without ceremony. . . . He is not interested in the affectations and showmanship that distract many persons; I think he has never been interested in having a career, but only in doing his work well."

The experiences of that first day on Wildcat Hill entirely bore this out. After Edward had asked a few questions, and we had talked there under the trees long enough to recognize that we were likely to be friends — Edward's word for it from Mexico days would have been *simpatico* — he took me inside in response to my presumptuous questions about studying photography with an empty pocketbook, and handed me a letter from his desk: "You won't believe it, but this is what I was writing when you phoned." The letter was to his friend, the

photographer Ansel Adams, inquiring for a husky young man with a car who would be interested in acting as chauffeur and lugging his photographic gear in return for a free apprenticeship in photography. Only in fairy tales, indeed! Yet it seemed I had wandered into Walden instead of Oz.

The interior of the cabin was predictably unpretentious, honed down to essentials, consisting of one large studio room with a minuscule bath and equally small darkroom off one side (figure 12). Edward's desk was the only notable piece of furniture there, an immensely tall, Victorian escritoire, replete with drawers, bookshelves, and delicious cubbyholes, all occupied (figure 44). Here he had penned, over the years, many of the irregularly kept journals (he called them Daybooks) which are so full of the revealing gossip and struggles of his life. He wanted passionately to photograph only as he believed; but for long years economic exigencies forced him to photograph in ways that would sell; and the clash between these objectives filled the Daybooks with the sounds of crisis, and worries about the next pot of beans. He always said he had written out his "bellyaches." Being an early riser, no matter where he lived he used to get up in the chill of dark mornings before his household stirred, and sitting down at his desk scratch away in a series of cheap school note-books with a bold black scrawl, warming himself with coffee — and let off steam.

Beyond the desk, on that first day, I had an overwhelming impression of cool dark corners bordering a prodigal warm pool of light that spilled from the skylight and French doors, striking peripheral glints from dusky regions here and there: from the breast of a pre-Columbian figure resting on the mantel; from the primitive bright flowers, obviously Mexican, painted on a wooden salad bowl; from a pair of reading glasses left lying on a little wooden table; from a pair of cat's eyes gleaming from the curled depths of a comfortable and shabby chair. Since it was not named Wildcat Hill for nothing, there were in fact four cats ranged unobtrusively about the room (of a total population of eight or so), but they were so well trained as kittens they left their voices at the door — *their* door, beside the large one, through which, I later learned, they came with catty caution day or night. Edward had a strong affinity for their independence and determined self-reliance.

The room's sole source of heat was the fireplace at one end, around which ranged a circle of canvas directors' chairs. Opposite stood a blue dresser and a dining table, both large, the latter serving as a photographic work center when not in use for general conviviality or food. There was a wall of open bookcases and closed storage for mounted prints, and a niche housing an inexpensive phonograph with a modest selection of records, mostly Bach. The walls were unpainted, the wooden floor was bare; the rug — a brilliant Mexican affair — was thrown over the double bed in the corner. The opposite corner was the kitchen, compact as a ship's galley, with an upside-down coffee pot on the electric stove and a charming milkmaid's latched window over the sink, through which one could survey the path to the front door and look across the small, flagged patio to the tiny cabin beyond that served as guest cottage or getaway room, where I was eventually to stay. The kitchen was partially screened off by a wooden panel on wheels, painted gray, which like the table had a second function:

when, rolled forward nearer the skylight and windows, it became a neutral background for portrait sittings. By changing its angle to the daylight with which he worked, Edward could lighten or darken its effect in the finished print.

When I remember that room I think of all those signs, both literal and figurative, of the past and current life of Edward Weston. Through the windows of the escritoire a small white card stated in black ink: "I do not lend books to friends. I do not want to lose my books or my friends. E. W." It was browning about the edges, though; evidently it had been there for some time. The World War II insignia of his four sons showed dimly in one corner, pinned to the wall. More prominently tacked up, a printed statement by the jazz musician Louis Armstrong read: MAN, IF YOU GOT TO ASK WHAT IS IT, YOU'LL NEVER GET TO KNOW.

I no longer recall much else of what was said that day; I do know that Edward let me see the darkroom, where one might with justification have finally expected some degree of mechanical sophistication, some mark of the Weston preeminence in one piece at least of the latest fine equipment, but no. Since he made only contact prints, in order to retain sharpness and a certain tonal quality, there was no enlarger. A bare, frosted bulb hung from the ceiling as printing light, controlled by a simple on-off switch and a battered darkroom clock whose loud ticking served as mental timer. Aside from the heavy old mounting press, the most complex apparatus in sight was the arrangement for keeping the print developer a constant temperature during work sessions: someone had hit on the idea

of installing a low-wattage light bulb in an open wooden box. The tray of developer sat on top like a lid, obliterating any taboo rays of light, and the heat thus generated was just enough to keep the solution properly warm in that cool and foggy climate. For the rest, everything, sink, floor, walls, a few workshelves and drawers, was of unpainted pine and the most modest proportions. A printing frame, some trays, a thermometer, 8 × 10 film holders hanging from a peg, a few bottles of chemicals under the sink, more or less completed the equipment. As in the studio, all was neat and in its place. "The world is full of sloppy Bohemians," Edward wrote in the Daybooks, "and their work betrays them."

With what proficiency he had managed the blind skills of the darkroom by these well-arranged but Spartan means I promptly learned: he pulled up a chair for me under the skylight and showed me fifty photographs one by one on a small easel. I have never forgotten the astonishing effect of that first viewing. I was familiar enough with the Weston subject matter, which was Nature—the nature of a tree, the nature of a man, and by extension the things man made; and I had already responded to the brilliant and inventive use of form in the illustrations for *California and the West,* which had impelled me here. But, accustomed like the rest of us to the daily flood of drab reproductions, I was unprepared for the revelation of this kind of fine, original print. It must be seen to be believed. In that brilliant, pouring light, with no dulling, reflective glass to obscure them, those images shone with a mysterious inner light, arousing a sensuous response to their print quality alone: the blacks seemed rich as oil or deep as velvet, a thousand intermediate

grays gleamed out—soft pewters, glinting silvers—and at the upper end of the scale were whipped cream, pearls, and sunlight.

I then and there joined the ranks of those for whom a fine black and white print yields a deep esthetic pleasure. It was my first, stunning lesson in photography. I had never realized that this virtually infinite variety of intermediate shades between black and white constituted a unique phenomenon, not to be found in etching or lithography, nor in fact in any other medium in the entire history of art. It lies at the heart of black and white photography, this scale of grays which the skilled photographer—never mind the appearance of the original subject—can expand or contract like an accordion of unknown but variable length pretty much at will. Technically, it is called "continuous tone," and Edward had over the years empirically distilled an uncluttered and impeccable technique that took full advantage of it. In a landscape such as his "Eel River Ranch," he might use a realistically long scale of countless intermediate tones revolving around a triangle of sunlight, with a three-dimensional effect: he could modulate space as well as tone. In a deliberately high-key landscape of fifty-foot dunes he might flatten the perspective, rendering unguessable the original size of the subject. In another dune he might modify the shadows—in actuality the eye could see into them quite clearly—into an opaque black whose great curving forms dominated the print, causing it to teeter back and forth for the beholder, like those tricks made by op art painters, between the recognizable and the abstract.

The power and purity of those luminous prints, together with the shock of being

there at all, combined to render me speechless before them. Long afterwards I learned that Edward found this silence most refreshing. So many of his visitors felt compelled to find something to say about each print. The more naive often exclaimed over the sharpness for which his prints were known, although actually that quality is easily achieved with normal equipment and a minimum of knowledge, while the manipulation of the tonal scale requires a complex technique backed up by considerable experience.

For of course he did have frequent visitors. I discovered rather quickly when some months later I came to take up my apprenticeship that my case had not been unique. Edward was in the habit of welcoming travellers from all over the world, from all walks of life, who came to look, to purchase, to seek advice, or to sit for portraits. The truth was, for almost forty years he had been "at home" to the public. He had spent his professional life tied to a series of studios of which this was merely the last. It was his bread and butter.

Not surprisingly, I also found that to many visitors, Edward himself, and his way of life, were almost as remarkable as his works. Yet he did not have a particularly scintillating personality. He was rather a quiet man, in fact, with a soft voice and a life-long habit, well known to his friends, of falling asleep in the evenings, even at parties; those parties, that is, when he did not dance until dawn, for in his prime he loved to dance and, when the mood struck, clown about. He had a distaste for doctors and a leaning toward vegetarianism; he particularly disliked hypocrisy and stuffiness, and persons whose pretensions—to "Art" or to

anything else—were false. Once, finding a gathering distasteful for this reason, he stole away early, although he was the guest of honor: "I could not stomach the mess longer."

His politics were humanitarian and liberal, but not extreme. He may have been swayed by the more militant and pro-labor attitude of his witty, trenchant wife Charis toward the end of his life; and the mistress with whom he went off to Mexico in 1923, the voluptuous and dashing Tina Modotti, became an ardent Trotskyite under the influence of the revolutionary intellectual milieu of that heady period in Mexico, so that when, some years after she and Edward parted, she died suddenly, having hurriedly left a party and thrown herself into a hack, begging, too late, to be rushed to a hospital, it was widely believed that she had been the victim of political assassination. But one had the feeling not much of this rubbed off on Edward. His roots were too American. His ancestors went back to the New England beginnings, his son Brett came by that name honestly through the family tree. Edward paid his taxes and never broke the law. If anything, he was at bottom apolitical, I always felt; at any rate there lurked something as patrician as republican in his attitudes. I can hear him now quoting a favorite phrase whose authorship he had forgotten: "the unlovely level of ten thousand good people." He had the artist's distaste for the bourgeoisie, but none of the Marxist's blind affection for the proletariat. He wrote once about "the boredom and narrowness which rises directly from mediocre mass thinking." He disliked masses of people in any form: he could never stay in cities long. He was the individualist, the non-joiner: "In union

there is strength—yes—commercial strength—mob strength—fine motto for labor unions—for politicians—but for the individual who would create—no."

On the other hand, he had charged $25.00 for a mounted print in times when this represented considerable purchasing power, but twenty years later when I knew him, during which time his reputation and the cost of living had risen steadily, he was still charging the same amount, and rather pleased about it, because it represented the essential democracy of photography: the number of prints obtainable from a negative was theoretically limitless, and therefore many persons should be able to share it, at a reasonable price. He disagreed emphatically with the photographers who tried to impose the scarcity value natural to paintings on their photographic works.

I have heard it said that when Edward was younger he never laughed, and I have never understood how that could be so. When I knew him he laughed often enough, and in the face of tragedy, having grown old suddenly after an exceptionally long physical youth that extended well into middle age, and having had to give up his photography as a consequence. It must have been like giving up his life. The gentle onset of Parkinson's disease meant he could no longer wrangle his heavy gear about, though in the early years of his disability he could manage with a strong arm to help him, which was the occasion for my apprenticeship. All the years I knew him, though, until his death, I never heard him once complain, nor lose his sense of humour. Somewhere there is a lively snapshot of him in full, untidy beard, in which he is obviously laughing out loud to beat

hell. It is one of the few portraits of him I ever liked, it gives some idea of his vitality and love of life.

In a pixie way he liked to make others laugh as well. Unfortunately, *I* kept no journal, and so can recall now only a few mild examples, such as his teasing two visiting Easterners by saying straightfaced that New York was much too *slow*—one was forever waiting for something there—a cab, an elevator, an appointment. I only remember that his wit was likeable, with the edge of truth in it. There was many a dinner around the big table under the skylight, with the talk rolling along among friends or family, and Edward listening quietly in his Captain's chair at the head of the table. When everyone had had his say, a soft, Edwardian sentence could set the company howling. Often his statement turned on the recognition of some unspoken truth in the matter under discussion, for he seemed able—and it was a notable quality much discussed, applying not only to his humour—to cut through rambling talk and disparate formulations, right through to some essential. This ability was not intellectual, despite the evidence of the Daybooks. It seemed rather to be an intuitive flash to the core of the subject at hand, and related somehow to the general simplicity of his means—as in the darkroom—which was the result neither of poverty nor accident, but welled up from sources deep in character. He had no turn for the mechanical in any case: he never learned to drive. More than once I heard him poke fun at the sort of photographer who became more interested in "gadgets" than in substantive results. He was always sweeping non-essentials out the window.

In general, he was less stimulated throughout his life by photographers than by painters, poets, and musicians, although he was always generous with his time when aspiring photographers consulted him. Sometimes young photographers, usually students, would question the seeming constriction of his unvarying format—the identical 4 × 5 or 8 × 10-inch proportions—from which in his mature work he never departed. They did not know his background; and it was some time before I learned to understand his answer. Suppose, they innocently asked, he came across a subject that by its nature cried out for a long, narrow format, or perhaps a round one? His reply was always to the effect that only boundaries set one free.

Obviously, for Edward the mastery of one's craft preceded creativity in it. Well aware that his own vision was non-transferable, he showed me the basic principles and techniques of photography without much comment. He never said to me—I never heard him say to anyone—"this is good," or "this is bad." He had no false modesty and knew his own worth, yet he disliked such sweeping value judgments. It was a great day the first time he looked at one of my prints and said, "I like that." He liked or didn't like—it was a personal opinion—that was as far as he would go.

And so I learned largely by example. I remember a trip by car with photographic friends to Rhyolite, the Nevada ghost town beyond Death Valley that Edward called "The Athens of the West," whose ruined stones and arches he had photographed in previous years with all the attention another might lavish on the Parthenon. Our party

camped in a long-deserted shack, and in the morning, having cooked our breakfast on the pot-bellied stove still rusting in the kitchen, we packed our gear for the day's photographic foray. But Edward had a cold and sent us on without him. When we returned, hot and dusty after a busy, fruitless morning searching desert dunes and greasewood flats, looking at abandoned gold mines and cement-mixer-baroque railway stations where no trains came, we found Edward with his camera out, serenely photographing an old boot he had found lying on the ground and stuck up on a projecting nail against the wall. He was testing a new color film emulsion that Eastman Kodak Company had sent him, and to his eye the marvelous discolorations of weathered wood and twisted leather balanced with perfect tension the black shadow of a rusty nail. The moral was obvious, though unspoken. A photograph existed in the eye of the photographer; not in special subject matter, but potentially in any subject matter. A photograph was nowhere. It was in your own back yard.

Another time the two of us were out with cameras on Point Lobos, that spectacular stretch of shore and headland whose entrance I had passed a few miles from his home, which over the years had drawn him back repeatedly to photograph. That day, however, I confessed I could see nothing worth my film. Edward bet me that we would find something of interest if we merely looked down from our low bluff into the next cove, whatever it might be; and walked over to the edge. But it was just a poor nook of dull, dark sand with a few small, uninteresting rocks scattered about. He stood peering down several seconds. I still saw nothing, but in that time he decided how his finished print would look. With absolute certainty of knowledge and economy of movement he set up the camera and tripod and made preparation. While he measured the light I examined the image on the ground glass at the rear of the camera, under the black sateen cloth which shut out the light, and saw glimmering there, upside down and backwards, a lovely ensemble of silver rocks sailing in pewter sand.

The demonstration was so effective I have not forgotten it these twenty years: how technique must become, as it was for him, instinctive as breath; how after basic technique one trains the eye; how ultimately something must reside behind the eye beyond all training. For quite a while Edward called that photograph the "Dody Rocks," and thought it good enough to include in his final book, *My Camera on Point Lobos. I* always called it "Something out of Nothing." Recently I heard it put this way by a photographer: "Ansel [Adams] reveals the beauties of nature that the ordinary man sees but cannot express. Edward reveals what no one has seen."

Edward taught me nothing about the use of artificial lighting, since he had entered photography long before "flash" left the flash-bang-possibly-burn stage, and so mastered natural light early and kept his allegiance to it. On our photographic expeditions he particularly liked to work in a certain luminous, high fog light frequently occurring on that coast; it was a clear, enveloping light, that had a way of revealing the subject without drama or exaggeration. Impressionism no longer interested him; by which he meant, as he once protested in the Daybooks:

" . . . for example a tree momentarily shimmering in a brilliant sun or the same tree drenched, half hidden by a passing storm . . . the transitory instead of the eternal.

"But I do not want the play of sunlight to excite the fancy, nor the mystery of gloom to evoke the imagination—wearing colored glasses—I want the *greater mystery of things revealed more clearly than the eyes see,* at least more than the layman—the casual observer, notes."

He did not say so, but it was not merely "impressionism" he had renounced; it was the entire romantic tradition. One need not pore over his works as I daily did to notice their total lack of sentimentality. Often the very choice of subject was revealing: a bed-pan; a toilet; a workman's dirt-encrusted glove flung down like a challenge on the earth; a wrecked car forever stalled in lonely fog; a dead man dessicating in the desert; a dead pelican floating darkly on dark waters, or lying twisted by the accident of death in a textured pattern of bright feathers and sharp sand. Such subjects form a significant portion of his work. He had no objection to conventionally attractive subject matter, as long as its rendering was not banal. Photographing in the dunes one day, he had glanced around to find that Charis was sun-bathing while he worked. He quickly turned his camera toward that exquisite nude curve arching face down in sunlit sand. But at another time and place, when a professional dancer performed nude before his lens, he found her sinewy, tense, unpretty, and angular contortions equally worthy to record.

It seemed that Edward had not only followed but contributed to the general migration of sensibility away from the romantic in this century; yet his uncomfortable subjects, although dutifully reproduced (at least in his books, which have been in the hands of persons of integrity and taste) are rarely purchased, and one concludes they form the least popular segment of his work. *My Camera on Point Lobos* contained perhaps the highest proportion of quiet and sometimes somber works, many of them displaying a high and subtle intricacy but little immediate dramatic impact; they have been said to parallel Beethoven's last quartets but, although the book has now been reissued in the United States, it was remaindered after its first publication in 1950.

Gradually I came to feel at home on Wildcat Hill; and as the tranquil, busy days went by it seemed I had been learning imperceptibly, through books and friends, other photographers and Edward himself, the history of photography in addition to its craft, and so arriving at a clearer view of Edward's place in it. I began to catch glimpses of a long Weston pilgrimage, which opened with a very different Edward Weston than the simple, strong old man I knew; and its initial stages went far to explain his determined flight from the romantic.

Photography, I found, trailing all the other arts, was the last to have its romantic fling, in an effort to prove that it was as much an art as painting. Originally, photographs were sharp and lifelike: Daguerreotypes of our great-grandparents display each mole and filigree of lace with equal candor. Clearly this new medium would before long preempt the task of recording fact; and indeed representational painting went out, by way of the impressionists, just as photography came in. Then, as the impressionists

themselves disappeared around the bend of the century in the direction of succeeding phases of modern art—expressionism, cubism, the abstract, dada, the surreal, everything but the objective literalness rendered by the lens—photography, a little late, came panting up to grab the tail of the procession, topping its original theft of subject matter by borrowing a style. If one could not paint a Whistler, the thing to do was photograph a Whistler by purchasing a lens deliberately manufactured *not* to focus sharply, rendering instead a "soft" image fondly believed by most photographers to be the hallmark of Art, with a capital "A." This belated form of impressionism caught the public fancy, particularly with regard to portraits, since the lack of focus gentled lines and softened unwanted features, whatever violence it did to character and truth. A widely known print, entitled when it was shown at the Brooklyn Museum of Arts and Sciences in 1916 *Ruth St. Denis—A Fleck of Sunshine,* was an outstanding example of the style, less woman than airy shimmer and suggestion, with hints of its derivation from the Japanese print and *art nouveau* discernible not only in the dancer's flowered robe but in the signature of elongated and slightly curling letters down one side:

W
E
S
T
O
N.

Jeffer's surmise was incorrect that "Weston never wanted a career:" he wanted this one. There had in fact been two careers; and in this first one, roughly between 1910 and 1920, Edward Henry Weston had scaled the heights of Pictorialism, as it was called, with definite intent. Starting in 1911 at the age of twenty-five from a modest studio in what was then the country but is now Glendale, California, an adjunct of Los Angeles, he succeeded within a few years in bringing down a golden rain of honors, trophies, international exhibits, and portrait commissions on his beginning-to-be-lionized head; ultimately the Weston name was so well known it drew remunerative offers for national testimonials to advertise a lens—a tasty topping for a livelihood based on portraits of the dowagers and socialites of nearby Pasadena and the rising lights of infant Hollywood. That self-made career by a young man of little education and no capital was the stuff American dreams are made on: By Own Effort Unknown Boy Makes Good.

Many years later Edward confessed to a friend, "That whole soft-focus period in retrospect seems like a staged act; I even dressed to suit the part; Windsor tie, green velvet jacket—see, I was an artist." His studio was artsy too, having of course its necessary skylight and windows, with muslin-covered stands to control the natural light; but Oriental-bare, an urn resting near a corner, one stylish, silvered wall (useful for high-key effects); and outside in the arbored garden he made misty, sentimental portraits tipped with sunlight. In 1917, the year T. S. Eliot's *Prufrock and other Observations* was published in England, the year Eugene O'Neill's one-act plays, and H. L. Mencken's *Book of Prefaces* were stirring excitement in the United States, the year Picasso's designs for Diaghilev created that unforgettable uproar at the first night of the ballet *Parade* which finally brought cubism to the collective awareness; that same year,

ironically, Edward Henry Weston was elected to the London Salon of Photography, the very apogee of international Pictorial acclaim.

But even as his success grew in the Pictorialist genre, his taste grew and outran it. If the famous armory show in 1913 brought Marcel Duchamp's *Nude Descending the Stairs* to a startled Manhattan, the San Francisco Fair in 1915 brought *les fauves* to the other coast, where Edward saw their works. Fashionable photography was still Pictorialist: but he had already become aware of another line descending from the clear beauties of the Englishman D. O. Hill in the early 1840s, just after the inception of photography, straight down through the Photo-Secession movement in New York at the turn of the century, organized in protest at the prevailing artificiality by Alfred Stieglitz. In an issue of *Camera Work,* which Stieglitz published quarterly from his provocative and avant garde gallery of international painting, sculpture, and photography, Edward might find photography by Gertrude Kasebier or Paul Strand; Matisse's sculpture; or an article by Bernard Shaw. By 1915, the sign over Edward's retouching desk read "LIAR." The big silver award cup resting on the mantel ("Daddy, who brought the can?" pipes a childish treble in the family annals) slowly transformed itself from prized trophy to the contemptuous practicality of container for shoe polish. As a final gesture, before taking off for Mexico in 1923, Edward threw it hard into the weedy lot next door.

It had been a crucial decade, accomplishing a double transformation. Edward had begun it as a nice young ordinary chap married in 1909 to Flora Chandler, a nice schoolteacher wife as uprightly bourgeois as himself; he was apparently intent on nothing more than raising his growing family of sons and trying for commercial success in a business he happened to enjoy. From this dun chrysalis had burst forth the bright creature in the velvet jacket and Windsor tie, to be followed in turn by the emerging artist — this time without capitals or artifice. The metamorphoses had been accomplished in part through the magic of his second love — "the first important woman in my life," he called her — careless, intense Margarethe Mather, sensitive, neurotic, devotee of mystery and the arts, the first of a long line of women, often his mistresses, to whom Edward taught photography. Another major influence was the intelligent friendship of Ramiel McGehee, a homosexual whose quiet affection, taste, and erudition Edward deeply trusted until Ramiel's death.

"One can only learn," Edward used to tell me, "what by right of understanding is already one's own." Throughout his life he retained the remarkable flexibility and openness that marked his receptivity to the restless iconoclasm of that decade, to the new aesthetics everywhere in the air. Flora, from roughly the same background as himself, must have been exposed to many of the same friends and influences during that formative period. But I knew her in her old age, when her sons had, by their own labor, built her a cottage in Carmel; and she remained the same person Edward had married: excitable, generous, energetic, and pedestrian. He grew up out of sight; she remained tragically, implacably herself, with a narrow view of life and no understanding of the arts. Though she continued indomitable and staunch, raised the boys and helped

144

Edward pay the bills (he usually managed by rotation to keep at least one of his sons with him wherever he went), the rift which opened between them a handful of years after their marriage was never closed, and eventually Chandler, Brett, Cole, and Neil, grown up, moved one by one into Edward's vital orbit, dutiful to their mother, but not attached.

Edward went to Mexico much as Gauguin went to the South Seas: his old work was intolerable to him, his new work went unappreciated; and he felt with other expatriates of his day—Gertrude Stein, Eliot, Pound, Hemingway—the need to flee what seemed to them the crass commercialism and provincial mediocrity of America. The atmosphere had become to Edward stifling: "A musician cannot play forever to an empty house." Europe was too far from his boys; but Mexico City hailed an exhibit of his photographs with exuberance; the beautiful Tina, with whom he had fallen deeply in love, was returning there to nurse her dying husband: they would go together.

At this point, the Daybooks as they remain today take up the story. (In the twenties he destroyed his previous writing in disgust at his own posings, and to protect from his increasingly public destiny persons about whom he had commented with private abandon.) No need to repeat here the vivid life among Mexico's artistic and intellectual elite, whose members welcomed Edward and his photographs with bravos and fell in love with Tina. Their perceptive understanding buoyed and aided him. Nevertheless he was struggling to find his way in a young medium, and the only photographers in sympathy with his emerging aims—Easterners like Paul Strand, Charles

Sheeler, Stieglitz—were a continent away. He was thirty-seven years old. Counting his apprenticeship, he had already spent something like fifteen years as a professional photographer. He had given up success and was starting over, essentially alone.

He had spent twelve years in his Glendale studio. Now for another decade he roved from whitewashed rooms in Mexico to studios up and down the California coast in San Francisco, Carmel, Glendale, Santa Monica, and the final studio I knew so well in Carmel Highlands. In all but the last he spent tedious hours waiting for business, afraid to leave, sometimes, for fear of missing a customer; and often putting in grueling hours "retouching"—carefully and minutely reworking portrait negatives by hand with a fine, sharp pencil, eradicating freckles, wrinkles, and jowl lines—an activity he felt with distaste was the eradication of character, of life itself, from the faces passing beneath his skillful hands. Sometimes he "worked all day till my eyes were a blur and my nerves raw." But he always found or made interstices in which to follow the tug of those eyes rather than his pocketbook, asking a friend to sit for a portrait, issuing forth on a photographic junket, or photographing in the studio "for himself." If a truck rumbled by outside, as sometimes happened, causing an imperceptible but ruinous tremor that spoiled hours of work during a studio session of close-ups of vegetables or fruit, he knew the perishables might wilt before he could spare time to return to them; "and there is yet another danger, which concerns the afternoon appetites of small boys," he wrote about an incident with disappearing bananas. "Fortunate they can be eaten," he added a few days later. "I could not afford to buy them for Art's sake."

Since he lived as well as worked in them, the studios were also witness to a good deal of bohemian bonhomie and not a little amorous dalliance. Always friends came, and wealthy or sympathetic patrons; they happened in unannounced or arrived for appointed visits, talks, soirees, and feasts. "Gjura brought a loaf of his famous bread, but it was too salty: all his arts are failing." In Mexico, Tina read poetry movingly aloud to friends; Diego praised it, Edward caught on film the moment when the real tear rolled down her cheek. In San Francisco some years later (by which time he and Tina had parted) there was dancing until daylight at a costume party, Edward in borrowed woman's clothes. In the Highlands in the thirties, they sat up late and cosily around the fire, talking literature, art, politics, and devising bawdy limericks.

Yet all this ardent living represented the mere tittle-tattle of his life, whose surface excitements were forever superimposed over the passionate seeking in photography. Edward was one of those fortunates, the single-pointed person who like Mozart is born with his music in him. From the first prosaic photograph of chickens on a boyhood vacation farm ("I think I can work it all right," he wrote thanks for the camera to his father with unforeseeable irony) he never ceased to photograph; it is unlikely he thought of photography as art. But starting at some unknown moment in that crucial decade before 1920 a single thrust cleaves through his life: the total impulse of the artist, overriding loves, jealousies and heartaches, marriage, problems and fulfillments, fatherhood and livelihood. "For what end is the camera best used?" he questioned himself repeatedly, striving to forge an honest answer. By an uneven movement of forward jumps and retrogressions, year by year the answers and the growth arrived, paradoxically, through a process of stripping away, one by one, aesthetic and even personal affectations. How could the questioning students of my day have known that Edward had been through all that—enlargement, vignetting, unusual formats, tricky camera angles—long before some of them were born, and had outgrown it? (*Ruth St. Denis* was, I believe, a 16 × 20 print.) Having dispensed with what he called the stylistic "fogs and light effects" of Pictorialism, he had a brief "cubist" period circa 1920, emphasizing cubes and cones of light and shadow, sophisticated placements, clever and artificial framings: a woman's profile beneath a huge triangle, her head cut off below the nose; Ramiel seen small beneath the great angular spaces in his attic; the abstract geometrics created by his camera pointed up a stairwell. But by 1924, these artifices, too, were cut away: "I see in my recent negatives . . . pleasant and beautiful abstractions, intellectual juggleries which presented no profound problem. I feel definite in my belief that the approach to photography—and its most difficult approach—is through realism."

His revulsion from the romantic was so profound that at first Mexico was "too beautiful" to photograph. Soon, however, he was vigorously attacking its distinctive city and country landscapes, and atoning for the hazy portraits of the past with a powerful series of heads seen big against the sky: Nahui Olín glaring green-eyed and defiant as a tigress; Rose Covarrubias demurely smiling, sunlight caught in the shy lashes of her downcast eyes. Some years later Edward photographed the dancer Kreutzberg with his shaven head flung up; and when, in a

Figure 21.

Figure 22.

Figure 23.

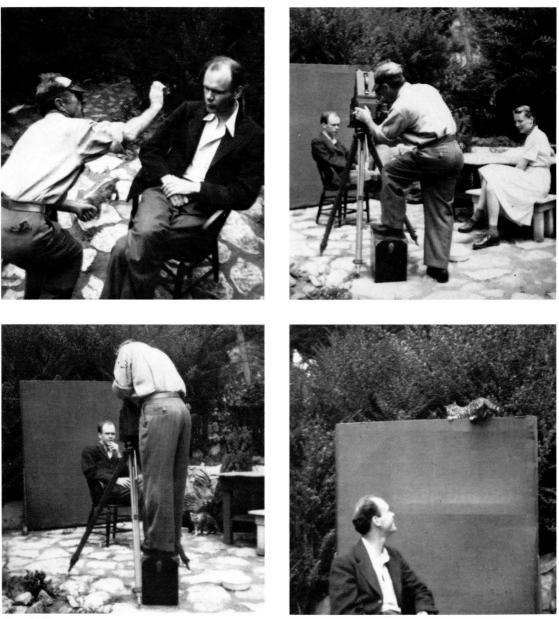

Figures 24-27.

Figures 28-29.

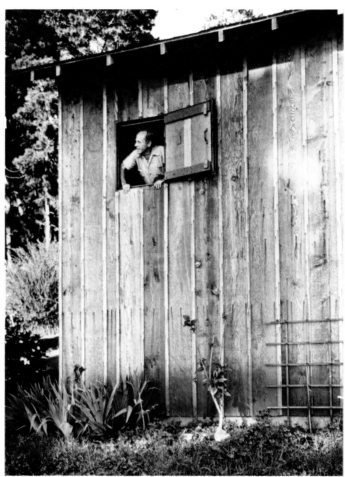

Figure 30.

Figure 31.

Figure 32.

Figures 33-34.

Edward Weston, *Beaumont Newhall,* 1940

Edward Weston, *Nancy Newhall,* 1944

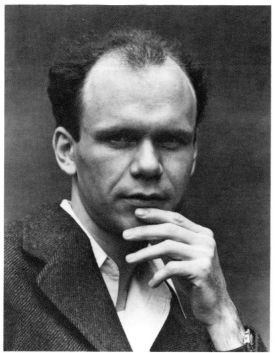

Figure 35.

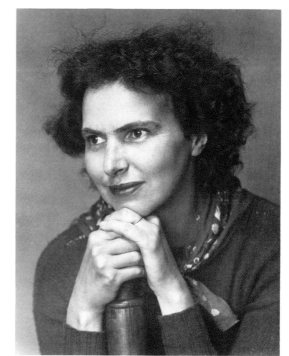

Figure 36.

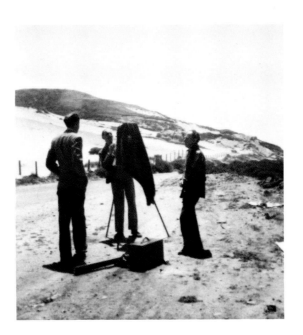

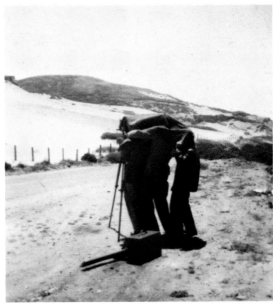

Figures 37-38.

Figure 39.

Figure 40.

Figure 41.

Figure 42.

Figure 43.

Figure 44.

paroxysm of admiration for the dancer, Edward's daughter-in-law Elinore shaved off her own lush mop, Edward caught her extremely independent strength by photographing her in the same manner. He had finally ceased striving for effect, which in the past had meant the photographer's effect: the projection of his own personality upon the subject; now he could put himself aside, so empathetic to his sitter that he caught the spontaneous moment when character stood revealed.

This openness to people was equalled by his openness to things, by which he looked at objects freshly, saw in new categories, revealing "what no one has seen." In 1930, who else considered a cabbage leaf or a green pepper from the kitchen (figure 16)? An egg slicer? Two summer squash, hung floating in his photograph like soft stars in some gentle night? Or an "excusado," as the Spanish so adroitly named the toilet bowl Edward photographed in Mexico, to the horror of his maid, who (so Edward used to tell it) attempted to mitigate this madness by adding next day a great bunch of flowers for the señor to find. Edward was amused and exasperated by her naivete: but she was righter than she knew. Having no interest in its daily connotations, he had in truth magnified it into what might have been a great swelling porcelain vase. He had abstracted it from normal definition. It was transmogrified by his incredibly diverse and potent use of form. "When I can feel a Bach fugue in my work, I know I have arrived," he wrote; and during forty years produced mutations of composition impossible in their variety to classify.

But form for form's sake would have been empty. He agreed with the then current

dictum emanating from the Bauhaus that form followed function: with his own proviso that photography required a special almost mystical receptivity, a "flame of recognition." A rock, a tree, a face: one watched to catch the essence. "The Thing Itself," he called it, and like Shaw's Professor Higgins he treated them all alike. It was here that he diverged, finally, from all those other contemporary photographers whose aesthetics were ultimately subjective; not only from surrealists, but from neorealists like Steiglitz (who referred to one of his most famous series of photographs of clouds as poetic "equivalents" to an inner state). Those photographers looked into themselves for truth; he looked into his subject for it, with an attempt to sweep the Self away. Increasingly, he valued the qualities of objectivity and givingness, in his life as in his art: "The artist is not a petty individual God on a throne, exploiting his heartaches and bellyaches—he is an instrument through which inarticulate mankind speaks," he wrote in 1932 in his current Daybook, in the midst of describing a discussion with some painters met at an exhibit. The talk had centered on what was to him, after more than twenty years, the tired old subject of whether or not photography could be considered art:

"I suddenly realized I did not care what photography was labeled . . . that a great gulf separated their intent and mine. . . . These painters, most painters, and the photographers who imitate them, are 'expressing themselves'. . . . I am no longer trying to 'express myself,' to impose my own personality on nature, but without prejudice, without falsification, to become identified with nature, to see or know things as they are, their very essence, so that what I

record is not an *interpretation* — my idea of what nature should be — but a *revelation* . . . an absolute, impersonal recognition [of] the significance of facts. . . ."

The whole tenor of thought calls to mind the ancient Chinese principle of "tse ran," by which a novelist was expected to be self-effacing, like a clear vessel transmitting but not coloring the life material that flowed through him. "The last vestiges of self-obsession have disappeared," wrote Edward's friend the painter and critic Jean Charlot in the same year, speaking of Edward's most recent photographs. It was, Charlot concluded with obvious feeling, "the apologue of the man who found himself by losing himself."

A moving insight; and with the realization of its accuracy it seemed I had come to a final understanding of the relationship between Edward and his work. And yet for years I had a teasing sense of having overlooked something, some obvious and important property of the photographs themselves that was at once distant and familiar, to which people responded yet which no one named. For it will not do to leave a negative impression from earlier paragraphs of a merely harsh or somber realism. Nothing could be less true. There is a positive quality in most of the photographs, and an overwhelming impression from their totality, of an affecting and harmonious beauty; and it was this quality that I so often witnessed people struggle to express, or put a name to.

I was myself inhibited from further exploration by a disdain for critical analysis, as being an unnecessary verbalization of what had after all been marvelously stated as pic-

ture; and for years blinded, I now think, by the fight against romanticism (though Edward never called it that) with all its drive toward realism; for he himself, as well as his peers, saw the struggle as being chiefly for the restoration of honesty in photography, as an antidote, like so many movements of the day, to Victorian prudery, sentimentality, and cant. I was too familiar with every skirmish in that long battle to have perspective; I knew too well how, running against popular taste, he gave up buff and other tinted paper stocks for the unobtrusive purity of a white base; gave up the traditional matte papers for the invisible clarity of glossy surfaces; was persuaded (the non-joiner) to spearhead in 1932 the Group *f*/64, a movement of (mostly) young turks who by 1930 began to form a fighting phalanx around him on the West Coast, their title referring to a lens setting that yielded optimum sharp focus. Once his landscapes were called "theatrical" by an Eastern critic. He replied they might be more justly termed "dramatic," that Easterners were unaccustomed to the space and scale and power of the West. His vision of familiar objects having transformed them into abstract sculpture, he was accused of copying Brancusi. He denied it. They were both deriving forms from nature: "All basic forms are so closely related as to be virtually equivalent. . . . I have had a back (before close inspection) taken for a pear, knees for shell forms, a squash for almost everything imaginable."

When he sent back to his Mexican circle of friends some of the first in the shells and vegetables series (figures 14, 16) they raved — and read Freud in seashells; found the images sensual, phallic, symbolic. Rivera thought the pictures marvelous but

asked, "Is Weston sick?" As usual Edward gathered his thoughts indignantly in the Daybook: "If there is symbolism in my work, it can only be in a very broad consideration of life, the seeing of parts, fragments, as universal symbols. . . ."

And in truth today, with the shock value of unexpected subject matter passed, we see in these halved artichokes and whole peppers only a heightened actuality.

These incidents, however, merely rippled the steadily widening waters of national and international acceptance. By 1934, Edward had at last dared, in the midst of the Great Depression, to hang out the sign "Unretouched Portraits," ending the long dichotomy. He was no longer alone; his group included his young sons growing up to join him, Brett in particular turning into a brilliant photographer in his own right (figure 40); and in the same year Edward met Charis, lovely, forthright, highly literate, the woman finally whom he could love and settle down with in Carmel Highlands for the culminating fourteen years of work, at the apex of his career and at the top of his form.

Edward always credited the arts — and particularly music — and especially Bach — as greater influences than photography; and now, as always, his friends and admirers included many thoughtful and gifted persons in the world of art and letters: José Clemente Orozco personally took charge of hanging the first one-man Weston show in New York; Merle Armitage published the first Weston book; Lincoln Steffens took a packet of Weston photographs under his arm to show in Paris; Walter Arensberg steadily added Westons to his wide-ranging private art collection, where he felt the photographs equal to hang among his Picassos and Cézannes. And running through every admiration was this thread of thought: that the Weston vision was original, unique, unlike anything being done anywhere in any medium. Everyone saw that vision as breaking ground for the future; I see it now as expressing one of the great principles of the past. For what was perhaps self-evident to others (though I have never heard it, and least of all from Edward himself) at last became evident to *me*: that "realism" was a side issue; that the true antithesis to "romantic" was, obviously, "classic."

The architectonic nature of the work is of course striking, and, although unlike the Greek in their asymmetry, the photographs convey by their visual dynamics a similar sense of final rightness. But I do not mean classic in this narrow sense, for Edward's mature work never fell into the sterile formalism that often brands the classicist, and frequently constitutes our definition. I see man and work rather as expressing that characteristic temper, that constellation of attributes we ascribe to the literature and art of only one time and place — the fifth century B.C. in Athens. The list of Weston qualities reads like a text on that "Greek way:" not only the Weston emphasis on form, but the supreme objectivity; the love of the concrete; the lack of symbolism; the hunger for a sort of Apollonian clarity, with the world seen in a lucid, unexaggerated light (reminiscent of the Greek axiom "nothing in excess"); the clear-eyed, unembellished approach to truth (for which Greek art has been called "plain art"); the love of the real world, but seeing in its actuality a heightened, almost mystic, beauty.

Like the Greek, the Weston art was realism, true enough. The essential reality of his subject matter is recognizable in his most "abstract" images. Yes, all those Weston dunes and duffs and desert mountains, kelp, smokestacks, and summer squash (figures 10, 22), are real—but not *only* real. "This then," he said, "to photograph a rock, have it look like a rock, but be more than a rock." And so the photographs, like those dreaming *kouroi* of ancient Greece—statues so clearly human, yet more than the individual youth or maid whose form they took—seem poised in a timeless equilibrium between the specific and the generic. Their kinship is with that balanced, serene, and somehow pure spirit of the aspirations of the Golden Age. They are classic in the truest sense.

It may be thought needless to put a name to the character of Edward's accomplishment; it is just their glory that great works are not bounded, nor explicable; and the photographs stand, as objects of art, complete in themselves, requiring no outside reference. Yet it seems inevitable that there will be more of the so far scant critical analysis of photographs in terms that will fit them into the great art continuum as well as the narrower history of photography or technics. And Edward's work demands this in particular, since it continues to live, and to stand, as so many of his contemporaries felt it to do, with the first works of his time.

The remarkable thing is that a spirit should have been distilled so very rare for our century, which has never been conducive to the classic outlook. That it was such a spirit, so maverick to our times, explains however why his creations were "unlike anything being done," and clarifies a few minor myster-

ies as well, such as why Edward outgrew his original "idol-worship of Stieglitz" (Edward's phrase for it), and why some persons of sensitivity (especially documentary photographers, usually unfamiliar with his thousands of portraits) have felt his work not timely enough, and lacking sufficient interest in people. He was working in another mode: it seems an inner-directed Edward Weston could do no else; and his life and his art converged ultimately into an inseparable unity, so that one felt the same serenity and power in Edward as in his photographs. This, then, was the true reason he needed no "scintillating personality." He was, finally, a whole man, with the consequent rare and compelling ability both to live as he believed (for most of us certainly believe one way and live another), and to be creative in ways expressing his essential being. In our fractured times, such integrity was healing. If my admittedly partisan report seems too based on loving memory, let me say that I have seen business men with no interest in the arts wordlessly commune with Edward, making a yearly pilgrimage to refresh the springs of their own being, and similar responses from persons of every sort. Not long ago I asked an old friend of his, who with her husband had known him from the 1920s what she remembered most: "He was so full of love—for people, for things, for life!" Another time, in a crowded room noisy with talk of cocktail matters, I asked a worldly journalist about his memories of Edward. His face lit up, its whole aspect changed. "He was one of the greatest men I ever knew!" Why? What did he especially recall? "The integrity of the man," he shot back, and described how merely knowing Edward had altered the course of his life by an example which gave him courage to

change his manner of livelihood. His memories, it seemed, were indelible. He had encountered Edward exactly twice, some fifteen years before our conversation.

Wholeness. Integrity. These were the lodestones. One felt them in the man, saw them in the work. For most people integrity is a word, or at best something to be dragged out and used, if necessary, in a crisis. For

Edward Weston, and for those who remember him, it was a life lived. Edward died quietly in his chair on New Year's Day in 1958. His sons saw to it there was as little fuss as the law allowed, and gave back his ashes on Point Lobos to the winds and sea.

Malahat Review (University of Victoria, British Columbia, No. 14, April 1970): 39-80.

Beyond Peppers and Cabbages

A. D. Coleman

THREE YEARS AFTER he wrote this article, A. D. Coleman placed Weston's work in another perspective:

"Yet, though, his body of work is, for me, more resonant by far than those of Strand or Adams, it is my belief that he will eventually be seen as an awesome, monumental boulder in the path of the evolution of photography in the twentieth century. For the theory which accompanied his work is both a summation and a source of the central misunderstanding of photographic communication: the confusion between the being, object, or event in front of the lens and the image which is made thereof."[1]

—A. C.

WITH PHOTOGRAPHERS, as with other artists in our culture, we have a decided tendency to anthologize. Within a few years after a photographer's demise (and sometimes even during his lifetime), a mysterious process seems to take control of his/her total body of work, divesting it of all but the very skeleton of development and continuity, stripping it down to a handful of images. The end product of this process is, inevitably, a "Greatest Hits of —" collection with which we beat ourselves unmercifully over the head (or, rather, around the eyes) in exhibit after exhibit until finally we simply stop seeing them. Then, after a brief period of blind homage paid to such icons, we may finally write them off for lack of staying power.

This is, of course roughly equivalent to banging our heads against walls because it feels so good when we stop. The motives behind such a compulsion toward cultural masochism are not entirely clear to me, but the syndrome is nevertheless obvious. In certain instances—as when dealing with photographers whose output was highly limited, or whose major work was done during a very brief period—it actually gives a semblance of making sense (which makes the habit that much harder to break), but its awkwardness and insufficiency are most apparent when it is applied to the *oeuvre* of any photographer with a long creative line and a consistent output.

Two who have suffered in this way are Eugene Atget and Edward Weston. In terms of homage paid, the posthumous cups of both overflow; yet how many members of the audience—excepting those few with access to their respective archives—have seen more than the five or six dozen "standards" which we assume define the photographer but may in fact only define the sensibilities of the exhibitors who chose them.

The necessity of breaking our mental set in relation to certain photographers is what makes shows such as the Witkin Gallery's first presentation in its new quarters at 243 East 60th Street— "Edward Weston: Nudes, and Vegetables"—so vital. For though it reiterates a number of Weston classics, it does so within a context which includes a large number of unfamiliar images, a context which makes one rethink his attitudes toward Weston.

Not all these images are neglected masterpieces by any means, but the revelation that Weston put his stamp of approval on work of lesser significance such as *Nude and Oven,*

1941—is revealing in itself. However, there are a number of truly exciting finds among the unknowns in this show, each of which affords insights. The four small compact, dynamic nudes grouped together on the west wall, for example, are not only a concise restatement of Weston's approach to the human body as form but also an indication of his ability to abstract without depersonalizing, despite the headlessness of almost all his models.

His nude on a bed of palm fronds with a gas mask remains an unsuccessful if not entirely uninteresting gag, but Weston's sense of humor appears in a much clearer light when this image is contrasted to his charming self-advertisement and the jocular ominousness of a trench-coated nude (which has a direct, electric eroticism I would not have expected from Weston).

The selection of vegetable images in the show also takes us well beyond the normal boundaries of peppers (figure 16) and cabbage leaves, to squash and eggplants and cantaloupes and watermelons, in all of which we can see Weston searching out fantastic forms in unaccustomed ways. The watermelon, for example. There is not much you can do with a watermelon; its lines are less than fluid and rarely unique. Weston perched his atop a basket of some sort horizontally, where it sits incongruously in its placid bulk, looking for all the world like a refugee from Uelsmann's negative file.

The show is accompanied by a portfolio of prints from Weston's negatives made by his son Cole and published in a numbered edition of fifty copies by Witkin-Berley, Ltd., an offshoot of the gallery. Priced at $600 through December of this year ($750 there-

after), the portfolio contains nine black and white prints, mostly classics, and a dye-transfer print of *The Blue Dune,* one of Weston's few color images. Though it takes time to get used to, the latter is a beautiful object, though that very beauty—given the astringency of Weston's vision in black-and-white—makes it seem somewhat decorative. Despite that, though, I'd love to see a book of Weston's forty-odd color photographs (made during the middle 1940s); it seems silly to hide them away, which in effect is what had been done with them, and such a volume strikes me as natural for the Sierra Club.

The Witkin's expanded quarters make possible two concurrent shows. Along with the Weston images (prints of which are uniformly priced at $75), there is a group of Lee Friedlander's prints. . . .

For those whose wallets are not full enough to buy one of the Weston portfolios Grossman Publishers has, coincidentally, just reprinted an expanded and revised edition of "Edward Weston: Photographer," the *Aperture* monograph edited by Nancy Newhall and first issued in 1965.

This is a particularly valuable reissue, since there is only one other Weston book in print at present (*My Camera on Point Lobos*) not counting Volume II of his *Daybooks.* The new edition features a slightly larger format which permits a small but welcome enlargement of the reproduction size; sixteen additional images, among them such marvels as *Wrecked Car, Crescent Beach,* and *Dunes, Oceano, 1934;* some added quotes from the Daybooks; a portrait of Weston by Beaumont Newhall; the replacement of two images in the first edition—*Nude on Dunes,*

1939, and the portrait of Tina Modotti—with variations thereon; and a reproduction quality which improves upon what was already excellent.

The only loss in the new edition, in fact, is the disappearance of one of my favorite Weston images, *Sandstone Erosion, Point Lobos, 1945,* by whose light John Szarkowski's description of Weston (on the jacket blurb) as "a discoverer of seminal form" can be read quite literally. And the only flaw is the carelessness with which the "Brief Bibliography and Guide" has been updated. (According to it, Robinson Jeffers is still alive, *My Camera on Point Lobos* has not been reprinted, and the two documentaries on Weston prepared by KQED—shown on the West Coast years ago, and here over the summer—have never been broadcast.)

These, however, are minor failings. Especially in its new version, this is a superb monograph on one of the central figures in twentieth-century photography, a book that should never be out of print. I welcome it back and commend it to you, particularly if you don't own a copy of the first edition. The price is $5.95 in paperback, $10 hardbound.

New York Times (12 September 1971).

1. A. D. Coleman, "Art Critics: Our Weakest Link," in his *Light Readings: A Photography Critic's Writings 1968-1978* (New York: Oxford University Press, 1979): 190.

Edward Weston's Privy and the Mexican Revolution

Hilton Kramer

As HILTON KRAMER POINTS OUT, Weston's work in Mexico from 1923 through 1926 upsets the notion that the role of art in a revolutionary situation is to support the cause or, as Kramer states: "Art is expected to subordinate its interests to immediate political goals." Obviously the most facile way to create "revolutionary art" is by portraying symbols, in this case submachine guns, hammers and sickles, serapes and sombreros.

In Mexico, Weston's style changed radically; however, he avoided symbols that could be considered political or provocative—to the extent of not photographing people who could be construed as representative of the revolutionary masses (although his picture of his friend Senator Hernández Galván was used on a political poster). What he did do was revolutionary in the most idealistic and humanistic sense: he established a harmonious relationship with his subject matter so that, unlike a classic pictorialist, he did not exploit it; and unlike a documentary photographer, it did not exploit him. His work was almost never an object or a substitute for an object but clearly a photograph of one. What he most admired and respected about Mexico was the creativity of the people which he recorded by composing still lifes of things they had made, globular pots from Oaxaca or gourds painted like fish, and he happily elaborated upon this theme. Like the toilet, he portrayed the commonest of objects in such a manner that they contained that indefinable aesthetic he called "the plus."

—A. C.

THE RELATION IN WHICH artistic ideas stand to the pressures of revolutionary politics is too often assumed—almost always for political rather than artistic reasons—to be a simple one. Despite a mountain of evidence to the contrary, the belief persists that art, if it is sufficiently "advanced" aesthetically, will naturally ally itself with the ideology of revolution. What this usually means in practice is that art is expected to subordinate its interests—assuming that art has genuine interests of its own, which the ideologues of revolution are not in the habit of admitting—to immediate political goals. It all comes down to the notion that art will somehow provide a service, a store of aesthetic hygiene, helping to cure the social and cultural diseases that linger in the aftermath of every revolutionary situation.

This is, to say the least, a naive belief. It is naive, above all, about the way the artistic impulse—especially the modernist impulse—responds to experience. It is mistaken, when it is not openly cynical, in its easy assumption that the artistic imagination has no more serious function than to deliver a message. The actualities of art are otherwise, however. They are often characterized by the kind of paradox that drives revolutionary ideologues to despair—which is to say, to censorship and repression.

Take the case of Edward Weston. In 1923, at the age of thirty-seven, Weston went to Mexico. He was already a photographer of considerable distinction. He had begun his career by producing delicate, soft-focus portraits in the established romantic mode, and had then turned his attention to the urban

scene. What interested him in the latter, however, was not its human pathos but the abstract beauty of its newly created forms. It was in the care he lavished on pictures of factories, machinery, and smokestacks that he began to develop the extraordinary clarity and precision for which his photographic style has ever since been celebrated (figure 10).

In Mexico, Weston was accompanied by Tina Modotti, a remarkable woman who was something of a personality in the left-wing parties of Mexico, Cuba, and Spain. (Tina Modotti developed into a first-rate photographer herself. Her uncommonly dramatic life cries out for a biography, and an exhibition of her work is surely overdue.) The household and studio that Weston and Modotti established in Mexico very quickly became an important part of the cultural life that was beginning to dominate Mexico in the wake of the revolution. Diego Rivera, who functioned as something of a cultural commissar as well as his own chief client in this period, was a close friend and supporter. Siqueiros and Orozco, too, hailed Weston as a master, and he seemed for a while to belong—mainly on the basis of his vivid interest in the folk art and archaeological objects which were then beginning to be upheld as symbols of an indigenous aesthetic tradition—to that "renaissance" in Mexican art in which political and aesthetic interests appeared to be united.

Weston's experience in Mexico was relatively brief—by 1926 he had permanently returned to California—but it was nonetheless profound. It was in Mexico that he fully matured as an artist—in my view, one of the greatest American artists of the century. But the very nature of his artistic development during this period confounds all the conventional assumptions about the relation of art to life, especially political life. Weston clearly responded to the ethos of the Mexican revolution with enormous enthusiasm, yet the effect of his Mexican experience was to deepen the purely formal aesthetic interest he brought to his photographic work. The truth is, he had no real political interest at all. The atmosphere and momentum of revolution served, in his case, to abet a very personal vision that located itself, ideologically, at a very great distance from the characteristic obsessions of the Mexican "renaissance." In the face of revolution, Weston becomes the complete aesthete.

In the exhibition of thirty-five Weston photographs which Phyllis D. Massar has now organized at the Metropolitan Museum of Art (through June 7), there is one—a famous one—that dramatically illuminates the paradox I am speaking of. It is the great platinum print of 1925 called *Excusado*—one of the series Weston devoted to the white toilet bowl in his house in Mexico. This picture is neither an anti-art statement in the dada manner nor a documentary effort of the social realist type. It is an essay in pure form, and it was as such that Weston saw it. He was fully conscious of what he set out to achieve in photographing so unorthodox a subject.

Indeed, Weston himself did not hesitate to compare this "portrait of our privy," as he called it in his *Daybooks,* to the Victory of Samothrace. Here are the passages from his journal in which he speaks of this project:

"I have been photographing our toilet, that glossy enameled receptacle of extraordinary beauty. It might be suspicioned that I am

in a cynical mood to approach such subject matter when I might be doing beautiful women or 'God's out-of-doors'—or even considered that my mind holds lecherous images arising from restraint of appetite.

"But no! My excitement was absolute aesthetic response to form. For long I have considered photographing this useful and elegant accessory to modern hygienic life, but not until I actually contemplated its image on my ground glass did I realize the possibility before me. I was thrilled!—Here was every sensuous curve of the 'human figure divine' but minus imperfections.

"Never did the Greeks reach a more significant consummation of their culture, and it somehow reminded me, [in its] forward movement of finely progressing contours, of the Victory of Samothrace."

We may still smile at the attitude expressed in this passage—Weston's own household thought him quite crazy ("Brett offering to sit upon it during exposure, Mercedes suggesting red roses in the bowl," etc.) but we would be mistaken if we allowed this smile to divert us from an understanding of what Weston's effort here signifies. For this picture marks one of those turning points in the history of a medium—and all the more so in this case because the medium was

one, and remains one, in which "the subject" counts for so much. In exalting so humble and so unexpected a subject, Weston was asserting the primacy of the medium over the materials it recorded, and yet doing so without denying or denigrating the necessity for a "subject." He was, in short, doing for photography what his peers among the painters—though not in Mexico!—had already done for painting.

The other pictures in the Met show speak for the great variety of subjects that continued to interest Weston. The show ranges in date from 1921 to 1944, and virtually every one of his characteristic motifs is represented. But *Excusado*—together with the comments he made on it—has lost nothing of its special aesthetic and historical significance. Weston was an artist in love with the perfection of form. In the passage I have quoted, his reference to the lack of "imperfections" in the object under scrutiny sums up the very essence of his vision and the nature of his artistic ambitions. It is not the sort of vision we have been led to expect from the ferment of revolution, but there it is—an object-lesson in the illusions that a "committed" view of art has all too often generated in the endless discussion of culture and revolution.

New York Times (7 May 1972).

Edward Weston's Later Work

John Szarkowski

In 1975, the Museum of Modern Art, New York, presented its second retrospective exhibition of photographs by Edward Weston. It was selected and installed by Willard Van Dyke, a long time friend of Weston's (figures 20, 21).

John Szarkowski, the museum's Director of Photography, briefly analyzes stylistically the work that Edward Weston did during the tenure of his Guggenheim Fellowships in 1937 and 1938. These grants gave him, to a degree, freedom from major economic concerns and allowed him to express himself to the utmost and to produce a body of work amazing in quantity and quality.

— B. N. and A. C.

IN 1937 Edward Weston was fifty-one years old, and he had not yet known a year that he could devote to the pursuit of his personal goals in photography. Although much of his best and most influential work was behind him, this work had been done during hours borrowed from the portrait business that provided his precarious livelihood.

In that year Weston was granted the first Guggenheim Fellowship ever awarded to a photographer, and a year (later extended to two) in which he could pursue his art free of immediate financial worries. Weston defined his project as the continuation of "an epic series of photographs of the West," but in further explanation of his intention he admitted that in other circumstances his work could as well be done anywhere on the globe; the Pacific Coast was right for him because it was accessible and varied, and because he loved it. He also explained his intention to work freely, intuitively, and prolifically. After decades of work and constant self-criticism, his technique and his seeing were sure and confident; photography might now be not a heroic struggle against formlessness, but an act as simple and natural as a morning stroll.

A decade earlier it had been different for Weston. His diaries (Daybooks) of the twenties reveal—sometimes with an embarrassingly confessional fervor—the intensity, difficulty, and riskiness of his commitment. Weston's ambitions for the art of photography, and for himself as an artist, were very high, and after turning his back on the easy and popular successes of his youth he worked almost wholly alone—without the support of true colleagues, powerful patrons, understanding critics, or a visible audience. His photographs of these years are tense, muscular, nearly absolutist in the rigor of their perfect formal resolution—as though each successful picture must demonstrate beyond challenge that photography is a great art and Edward Weston a great artist.

Remarkably, the work did this. Weston's photographs redeemed the extravagant claims of Weston's ego. Most important, it would seem that the work persuaded Weston himself. By 1933, entries in the self-exhorting Daybooks have become much less frequent; in 1934 the diaries are put aside, no longer necessary, and Weston gives himself up wholly to photographing.

Weston's later work is more complex, more subtle, less obviously formal, richer (and less clear) in its allusions. The great proto-typical pictures of the twenties and early thirties were characteristically constructed of a discrete figure against a flat ground: head or cloud against the sky, pepper or shell or nude in a shallow neutral space, rock on beach (figures 13-19). From about his fiftieth year, Weston's pictures more and more often describe a space that is continuous not only in depth, but (by implication) continuous beyond the rectangle that defines the picture plane. Landscape became the most challenging of photographic problems for Weston, for in landscape there could be no simple apposition of object and background—in landscape there *was* no background, nor was there a given boundary to the subject, as there is to a pepper. Deep space and horizons enter his pictures with increasing frequency, because they made the problem of design more difficult and thus more interesting. Closed, centripetal compositions, in which the subject could be imagined to exist independently of the picture, are replaced by centrifugal ones, in which the subject is defined by the film's edge.

In Weston's work of his Guggenheim years this new spirit of ease and freedom became more and more ascendant (figure 22). For two years, Weston and his wife, Charis Wilson, wandered on the back roads of the West from one beckoning place name to another, finding the raw material that could be smelted into Weston photographs—ghost towns, road signs, scenic wonders, sunsets, and beautiful junk—and then passing happily on toward the next discovery, much like ordinary tourists. *Wrecked Car, Crescent Beach* (1939) was one of the last of the thousands of negatives that Weston made on his Fellowship travels. It is a picture that might be mistaken for a technically beautiful record shot, and one that Weston would not have made five years earlier.

Paradoxically, these more difficult and more sophisticated pictures seemed on the surface more casual, more natural, and somehow less *artistic* than the graphically more dramatic early work. The difference is surely one of attitude as well as aspect. The later pictures suggest a shift in the relationship between Weston and his subjects: though the subject is still under perfect control, that fact is not flaunted. The photographer's authority is maintained with a looser, gentler rein. A sense of the rich and open-ended asymmetry of the world enters the works, softening their love of order.

MOMA, No. 2 (Winter 1974-75).

The Dark Life and Dazzling Art of Edward Weston

Janet Malcolm

THE SPONTANEITY and literal mindedness of Janet Malcolm's review of Weston's 1975 retrospective exhibition at the Museum of Modern Art are refreshing and provocative. She prefers Stieglitz's "more literal rendering of 'the thing itself' than Weston's razor-sharp close-up of a halved artichoke." She writes: "Optical sharpness, after all, is more an attribute of the buzzard than of the human eye"—although the camera and the eye are not the same thing and despite the fact that Weston had spent a good portion of his career trying to define how the camera, not the eye, could be best used as an instrument of expression.

Malcolm notes: "The nudes are strikingly sexless and impersonal, transmuted into forms that follow no mere human (or sexual) function; even those showing pubic hair show it with formal rather than erotic intent (figures 18, 19)"; and she adds that the starfish-like nude of Charis lying on the dunes was "evocative of death and sleep rather than of lovemaking."

Today, in itself, it could be considered a significant contribution to the history of photography that Weston did not portray the female nude as a sexual object, an erotic stimulus, or as a hungry woman waiting to be satisfied by the photographer. Unlike many of his contemporaries, he admired the naturalness of nudity. He insisted that photographs of nudes seen from the front, that is showing pubic hair, be included in his 1946 retrospective at the Museum of Modern Art. He wrote: "If you cut out 'fronts' you will be cutting off your own nose!"[1] Although he knew that even the U.S. Post Office prohibited mailing images of nudes with visible pubic hair, he continued to argue for his case.

—A. C.

The large Edward Weston retrospective now at the Museum of Modern Art (it includes 280 prints selected by Weston's friend and one-time disciple, Willard Van Dyke), and a large complementary exhibition at the Witkin Gallery, offer a definitive corrective to the notion of Weston's career as a progression from beautiful but empty abstractions to a mature and meaningful realism inspired by the elemental wilderness of California—a notion invented by Weston himself and unthinkingly perpetuated by his followers. "I shall let no chance pass to record interesting abstractions, but I feel definite in my belief that the approach to photography is through realism—and its most difficult approach," Weston wrote in a much quoted entry in his *Daybook* of 1924. A year and a half later, somewhat to his consternation, he created a dazzling series of nude abstractions—among them the famous pear-shaped nude—and for the next two decades intermittently and fortunately continued to revert to the "not so fine use of my medium" on which his artistic reputation rests.

Like Weston, Van Dyke has built better than he appears to know (in his introduction

to the museum exhibit, he writes of how Weston "matured as an artist" at Point Lobos, having shed his former "assertiveness and self-conscious artistry"), and he has heavily weighted his selections toward the abstract works, keeping the show fairly, if not entirely, free of the "ain't nature-grand" (as the photographer once styled it) kind of photograph that Weston gravitated toward in the last part of his career. Weston's major works (most done in the 1920s and 1930s) patently are the nudes, vegetables, shells, clouds, and landscapes that have been transformed—sometimes almost beyond recognition—into pure, cold, perverse, unmistakable Weston abstractions (figures 13, 14, 16-19, 22, 23, 32).

The sight of these strange, strong compositions casts doubt on another accepted idea about Weston. This is his presumed role in the history of photography as a prime mover in the revolution that overthrew the "pictorial" approach of the Photo-Secession and established "straight" photography as the medium's legitimate code. In actuality, what Weston did (as Paul Strand and Man Ray had already begun to do) was simply to bring pictorialism up to date: to replace the Impressionist, Symbolist and Pre-Raphaelite models of the Photo-Secession with those of Cubist, Futurist, Dadaist, and Surrealist art. Straight photography—whatever it is—is hardly exemplified by peppers like clenched fists, thighs like shells, shells like vulvas, cloud formations like elongated torsos, palm trunks like industrial smoke stacks—forms that Weston saw because he had seen modern art. (Indeed, Weston's work presents one of the strongest cases there is for viewing photography as an ancillary rather than primary form—one that is tied to painting and always a few steps behind it.)

The technical innovations of straight photography that were erected into a kind of religion by its practitioners—the change from soft-focus to sharp lenses, from manipulated to unretouched prints, from warm and soft to cold and glossy printing paper—were, again, changes dictated by the appearance of modern art rather than by the claims of "reality." Optical sharpness, after all, is more an attribute of the buzzard than of the human eye; Steiglitz's blurry view of the Flatiron Building on a snowy day is surely a more literal rendering of "the thing itself" than Weston's razor-sharp close-up of a halved artichoke.

Yet another alteration in thinking that the retrospective invites concerns that relationship between Weston's work and what we know about his life—and we know quite a lot, thanks to the intimate *Daybooks* that he kept between 1922 and 1934 and to Ben Maddow's fine biography (both recently published by Aperture). The picture of Weston that emerges from these sources—of a vital and virile romantic who lived a life of physical simplicity and emotional richness in warm climates with one beautiful woman after another, who had the courage to leave his wife and children and go to Mexico with his mistress, Tina Modotti, on what Maddow calls an Odyssean "psychic journey"; who finally found the love of his life in his second wife, Charis; who enjoyed the friendship of such artists and intellectuals as Diego Rivera, Jose Orozco, Robinson Jeffers (figure 15), and Ramiel McGehee—is at curious odds with the static, indrawn, remote, and sometimes even morbid character of the photographs.

The nudes are strikingly sexless and impersonal. They are bodies (usually faceless) or parts of bodies transmuted into forms that

follow no mere human (or sexual) function; even those showing pubic hair show it with formal rather than erotic intent. A well-known photograph of Charis stretched out face-down on the sand—one of Weston's most apparently straightforward nudes—has an attenuation, a starfish-like quality of in-anition that is evocative of death and sleep rather than of lovemaking. The close-ups of radishes and bananas and urinals, the ar-rangements of rocks and kelp and dead birds, the wind-swept dunes, the desert hillocks, the roots of cypress trees, have a similar hushed deadliness, redolent of the "assorted characters of death and blight" in Robert Frost's scary poem, "Design."

Rereading the *Daybooks* and the biography under the weight of these impressions, one's sense of Weston darkens; one gets the feel-ing that he didn't enjoy himself very much. (What artist does?) He was happy at the start of a love affair ("The idea means more to me than the actuality," he confessed, and pondered, "Is love like art—something al-ways ahead, never quite attained?"); when intoxicated (or *borrachito,* as he liked to call it); when in the presence of beauty ("I re-ceived by mail from Cristal a box of lilacs, white and lavender, so exquisite that my eyes filled with tears"); when doing "my work," in contradistinction to the portrait-photography he did to earn his living. (It would be interesting to see examples of the "commercial" work and compare it to the portraits, done for art's sake, of his friends and family.) But far more frequently than happiness, the *Daybooks* express the anxiety and loneliness and eccentricity that under-lay and undermined the surface exuberance and gregariousness and conventional bo-hemianism. The entries written during the romantic trip to Mexico are pervaded with worry about money, housing, equipment: with sorrow about the deadness of his feel-ing for Tina (which Weston was to feel toward all the women he loved); and with guilt about the three children he had left behind. (In a film based on the *Daybooks* that Robert Katz made for public television in 1965, which is being shown at the mu-seum during the duration of the show, there is a painfully moving scene in which Neil, the second-youngest son, talks of how he felt during his father's desertion; the camera, focused on his face, reveals how much it still hurts.)

The *Daybooks* written on Weston's return from Mexico continue to reflect the aliena-tion from family, friends, and lovers, and from the cultural and political life of the time, that Weston felt—an alienation that seems to be one of the preconditions of pro-ducing art in this country. A small, but tell-ing detail is the repeated reference in the *Daybooks* to the vegetarian meals Weston en-joyed ("supper: *aguacates,* almonds, persim-mons, dates, and crisp fresh greens")—always accompanied by a reference to the gross steaks or greasy pork chops that other people eat and that he had narrowly escaped from as if his enjoyment of one depended on the repudiation of the other. A similar, though less explicit polarity, is set up between the lithe, ever-younger girls Weston fell in love with and the threatening "hog-fat" bourgeoise American woman, into which category his abandoned wife Flora evidently fell. (One is reminded of Hum-bert Humbert's distaste for grown-up women like Lolita's mother in comparison to nymphets.)

In 1944, Weston contracted Parkinson's disease, which took his life in 1958.

"Whatever has happened to me, I've brought upon myself," he said of the illness, prompting Maddow to astutely observe, "It is not astonishing that he attributed the fault of his (then) incurable disease to himself: for if one brings it about one can, perhaps, undo it." And yet there is another dimension to Weston's feeling about his final illness. A film made by Van Dyke in 1946 for the USIA and intended for distribution in twenty foreign countries (it is also on view at the museum during the retrospective) shows Weston in the first stages of the disease, his gait a slow shuffle, his expression frozen and mask-like—a ghostly figure not really there, impervious to the bouncy young people with 1940s clothes and 1940s smiles who posture around him, to the mindless chatter of the propagandist narration, to the dated crescendos of the background music. The film is a depressing example of the drivel we were sending abroad at that time, and a depressing look at a sick man. It can also be taken as a metaphor for the condition of the artist—who, out of step with his time and locked in a prison of his own making, escapes time's depredations—and for the achievement of Edward Weston.

New York Times (2 February 1975).

1. Edward Weston and Charis Weston to Nancy Newhall, 6 December 1944, Department of Photography, Museum of Modern Art, New York.

Weston on Photography

Nathan Lyons

NATHAN LYONS, Director of the Visual Studies Workshop in Rochester, New York, presented the following lecture at the Museum of Modern Art, New York, during the Edward Weston exhibition in 1975. It is an excellent review and an analysis of Weston's extensive writings about his personal photographic aesthetic from 1915 to 1950.

Lyons mentions that Weston told Nancy Newhall that he saw modern paintings for the first time at the San Francisco World's Fair in 1915, and asks "What modern paintings could Weston have seen?" According to his research, the art exhibition was notably conservative.

In answer to this question, Peter C. Bunnell, professor of art at Princeton University, wrote Lyons stating that further research indicates that paintings by Edvard Munch and the Italian Futurists were shown at the 1915 exposition. In reply to Bunnell, Lyons points out that Weston owned books on modern art, which may well have headed him to the new stylistic changes that mark his work in the twenties.

—B. N.

LOOKING AT TWO chronologies of Edward Weston, one has the distinct impression that 1915 marks an important event in his life. It's also the same year that Lieutenant-Captain Schwieger, commander of U-boat 20, peered through his periscope and sent torpedoes exploding into the *Lusitania*, killing 114 Americans. It was the same year that Congress passed a bill for Mother's Day. The world speed record was set at 102.6 miles per hour, Ford produced his millionth automobile, and Edward Weston is reported to have had his life changed at the 1915 San Francisco Fair where "he saw modern painting for the first time."[1] One can't help but wonder what it was that he saw. Oliver Larkin, in *Art and Life in America,* indicates that "there was of course, no room for experiment in the great Art Palace of the Panama-Pacific International Exposition two years after the Armory show." Larkin continues, "Beyond mild impressionism the exposition would not go, and she announced with pride that nothing 'radical' or 'modernistic' had been admitted to the Panama-Pacific."[2] I can find no indication that any other major exhibition took place in San Francisco in 1915. These chronological entries about the effect of the Fair upon him are confusing. Weston is still deeply involved in pictorialistic issues and writing on the subject. In *American Photography* (August 1916), he contributes an article entitled "Notes on High Key Portraiture," stating "To me there is no other way so beautiful in which to render the charm of childhood—the psychology of the little ones."[3] (How the language is to change.) The article is illustrated with a series of examples of his work exhibited at the London Salon of 1915. It would have been later, possibly between 1920 and 1922, that there is a decided shift in his work.

The commitment is sounded no more strongly than in a letter he writes, identifying the dominant influences which have effected this change, in *Principles of Pictorial*

Photography, published in 1923 by John Wallace Gillies as a supplementary text for use by the New York Institute of Photography:

"Dear Gillies:

"You ask me to write a short ms. on 'Pictorial Photography,' in other words, 'illustrative photography,' for such is my understanding of the word pictorial. Well, I cannot, for it has been years since I left the genre field, and anyhow there are so many painters well fitted to carry on this little by-product of literature. Forgive me, Gillies, for playing with words, but really, is not just 'Photography' good or bad, significant without 'Pictorial' or 'Artistic' tacked on?

"Again, you ask for 'its reasons, hopes, requirements, ends, and what a man should be and try for, to be successful.' Immediately my thoughts turn back to a series of intensely interesting and understanding articles on photography, written around Stieglitz and what he symbolizes, all published within the last year or two. So if I quote from them, and bring together a prose "Waste Land" of photographic notes, it should be more valuable than my lone and hurriedly jotted thoughts.

"Now then, for a few 'reasons,' and I quote John Tennant on the Stieglitz exhibit — 'A demonstration of what Hurter and Driffield years ago asserted to be "the most valuable distinction of photography, i.e., its capacity to truthfully represent natural objects, both as regards delineation and light and shade." A revelation of the ultimate achievement of photography, controlled by the eye and hand of genius and utterly devoid of trick, device, or subterfuge.' And further, 'in the

Stieglitz prints you have the subject itself, in its own substance or personality, as revealed by the natural play of light and shade about it, without disguise or attempt at interpretation, simply set forth with perfect technique,' and from Paul Rosenfeld in *The Dial* — 'Never, indeed, has there been such another affirmation of the majesty of the moment. No doubt, such witness to the wonder of the here, the now, was what the impressionist painters were striving to bear, but their instrument was not sufficiently swift. For such immediate response, a machine of the nature of the camera was required.' Good reason, indeed, for photography's existence.

"Its 'hopes,' Paul Strand writes in *The Broom* — 'in thus disinterestedly experimenting, the photographer has joined the ranks of all true seekers after knowledge, be it intuitive and aesthetic or conceptual and scientific. He has, moreover, in establishing his own spiritual control over a machine, the camera, revealed the destructive and wholly fictitious mass of antagonism which these two groups have built around themselves. Rejecting all Trinities and all Gods, he puts to his fellow workers this question squarely, "What is the relation between science and expression? Are they not both vital manifestations of energy whose reciprocal hostility turns the one into the destructive tool of materialism, the other into anemic fantasy, whose coming together might integrate a new religious impulse? Must not these two forms of energy converge before a living future can be born of both?" '

"What a forecast — what a hope.

"Its 'requirements' — from Sherwood Anderson in the *New Republic* — 'It has something

to do with the craftsman's love of his tools and his materials. In an age when practically all men have turned from that old male love of good work well done and have vainly hoped that beauty might be brought into the world wholesale, as Mr. Ford manufactures automobiles, there has always been here in America this one man who believed in no such nonsense, who perhaps often stood utterly alone, without fellows, fighting an old man's fight for man's old inheritance—the right to his tools—his materials, and the right to make what is sound and sweet in himself articulate through his handling of tools and materials.'

"Its 'ends'?—read Herbert J. Seligman in *The Nation*—'What is it that this despised box, fitted with lens and shutter and called the camera, has done in this man's hands? It has penetrated the fear which human beings have of themselves lest those selves be made known to others. So doing it has laid bare the raw material which life in America has not yet dared look upon and absorb. When Americans are ready to undertake inquiry about themselves, their nation, the world, as the camera has been made to inquire, there may dawn a sense of common humanity.'

"And finally 'what should a man be and try for'— Paul Rosenfeld in *The Dial*—'Stieglitz— for himself, so his works attest, has always been willing to live every moment as though it were the last of his life, the last left him to expend his precious vitality. He himself has always been willing, in order to fix the instant, the object before him, and to record all that lay between him and it, to pour out his energy with gusto and abandon'—and further, 'And in ourselves, too, confronted by these noble monuments, there surges a great yea-saying to life: "We too, before the works of this man who has included things great and small in his sympathy, who has accepted so freely his own moment, his own life, the pain as well as the beauty of the world; we, too, find the will to accept to the utmost the present, even though it be the present of a turmoiled world, a raw America, to see what there is directly in front of us, to express ourselves in terms of our own time, to live in our own careers." '

"My dear Gillies, need I say more?

EDWARD WESTON."[4]

Consider the level of criticism Weston's own work was receiving. From *The Camera*, June 1916:

"Our cover design for this month has been selected from the work of Mr. Edward H. Weston, of Tropico, California. . . . Altogether, Mr. Weston's work has the charm which an admirably painted portrait possesses, and his examples make a valuable object lesson of the application of high art principles to photography, and demonstrate the fact that technical skill and legitimate work by the camera may be intimately associated with the best art of the painter to make something beautiful, and withal, true.

"Mr. Weston will demonstrate at the National Convention at Cleveland, and every progressive photographer is sinning against his light if he fails to avail himself of this valuable opportunity of learning how such beautiful results as these are secured."[5]

The Strand article, which Weston refers to in his letter to Gillies, appeared in *The Broom* in November of 1922 at the same

time Weston had traveled east to visit Stieglitz. This would definitely confirm the fact that the article was written after Weston had met Stieglitz and was reinforced by his visit. The remaining *Daybooks* begin in effect with this visit and indicate that he left for Mexico in August of 1923. For all practical purposes, the *Daybooks* leave off with an entry made in December of 1934, with the indication that he has not made an entry for eight months. The final entry chronicles a ten-year period of time up until April 22, 1944. Beyond the *Daybooks* (and dependent upon them as a source), another major collection of his writings appears in the form of numerous articles written by him between 1914 and 1951. Together with the *Daybooks*, they provide one of the most extensive collections of writings by one photographer which are generally available for study.

In 1929, Weston contributed a foreword to the American section of the Deutsche Werkbund Exhibition, "Film und Foto," in Stuttgart, Germany. With Edward Steichen he helped to organize the American section. This article, entitled "America and Photography," together with two other articles — "Photography — Not Pictorial" (1930) and his "Statement," appearing in *Experimental Cinema* in 1931 — amplify his earlier reaction in 1923, and also reflect a decided awareness of issues that have been incorporated in his own work. [6]

In discussing influences (1931), Weston reveals the following:

"I feel that I have been more deeply moved by music, literature, sculpture, painting, than I have by photography, that is by the other workers in my own medium. This needs explaining. I am not moved to emulate — neither to compete with nor imitate these other creative expressions, but seeing, hearing, reading something fine excites me to greater effort (inspired is just the word, but how it has been abused!). Reading about Stieglitz, for instance, meant more to me than seeing his work. Kandinsky, Brancusi, Van Gogh, El Greco, have given me fresh impetus: and of late Keyserling, Spengler, Melville (catholic taste!) in literature. I never hear Bach without deep enrichment — I almost feel he has been my greatest 'influence.' It is as though in taking me to these great conceptions of other workers, the fallow soil in my depths, emotionally stirred, receptive, has been fertilized." [7]

To this I would like to add that, in a photograph by Dody of Edward Weston's desk, there is a note which is just readable, suggesting, "I do not want to lose my books — or my friends." It is signed "E. W."

In 1929, Weston's dominant concern as expressed is the ability to photograph "the thing itself" clearly and without subterfuge. In 1930 he emphasizes this by saying, "To pivot the camera slowly around watching the image change on the ground glass is a revelation; one becomes a discoverer, seeing a new world through the lens. And finally the complete idea is there and completely revealed. One must feel definitely, fully, before the exposure. My finished print is there on the ground glass, with all its values, in exact proportions. The final result in my work is fixed forever with the shutter's release. . . . [There is] no after consideration." [8]

It is also interesting to note that Weston did not use the term "previsualization," one

which is generally associated with his philosophy. The closest he seems to come is by saying, ". . . the artist must be able to visualize his final results in advance or prevision them." One does find the term utilized by Beaumont Newhall in his *History of Photography* when he states, "The most important part of Edward Weston's approach was his insistence that the photographer should previsualize the final print before making the exposure."[9] Historically, the term "previsualization" has placed too much emphasis on the question of technique rather than on perceptual and philosophical issues. It is important to explore a series of concepts that I feel Weston was sensitive to and which he continually attempted to clarify through his work as well as his writings.

As I have indicated, a dramatic shift seems to take place in Weston's working attitude between 1920 and 1922. Considering a poem published by him in 1914, entitled "The Gummist" ("With Apologies to Rudyard Kipling, Author of 'The Vampire' "),[10] in contrast to his letter to Mr. Gillies in 1923, his poetic frame of reference has shifted to a prose "waste land" of photographic notes. T. S. Eliot's *Prufrock and Other Observations* appeared in 1917, and *The Waste Land* in 1922. Could Weston have formed some personal identification with J. Alfred Prufrock?

"And would it have been worth it, after all,
Would it have been worth while,
After the sunsets and dooryards and the sprinkled
 streets,
After the novels, after the teacups, after the skirts
 that trail along the floor —
And this, and so much more? —
It is impossible to say just what I mean!

But as if a magic lantern threw the nerves in patterns
 on a screen:
Would it have been worth while
If one, setting a pillow or throwing off a shawl,
And turning toward the window, should say:
 'That is not it at all,
 That is not what I meant, at all.' "[11]

Weston was already thirty-five, married, with children, a growing reputation — he had recently been elected to the prestigious London Salon — but above all else he was questioning and restless. Weston had indicated that he was aware of Sheldon Cheney's writings, whose *Primer of Modern Art* was first published in 1924. In it Cheney suggests, "Subject-matter is somehow an inseparable part of the completed picture, and there must be a linking with life, but the heart of creative work really lies beyond subject-interest, beyond picturesqueness, sentiment, and slices of life. It also lies beyond cleverness of transcription, beyond illusions. [And here it comes.] The photographic element, the factor that makes a picture beloved for its 'perfect likeness,' is equally incidental."[12] Working within the photographic idiom, Weston would have to find some way through his work and the expression of his philosophy to counter the stigma of "photographic" as a negative or a pejorative term in relation to human expression. Weston would probably [have] been more sympathetic to Cheney's assessment of romanticism and modernism:

"Romanticism is at the far pole from modernist endeavor because it is based on a purely objective vision of a realm imagined from outward experience, much as Heaven is imagined with harps and streets of gold. The romantic artist merely takes the spectator away from life into a world of sentimental

adventure—a weak escape from living. He ordinarily deals nine-tenths in glamor, bombast, and sentimentalism.

"The art of today lies rather in the direction of a more abstract means, of stark expression, not with symbols or illusory veils or pretty excursions, but with emotional reality intensified and crystallized in formal expression."[13]

The problem for Weston, then, was whether or not photography was capable of conveying abstract ideas. In 1930, he invokes William Blake to press his argument. He quotes Blake in "Photography—Not Pictorial": "Man is led to believe a lie, when he sees with, not through the eye." Weston continues, "And the camera—the lens—can do that very thing—enable one to see through the eye, augmenting the eye, seeing more than the eye sees, exaggerating details, recording surfaces, textures that the human hand could not render with the most skill and labor. Indeed what painter would want to—his work would become niggling, petty, tight! But in a photograph this way of seeing is legitimate, logical."[14] In 1931, Weston uses an earlier statement made for an exhibition in Houston, Texas, in May of 1930 as the basis for a most developed counterargument in *Experimental Cinema* to photography's critics. It is worth communicating it intact because it does form the basis for most of his subsequent writing:

"1931—today—the tempo of life accelerated—with airplane and wireless as speed symbols—with senses quickened—minds cross-fertilized by intercommunication and teeming with fresh impulse.

"Today—photography—with capacity to meet new demands, ready to record instantaneously—shutter co-ordinating the vision of interest impulse—one's intuitive recognition of life, to record if desired, a thousand impressions in a thousand seconds, to stop a bullet's flight, or to slowly, surely, decisively expose for the very essence of the thing before the lens.

"Recording the objective, the physical facts of things, through photography, does not preclude the communication in the finished work, of the primal, subjective motive. AN ABSTRACT IDEA CAN BE CONVEYED THROUGH EXACT REPRODUCTION: photography can be used as a means.

"Authentic photography in no way imitates nor supplants paintings: but has its own approach and technical tradition. Photography must be—Photographic. Only then has it intrinsic value, only then can its unique qualities be isolated, become important. Within bounds the medium is adequate, fresh, vital: without, it is imitative and ridiculous!

"This is the approach: one must prevision and feel, BEFORE EXPOSURE, the finished print—complete in all its values, in every detail—when focusing upon the camera ground glass. Then the shutter's release fixes for all time this image, this conception, never to be changed by afterthought, by subsequent manipulation. The creative force is released coincident with the shutter's release. There is no substitute for amazement felt, significance realized, at the TIME OF EXPOSURE.

"Developing and printing become but a careful carrying on of the original conception, so that the first print from a negative should be as fine as it will yield.

"Life is a coherent whole: rocks, clouds, trees, shells, torsos, smokestacks, peppers are interrelated, inter-dependent parts of the whole. Rhythms from one become symbols of all. The creative force in man feels and records these rhythms, these forms, with the medium most suitable to him—the individual—sensing the cause, the life within, the quintessence revealed directly without the subterfuge of impressionism, beyond the range of human consciousness, apart from the psychologically tangible.

"Not the mystery of fog nor the vagueness from smoked glasses, but the greater wonder of revealment—seeing more clearly than the eyes see, so that a tree becomes more than an obvious tree.

"Not fanciful interpretation—the noting of superficial phase or transitory mood: but direct presentation of THINGS IN THEMSELVES."[15]

If Kandinsky is cited by Weston as influence, then it may be important to review Kandinsky's position briefly:

"A work of art consists of two elements, the inner and the outer. The inner is the emotion in the soul of the artist; this emotion has the capacity to evoke a similar emotion in the observer.

"Being connected with the body, the soul is affected through the medium of the senses—the felt. . . . Thus the sensed is the bridge, i.e., the physical relation between the immaterial (which is the artist's emotion) and the material, which results in the production of a work of art. And again, what is sensed is the bridge, the bridge from the material (the artist and his work) to the immaterial (the emotion in the soul of the observer)."

He continues, "The two emotions will be like and equivalent. . . ." (Here we must recognize Steiglitz's concern for equivalence and recognize that each is probably affected by Emanuel Swedenborg's "Doctrine of Correspondence.") Kandinsky again: "The inner element, i.e., emotion, must exist; otherwise the work of art is a sham. The inner element determines the form of the work of art."[16]

In the introduction ("A Contemporary Means to Creative Expression") to his first book in 1932, *The Art of Edward Weston*, Weston shifts the emphasis from the medium of expression by suggesting:

"Man is the actual medium of expression—not the tools he elects to use as a means. Results alone should be appraised; the way in which these are achieved is of importance only to the maker. . . . The present status of photography, recognized as a unique, untraditional form and valued for exactly what it is, could not have been achieved without the very qualities, once depreciated, seen as a bar to 'self expression'. . . . I make but one reservation in determining the objective of photography: that it should not be used to create a work in which it is apparent that a clearer communication might have been established in other ways. Excepting this, I have no theories which condition my work; theories follow practice, are never part of the creative process. Logic implies repetition, the dullness of stability; while life is fluid, ever changing. Understanding is not reached through vicariously acquired

information, but in living and working fully." [17]

The mimetic machine, photography, has freed painting from its mimetic constraints only to leave photography stigmatized, as a Chaplinesque hero, always feeling the total pangs of rejection. Weston's answer to the argument of mechanical camera is to suggest, in an article entitled "Photography," published in 1934, that:

"Both the limitations and the potentialities of a given medium condition the artist's approach and the presentation of his subject matter. But limitations need not interfere with full creative expression; they may, in fact, be affording a certain resistance, stimulate the artist to fuller expression. The rigid form of the sonnet has never circumscribed the poet. In the so-called limitations of its means may be discovered one of photography's most important and distinguishing features. The mechanical camera and indiscriminate lens-eye, by restricting too personal interpretation, directs the worker's course toward an impersonal revealment of the objective world. 'Self expression' is the objectification of one's deficiencies and inhibitions. In the discipline of camera-technique, the artist can become identified with the whole of life and so realize a more complete expression." [18]

One year later, in writing the introduction for Ansel Adams's book, *Making A Photograph,* Weston essentially restates this position but concludes with the following remark: "In the last analysis, man himself is seen as the actual medium of expression. Guiding the camera, as well as the painter's brush, there must be a directing intelligence—the creative force." [19]

In Weston, one finds the fusion of the Zeitgeist (the spirit of time), a living, changing, pulsating energy with the "Sei Do" of Oriental art philosophy (the felt nature of the subject, by which the discovery and expression of which the artist reveals a vision of the universe, achieved by presenting the essential character of the subject).

Somewhere one is left with the distinct impression that Weston is trying to resolve Keyserling's philosophy of relating the Western notion of doing with the Eastern notion of being.

Through his work and writings Weston is to find himself the reluctant spiritual leader of a group of photographers who identified themselves in August of 1932 as Group *f*/64. The original members included Weston, Ansel Adams, Imogen Cunningham, Willard Van Dyke, Sonya Noskowiak, Henry Swift, and John Paul Edwards. Later members added to the group were Dorothea Lange, William Simpson, and Peter Stackpole. It was immediately interpreted by the pictorialists as a militant group, but in answering this charge John Paul Edwards suggested, "It has no controversy with the photographic pictorialist. It does feel however, that the greatest aesthetic beauty, the fullest power of expression, the real worth of the medium lies in its pure form rather than its superficial modifications. . . . The modern purist movement in photography, emphasized by the work of Group *f*/64 presents nothing essentially new, but it is a definite renaissance." [20] Edwards was correct in indicating that *f*/64 "presents nothing essentially new." As early as 1858, George Shadbolt had attacked the prevailing "Fuzzy School" of photography as evil,

raising the banner of what was termed the "*f/64* man." Indications seem to suggest that Weston gradually withdrew from the group, feeling that it had become too pedantic. While it only lasted a few years, its repercussions were to continue, with Weston receiving the brunt of the attack. The argument continues, and the pages of *Camera Craft* become a raging battleground between the "Pictorialists" and the "Purists." In 1934, editor George Allen Young remarks, "This closes the present discussion as to Pure vs. Romantic photography in this department until such time as evolution or new incidents seem to warrant a renewal of the debate."[21] In 1938, Paul Louis Hexter, a spokesman for the Pictorialists, thrusts again in an article entitled "Eclectic Photography." It is a frontal attack upon what have become firmly identified as the "Purists," with Weston again appearing at the center of the controversy.

Weston begins an extensive series of articles in January of 1939 in the pages of *Camera Craft,* with his article "What Is a Purist?"—asserting that he is not speaking for the "Purist Party," but only for himself. "It is my misfortune to be called a Purist. I hope now, once and for all, to disown the title. The specifications for Purist that are so frequently put into print stink of pedantry, and above all things, I am not pedantic about photography. If by printing on a sensitized door-mat I could produce something finer than either photography or painting, I would certainly do it. It so happens that to date I have found no way to achieve that beauty which is uniquely photographic, except by using photographic methods."[22] Another point is made: "In any case I am not concerned with trying to copy nature, or trying to reproduce 'correct values.' Quite

often for emphasis or emotional impact, I allow a shadow to go black."[23] Response is positive, and it is evident that his views are being accepted. In February and March a two-part article appears, dealing with his Guggenheim Fellowship: 22,000 miles and over 1200 8 × 10 negatives are produced. In May, he discusses "Light vs. Lighting." In it he states, "The study of light is the study of the whole photographic process, with the emphasis placed on the results rather than the means. The kind of equipment used is not what matters. The important thing is that you stay, with whatever equipment you choose, until it becomes an automatic extension of your own vision, a third eye. Then, through this photographic eye you will be able to look out on a new light-world, a world for the most part uncharted and unexplored, a world that lies waiting to be discovered and revealed."[24] In June, he raises the question, "What Is Photographic Beauty?" suggesting, "If his seeing enables him to reveal his subject in such terms that the observer will experience a heightened awareness of it and so inevitably share in some measure the photographer's original experience—and if his technique is adequate to present this seeing, then he will be able to achieve photographic beauty."[25] In the September and October issues, he discusses "Thirty-Five Years of Portraiture."

In November of 1939, Roi Partridge, printmaker friend of Weston and husband of Imogen Cunningham, contributes an extensive article entitled "What Is Good Photography?" One of his major points is that art must not fail to express its period, that art must concern itself with its time, its age, its Zeitgeist or time-spirit. "Art—any form of art including photography—cannot have the

same form today, our day of speed and light, as it had a few decades ago when we lit our homes with kerosene lamps or gas, considered saving a virtue, and drove behind a horse at ten miles an hour."[26]

Weston is invited and publishes in 1941 an article on "Photographic Art" in *Encyclopedia Britannica.* It is in effect a major justification for his own working position, placed in the context of *The History of Photography.* In his concluding remarks he suggests, "Conception and execution so nearly coincide in this direct medium that an artist with unlimited vision can produce a tremendous volume of work without sacrifice of quality. But the camera demands for its successful use a trained eye, a sure, disciplined technique, keen perception, and swift creative judgment. The artist who would use his creative powers to the full must have all these, plus the first requisite for the artist in any medium—something to say."[27]

Two subsequent articles are published. In 1943, he contributes "Seeing Photographically" to *The Complete Photographer;* and "What is Photographic Beauty?" to *American Photography* in 1951.[28] Each tends to restate much of his earlier writing and with noticeably less fervor. In "Seeing Photographically," he explores the historical effect that painting has had upon photography and, in an attempt to clarify this, he states: "The conviction grew that photography was just a new kind of painting, and its exponents attempted by every means possible to make the camera produce painter-like results. This misconception was responsible for a great many horrors perpetrated in the name of art, from allegorical costume pieces to dizzying out-of-focus blurs.

"But these alone would not have sufficed to set back the photographic clock. The real harm lay in the fact that the false standard became firmly established, so that the goal of artistic endeavor became photo-painting rather than photography . . ."[29] denying thereby or confusing the exploration of photography in relation to its own potentials.

Weston was to exclaim in 1930, "To see the thing itself is essential. . . . This then: to photograph a rock, have it look like a rock, but be more than a rock. Significant presentation—not interpretation."[30] How this relates to the undercurrent in his working philosophy may best be understood by an observation made by Ch'ing Yuan, who wrote: "Before I had studied Zen for thirty years, I saw mountains as mountains and water as water. When I arrived at a more intimate knowledge, I came to the point where I saw that mountains are not mountains, and waters are not waters. But now that I have got to the very substance I am at rest. For it is just that I see mountains once again as mountains, and waters once again as waters."[31]

In his foreword to *My Camera on Point Lobos,* published in 1950, Weston cites an earlier Daybook entry from 1931 to reaffirm: "My work is always a few jumps ahead of what I say about it. I am simply a means to an end: I cannot, at the time, say why I recorded a thing in a certain way, nor why I record it at all. The artist is an instrument through which inarticulate mankind speaks: he may be a prophet who at a needed moment points the way, forming the future, or he may be born at a time when his work is a culmination, a flowering in

soil already prepared. If my work has vitality, it is because I have done my part in revealing to others the living world about them, showing to them what their own untrained eyes had missed."[32]

Finally, from his Daybook in March of 1931: "I am not a reformer, a missionary, a propagandist. I have one clear way to give, to justify myself as part of this whole — through my work. Here in Carmel I can work, and from here I send out the best of my life, focused onto a few sheets of silvered paper."[33]

Afterimage 3 (May-June 1975): 8-12.

1. Nancy Newhall, *Edward Weston* (New York: Museum of Modern Art, 1946): 6. See also Ben Maddow, *Edward Weston: Fifty Years* (Millerton, N.Y.: Aperture, 1973): 281.

2. Oliver Larkin, *Art and Life in America* (New York: Rinehart and Co., 1949): 364.

3. Edward Weston, "Notes on High Key Portraiture," *American Photography* 10 (August 1916): 407.

4. John Wallace Gillies, *Principles of Pictorial Photography* (New York: Falk Publishing Co., 1923): 28-32.

5. *The Camera* 20 (June 1916): 343-44.

6. Edward Weston, "America and Photography," foreword to the American section of Deutsche Werkbund Exhibition, "Film und Foto," Stuttgart, Germany, 1929. See also Weston, "Photography — Not Pictorial," *Camera Craft* 37 (July 1930): 313-20, and "Statement," *Experimental Cinema* 1 (1931): 14-15.

7. *Daybooks II:* 234.

8. Weston, "Photography — Not Pictorial": 318-20.

9. Beaumont Newhall, *The History of Photography* (New York: Museum of Modern Art, 1964): 124.

10. *Photo-Era* 32 (April 1914): 182.

11. T. S. Eliot, "The Love Song of J. Alfred Prufrock," *Collected Poems: 1909-1962* (New York: Harcourt Brace & World, 1963): 6-7.

12. Sheldon Cheney, *A Primer of Modern Art* (New York: Boni and Liverright, 1924): 9-10.

13. Ibid.: 49.

14. Weston, "Photography — Not Pictorial": 314.

15. Weston, "Statement": 14-15.

16. Wassily Kandinsky, *Concerning the Spiritual in Art,* The Documents of Modern Art Series (New York: Wittenborn, 1947): 23-24.

17. Weston, *The Art of Edward Weston* (New York: Armitage, 1932): 7-8.

18. Weston, *Photography* (Pasadena: Esto Publishing Co., 1934).

19. Ansel Adams, *Making a Photograph* (London, The Studio Limited/New York: The Studio Publications, 1935): ii.

20. John Paul Edwards, "Group *f*/64," *Camera Craft* 42 (March 1935): 107.

21. *Camera Craft* 41 (October 1934): 500.

22. Weston, "What Is a Purist?" *Camera Craft* 46 (January 1939): 3.

23. Ibid.: 4.

24. Weston, "Light vs. Lighting," *Camera Craft* 46 (May 1939): 197-205.

25. Weston, "What Is Photographic Beauty?" *Camera Craft* 46 (June 1939): 255.

26. Roi Partridge, "What Is Good Photography?" *Camera Craft* 46 (November 1939): 540.

27. Weston, "Photographic Art," *Encyclopedia Britannica* 17 (1941 ed.): 799.

28. Weston, "Seeing Photographically," *The Complete Photographer* 9 (January 1943): 3200-06. See also Weston, "What Is Photographic Beauty?" *American Photography* 45 (December 1951): 739-43.

29. Weston, "Seeing Photographically": 3200.

30. *Daybooks II:* 154.

31. Arthur C. Danto, "The Artworld," *Journal of Philosophy 61* (October 1964): 579.

32. Weston, "Foreword," *My Camera on Point Lobos* (Boston: Houghton Mifflin and Yosemite: Virginia Adams, 1950).

33. *Daybooks II:* 207.

Letter to the Editor:
From Peter C. Bunnell
"Weston in 1915"

With the reference to the publication in your May-June issue of the article, "Weston and Photography" by Nathan Lyons, I would like to contribute to the documentation which he provided and also illustrate a lesson in research methodology.

When I first heard Mr. Lyons's lecture at the Museum of Modern Art, and again when I read it, I was struck by the emphasis placed on the year 1915 and Weston's possible experiences at the Panama-Pacific International Exposition held that year in San Francisco. The fact that Lyons saw fit to quote only a secondary source, albeit a respected one in Oliver Larkin's *Art and Life in America,* when characterizing what was shown at the exposition, sparked my curiosity as to whether Lyons and others had all the facts with regard to what was exhibited. [1]

Lyons quotes Larkin's commentary from his 1949 edition. The quote in *Afterimage* is not fully accurate and the following is from Larkin's text:

"There was, of course, no room for experiment in the great Art Palace of the Panama-Pacific International Exposition two years after the Armory [Show]. . . . The best one could say for the art display was that certain recently dead Americans were given individual rooms — Homer and La Farge, Twachtman and Robinson — and that Duveneck among the living came into his own along with Chase, Sargent, Alden Weir, Tarbell, and Hassam. Beyond a mild impressionism San Francisco would not go, and she announced with pride that nothing 'radical' or 'modernistic' had been admitted to the Panama-Pacific." [2]

In checking the accuracy of Lyons's quote when preparing this piece I turned to my personal copy of Larkin's book which happened to be the revised and enlarged edition of 1960. There, interestingly, appears the following paragraph about the Exposition:

"There were few signs of experiment in the great Art Palace of the Panama-Pacific International Exposition two years after the Armory [Show]. . . . In the American section of the Palace of Fine Arts, certain recently dead painters were given abundant room — Homer and La Farge, Twachtman and Robinson. Duveneck came into his own along with Sargent, Chase, Alden Weir, Tarbell, Whistler, and Hassam. The Eight were well represented. Maurer and Prendergast were the most radical artists there, although the foreign rooms displayed Kokoshka *[sic]* and also the work of Balla, Boccione *[sic]* and other Futurists." [3]

This is a dramatically different characterization of the exposition than that which Larkin wrote in 1949. Without commenting further on his analysis, we must conclude that when investigating a problem such as the one regarding Weston's possible experiences we should research original or primary sources and make our *own* judgments. It is clear that between 1949 and 1960 Larkin discovered his error — probably because someone pointed out to him the facts to be found in the 1915 exhibition catalogs.

From a study of these catalogs and of other contemporary sources, facts become evident which clearly show that there was exhibited

at the Exposition what I believe could be described as "modern paintings," the phrase Nancy Newhall used in her 1946 Weston monograph and a term which presumably she obtained from him. [4] The phrase "modern paintings," or "modern art," must be used cautiously because the frame of reference today is considerably different from that of 1915. In particular, its usage must be very specific with reference to someone of Weston's background and knowledge of the arts at the time and even later. The American exhibition in San Francisco, as Larkin pointed out in 1960, included such figures as Maurer and Prendergast, as well as members of The Eight. If one turns to the European paintings, especially the French representation, bearing in mind that Larkin's perspective in writing his book was primarily American, I believe we have an even greater instance of what Weston could have viewed as modern art. The French section, like other national representations, was an official sampling roughly divided into two sections — retrospective and contemporary. Each national exhibition was reflective over-all of official or academic thinking which was equally mirrored in the current European salons. The point is, however, that each national section did contain art which to varying degrees was only steps behind what we see today to be the more avant-garde and in every case there was art of near contemporary date. For instance, the following French artists were represented: Bonnard, Boudin, Carriere, Cézanne, Degas, Denis, Fantin-Latour, Gauguin, Monet, Monticelli, Moreau, Pissarro, Puvis de Chavannes, Redon, Rodin, Signac, Sisley, Toulouse-Lautrec, Valloton, Van Gogh, and Vuillard. [5]

One part of the art exhibition which seems to have been overlooked not only by Professor Larkin in 1949 but by numerous contemporary writers in 1915, was that in an annex building which was located near the Palace of Fine Arts. This building, which contained special exhibitions called the "International Section," was arranged by J. Nilsen Laurvik, a critic who was also an official of the Department of Fine Arts. [6] The Section filled several galleries and, curiously, it was composed of many works by eastern European artists. Also represented were contemporary artists from Spain, England, Finland, France and, importantly, the Austrian expressionist, Kokoschka, who showed sixteen paintings. Of notable significance was the Norwegian exhibition, not mentioned by Larkin in either of his texts, which was composed in part, of fifty-seven canvases by Edvard Munch. [7] All of Munch's pictures hung together in a single gallery. Adjoining this gallery was a remarkable exhibition of works by the Italian Futurists — the first to be held in the United States. [8] The works were grouped under that title and included were paintings and sculpture by Balla, Boccioni, Russolo, Carra, and Severini. Boccioni contributed an essay to the catalog entitled, "The Italian Futurist Painting and Sculpture: Initiators of the Futurist Art." [9] This essay was first published in Paris in 1912 with the title, "The Exhibitors to the Public." [10] It seems to me that these three exhibitions — Kokoschka, Munch, and the Futurists — constitute a significant showing of modern art at the Panama-Pacific International Exposition.

One of the most interesting books of commentary on the fine arts section of the

Exposition is Christian Brinton's *Impressions of the Art at the Panama-Pacific Exposition.* [11] The book opens with his essay, "The Modern Spirit in Contemporary Painting," in which he discusses in considerable detail the contemporary work in France, including that by Picasso, Matisse, and Picabia. Brinton clearly reflects the most advanced American awareness of the modern scene after the Armory Show and, of course, Stieglitz's exhibitions at "291." In his detailed analysis of the galleries at the exposition, he mentions the annex building briefly, giving only passing coverage to Munch's exhibition. In his essay he includes the Futurists, though he does not point out their appearance at the exposition, and he writes that he considers them an "extended stride" from the Cubists. [12] From our perspective today, the fact that Picasso, Matisse, and others of the French avant-garde were not exhibited is what gives us some trouble in characterizing what was shown in San Francisco as modern art. This view is correct only to a degree, as I believe the facts presented here show.

My experience in assessing the influence of such fairs or international art exhibitions on photographers, for instance with the case of Clarence H. White and the Chicago Exposition of 1893, suggests that persons like White (and here I would also include Weston) had a rather limited background and knowledge of painting movements and directions. They tended to consider as modern, works which were simply contemporary, usually foreign, and which would be viewed by us today as mild in conception when compared to what else we now know was going on at the same time. Such may be the case with Weston's memory of what he saw in San Francisco, or it could also mean, especially in light of what has been presented here, that with a degree of knowledge he came to specifically refer to the work of certain French artists, to Munch, Kokoschka, or to the Futurists when he recalled his experiences of 1915. [13]

Afterimage 3 (December 1975): 16-17.

1. I am indebted to Beaumont Newhall for his observations on this question and for his suggestion that I consult Joshua C. Taylor's *Futurism* which is cited below.

2. Oliver W. Larkin, *Art and Life in America* (New York: Rinehart & Company, 1949): 364.

3. Ibid.

4. Nancy Newhall, *Edward Weston* (New York: The Museum of Modern Art, 1946): 6. The same term, "modern painting," is used in her chronology on p. 34. Ben Maddow, in his book, *Edward Weston: Fifty Years* (Millerton, N.Y.: Aperture, Inc., 1973), repeats this wording in his chronology on p. 281. However, in his text, on p. 38, Maddow writes, "It is certain that he [Weston] never saw the Armory Show, and there is considerable doubt whether he saw the San Francisco show. Certainly, he never mentions it, and Nancy Newhall, who researched this particular point, doubts that anything was shown in San Francisco except the paintings of conventional American impressionists."

5. John E. D. Trask, and J. Nilsen Laurvik, *Catalogue Deluxe of the Department of Fine Arts Panama-Pacific International Exposition* (San Francisco: Paul Elder and Company, 1915).

6. J. Nilsen Laurvik was a well-known critic in photographic circles, having written on photography as well as painting. He made color photographs with the *Lumiere Autochrome* process and he contributed frequent articles to Stieglitz's *Camera Work.*

7. Trask and Laurvik, *Catalogue Deluxe:* 278.

8. Ibid.: 273-74. Peter Selz, in his Foreword to Joshua C. Taylor, *Futurism* (New York: The Museum of Modern Art, 1961), writes that "while the Futurists decided, as a group, not to participate in the Armory Show of 1913, they arranged a comprehensive exhibition of their work in 1915 at the San Francisco Panama-Pacific International Exposition."

9. Trask and Laurvik, *Catalogue Deluxe:* 123-27.

10. Taylor, *Futurism:* 127-29. Taylor reprints this essay in English.

11. Christian Brinton, *Impressions of the Art at the Panama-Pacific Exposition* (New York: John Lane Company, 1916). The volume is also interesting as it contains reproductions of two architectural photographs by Francis Bruguiere of buildings at the Panama-California Exposition held in San Diego previous to the Panama-Pacific Exposition.

12. Ibid.: 20.

13. My concluding phrase is, of course, based on the assumption that Nancy Newhall was correct in her 1946 statement that Weston attended the San Francisco exhibition.

Reply
From Nathan Lyons

First let me indicate how pleased I was that you took the time to reply to the Weston lecture, and for your enthusiasm regarding the development of *Afterimage* in your cover letter. I also wish to acknowledge the spirit in which it was sent, that of "scholarship and cooperation." It is in this light that I have considered your remarks, and I trust that it is in this light you will now consider mine.

Let me say that in principle I do agree with your findings regarding the use of the term "modern art," although I feel that your argument needs to be explored further and placed in the context of my lecture. The first point which should be noted is that I did not intend to make a major issue of Weston's 1915 experience at what was termed by Nancy Newhall in her 1946 chronology as occurring "at the San Francisco Fair." My remarks, as brief as they were, were an attempt to place Weston and his concerns in the context and flavor of the time and reflect upon what I felt to be some confusions which have not been resolved by two leading biographers (Newhall and Maddow) regarding an im-

portant change in his life and subsequently his work. My determination about this did not come from any written accounts or a willingness to accept that it was in fact the Panama-Pacific Exhibition that he had viewed. I felt this question had to be raised to aid in understanding the development of his work in relation to his public writing. There is additional research which might support your position, and some which might indicate that the event occurred one year later, if it occurred at all.

My questioning of these citations came from reviewing and tracing his photographs (a number of which were shown during the lecture at the Museum of Modern Art). Presenting his photographs, I thought, would raise the question that if Weston actually were so moved by the experience of modern art (and not "avant-garde" or "modernistic" art, a point with which I certainly agree, even without considering Larkin's comments), then why was it that no dominant change seems to take place in his work until 1919-20, and in his writing until much later?

There are a few other matters that I think need to be explored, if one is to speculate about this possible occurrence in 1915. Regarding Larkin's comments, I acknowledge your pointing out his shift from "no room for experiment" in 1949, to "there were few signs of experiment" in 1960, but I am not sure that this gives us that much to build upon. In your fourth note, you refer to one of the major problems in relying upon Nancy Newhall or Maddow regarding this point. I think that your research helps clarify Maddow's remarks, based upon what he discusses as Nancy Newhall's research, and also the research of Larkin. But as I

stated in the lecture, I still find this point rather confusing, based upon the work Weston was exhibiting from 1916 to 1919. Studying the photographs as primary source material led me to these observations and to the conclusion that it seemed appropriate to question preceding research. I am quite confident that we cannot assume that Nancy Newhall is correct regarding this point. It is interesting to note that in subsequent chronologies (even though cited as "brief") she does not include this entry at all. When I was preparing the biographical notes for *Photographers on Photography* in 1966, she did not take exception to my citation, "Around 1920 re-examined prior work, experimented with semi-abstractions."

I am not sure what help it may be, but additional research has revealed a plausible reason for Weston to have visited the exposition—to see his own work. He exhibited photographs as part of an exhibition of Pictorial Photography in the Department of Liberal Arts. Three photographs were accepted, one of which, "Child Study in Gray," was awarded a bronze medal.[1] In addition, there is yet another possibility that the visit may have actually occurred in 1916. A Post-Exposition Exhibition was held in San Francisco from January 1 to May 1, 1916. During this period, the Futurist exhibition and the International Section were moved into the south wing of the Palace of Fine Arts, and works by Picasso, Francis Picabia, Matisse, and John Marin were added.[2]

It is with your last point, when you discuss the effect of fairs and international art exhibitions on photographers and include Weston in the same light as Clarence White, that I would register some caution. As early as 1911, in an article entitled "Artistic Interiors," Weston recommends to other photographers that they study the writings of Arthur H. Dow and Henry R. Poore.[3] There is as yet no substantial information to lead us to assume that Weston "had a rather limited background and knowledge of painting movements and directions."

I trust that you will find this research of some value, although I feel that the major question must still be regarded as unresolved.

Afterimage 3 (December 1975): 16-17.

1. Official Catalogue of Exhibitors, Panama-Pacific International Exposition, rev. ed. (San Francisco: Wahlgreen Co., 1915): 19.

2. Illustrated Catalogue of the Post-Exposition Exhibition, in the Department of Fine Arts, Panama-Pacific International Exposition (San Francisco: San Francisco Art Association, 1916).

3. E. H. Weston, "Artistic Interiors," *Photo-Era* 27 (December 1911): 300.

I should like to thank three of my students—Dan Meinwald, Ed Earle, and Kevin Osborn—for their research assistance.

Willard Van Dyke Reminisces about His Early Years with Edward Weston

Jacob Deschin

JACOB DESCHIN WAS, up to his death in 1983, not only a prolific critic, but the chronicler of the photographic scene in lively articles in newspapers and magazines. This interview took place in the Museum of Modern Art, New York, at the time of the Weston exhibition that Van Dyke directed. A long-time friend of Weston and an excellent photographer, Van Dyke is also well known as the producer of outstanding documentary films, including one on Weston.

— B. N.

WILLARD VAN DYKE was twenty-three in 1929 when he met Edward Weston, then forty-three, at a large exhibition of pictorial photography in San Francisco. He recalled the occasion during a recent walk-around with this writer at the Weston retrospective at the Museum of Modern Art in New York. Van Dyke served as guest director for the show.

"The Palace of the Legion of Honor in San Francisco had a big show of pictorial photography, and I went there with John Paul Edwards, who was a pictorialist and knew Weston. There was the usual run of pictorial stuff except for two photographs. One was the now-famous portrait of Galván poised for shooting practice, and the other was that equally famous photograph of the single shell curled upward.

"Well, they just knocked my eyes out, and I said to Edwards: 'This is different; who made them?' He said a fellow named Weston, and would I like to meet him, and I said, 'Well, I sure would!' Weston was there at the show, and Edwards took me over and introduced me. I was sort of tongue-tied; I didn't know what to say. I was just starting in photography; and when he came out to Berkeley a year later, where he gave a lecture, I asked him if he ever took pupils. He said, no, but occasionally people came and worked with him; he didn't have any time right then, but when he did he'd let me know. Much to my surprise, about eight months later, he really followed through. He wrote me, 'I've got a little time now, and would you like to come?' So I packed my sleeping bag and went down to Carmel and stayed there with him for a couple of weeks. He looked at my portfolio and very generously said of two of my prints: 'I would have been proud to make these two.' Well, that was very sweet of him; they weren't all that good. They were different from the kind of thing I'd been doing, which was soft focus, using the Karl Struss lens. I kept thinking of his Galván and shell pictures, and began to look at things a little differently than I had been previous to my encounter with Weston. At the end of the agreed-upon two weeks of study with him, I said, 'Well, how much do I owe you?' And he said he

couldn't take my money. 'Then let me commission you to do my portrait so I can give it to my family for Christmas.' So he did the portrait (figure 20)."

How much did he charge, I asked.

"Oh, I think they were three for $25, something like that. From then on we were close friends until he died in 1958. Later on we exhibited together. The *f*/64 Club was formed in my little studio, and he was part of that. I had a car, and he didn't drive; on Weston's Guggenheim trip to northwest California we used to go on trips together."

I said I thought Weston went on that trip with his wife Charis and his son Cole.

Van Dyke said, "Not on that particular trip. He had two Guggenheim Fellowships, and he had many trips on that money."

As we walked around the museum show, the comments inevitably turned to Weston's nudes. Van Dyke remembered a couple of nudes that showed pubic hair, and that the museum trustees at the time had decided that was going too far and instructed a secretary to write Weston that they would not show *public (sic)* hair, "and from then on for the rest of his life he always called it *public* hair. The secretary had simply made a typographical error. There was one nude that he took quite by accident; it was shot from the back and was just too revealing, so he didn't normally show it."

Did he have something in mind when he practically always photographed nudes with their faces turned away from the camera or otherwise not showing?

"Many of these," Van Dyke said, "were done at a time when women didn't want their faces shown. It was a hangover from the Victorian period, and in some cases these women didn't want people to know that he had photographed them this way." Also, there was one shot that looked like a woman's derriere, and that inspired one male to remark to John Szarkowski that the picture really turned him on. "A pair of *knees* turns you on?" Szarkowski said incredulously.

Weston was frequently accused of being overly sex-oriented when he photographed certain shapes, as in the case of his famous peppers and other vegetables.

When his artist friends in Mexico—Rivera and others—saw his peppers and shells as sex symbols, he said that he could not understand how people could read these interpretations into his subjects; they weren't there in his mind when he photographed, he insisted (figures 14, 16).

He used to say to Van Dyke that the same forms were all through nature; they were in the human body as well as in nature and in vegetables; he just saw the forms as beautiful. "I think he would have said that if you saw the pictures as reflecting sex, the sex was in your mind, not in the subjects."

How did he happen to hit on vegetables as subject matter?

"At the time he was doing these things he also was running a little studio," Van Dyke explained, "and he needed to be around in case clients dropped in. He didn't have many sittings but he wanted to be there in

case somebody did come by. Besides, he didn't have a car so he had to photograph what was available. He was insatiable about photographing, so the vegetables became an important thing for him around 1931."

The story goes that he used to haunt the vegetable stands in search of interesting shapes to photograph.

"Well, okay," said Van Dyke, "if he was going to buy a pepper for dinner he would look to see if he could find one that was tasty as well as photogenic, that's all! Incidentally, to provide neutral backgrounds for his peppers, he hit on the idea of using a tin funnel, placing the pepper inside, or find[ing] a gallon jug for the purpose."

There were comments and recollections as we passed from one print to the next.

Was Weston conscious of the representational aspects of some of his abstractions? No, if anyone called his attention to such a picture, he ignored the comparison. Did he ever pick up a leaf and place it somewhere else? Van Dyke didn't think Weston was beyond that, but he didn't do it too often. Did Weston know about Atget? Yes, but he felt there was a lack of interest in form for the sake of form: he saw Atget as a good photographer, a faithful chronicler of his place and time. There was a 1945 photograph showing Charis in the nude leaning against a porch post; "it was probably the last nude he did of her when she had already told him that she was leaving him." He often said that if anything reminded him of Bach he knew he had made a good photograph.

There were some photographs in the show of Johan Hagemeyer, a close friend of

Weston. They had bachelor quarters together at one point; and in one picture taken after they'd had a party the night before, there were evidences of the party lying around. Why did he photograph his son Neil so much and the others so seldom? Well, at that point, Neil was around the house a lot of the time. Here was a photograph Van Dyke had taken of Weston with an 8 × 10 camera near a tree that had become famous because Weston had photographed it so often.

"You know," Van Dyke said at one point, "those Mexican artists helped Weston a great deal because they talked art; they didn't talk about lens stops and that kind of thing, and that made a big difference to Weston — to have someone to talk with on that level."

Van Dyke mentioned that many of the pictures Weston took in 1941 for the Limited Editions Club's issue of Walt Whitman's *Leaves of Grass* have never been seen by the public (figure 32).

Why is that, I asked, and who has them now? A collector "out East somewhere" bought everything that was left. "The reason they didn't get seen more," Van Dyke said, "was that at that point the war came along, and when people came to see Weston's portfolio, they wanted to see the familiar ones; those were the pictures they bought, so he didn't drag out this vast collection of stuff he had done, and then he got sick, and the stuff just got put away. There was an awful lot of it."

Will we ever see them? Later, perhaps?

There is a "mystery man, a Mr. Lane, who has several thousand of them and may

perhaps give the prints to the museums some day," in this way to make them available to the public.

Lane "collected them because they were being sold off piecemeal, and he wanted to keep them intact." What he wanted to do eventually, he told Van Dyke, would be "to make selections and give a collection of them to a museum starting a photographic collection. There are many of his photographs here in New York, many on the West Coast. In the middle part of the United States there aren't so many, Indiana has a few. . . . I think it's a laudable thing that Lane is doing, preserving the collection.

"Lane was a manufacturer. He was also a collector of American painting, and he has some of the best Sheelers, not only Westons, and a fine collection of Georgia O'Keeffe paintings. He got priced out of the market, and so he began to look at photography."

Cole Weston said that Lane went to Carmel and "scooped up what he could find and bought them for $75 a piece," leaving Cole with practically nothing.

"Well," Van Dyke continued, "the boys sold them because they thought they could get a good price. Weston had told the boys not to sell his prints for less than $30. When Lane offered them $75 for each, they asked $100 but then accepted $75 for everything, good, bad, or indifferent; everything they wanted to sell he would buy at $75 each. It added up to a lot of money.

"Lane is not interested in selling Weston prints. He's got a lot of money to live on and doesn't need to sell. I must say he's done a marvelous job of preserving them. He built a fireproof vault that is humidity-proof and temperature-controlled, and properly protected with alarm systems, and that kind of thing. It's part of his house, where he lives with his wife.

"The stuff is catalogued, and he has somebody helping him to take care of it."

What interested Lane about the Weston collection; had he known about Weston before and been an admirer?

Here's the way it happened, according to the story Lane told Van Dyke. Lane decided one day he would like to buy some Ansel Adams prints, called him on the phone, and asked if he could buy some. Of course, come on up, Adams said.

So Lane got on a plane with his wife, and on the way out, said to her, "You know, Weston used to live in Carmel; maybe we could buy some Weston prints." So Ansel introduced him to the Weston boys. As Lane examined the prints, he found some had not been properly cared for. These may be some that had gone to a grandson Ted, the son of Chandler, another Weston son. He said he would like to see them together and that they would be preserved properly. This was one of the motivations that led to the ultimate transaction; he made the boys an offer that came to a lot of money.

So far, it's "no sale." Lane continues to hold on to everything and is not even approachable.

Popular Photography 77 (July 1975): 16, 192, 196, 200.

Review of
Edward Weston Nudes: Sixty Photographs, Remembrance by Charis Wilson

John Canaday

JOHN CANADAY, ART critic for the New York Times, *reviewed the publication of Weston's nudes by Aperture as an opportunity to discuss what he believed to be the territory of photography. In its time, it seemed radical when Weston strove to make his work as straightforwardly photographic as possible. It seems conservative if not retrograde, however, for Canaday to state that the uniqueness of photography is to be found in its ability to transfix palpitating life, and not to deal with "lines, forms, and volumes which are the traditional province of other arts." Fifteen years previously Canaday had written: "Photography has not liberated the painter into the realm of pure art, but has robbed him. He is left with pure form and pure color, and he is left free to manipulate them in abstract exercises for the spiritual pleasure that manipulation may give him."[1]*

—A. C.

EDWARD WESTON WAS stricken with Parkinson's disease in 1948 and died ten years later at the age of seventy-two, which means that his last photographs were made a full generation ago and that some of his most famous have passed their half-century mark. A new book, *Edward Weston Nudes,* is composed of sixty photographs with a brief memoir by his second wife, Charis Wilson, who posed for a large percentage of them. Feeling, she says, "more like a historical monument than is quite comfortable,"

Charis Wilson finds that for the college students who ask her about Weston today, "Edward belongs with a past as distant as Brady or Daguerre."

As distant and, I found myself adding while first looking through this book, less viable —as far as the nudes are concerned. These are exquisite images, unspoiled by familiarity after all these years, and uncontaminated by the hundreds of proficient imitations and variations they have spawned. But I cannot help feeling that they represent the fulfillment of one concept of photography that is no longer vital, rather than a chapter that began with men like Daguerre and Brady and has grown richer and more exciting ever since. (Remember that we are talking about nudes, not Weston's photography in general.)

Say what you will, point to as many hybrids and borderline cases as you wish, and it will still be true that photographs fall into one of two classifications. Either they are art-photographs where first importance is given to inventive manipulation of the subject, or they are documentary photographs where the unviolated subject comes first even when the photographer—a photographer like Weston's contemporary, Lewis Hine—extends the documentary record into the field of revelation. And Weston's nudes are art-photographs. I am willing to risk the

flat statement that they are the best art-photographs ever made, but art-photographs they remain (figures 18, 19).

No one is going to love me for saying it, but there is less life in these photographs of beautifully posed living models than in the crudest Brady photograph of a soldier lying cramped and twisted in the haphazard attitude of death. Weston's nudes are a partial contradiction of his historical position, his insistence that photography, as "the most important graphic medium of our day . . . does not have to be, indeed cannot be—compared to painting—it has different means and aims," a premise that has become a cliché among photographers even when they don't observe it. In his earliest nudes, Weston went in for gauzy effects derived from impressionist painting and precious Whistlerian Japanesey arrangements of figure and background. A few examples are included in this new book for their retrospective interest. Obvious borrowings of this kind soon disappear, yet a fundamental relationship to the aesthetics of painting (and sculpture) is undeniable in even the most "photographic" of the later work.

On one hand a great deal has been said about the sensuality of Weston's nudes, and on the other, just as much (and just as mistakenly) about his transformation of that sensuality into an area of philosophical abstraction. I don't see that either of these exaggerations, either way of trying to see these nudes, holds. Weston himself was sometimes given to highflown romantic philosophizing about the content of his art, and we know destroyed a series of notebooks in which he found his perorations embarrassing. Against all this, I would balance a single instance, Weston's response

to a new model, when, seeing her nude for the first time, there "appeared to me the most exquisite lines, forms, and volumes."

Lines, forms, and volumes as manipulated by painters and sculptors have been the components of art since ancient Egypt. The revolution of photography that sets it apart from other pictorial arts is that by recording unmanipulatable momentary images it can capture philosophical implications and varieties of emotional impact different from those that painters synthesize in images created by theory. The immediate image of a living moment transfixed by a lens in the service of an adroit and sensitive technician is the unique character of photography, which is weakened when it imitates the analytical manipulation of lines, forms, and volumes which is the traditional province of other arts.

Charis Wilson said indirectly what I have been trying to say when she commented, "I never really did think of these nude photographs as pictures of *me*. They were photographs by *Edward*—his perceptions and his artistry." Weston also observed about one of his nude series that they were "entirely impersonal, lacking in any human interest which might call attention to a living, palpitating body"—a denial, to my way of thinking, of the supreme birthright of the photographer, which is to show, as Hine did, that each face, each body, in the multimillions of human beings who have lived, is indeed entirely personal, and filled with human interest, identifying a living, palpitating individual in a living, palpitating, human mass.

The impersonality of Weston's nudes was impressed upon me a few years ago when I discovered—some twenty-five or thirty years

after it was taken — that one of the photographs of a woman's back that I had particularly admired (and still do) was of a friend of mine, Anita Brenner. After all I had known Anita in high school and off and on through the years when she was making her reputation as an authority on Mexican art and, as it turned out, posing for Weston, but I keep looking at this photograph and saying to myself, "That's really Anita? All that roundness, that abstraction of a backside to the form of a great pear-like fruit?" Anita just wasn't like that. She was a hard-driving intellectual with a vigorously featured face (hidden in Weston's photograph) and nothing at all, in appearance, manner, or conversational gambits, could identify her with the process of lush, impersonal, mother-nature fertility and procreation with which Weston arbitrarily identified her.

If the question is, "What's wrong with that?" the answer is "Nothing at all." Weston achieved what he was after in these nudes, and they continue to impress me. But if I have said that none of them has the life of one of Brady's dead soldiers, let me add that neither do they have the life of the fields, the dunes, the vegetables, that Weston photographed without reference to their precedents in painted images (figure 16). It is, after all, quite something to have attained the apogee of art-photography and to have been as well the pivotal figure in liberating photography from exactly that limitation. Weston has a right to both titles.

Coda: *Edward Weston Nudes* is a handsomely produced volume. Charis Wilson's remembrance is poignantly evocative, and the book belongs in every library of photography.

New Republic 177 (29 October 1977): 31-33.

1. John Canaday, "The Camera Did It. Why Deny It?" *New York Times* (10 June 1962); republished in his *Culture Gulch* (New York: Farrar, Strauss and Giroux, 1969): 19.

The Daybooks of Edward Weston: Art, Experience, and Photographic Vision

Shelley Rice

SHELLEY RICE ARTICULATELY discusses some methodological problems involved with evaluating Weston's art in relation to his writings. He also describes aspects of his stylistic evolution. On the whole, his analyses show incisive observation, although I question that the linear relationship he establishes between the progression of Weston's Parkinson's disease and presentiments of death are indeed manifested in his work.

Weston's vision continually evolved. He tended to take his own past less seriously than his present or future and, certainly by the 1940s, as he clearly indicated in his Daybooks, *he gradually became more sensitive to vital and natural processes and passings. He wrote to Minor White that, as far back as 1910, "Death was not a theme — it was just part of life — as simple as that."[1]*

—A. C.

ONE REPENTS HAVING written succinct and lapidary phrases upon art. — Bonnard

Robert Goldwater began his introduction to *Artists on Art* with the observation that "the contemporary artist, asked to write about his art, hesitates." Yet the contemporary scholar, faced with the words that the artist did persuade himself to write, must hesitate as well. Although formalist criticism has undermined the primary importance of biography and intention in the interpretation of works of art, the verbal production of artists in the twentieth century is too

large a legacy to be ignored. These resources do exist; the issue which must be discussed is the manner in which they are used.

In any study of the photographer Edward Weston, this problem is a complex one. Weston was a prolific writer throughout his career, and he produced not only aesthetic writings but a significant body of letters and two published diaries, *The Daybooks,* which record his activities and associations from 1923 to 1934. The existence of these journals has unfortunately caused historians and critics to revert to biographically based methods of pictorial analysis and interpretation. The major monograph on Weston by Benjamin Maddow, for instance, provides sorely needed biographical data, but it fails to penetrate into aesthetic issues or judgments beyond the words of Weston. Janet Malcolm, reviewing the Museum of Modern Art's retrospective of Weston's work for the *New York Times,* chose to focus not on critical comments about photographic realization but rather on a negative judgment of Weston's sex life as described in the *Daybooks.* Using this information, Malcolm projected this aspect of Weston's personality into her interpretations of the pictures. Such a use of biographical material, which fails to separate the artist's activities from his art, can only be misleading. When dealing with documents like the *Daybooks* of Edward Weston, this distinction must be made. As Weston himself commented: "Do

you ask of your butcher his moral attitude before buying a slice of ham?" (*Daybooks I:* 49).

The diaries are a record of the physical and emotional life of an artist over a period of eleven years, and they record the people, places, impressions, and moods of Weston's experience during this time. They are a refreshing and lively means of understanding the artist's response to his life; his descriptions of his angers, loves, insecurities, and commitments resound with the energy and intensity which are so powerful in Weston's prints. Yet they are not simply a verbal translation of the photographs, and any attempt to "restore the continuity between the refined and intensified forms of experience that are works of art and the everyday events, doings, and sufferings that are universally recognized to constitute experience"[2] must recognize their relationship in Weston's work. The journals are valuable in establishing a context for the artist's work, but a close reading of the *Daybooks* reveals that it is the opposition between art and experience — not the continuity — which must be stressed in any critical interpretation of Weston's works during these years.

To Weston, the activities recorded in the *Daybooks* represented an aspect of his life which was separate from his creative work. The diaries contain few explanations or analyses of particular photographs; the mentions of works which pervade the diaries are usually discussions of technical matters, superficial descriptions, or comments on the interpretations of others. As Ansel Adams noticed, the *Daybooks* "abound with beautiful observations of men and women, places, things, situations and deep

personal experiences. Never do we find Edward explaining a picture. But always we observe him praising, reacting, narrating, evaluating external things and situations. Once any of these were selected as the subjects of his photographs words ceased and the image took over completely."[3]

To Weston, the "headaches, heartaches, bellyaches" recorded in the *Daybooks* were "the mere tittle-tattle . . . the surface excitements . . . superimposed over the passionate seeking in photography."[4] The journals contain many comments reflecting the artist's displeasure with the transitory nature of his impressions, observations, and feelings: "I am doubting more and more the sincerity of these daily or semiweekly notes as they concern me personally — my 'real' viewpoint and feelings uncolored by petty reactions, momentary moods." (*Daybooks I:* 49).[5] Weston saw these vagaries of experience and change as surface impressions which obscured rather than clarified the "reality" he sought in his art, "the real — the object unaffected by atmosphere, moods . . . the eternal basic quintessence each object has." (*Daybooks II:* 46).

Weston's attempts to achieve "the real" are most evident in the still-life photographs which span the years during which the *Daybooks* were composed. The artist verbally described these works as "objective" revelations of pure form, straight photographic reproductions devoid of interpretation or manipulation. The prints were carefully preconceived and previsualized. The possibilities of movement, change, or accident were deliberately minimized, as were any temptations to willfully inject his own momentary impressions and subjective moods. Weston was seeking to purge from

these images the transitory actions and moods which he criticized in the record of his daily experiences.

The still-life photographs are detailed, close-up examinations of isolated forms. Standing out against dark backgrounds and filling the picture plane, these chambered nautiluses, peppers, cabbage leaves, artichokes, etc., are severed from their usual connotations (figures 14, 16, 17). Photographed during long exposure sessions, the physical forms of common objects are accentuated and intensified. Eternalized and monumentalized, these images seem to exist in an aesthetic realm removed from experiential reality, a static and silent vacuum in which normal temporal and spatial laws have been suspended.

When Weston did discuss these works in the *Daybooks* he described them with such adjectives as "heroic," "detached," and "classical." Dody Thompson also referred to the "classical" quality of Weston's imagery in her article in *Malahat Review*.[6] Formally, they appear "classically" monumental and static. But a further definition of the term in this context is essential if it is to be used in the expanding vocabulary of photographic criticism.

The scholar J. J. Pollitt described the Greek artist's aversion to "the ebb and flow of nature . . . its subtle changes. Rather he chose to stand aside from nature, to analyze what its constituent elements were."[7] In seeking the "eternal basic quintessence each object has," Weston too was choosing to "stand aside from nature" in order to "objectively" present images isolated from their normal contexts in time and space. Photography is a temporal medium, but Weston's avoidance of the "ebb and flow of nature," his attempt to transcend time rather than to accept immersion in it willingly, is photographically "classical."

Weston's treatment of nude figures during these years retained the same aesthetic aversion to recording the "ebb and flow of nature (figures 18, 19)." The nude bodies are isolated and monumental, and the images often show close-up views of partial figures rather than whole ones. Faces are rarely present; psychological examination was rejected in favor of the presentation of the body for its purely aesthetic properties. These works were conceived to express a static balance which denies the expression of momentary animation or vital action. Gestures and movements are captured and frozen in a static tableau; the transitory stages of movement which would have placed the body within the flow of experience were excluded. Instead Weston sought the discovery of "the simplified forms . . . in the nude body . . . the infinite combinations of lines which are presented with every move." (*Daybooks II*: 12). It is this aesthetic aim that Janet Malcolm criticized in her review in the *New York Times*: "The nudes are sexless and impersonal . . . bodies transmuted into forms that follow no mere human (or sexual) function; even those showing pubic hair show it with formal rather than erotic intent." But Weston was consciously attempting to avoid the "human"; the vagaries of action and mood represented a world of experience which he was attempting to transcend.

The years 1929-37 mark a major change in Weston's artistic aims, a change which is indicated by his abandonment of the studio

still lifes. The discontinuance of the published *Daybooks* occurred simultaneously: the journals conclude in 1934, although regular entries end in 1932. The relationship between these two events does not appear to be coincidental. The late photographs abandon the classical detachment of the earlier work; as Weston's approach became more action-oriented, the "steam valve" of his experiences, once opened into the *Daybooks,* was incorporated into his art.

On March 21, 1929 Weston exclaimed in the *Daybooks:* "Point Lobos! I saw with different eyes." (*Daybooks II:* 114). The Point Lobos photographs were a catalyst to a change in Weston's visual patterns for a simple but significant reason: his "studio" was no longer his own home. The trips to the Point began to integrate the active experience of the artist into the creative act, for prior decisions about selection, arrangement, and visual focus were no longer feasible. The choice of subject matter was the result of an encounter between the photographer and the external world; the selection of imagery demanded Weston's full participation in discovery. The artist's excitement about the possibilities of recording spontaneous visual impressions intruded on his detachment: no longer able to "stand aside from nature," he gradually began to fuse the "classical" duality between his art and his experience.

The early Point Lobos photographs do not yet realize the potential artistic changes which Weston was to achieve later. Prints such as *Cypress Root* (1929) and *Eroded Rock* (1930) still show that Weston was limiting his imagery to single isolated forms. It is interesting to note that Weston's writings reflect his changing conception of the medium years before he was able to express it fully in the photographs. On June 19, 1930 he discussed the implications of photography's potential as an action medium in his *Daybook* entry: "photography suits the tempo of the age of active bodies and minds. It is a perfect medium for one who acts decisively, accurately" (*Daybooks II:* 168). This attitude first appeared in his aesthetic writings in 1931, in the "Statement" published in *Experimental Cinema:* "Today—photography—with capacity to meet new demands, ready to record instantaneously —shutter coordinating with the vision of interest impulse—one's intuitive recognition of life, to record if desired a thousand impressions in a thousand seconds."[8] "Previsualization"—his maxim, formulated in the early twenties, that a print be envisioned in its entirety before exposure—was earlier a means of achieving unmanipulated visual truth; now it became a function of the coincidence of vision and artistic response realized in a photograph, or what Peter Bunnell called "the relationship between significant action and revelation."[9]

The participatory nature of the new action aesthetic led to a decisive shift in Weston's verbal statement about the relationship between his photographic images and his own subjectivity, a shift which is clearly evident in the photographs by the mid-1930s. The *Daybooks* contain several defensive denials by the artist that his prints reflect his own interpretations of the subject matter. But by 1932 both the *Daybook* entries and the aesthetic writings indicate that he had reevaluated this question and accepted the role of subjective artistic response in straight photography. In the 1932 article "A Contemporary Means to Creative Expression," he stated for the first time that

"man is the actual medium of expression — not the tool he elects to use as a means."[10] He was no longer seeking to avoid his transitory impressions or emotional responses; his awareness of his dependence on his own experiential perceptions linked his photographs inextricably to time, space, and his own consciousness.

Weston fully realized the breadth and variety of "mass-production seeing" during his Guggenheim project of 1937-39. He was unfamiliar with the territory he traveled during the trip, yet he covered thousands of miles and exposed over 1500 negatives. The speed with which Weston chose to work did not allow for intense concentration on single forms; rather he became practiced in intuitive spontaneous judgments of the "strongest way of seeing" the myriad relationships of the complex and unfamiliar environments and landscapes. Vision and artistic action had to coincide; the power of his photographic responses had to be developed to correspond instantaneously with the temporal and spatial links of his own activity.

The effects of this change in Weston's understanding of his medium are obvious in a comparison of prints from the early and the later works. In 1925 he photographed a Mexican "Excusado," and devoted a passage in the *Daybooks* to its description: "I have been photographing our toilet, that glossy enameled receptacle of extraordinary beauty. . . . My excitement was absolute aesthetic response to form. . . . Here was every sensuous curve of the human form divine but minus imperfection." (*Daybook I:* 132). The image is a close-up of the bowl and support of a toilet which almost fills the picture plane; the curves and details of its shiny surface are clearly emphasized. But

the photograph of the toilet in the *Golden Circle Mine, Death Valley* of 1939 uses the same iconography to express a very different conception. The toilet, although centered, takes up only a small part of the picture plane. The image encompasses three walls of the room in which the object stands, and the details are now concentrated throughout the print with equal intensity. The toilet is obviously old and worn; its cover shows cracks, its base is soiled and black. Above it is a broken window through which ramshackle buildings can be seen. No longer isolated, the toilet is seen in the context of the space in which it once functioned and the ongoing time which led to its desertion. This image is not a study in pure form; it is Weston's expression of the decay in the abandoned mining town.

At this time Weston was fifty-three years old; within several years he was to become ill with the Parkinson's disease which ended his photographic career in 1948. During these years, the subject matter of his prints shows an increasingly gloomy cast, as if the artist's presentiments of death and decay caused him to focus on natural forms and scenes which expressed his fear. *Golden Circle Mine, Death Valley* is a case in point; *Wrecked Car* of the same years is a gray and desolate image of an abandoned car which has been destroyed by natural forces on Crescent Beach. Elemental forces such as erosion and decay are major recurrent themes throughout Weston's work, but they play different roles in the early photographs and the late. *Eroded Rock* of 1930, with its beautiful interplay of the light rock against the dark ground, is primarily a study of the rhythms and shapes of natural forms. The processes of time and elemental destruction shaped the rock, but they are secondary themes.

This is not the case in *Surf, Point Lobos* of 1947. Here, gnarled and furrowed rocks, their irregularly carved forms photographed with precise detail, are pounded by the breaking surf. The print emphasizes the intense contrast of dark and light between water and land. In this image Weston captures the violent and constant drama of the clash of elements, a clash in which natural forms are eroded and destroyed. Death is the theme here, not the beauty of pure and static form. The natural world is a reflection of the artist's understanding of his own life processes and impending death.

In these late photographs Edward Weston was able to merge the two levels of experience which had been distinct in his life during the period of the *Daybooks*. Rather than visual revelations of a detached and monumental reality, he saw his late images as the result of a communion established between nature and man. Weston saw that this union was possible through his ability to "identify myself in, and unify with, whatever I am able to recognize as a significant part of me: the 'me' of universal rhythms." (*Daybooks II:* 245). As John Upton wrote of the later works: "These photographs are not the order imposed by the man on his surroundings, but mirrors of the order within the man. There is no comment about these elemental forces, only a recognition of their existence in nature and in the man himself. Nature and man have achieved a complete rapport."[11]

Art Journal 36 (Winter 1976-77): 125-29.

1. Edward Weston to Minor White, undated, Center for Creative Photography, University of Arizona, Tucson.

2. John Dewey, *Art as Experience* (New York: Capricorn Books, 1958): 3.

3. Ansel Adams, "Review of *The Daybooks of Edward Weston, Volume 1: Mexico*," *Contemporary Photographer* 3 (Winter 1962): 48.

4. Dody W. Thompson, "Edward Weston," *Malahat Review* (April 1970): 58.

5. All short, unmarked quotations are from the paperback edition of *The Daybooks of Edward Weston*, Vol. I and II (1973).

6. Thompson, "Edward Weston": 62.

7. J. J. Pollitt, *Art and Experience in Classical Greece* (London: Cambridge University Press, 1972): 5.

8. Edward Weston, "Statement," *Experimental Cinema* No. 3 (1931): 15.

9. Peter Bunnell, "Photography as Printmaking," *Artist's Proof* No. 9 (1966): 24.

10. Edward Weston, "A Contemporary Means to Creative Expression," reprinted in Nathan Lyons, *Photographers on Photography* (Englewood Cliffs, New Jersey: Prentice Hall, Inc., 1966): 158.

11. John Upton, "Edward Weston: Photographer," *Image* 4, No. 6 (September 1955): 45.

Clouds (1924): Edward Weston and the Essence of the Object

James L. Enyeart

JAMES L. ENYEART IS *Director of the Center for Creative Photography at the University of Arizona in Tucson, the institution now responsible for administering Weston's estate. In this essay he clarifies Weston's aesthetic in the 1920s by comparing it with those of the photographers Man Ray, Laszlo Moholy-Nagy, and especially Albert Renger-Patzsch. All of these men had shown works at the Film und Foto Exhibition sponsored by the Deutsche Werkbund in Stuttgart in 1929. Moholy-Nagy and Weston, moreover, had been partly responsible for the selection: Moholy-Nagy because he had been a master at the Bauhaus; Weston because the architect Richard Neutra had asked him to select photographs from the West Coast. Weston had also written an introduction which was published in the catalog. The purpose of the exhibition, it was announced, was to "bring together for the first time work of those people, at home and abroad, who have broken new paths in photography. . . ."[1] Gustaf Stotz, the director, exclaimed: "A new optic has developed."[2]*

—A. C.

AMONG THE TREASURES in the Edward Weston archive at the Center for Creative Photography, University of Arizona, is an early platinum print of a cloud made in Mexico in 1924. During the period that Weston lived and worked in Mexico his style underwent dramatic change and this cloud photograph is representative of that transition. Weston's admiration for the simple, direct paintings on the facades of the pulquerias and the forceful forms of the native crafts inspired in his own work an interest in the evocative potential of singular shapes and forms. The vestigial romanticism of his earlier pictorial work gave way to a concern for what he described as the essence of objects (figure 13 shows related images).

This cloud photograph and one of a palm tree that has often been recognized as one of his master works were made at the same time. Both embody his complex appreciation for "the thing itself." At the moment of creation of these two photographs Weston could not fluently describe the meaning that he felt made them different from all of his other photographs. Yet, he recognized that they represented a force in his photography that was growing and changing his vision. During this period he made notes to himself that would later contribute to his famous Daybooks. An excerpt from a note dated August 31, 1924 described the photograph of the palm tree:

"The trunk of a palm towering up into the sky—and not even a real one—a palm on a piece of paper—a reproduction of nature—I wonder why it should affect others so emotionally—and I wonder what prompted me to record it—many photographs might have been done of this palm—and they would be just a photograph of a palm—yet this picture is but a photograph of a palm—plus something—something—and I cannot quite

say what that something is—and who is there to tell me?"[3]

In the same note Weston also recognized that the palm photograph had the same "aesthetic value" as his earlier photograph of smokestacks (figure 10). His questioning about the special quality of the image was rhetorical in the sense that he knew that the answer was beyond verbal description. It was clear that he recognized the compositional and aesthetic links between the smokestacks and palm and now the image of a cloud. On September 30, and October 2, 1924, a month after writing about the palm photograph, Weston wrote these notes about the cloud print:

"One of my favorite *new* negatives, I despair of getting a good platinum print—it is a sky with delicate white cloud forms—and after repeated attempts I must admit that my original proof for study on 'Azo' pleases me more than the platinum—the 'gaslight' print is more nebulous—more subtle and its colder tone more suitable—I shall try one more—

"My print yesterday is an improvement but not yet what I visualize—the trouble is this—the slight tone of the buff stock is just enough to destroy the more subtle gradations in the clouds—their delicate brilliancy—and with the addition of bichromate to gain the apparent brilliancy of the Azo print—I cut the clouds out against the sky in a way as though they were pasted on—admitted—indeed—that one peculiarity of the summer clouds here is the way in which the clouds are 'cut out' against the sky—great white, ever changing, swiftly shifting forms against a ground of the deepest blue—there is an exaggeration in my print

not satisfactory—I shall bide my time—But I did pull a print yesterday to compensate for my other failure—a new printing of my palm—it is dazzling in its brilliance—and the improvement shows what might be done by repeated experiments."[4]

The answer to what Weston could not put into adequate words lies not in further description of the photograph, but in an overview of his final stance on the aesthetics of photography. This can be accomplished in part by referring to a parallel aesthetic concern of one of Weston's peers, Albert Renger-Patzsch.

Both photographers formulated and refined their technical skills and aesthetic approaches during the twenties, as described by Beaumont Newhall as a decade in which two directions predominated: "The direct use of the camera to bring us face to face, as it were, with the thing itself in all its substance and texture; and the exploration of a fresh vision of the world, even autonomous, images unrelated to realism."[5]

For those who chose either direction, an awareness of a strong opposing force provided an intense sense of dedication to individual beliefs. Certainly Moholy-Nagy served as a catalyst for Renger-Patzsch's ideas:

"The attempts of Man Ray, Moholy-Nagy and other newer photographers, to create something abstract with photography, are not real photographs. But they usually still need an object, which they singly strip of its everyday character. They don't really prove anything, and it's hard to understand why anyone would want to use photography to accomplish something art can accomplish more perfectly."[6]

In a different way Alfred Stieglitz was the catalyst that Weston needed to define his obsession with the object. Weston had visited Steiglitz in New York in 1922, shown him a set of prints, and received a mixed reaction of criticism and praise. Weston reported in his daybook that he felt "stimulated." However, by 1927 when Stieglitz expressed criticism of Weston's growing use of organic forms (shells, nudes, clouds), Weston exploded in his daybook:

"If I had sent my toilet, for instance, how then would he [Stieglitz] have reacted? And must I do nothing but toilets and smokestacks to please a Stieglitz! Is his concern with subject matter? Are not shells, bodies, clouds as much today as machines? Does it make any difference what subject matter is used to express a feeling toward life! And what about Stieglitz' famed clouds? Are they any more today than my subject matter? He contradicts himself!"[7]

Dan Helfferich, a good friend of Renger-Patzsch, wrote an article for *Foto* magazine (1967) which described the importance of the object to Renger-Patzsch: "For him the most important thing was discovering and experiencing the essence of objects, and he viewed it as the job of the photographer to reflect the being of things in as many ways as possible. He endeavored to capture the essence, brought forth by the object, in a photograph, so that observers could see the essence of the object in the photograph without being hampered by personal views of the photographer."[8]

Renger-Patzsch himself put it this way:

"Without getting lost in a tangle of conceptual definitions, we can safely say that the means of photography are a lens, camera, plate, and film and that its object is the visible world. Its purpose is therefore to produce pictures of the visible world. This job is not without its attractions, for photography takes over the role of the eye, and the photo represents the object that was seen. I said not without attraction because vision is a highly complicated, completely subjective, one could even say 'creative activity.' It presents the sum of many experiences over a period of time and joins them in a total picture for evaluation. The ability to see and to assimilate that which is seen is quite different in different people, depending on their personalities and education. Goethe declared with resignation: 'the hardest thing to do is to see that which is before our eyes.' To a certain extent photography is supposed to replace this activity of seeing. Thus, the object, which has been abandoned by modern painting and has hardly begun to be exploited by photography, stands as the greatest assignment."[9]

Weston's description of the "object" as subject matter was more spiritual than Renger-Patzsch's, but then so was his approach to making photographs: "For what end is the camera best used aside from its purely scientific and commercial uses? . . . The answer comes always more clearly after seeing great work of the sculptor or painter, past or present, work based on conventionalized nature, superb forms, decorative motives," he continued. "That the approach to photography must be through another avenue, that the camera should be used for a recording of life, for rendering the very substance and quintessence of the thing itself, whether it be polished steel or palpitating flesh . . . I shall let no chance pass to record interesting abstractions," he

concluded, "but I feel definite in my belief that the approach to photography is through realism—and its most difficult approach."[10]

A trust in realism and the enduring qualities which it promised inspired in Renger-Patzsch and Weston the common approach to making photographs that they used during the twenties. For Renger-Patzsch, Germany was in a period of reconstruction following World War I and the most firm foundation for faith in the future was logically rooted in "reality." Weston, on the other hand, lived and worked in a modestly self-imposed isolation. With all of nature (reality) about him in California and Mexico, he was free from the forces of intellectualism which pervaded the densely-populated metropolitan cities.

Renger-Patzsch's approach to the object was through careful selection of subjects which would reveal the hidden forms and universal feelings bound up in man's psyche. He often noted that not all objects were material for good photographs and that the photographer must first feel the essence of the object, before he can photograph it. In a sense, this was the concept most shared by Renger-Patzsch and Weston. However, their photographs reveal that while Renger-Patzsch looked for objects, Weston looked for forms. For both photographers, symbolism and interpretation were in the eyes of the beholder and the essence of the thing itself was their only goal.

The regard which these two artists held for the object was the foundation for their aesthetic philosophies. However, the analysis they applied to their own photographs is the key to understanding the complexity of those aesthetics. Their photographs represent composite statements of the many tangential ideas which they held about photography and life in general.

Renger-Patzsch was a pragmatist and, as such, assigned art to the idealist. He maintained that photography should not be concerned with art or craft. Rather, it was the vehicle by which the realist could perceive and reveal the real world as opposed to the imagined world of the artist. For a lecture delivered in 1956, he wrote:

"It is clear that photography is not a craft, because most of the hand work can be replaced by mechanization without affecting the quality of the photograph. So we have to assign photography to a category of its own. Its value is determined partly through aesthetic, partly through technical judgments (we're using the word *aesthetic* here in its original Greek meaning of *perceive* and not in the washed-out sense that it is used today)."[11]

Renger-Patzsch asserted that not every visible object is a photographic one. He cited landscape, portraiture, and architecture as examples of objects which were generally suitable for investigation by the photographer and concluded that "photography, regardless of which aspect of it we view, is a graphic process 'sui generis,' neither art nor craft. And on the basis of its mechanical structure, it seems to me to be better suited for doing justice to an object than for expressing an artistic individuality."[12]

Renger-Patzsch distrusted the emotional content of his own or any artist's decisions and insisted that the more one submitted to one's emotional drives, the greater the

danger of one being or becoming a dilettante. He was fond of quoting a letter of Turgenev: "If you know how to express something completely and briefly just as you perceived it, then perhaps there is a writer in you; but if, as you begin you give rein to your emotions and persist in this practice, then you will remain a dilettante."[13]

Edward Weston addressed the problem in this manner: "Now I want to see the eternal, basic quintessence each object has and its relation to the great whole." While this concept can clearly be seen as a common aspect of Renger-Patzsch's and Weston's aesthetics, it can also be misleading. Weston was interested in more than perception of the object. He desired to present "the significance of facts, so they are transformed from things seen to things known."[14]

Chance, emotions, and "Art," the very things which Renger-Patzsch seemed to have distrusted most, were major ingredients in Weston's philosophy: "I say chance enters into all branches of art: a chance word or phrase starts a trend of thought in a writer, a chance sound may bring new melody to a musician, a chance combination of lines new composition to a painter . . . I take advantage of chance—which in reality is not chance—but being ready," he continued, "attuned to one's surroundings—and grasp my opportunity in a way which no other medium can equal in spontaneity, while the impulse is fresh, the excitement strong. . . . So in photography," he concluded, "the first fresh emotion, feeling for the thing, is captured complete and for all time at the very moment it is seen and felt."[14] Thus his satisfaction in his study of the evanescent cloud.[15]

To Renger-Patzsch "emotion" was a word which described a non-objective, non-critical, non-discriminating state of thought, a facet of the human personality which could compromise the mind's ability to see clearly. But to Weston the word "emotion" was neither a threat nor an aid. It was simply a symbol for the well-spring from which all eternal feelings of "things seen and things known" derived. "That I am emotional to a degree I well know," he wrote, "that I feel intensely the drama of this life around me, and feel a part of it, I acknowledge: that I have been theatrical in my seeing I do not believe. If, with a clear vision, I have seen more than the average person sees—well that's my job!—to reveal, to sublimate."[16]

In his pragmatic way, Renger-Patzsch was also bound by his literal interpretation of the word "art." He rejected the idea that art and photography were compatible. For him art could not apprehend reality and should exceed it. Weston, on the other hand, did not believe art could be categorized or defined by medium. In his daybooks he periodically attempted to explain, defend, or simplify his understanding of art, artists, and the aesthetic morass which he felt clouded the meaning of the word. In a beautifully simple and direct way, he tried to clear the air when he wrote:

"I have always said—an abstract idea can be expressed by literal or exact representation, but I do not think it can be done unless the 'soul' be very much aware of it. If a soul be unaware, and a camera be used to copy an apple, the result can be no more than a record of an apple: but give the same camera and apple to one who sees more than said apple's surface and edible qualities, who

understands the apple's significance—then, the result will be— more than an apple!"[17]

Despite the spiritual differences which separated the aesthetic concerns of Renger-Patzsch and Weston in regard to art, emotion, and the object, both artists eventually divorced themselves from any concern or association with traditional aesthetic problems. They both rejected "self-expression" and "interpretation" as viable aesthetic concepts for photography. Each in his own way sought to identify with nature. They both believed that man could not create or imagine any form, no matter how abstract, that did not already exist in nature. Therefore, to them, interpretation and personal expression only veiled the eternal truth (nature) with sociological prejudices, psychological distortions, and romantic misconceptions. Neither man was a lover of others' work. Both attributed their greatest influences to literature and music. Renger-Patzsch and Weston were not self-taught artists in the manner of the true primitive, who is ignorant of all but intuition. Yet they both regarded intuition and feeling as prime ingredients of the artist's ability to recognize the essence of the thing itself.

Both Renger-Patzsch and Weston were well informed on international developments in the art world, past and present. The narrowness of the views which they held regarding their own work was not an attempt to deny the validity of other artists' work, but to fortify their own photographic approaches with potentials of their own—to give them the same flexibility as other mediums. In fact, flexibility was a word they both used to describe the virtues of the straight print. They felt that hand manipulation and aesthetic imitation of other mediums (particularly painting) only anchored photography to already established precepts. If the natural world encompassed all the forms that could possibly exist in the mind, then it was there that photography had its greatest flexibility.

Weston sought universal character in his photographs. He wrote:

"The photographer—the purist—like myself, going directly to record nature exactly, without the human interference of the hand, must be singularly free from personal interpretation of nature. I have used the phrase 'significant presentation' to indicate my way of seeing 'the thing itself.' My personal viewpoint, my individualism comes forth, the parts I select to present, the fundamental structure I feel and extract from nature, isolate in my negative. I have been related in articles to Brancusi in my use of 'abstract form.' Yet they are all forms abstracted from nature: my seeing of life, recognition of cause, intuitive understanding."[18]

Weston's "significant presentation" was not only presentation of the object—whether the nude or this cloud study—but presentation of those qualities within or about the object which paralleled his "recognition of cause," his intuitive understanding. The essence which Weston sought was more than a simple amplification of the object's own spirit. He took nature out of context. He isolated form and feeling from environment and circumstance. The essence he sought was his own.

Three Classic American Photographs: Texts and Contexts (Exeter: University of Exeter American Arts Documentation Centre, 1982): 23-30, 40-41.

1. Translated by Beaumont Newhall, "Photo Eye of the 1920s: The Deutsche Werkbund Exhibition of 1929" *New Mexico Studies in the Fine Arts* 2 (1977): 6.

2. Ibid.

3. Notes from the Edward Weston archive, Center for Creative Photography, University of Arizona, Tucson.

4. Ibid.

5. Beaumont Newhall, informational leaflet for "Photo Eye of the 20s" (New York: Museum of Modern Art, 1970).

6. Fritz Kempe, "Albert Renger-Patzsch, Der Fotograf der Dinge," [Exhibition catalog.] (Essen: Ruhrland und Heimatmuseum, 1966).

7. *Daybooks II:* 24.

8. "Bij het werk van Albert Renger-Patzsch," *Foto,* No. 11 (Doetichem, Holland, October 1967): 546-11 to 556-11.

9. Albert Renger-Patzsch, "An Essay Toward the Classification of Photography," *Schrift 6* (Essen: Folhwang Schule, October 1958). Reprinted in *Untitled* 12 (August 1977): 19-20.

10. *Daybooks I:* 55.

11. *Untitled 12:* 20.

12. Ibid.: 23.

13. Ibid.: 23.

14. *Daybooks II:* 241.

15. Ibid.: 155-56.

16. Ibid.: 251.

17. Ibid.: 220.

18. *Aperture* 12 (1965): 76.

Edward Weston Chronology

Nancy Newhall

1886 Born 24 March, Highland Park, Illinois.

1902 First photograph, with Bulls-Eye camera given by father.

1903 Left high school, worked for Marshall Field and Company. Continued to photograph.

1906 To California. Worked with surveyors on railroads in Los Angeles and Nevada. Decided to become a professional photographer. Started by house-to-house portraiture with postcard camera.

1907-11 Attended Illinois College of Photography. Worked as a printer in commercial studios in Los Angeles.

1909 Married Flora May Chandler. Four sons born: Chandler, 1910; Brett, 1911; Neil, 1916; Cole, 1919.

1911 Built own portrait studio in Tropico (now Glendale), California.

1914-17 Commercial and pictorial success; received awards and demonstrated portrait technique to Photographers Association of America. Elected to London Salon of Photography.

1921 Began to change style from the sentimental "pictorialist" work to sharply focused compositions highly influenced by modern abstract art.

1922 To New York. Visited Alfred Stieglitz, Paul Strand, Charles Sheeler. En route made photographs of the Armco factory in Ohio.

1923 To Mexico with son Chandler and Tina Modotti. Opened portrait studio. Met leading painters: Diego Rivera, Jean Charlot.

1924 In December he returned to California and shared a studio in San Francisco with Johan Hagemeyer.

1925 In August he returned to Mexico with son Brett. Rejoined Tina Modotti.

1926-27 In November he returned to California. Began series of close-ups of shells, vegetables. Also nudes in motion.

1928 Opened studio in San Francisco with Brett.

1929 To Carmel, California. Studio with Brett. First photography of Point Lobos. Selected work of West Coast photographers for Deutsche Werkbund exhibition "Film und Foto" in Stuttgart. Also contributed foreword to catalog.

1930 First New York exhibition, Delphic Studios.

1932 Invited to be a member of Group *f*/64, founded by Willard Van Dyke and

Ansel Adams. Merle Armitage published first book of Weston photographs.

1934 Met Charis Wilson, whom he was later (1938) to marry.

1935 Studio in Santa Monica with Brett.

1937 Awarded a John Simon Guggenheim Memorial Fellowship—the first given to a photographer. Photographed extensively in California, Arizona, New Mexico, Nevada, Oregon, Washington.

1938 Guggenheim Fellowship renewed. Divorced Flora, married Charis. "Wildcat Hill" built for them in Carmel by sons.

1940 Publication of book *California and the West,* a selection of photographs taken during Guggenheim Fellowship with text by Charis.

1942-43 Active in civil defense in Carmel during World War II.

1945 Weston and Charis divorced.

1946 Major retrospective at The Museum of Modern Art, New York.

1948 Stricken with Parkinson's disease, became unable to use camera and process negatives and prints. His last negative "Rocks and Pebbles, 1948."

1950 Major retrospective in Paris.

1958 Died January 1 at his home in Carmel.

Adapted from Nancy Newhall, *The Photographs of Edward Weston* (New York: The Museum of Modern Art, 1946): 34.

Article Credits

A. D. Coleman, "Beyond Peppers and Cabbages" (12 September 1971)

Hilton Kramer, "Edward Weston's Privy and the Mexican Revolution" (7 May 1972)

Janet Malcolm, "The Dark Life and Dazzling Art of Edward Weston" (2 February 1975)

Frances D. McMullen, "Lowly Things That Yield Strange, Stark Beauty" (16 November 1930)

—Copyright © by the New York Times Company. Reprinted by permission.

Nancy Newhall, "Edward Weston and the Nude" (June 1952)

Nancy Newhall, "Comments: Color as Form" (December 1953)

Nancy Newhall, "A Great Photographer Dies: Edward Weston 1886-1958" (April 1958)

Cole Weston, "Dedicated to Simplicity" (May 1969)

—Reprinted with permission from *Modern Photography* magazine.

Nathan Lyons, "Weston on Photography" (May-June 1975)

Peter Bunnell, "Weston in 1915" and Nathan Lyons "Reply (to Peter Bunnell's 'Weston in 1915')" (December 1975)

—Reprinted with permission from *Afterimage* magazine.

José Rodriguez, "The Art of Edward Weston: Edward Weston—Crazy About Photography as was Hokusai About Drawing" (November 1930)

F. H. Halliday [Charis Wilson], "Edward Weston" (January 1941)

—Reprinted courtesy of *Arts and Architecture* magazine.

Jean Charlot, "Edward Weston," from Jean Charlot, *An Artist on Art: Collected Essays,* vol. I (1972)

—Reprinted with permission from the University of Hawaii Press, Honolulu, Hawaii.

"Ex-Rabbit," from *The Talk of the Town* (23 February 1946)

— © 1946, 1974 The New Yorker Magazine, Inc. Reprinted by permission.

"People Talked About," from *The Carmel Pine Cone* (25 October 1929)

W. K. Bassett, "Dedicated to Edward Weston," and Mary Bulkley, Henrietta Shore, et al., "Appreciations of Edward Weston," from *The Carmel Cymbal* (17 April 1935)

—Reprinted by permission from *The Carmel Pine Cone.*

George P. Elliott, "The Monster as Photographer" (Winter 1962-63)

—Reprinted by permission from *The Hudson Review,* vol. XV, no. 4 (Winter 1962-63). Copyright © 1963 by The Hudson Review, Inc.

Dody Weston, "Edward Weston" (April 1970)

—Reprinted by permission from *The Malahat Review.*

Beaumont Newhall, "Edward Weston's Technique," in *The Daybooks of Edward Weston, Volume I: Mexico,* ed. by Nancy Newhall (1973)

—Reprinted by permission from Aperture, Inc.

John Canaday, "Edward Weston Nudes: Sixty Photographs; Remembrance by Charis Wilson" (29 October 1977)

—Reprinted by permission from *New Republic.*

James L. Enyeart, "Clouds (1924): Edward Weston and the Essence of the Object," in *Three Classic American Photographers: Texts and Contexts* (1982)

—Reprinted by permission from The University of Exeter, American Arts Documentation Centre, England.

Arthur Millier, "Some Photographs by Edward Weston" (2 January 1927)

—Copyright, 1927, *Los Angeles Times.* Reprinted by permission.

Kevin Wallace, "Edward Weston, Photographer: Birthday of a Modern Master" (2-3 April 1950)

— © San Francisco Chronicle, 1950. Reprinted by permission.

Minor White, "The Daybooks of Edward Weston," *Aperture* 10 (1962)

—Reprint courtesy of The Minor White Archive, Princeton University. Copyright © 1961 Aperture, Inc.

Shelley Rice, "The Daybooks of Edward Weston: Art, Experience, and Photographic Vision" (Winter 1976-77).

—Reprinted by permission from *Art Journal,* College Art Association of America.

Clement Greenberg, "The Camera's Glass Eye" (9 March 1946)

Bruce Downs, "Tortuous Animadversions" and Clement Greenberg, "Rebuttal" (27 April 1946)

—Copyright © 1946, *Nation* magazine, The Nation Associates, Inc. Reprinted by permission

Beaumont Newhall, "Edward Weston in Retrospect" (March 1946)

—Reprinted by permission from *Popular Photography* magazine.

Beaumont Newhall, "Fred Evans and Edward Weston on Pure Photography" (1964)

—Reprinted by permission from the George Eastman House, Rochester, New York.

Photograph Credits

All photographs are courtesy of the Center for Creative Photography, University of Arizona, Tucson, with the exception of the following:

Self-Portrait, 1911

Mr. Weston — Camera — Graf Variable, ca. 1918

Cover of *Irradiador,* no. 3, 1924, with Edward Weston's *Smokestacks* or *Steel* from 1922

Edward Weston Taking Beaumont Newhall's Portrait, Carmel, 1940

Edward Weston: After the Portrait, Carmel, 1940

Edward Weston in His Darkroom Window, Carmel, 1940

Prints and Fruit — Weston Studio, 1940

Edward Weston on Point Lobos, 1940

Nancy Newhall, 1944

Edward Weston and Beaumont Newhall "Help" Ansel to Photograph at Big Sur, California, ca. 1945

Edward Weston, ca. 1945

Beaumont and Nancy Newhall at Point Lobos, 1945

Edward Weston with Nancy and Beaumont Newhall at the Opening of His Retrospective at the Museum of Modern Art, 1946

Edward Weston's Desk, 1948

— From the Collection of Beaumont Newhall

Portrait of Edward Weston, Mexico, 1924

Weston in His Studio, Carmel, California, 1933

— University Press of Hawaii, Honolulu, Hawaii

Willard Van Dyke, ca. 1933

Edward Weston at 683 Brockhurst, ca. 1933

— Collection of Willard Van Dyke, Sante Fe, New Mexico

Portrait of Edward Weston, 1945

— From the Collection of Ansel Adams

Edward Weston Dry Mounting Prints, ca. 1945

— Courtesy of Bruce Holgers, Santa Cruz, California

Ricardo Gómez Robelo, 1921

— Collection of The Art Institute of Chicago, Chicago, Illinois

Robinson Jeffers, 1929

— *Time Magazine* (4 April 1932)

Edward Weston, 1915

Edward Weston's Studio in Tropico, 1915

— *The American Magazine* 80 (August 1915)

Carlota, 1914

— *American Photography* 10 (November 1916)

A Flower from the Land of Sunshine or *Study in Gray,* 1914

— *Photo-Miniature* 13 (August 1916)

El Cielo de Mexico (The Sky of Mexico), with photographs by Edward Weston, 1923-24

— *La Antorcha,* (15 November 1924)

Index